Botanical Riches

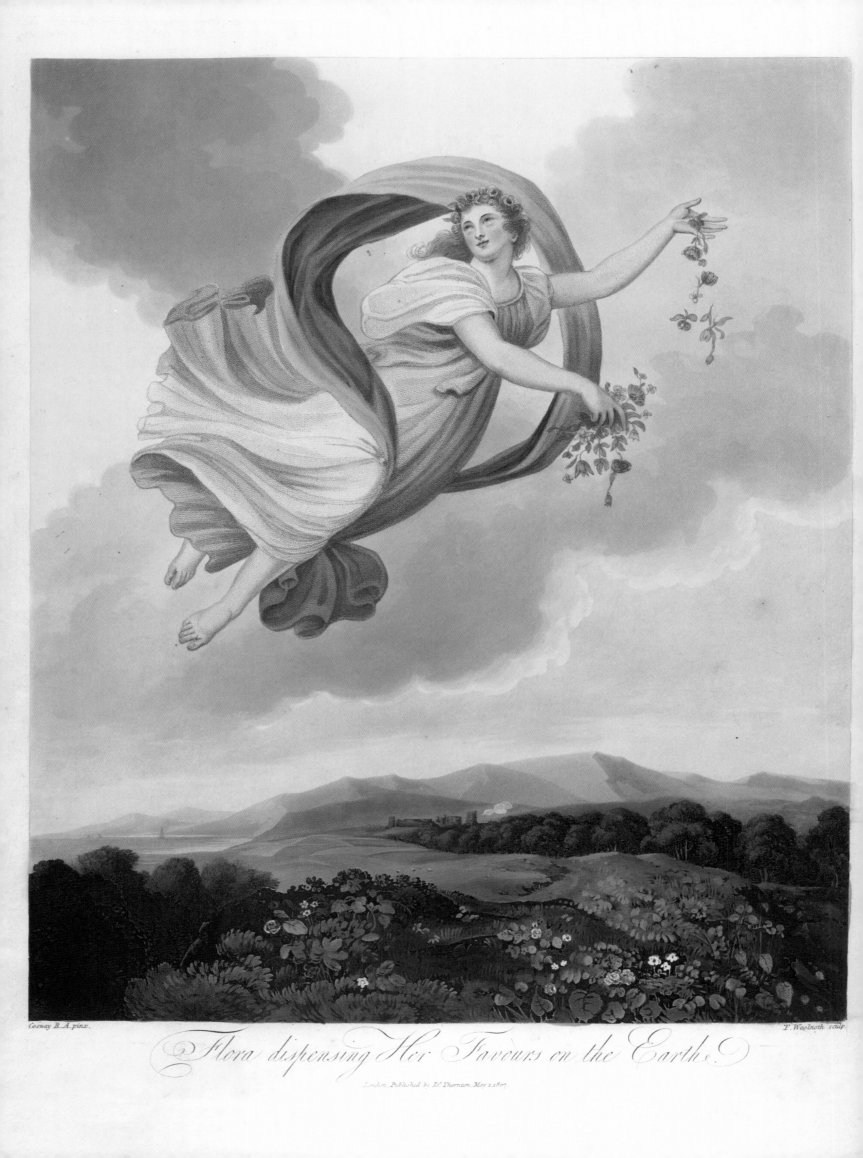

Cosway R.A. pinx.

T. Woolnoth sculp.

Flora dispensing Her Favours on the Earth.

London, Published by D.r Thornton May 2 1807

Botanical Riches

stories of botanical exploration

RICHARD AITKEN

LUND HUMPHRIES

Published in 2007 by
Lund Humphries
Gower House
Croft Road
Aldershot
Hampshire GU11 3HR

and

Lund Humphries
Suite 420
101 Cherry Street
Burlington
VT 05401-4405
USA

www.lundhumphries.com

Lund Humphries is part of Ashgate Publishing

British Library Cataloguing-in-Publication Data
A catalogue record for this book is available from the British Library

ISBN–10 0 85331 955 3
ISBN–13 978 0 85331 955 9

Library of Congress number 2006930125

First published in 2006 by

THE MIEGUNYAH PRESS

An imprint of Melbourne University Publishing
In association with the State Library of Victoria, Australia

Text © Richard Aitken
Design and typography © Melbourne University Publishing
Illustrations © individual copyright holders

Edited by Clare Coney
Designed by Pfisterer + Freeman
Typeset in Minion by Pfisterer + Freeman
Printed in Singapore by Imago Productions
Photography for the State Library of Victoria by Emilee Seymour

Image on page ii: from Robert Thornton, *New Illustration of the Sexual System
of Carolus Von Linnaeus*…and the Temple of Flora, or Garden of Nature…,
Printed, for the Publisher, by T. Bensley, 1799–1807 (detail from unnumbered
plate depicting 'Flora Dispensing her Favours on the Earth'). [Courtesy: State
Library of Victoria]; image on page viii: from Robert Thornton, *ibid.*, (detail
from unnumbered plate of 'The Queen' [*Strelitzia reginae*]). [Courtesy:
Heywood Bequest, Carrick Hill House Museum and Historic Garden,
Adelaide]

CONTENTS

Part III

SCIENTIFIC IMPERIALISM AND EXOTIC BOTANY

From the 1750s to the 1900s

Part IV

LIVING FOSSILS

The 1900s and Beyond

Acknowledgements

The research, writing, and production of this book have been greatly assisted by several generous partners. I would firstly like to acknowledge the very generous support of the State Library of Victoria through its award of a 2004–05 Creative Fellowship, and also for facilitating funding from the Charles Sunberg Bequest to support my research. The State Library of Victoria also very generously supported the publication by undertaking digital imaging of works from its collections. I am also grateful to David Thomas and directors of The Thomas Foundation for their generous financial assistance, and particularly to Max Bourke, director and keen student of garden history, who facilitated this support. In parallel with the publication of this book, an exhibition of the same title is being hosted by the Botanic Gardens of Adelaide and Carrick Hill House Museum and Historic Garden, Adelaide. I am grateful to those institutions and to the assistance of their directors, Stephen Forbes and Richard Heathcote, for their generous funding of the *Botanical Riches* project. The Botanic Gardens of Adelaide additionally funded digital imaging of all items from Adelaide-based institutions.

Within the State Library of Victoria I have been grateful for the help, support, and interest of all staff. It is a special joy to acknowledge the strong championing of *Botanical Riches* by Chief Executive Officer and State Librarian, Anne-Marie Schwirtlich; Director, Collections and Services, Shane Carmody; La Trobe Librarian, Dianne Reilly; Manager, Public Programs, Andrew Hiskens; and Rare Printed Collections Manager, Des Cowley. I would also like to extend my special thanks to Emilee Seymour for her expertise and diligence in undertaking the exacting task of digital capture of items from the Library's collection. Thanks also to Miyuki Chikamatsu for Japanese translations, to Rare Books Librarians Pam Pryde and Jan McDonald for their assistance with the Library's collections, and to Clare Williamson, Kim Fletcher, and especially Jane Rhodes for sharing my journey of discovery.

In Adelaide I have been greatly assisted by Stephen Forbes (Director, Botanic Gardens of Adelaide), Tony Kanellos (Information Resources Manager, Botanic Gardens of Adelaide), Richard Heathcote (Director, Carrick Hill), Ray Choate (Chief Librarian, The University of Adelaide), Cheryl Hoskin (Special Collections Librarian, The University of Adelaide), and Alan Smith (Director, State Library of South Australia). Paul Atkins of Atkins Technicolour undertook the digital capture of all Adelaide-based items with great skill and in record time.

As with my last book *Gardenesque*, Melbourne University Publishing has assembled a dedicated and talented team to shape and produce *Botanical Riches*. I especially wish to thank Chief Executive Officer and Publisher, Louise Adler, for her support; and Associate Publisher, Miegunyah Press, Tracy O'Shaughnessy; and Editor, Catherine Cradwick, for their creative skills and expertise in refining and polishing my words and ideas. Thanks also to consultant editor Clare Coney and designers Hamish Freeman and Klarissa Pfisterer for their great contribution.

I am particularly grateful for the assistance of Colleen Morris and Stephen Forbes who both critically read substantial portions of the manuscript. Acknowledgement is also made to the holders of copyright who so readily provided permission to publish images. For diverse assistance, my thanks are also extended to Elizabeth Anya-Petrivna, Diane and Tory Brennan, Ian Morrison, Gil Teague (Florilegium Books, Sydney), Gabrielle Tryon, Peter Watts (Historic Houses Trust of New South Wales), and David Way (British Library).

Once again, my wife Georgina Binns has been a great supporter of my work, for which I acknowledge a profound debt of thanks.

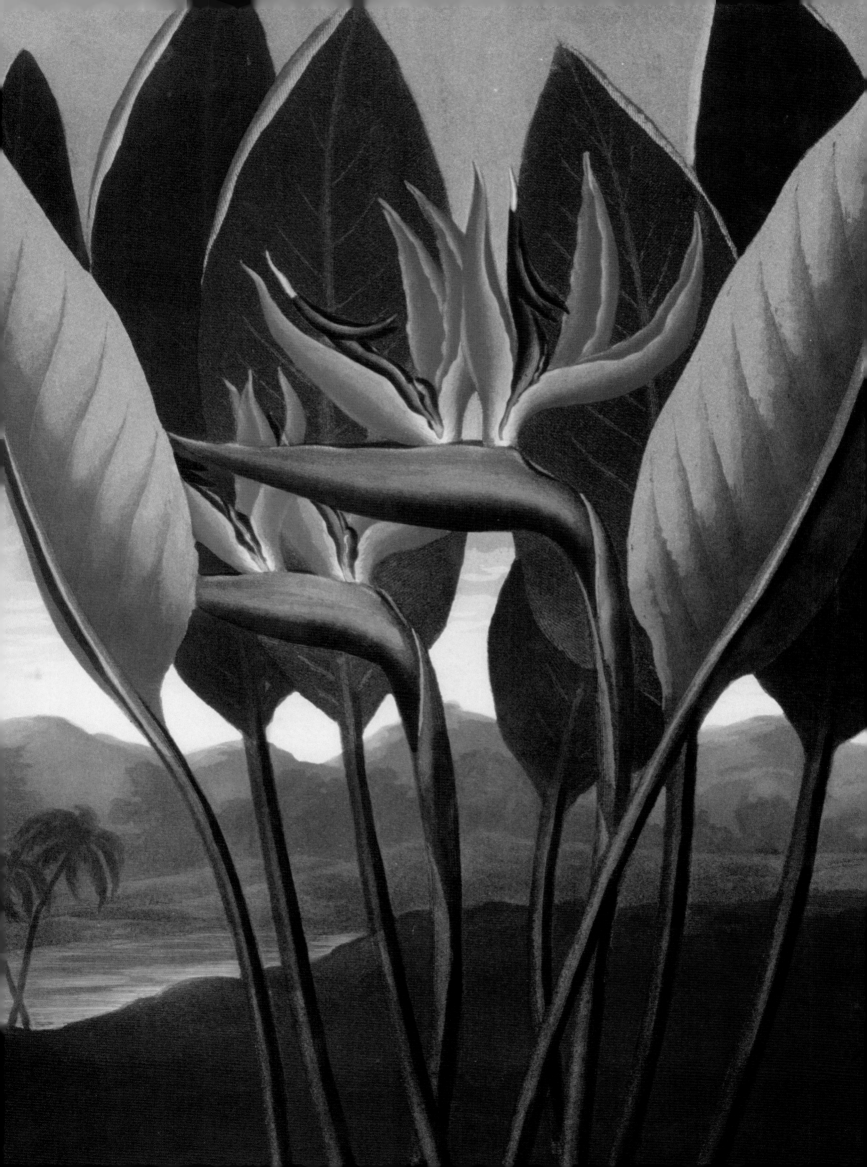

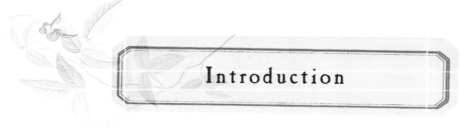

Introduction

THE BOTANICAL RICHES OF THIS BOOK ARE TWOFOLD. THE PLANTS themselves provide riches almost without limit, spanning an astonishing physical, social, and cultural spectrum. From utility to ornament, their almost inexhaustible patrimony has clothed, fed, warmed, protected, and inspired humans since the dawn of time. Across the millennia the use of plants by disparate communities and cultures has been predominantly instinctive, local, and balanced. By contrast, where plants have been translocated from their indigenous roots to distant civilisations, usage has been contrived, dislocated, and—often—profligate. Somewhere between these extremes is the transition that underpins the structure of *Botanical Riches*. It comprises stories of people as much as plants. Documentation of exploration, appreciation, introduction, and exploitation of plants is notoriously imprecise. For every finite record, there are a hundred others that are circumstantial or tantalisingly incomplete. Like the plants they describe, who knows how many records have been lost altogether?

It is the collective library of books that document this botanical exploration and appreciation of plants that forms the second of my botanical riches. Like the plants they depict, this resource is an extensive one, and one that is richly evocative of cultural and social history. Many of the world's great libraries contain such books, yet these are generally only available to those empowered to access them. *Botanical Riches* is thus a vehicle for bringing this rich legacy to wider notice and in doing so to share the joy of these plants and their depictions with new audiences. In many cultures the written word and graven image is inextricably linked to plants and plant products, so there seems a pleasing conjunction here between plants and their images. From papyrus scrolls of ancient Egypt, palm-leaf books of Asia, to the finest quality rag paper made of flax, is a record that is often inspirational and of great and sometimes, unintentional beauty.

opposite: The lure of botanical riches from exotic lands has proven irresistible to botanists, gardeners, and illustrators alike. Few books convey this richness better than Robert Thornton's *Temple of Flora*, published during 1799–1807. Here the *Strelitzia reginae* from southern Africa is subjected to a lush treatment, redolent of the romantic age.

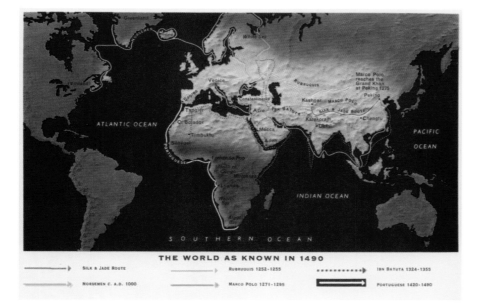

THE WORLD AS KNOWN IN 1490

| SILK & JADE ROUTE | RUBRUQUIS 1252-1255 | IBN BATUTA 1324-1355 |
| NORSEMEN C. A.D. 1000 | MARCO POLO 1271-1295 | PORTUGUESE 1420-1490 |

This is the world map of my childhood atlas, an arrogant conceit of light and dark. For those who still view the world with Euro-centric blinkers, the appreciation of plants by Indigenous peoples around the globe often comes filtered through lenses of ignorance and arrogance.

Introduction ix

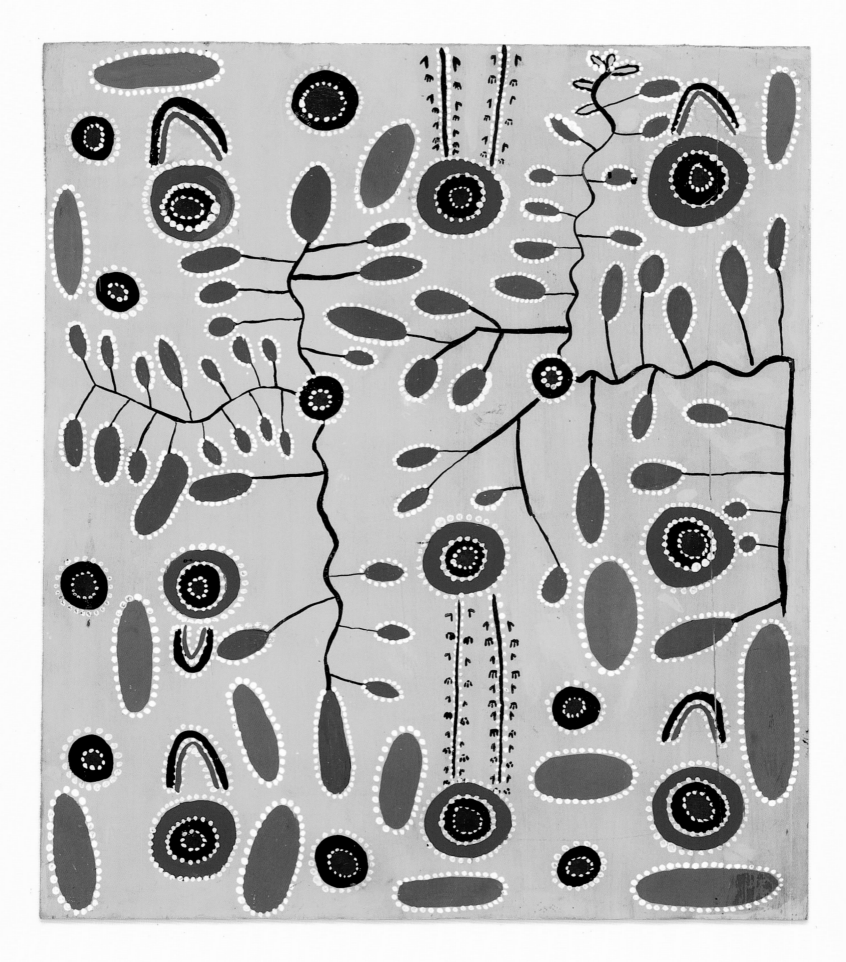

I had intended to use this book as a modest showcase of perhaps twenty-five or thirty great botanical books held by the State Library of Victoria. This library, opened in 1856, collected widely and ambitiously with generous funding from the colony's gold-rich coffers. Dealers such as Guillaume in London and Müller in Amsterdam guided natural history acquisitions. Treasures flooded into the collection. Thornton's *Temple of Flora*, Sibthorp's *Flora Græca*, Redouté's *Les liliacées*, and a host of other works graced its shelves. Its founders famously declared that the Library's books were available to all—'Every person of respectable appearance is admitted, even though he be coatless ... if only his hands are clean'.

With the passage of time and the increasing appreciation and value of illustrated natural history books, choice items have been one by one transferred from open shelves to the more secure confines of closed stacks. However, the wish of the State Library of Victoria to continue sharing these books in a lively and accessible manner has underpinned the publication of *Botanical Riches*. 'Why not tell stories of botanical exploration?' asked my publisher. 'Do you mean', I replied rather incautiously, 'worldwide, from the dawn of time to the present?' *Botanical Riches* is the result, richer and more rewarding than my wildest dreams.

opposite and below: The stories of people and plants are universal ones, not restricted to dominant cultures. Oral traditions—although not the focus of this book—complement the published record. Whether the Wild Potato ('Yala') Dreaming of Central Australia, painted here by Bill Stockman Tjapaltjarri, or the spiritual invocation of harvest in the Western Christian tradition, plants have a power to transcend the mundane business of daily life.

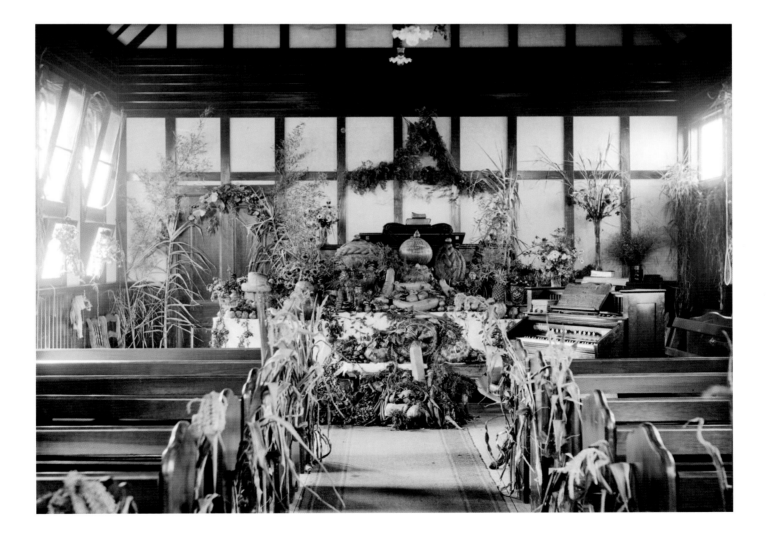

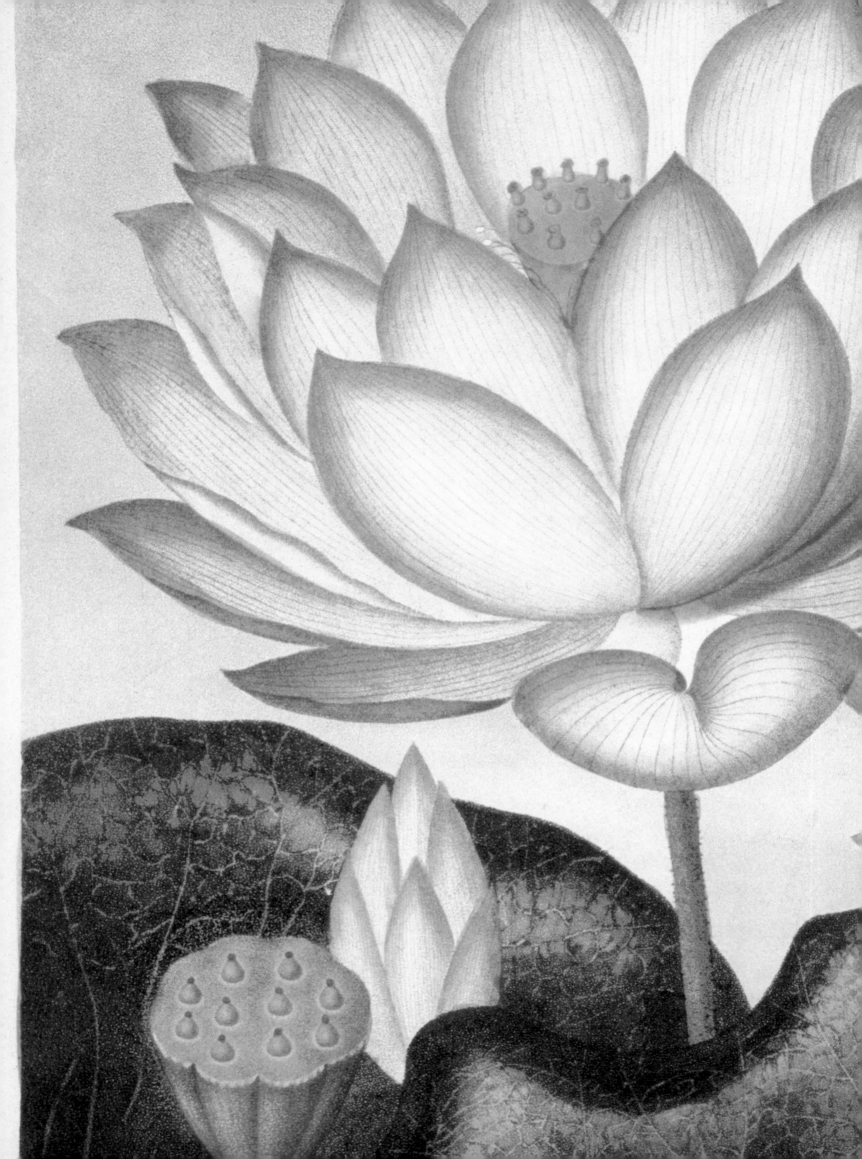

Part I

Plants of the Ancient and Classical Worlds:

From the Dawn of Time to the 1450s

棋頌韋蟄豐豆

Tab. XLVII.

Antoine lith.

Ged. b J. Höfelich.

1: Timeless Traditions

'ANIMAL, VEGETABLE, AND MINERAL': THIS ROTE CHANT OF THE SCHOOL-room should perhaps, with greater historical accuracy, be reversed, for it was not until after an almost imponderable geological age, as gases solidified and basic mineral nutrients coalesced, that the first plants evolved. Opportunistic, evolving, and rich with promise, lichens, mosses, and fungi presaged more complex plant forms. As protoplasm divided and multiplied, the web of life spawned organisms from the depths of the deepest oceans to the highest icy peaks. In the plasticity of evolution, plants and animals adapted in unforseen cadences, interacting with increasing complexity. The atmosphere that sustained life was purified by the photosynthesis of plants, absorbing carbon dioxide and returning oxygen in generous measure.

As human life dawned, animals and plants provided sources of food and shelter—hunting and gathering yielded the necessities for a sparsely populated planet. Local factors dictated the seasonal nuances of time and place, encouraging migration to and consolidation in fertile regions. Sustaining human life was basic and instinctive. In the world of the hunter-gatherer, plants were a major source of food, from easily accessible fruits to underground tubers such as the murnong or yam-daisy (*Microseris lanceolata*) of Aboriginal Australians. Control over fire—dependent on the use of wood (and plant fossils) as fuel—evolved as a basic social tool, and was ultimately the progenitor of many technologies, from its basic beginnings for cooking, warmth, and security.

Domestication of animals and cultivation of plants marked a transition—perhaps ten millennia before the present—from human nomadic foraging to a more settled existence involving agriculture. Basic foodstuffs differed with

opposite: **Nuts extracted from the cones of the Bunya Pine (*Araucaria bidwillii*) formed an important food source for Aboriginals on Australia's eastern coast. The cones—which came whistling through the branches from atop this ancient tree—were more than just good tucker: their seasonal collection was also a time of meeting and celebration.**

Local plants formed crucial natural materials for the implements, tools, and weapons of the South Pacific, their versatility augmented by animal bones and feathers.

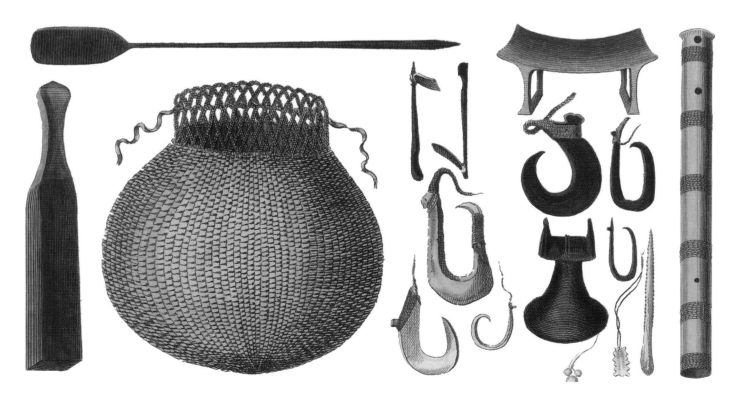

Plate 2.

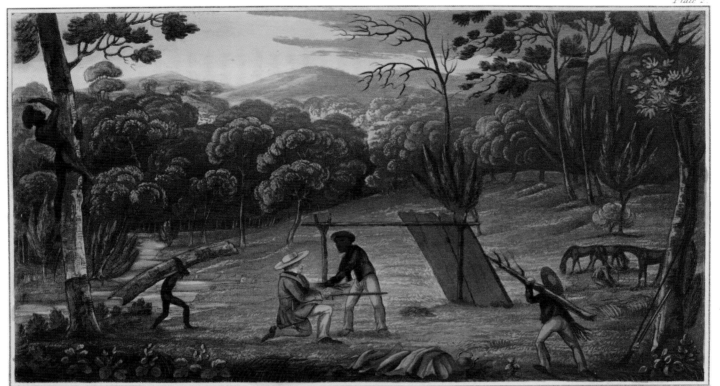

London, Published June 1820, by J. Cross, 18 Holborn, opposite Furnival's Inn

Page 137.

PARTY PREPARING TO BIVOUAC.

In many cultures, plants yielded the materials of shelter. Bark, leaves, stems, and branches all have rich traditions of use, inextricably linked to local floras and patterns of occupation. The party shown here, preparing to bivouac in early colonial New South Wales, drew on these traditions in an uneasy balance, Indigenous knowledge mediated by European sensibilities.

opposite: The power of cinchona bark to cure intermittent fevers was known to Peruvians well before European discovery of the New World. Amongst the earliest stories recorded of its use were of miners in Quito using a decoction of the pulverised bark to stave off fever following their immersion in cold water.

climate and geography, but for the majority of the world's population, cereals (wheat, barley, rice, sorghum, maize) and legumes (chickpeas, lentils, beans, peas) were the earliest cultivated crops. Vegetables and fruits broadened the diet, providing essential vitamins and minerals. Edible oils were extracted from olives, coconuts, peanuts, and soyabeans. Spices such as pepper, cloves, cinnamon, ginger, mustard, and paprika were increasingly used to flavour foods, enhancing and disguising according to need.

As plant processing techniques increased in sophistication, with the introduction of new tools and implements, so too did the range of plant-based foods. Plants products yielded beverages such as coffee, tea, and cocoa; distilled products of sugarcane and sugar beet sweetened bitter foods; heating and drying provided foodstuffs capable of storage, prolonging seasonal cycles of harvest. By trial and error, stimulants and narcotics were distinguished from poisons. Opium derived from the poppy (*Papaver somniferum*) relieved pain and induced sleep, smouldering leaves of marijuana and tobacco worked their habitual magic, fermented and distilled fruits produced alcoholic beverages, while the chewing of cola and betel nut stimulated the nervous systems of diverse populations in the tropics. Indeed, the medicinal properties of plants fuelled the earliest scientific interest in botany as the virtues of belladonna, foxglove, and cinchona were recorded by cultures on opposite sides of the world.

Plant products provided the basic framing and covering of much early demountable shelter. Reeds, grass, branches, bark, and leaves all were raw materials, whilst combinations of these using techniques such as weaving, and the introduction of animal skins or stonework, further extended their utility. With the transition from foraging to agriculture, and from hunting to herding, came the need for semi-permanent shelter, fuelling vernacular building techniques, such as wattle-and-daub construction. In its most sophisticated forms, the use of plant products gave rise to diverse dwellings ranging from elaborate Swiss

12. 14. 13. 18. 16. 19. 20. 22. 23. 15. 17. 21. Tab. XXIX.

Steinheil del. a sc.

12-18. CINCHONA OVATA. *19-23.* CINCHONA PUBESCENS.

N. Remond imp.

The tapa collected in the South Pacific by members of Cook's voyages was valued as an ethnographic artefact, the more prized for its bold patterning and bright colouring. The raw materials, the paper mulberry (*Broussonetia papyrifera*) and various species of the breadfruit genus (*Artocarpus* spp.), were originally derived from China and the tropical East Indies, where their use had produced early forms of paper.

The essentials of human comfort are rendered with elegance and direct simplicity in this palm–hammock tableau. For many cultures, the palm provided materials for shelter, food, tools, fabric, and ornament; it was perhaps only equalled in versatility by the bamboo.

lake dwellings on piles to the elegant, high-set, reed-thatched houses of Polynesia. Two plant groups in particular—palms and bamboos—provided an astonishing array of building materials, to say nothing of their uses as sources of food, fibre, and ornament.

Plants provided fibres that could be used for warmth, protection, personal adornment, and ostentation. Flax and cotton could be spun and woven to produce fine cloth. Cotton was not only one of the earliest vegetable fibres used for textile manufacture but had been cultivated since ancient times by cultures in two widely separate geographical centres, south Asia and Central America. Such was its pre-eminence as a natural textile that some European travellers to Asia wrote fancifully of lambs sitting inside the bolls (or fruits) producing cotton's soft fibres. Hemp, jute, and sisal also yielded material for rope, string, and coarse cloth. Yet other fibrous plants provided materials for brushes and brooms, stuffing for bedding or upholstery, and papermaking. Plants used by the Chinese for the manufacture of paper were also used to fabricate bark cloth—known to

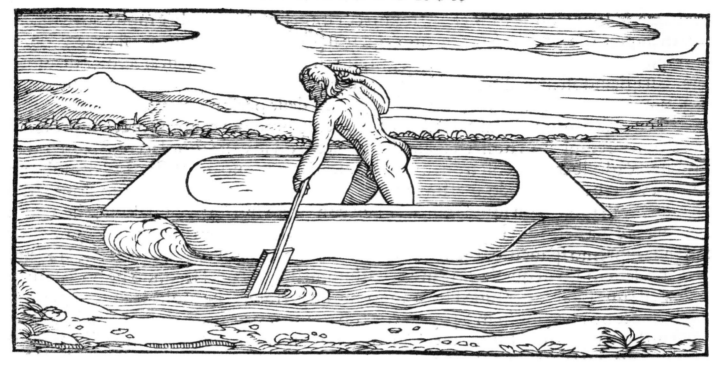

the Polynesians as tapa. The techniques involved in stripping, beating, and dyeing bark were known in widely separated cultures, from central Africa to northern South America.

The striking patterns of Polynesian tapa demonstrated another use of plants, as colouring materials. Madder, indigo, saffron, annatto, and a host of other plants yielded powerful dyes, used to colour fabrics, food, beverages, and—in some cultures—human skin. These were supplemented by tannins extracted from the wood, bark, leaves, and fruits of plants such as Sicilian sumac (*Rhus coriaria*), red mangrove (*Rhizophora mangle*), and black wattle (*Acacia mearnsii*). The peculiarities of individual dyes ensured some had a high value in commerce, true also for the rich trade in spices and perfume-yielding plants. The essential oils of plants such as lavender, rose, and jasmine were esteemed as perfumes, while aromatic plants such as citrus and mint found wide use for flavouring and fragrance.

The economic attributes of plants and their products extended well beyond mere commerce. Just as a world without colour, perfume, and flavour is beyond contemplation, so a world without gardens is difficult to comprehend. The journey from agriculture to horticulture, from the field and farm to the park and garden, is sparsely documented. Enclosure, ornament, and traditions of maintenance all figure in the archaeological record, yet this can only hint at the floristic richness, artistic inspiration, and emotions that may have distinguished gardens of the ancient world. With a rise in sea-borne transport came the means of appropriation of plants and their attendant horticultural traditions. Thus the earliest documented plant-hunting expedition, under sail from Egypt to the Isle of Punt, yoked new technologies with the timeless traditions of cultivation.

Renaissance elegance transformed the rude simplicity of this tropical American vessel into something that disturbingly prefigured the modern bathtub. Timber in the service of transport propelled many cultures, responding to needs and ambitions, extending trade and influence.

WE CANNOT BE SURE EXACTLY WHEN OR WHERE PLANTS WERE FIRST domesticated. Cereals, which provide the basis for human nutrition, were probably the first plants to be cultivated, a process begun during the Mesolithic (or Middle Stone Age). Agriculture thus evolved at a commonly accepted date of 10,000–8000 years before the present. Some of the earliest cereals are cultigens—cultivated genera—which have no known specific geographic origins or distribution, such is their antiquity. Others are known from wild forms, gradually domesticated by cultivation and selection. Thus from the primitive origins of wild einkorn (*Triticum boeoticum*), common or bread wheat (*T. aestivum*) was domesticated in south-eastern Turkey or the south-western Caucasus. We know this from the archaeological record—fossilised or carbonised remains, artistic representations, and incised physical records in clay and other impressionable materials.

The ability to cultivate plants—through the cycle of ground preparation by digging, planting saved seeds, watering by irrigation or naturally favourable climates, and harvesting—occurred independently and almost simultaneously in widely spaced centres in Africa, Asia, the Americas, and Europe. Of these, development of the so-called Fertile Crescent, an arc of land in south-western Asia (in present-day Iraq) depending for its productivity on the Tigris and Euphrates rivers, was amongst the earliest and most significant in the history of agriculture.

The Sumerian civilisation emerged in the Fertile Crescent (an area the Greeks later named Mesopotamia) approximately five thousand years ago. Supported by its produce and encouraged by the stability agriculture afforded, the Sumerians established a civilisation based on well-defined social groups and concentrated settlements. The arable plains of southern Mesopotamia were made additionally productive by the use of irrigated and drained terraces, placing crops just above flood levels. As well as various forms of wheat, other staples such as barley (*Hordeum vulgare*) and millet (*Setaria italica*) were grown as food crops. Barley was the principal grain used by Sumerians in brewing alcoholic beverages, a use well known in ancient Mesopotamia. Refinement of agriculture progressed simultaneously with the invention of the wheel and the advent of permanent writing in cuneiform (*c.* 3000 BCE), other lasting achievements of the Sumerian civilisation.

The Sumerian civilisation was successively overtaken by the Akkadian and Babylonian empires. Elsewhere in the Fertile Crescent, new kingdoms ebbed and flowed. The headwaters of the Tigris and Euphrates (in present-day Turkey and Syria) were elevated well above the fertile alluvial plains of southern Mesopotamia, but yielded their own diverse palette of plants. Geographically, the mountainous terrain of the Hittite civilisation in Anatolia had much in common with the region centred on the Caspian Sea, home to many of the most widespread

Cultivated wheats have a complex history, and were domesticated over 9000 years ago from earlier, wild forms. Common or bread wheat (*Triticum aestivum*), that versatile staple of agriculture, was inexorably spread from its presumed centre of domestication in south-western Asia to Egypt, India, China, and Europe.

***opposite:* The Fertile Crescent, located within a large arid zone having unreliable rainfall, depended for its fertility on the Tigris and Euphrates rivers that bisect the mountainous region to the north and desert to the south. In a region of extremes, the seasonal flooding of the river plains supported forested lowlands and sustained the earliest agricultural crops.**

PLANTS OF THE ANCIENT AND CLASSICAL WORLDS

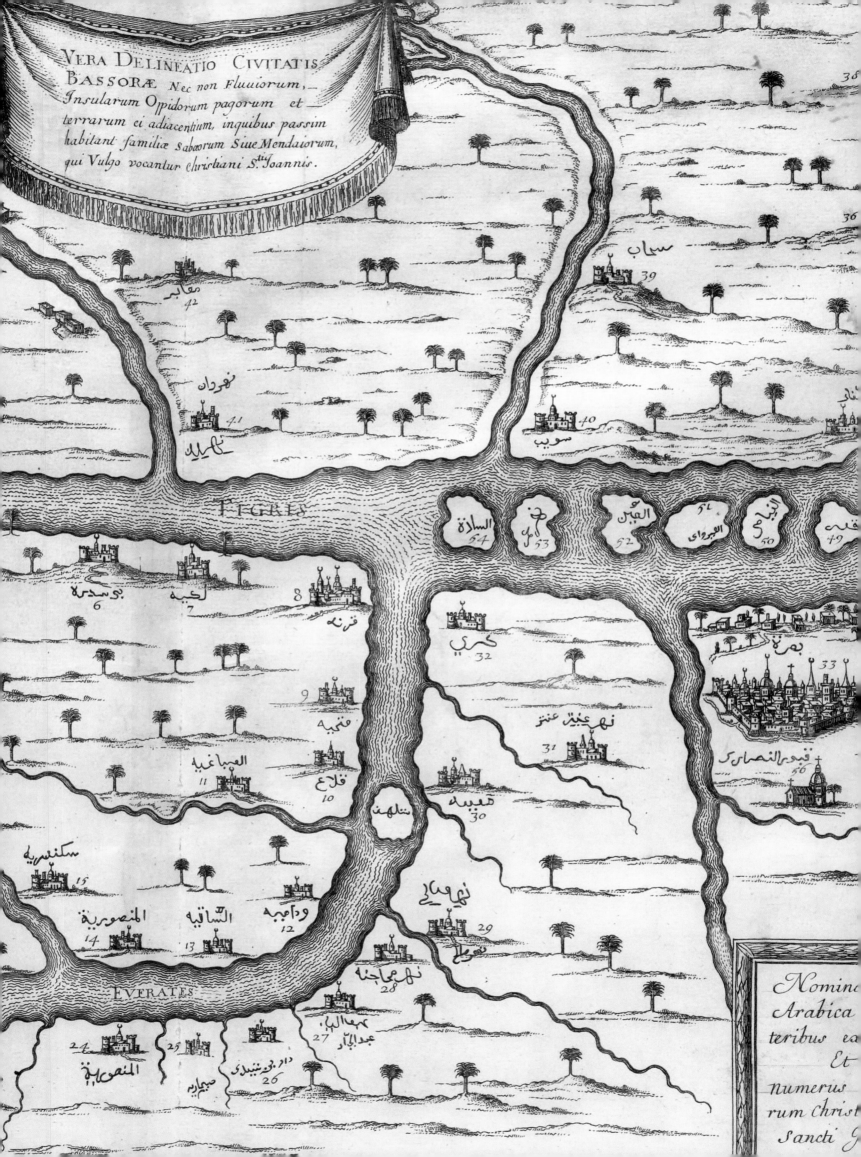

VERA DELINEATIO CIVITATIS
BASSORÆ Nec non Fluuiorum,
Insularum Oppidorum pagorum et
terrarum ei adiacentium, inquibus passim
habitant familiæ Sabæorum Siue Mendaiorum,
qui Vulgo vocantur christiani S.ti Ioannis.

TIGRIS

EVFRATES

Nomina
Arabica
teribus es
Et
numerus
rum Christ
Sancti

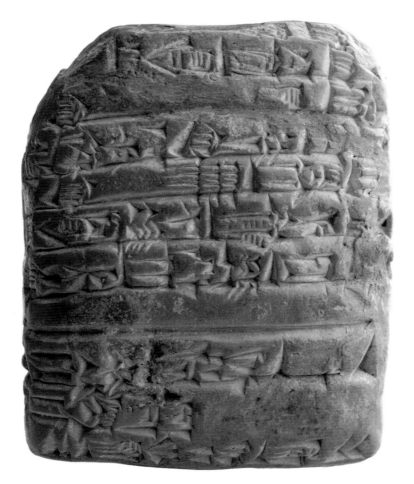

temperate-zone fruits. From the Caucasus Mountains of western Asia came the primitive forms of apple (*Malus domestica*), pear (*Pyrus communis*), plum (*Prunus domestica*), and quince (*Cydonia oblonga*). So too, the almond (*Prunus dulcis*), pomegranate (*Punica granatum*), and wine grape (*Vitis vinifera*).

Of the fruits, perhaps none had greater significance in the Fertile Crescent than the date. The date palm (*Phoenix dactylifera*) was a generous provider, yielding nutritious fruits in unpromisingly arid climates. From its initial centre of cultivation, the date palm found a home in Arabia, Egypt, and northern India, wherever the combination of heat and adequate groundwater replicated its Mesopotamian origins. The edible fig (*Ficus carica*) was another fruit with a long history of cultivation, beginning in Syria *c.* 4000 BCE and soon extending throughout the Mediterranean basin. The Garden of Eden was placed by later biblical scholarship in the Fertile Crescent, and the choice of the fig and the apple as its signature plants expressively conveyed the notions of antiquity imbued in the story of Adam and Eve. (Besides which, as a specimen of Old Testament lingerie, the fig's lobed leaves were perfectly suited to the job at hand.) Other species of *Ficus*, notably the sycamore fig (*F. sycomorus*), also graced gardens of the Fertile Crescent. The sycamore fig has been advanced by some authorities as instrumental in the advent of shade-tree gardening, whereby umbrageous trees provide shelter for young or tender plants.

oppposite: The free-fruiting date palm (*Phoenix dactylifera*) has perhaps the longest tradition of cultivation of any fruit tree in the Old World. It has had sacred significance to successive cultures in the lands centred on the Fertile Crescent since its first cultivation in ancient Mesopotamia over five thousand years ago.

The use of broad-spreading trees—
such as the sycamore fig (*Ficus
sycomorus*)—to provide shade for other
plants is a horticultural technique
believed to date from the Sumerian
civilisation in Mesopotamia. In the
world's arid zones, modification of
temperature proved a vital adjunct
to provision of adequate nutrients
for successful plant cultivation.

opposite: The edible fig (*Ficus carica*)
has a long tradition of cultivation,
commencing along the Euphrates
Valley perhaps five thousand years
ago. Its ripened produce—plump,
moist, and richly fragrant in the heat
of the day—teases the senses like few
other fruits.

Shade, whether from trees or the protection of courtyards, was an essential part of arid-zone gardening. The gradual evolution of ornamental horticulture from its primarily utilitarian traditions in agriculture heralded a new phase in garden and place-making. The Fertile Crescent yielded numerous plants with ornamental qualities, such as the tamarisk and willow, as well as palms and pines. The Hanging Gardens of Babylon, by tradition terraced above the Euphrates River, remain a powerful image of ornamental gardening in ancient Mesopotamia.

Gardens depicted in Assyrian reliefs, recording an empire that occupied the Fertile Crescent for a millennium after the fall of Babylon, show rich umbrageous and floral displays. This art also shows the craft of boat-building, which permitted trade along the Persian Gulf and into the Arabian Sea, including contact with the Harappan civilisation along the Indus Valley (present-day Pakistan). From distant lands new botanical riches came to Assyria, the beginnings of an enduring gardening tradition. King Tiglath-Pileser I (*c.* 1115–1077 BCE) has left us with one of the earliest written records of this process: 'Cedars and Box I have carried off from the countries I conquered, trees that none of the kings my fore-fathers possessed: these trees I have taken and planted in my own country'. By then, however, the earliest recorded depiction of plant hunting had already been made, in nearby Egypt.

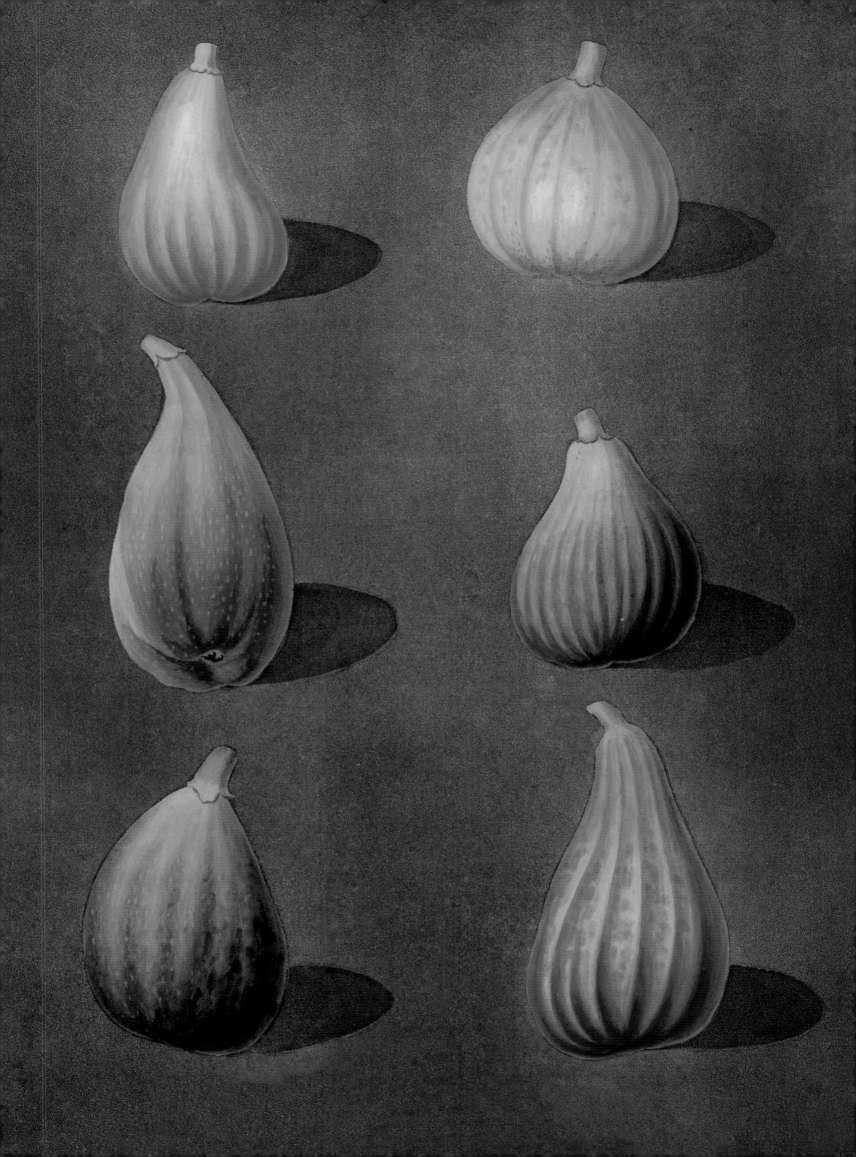

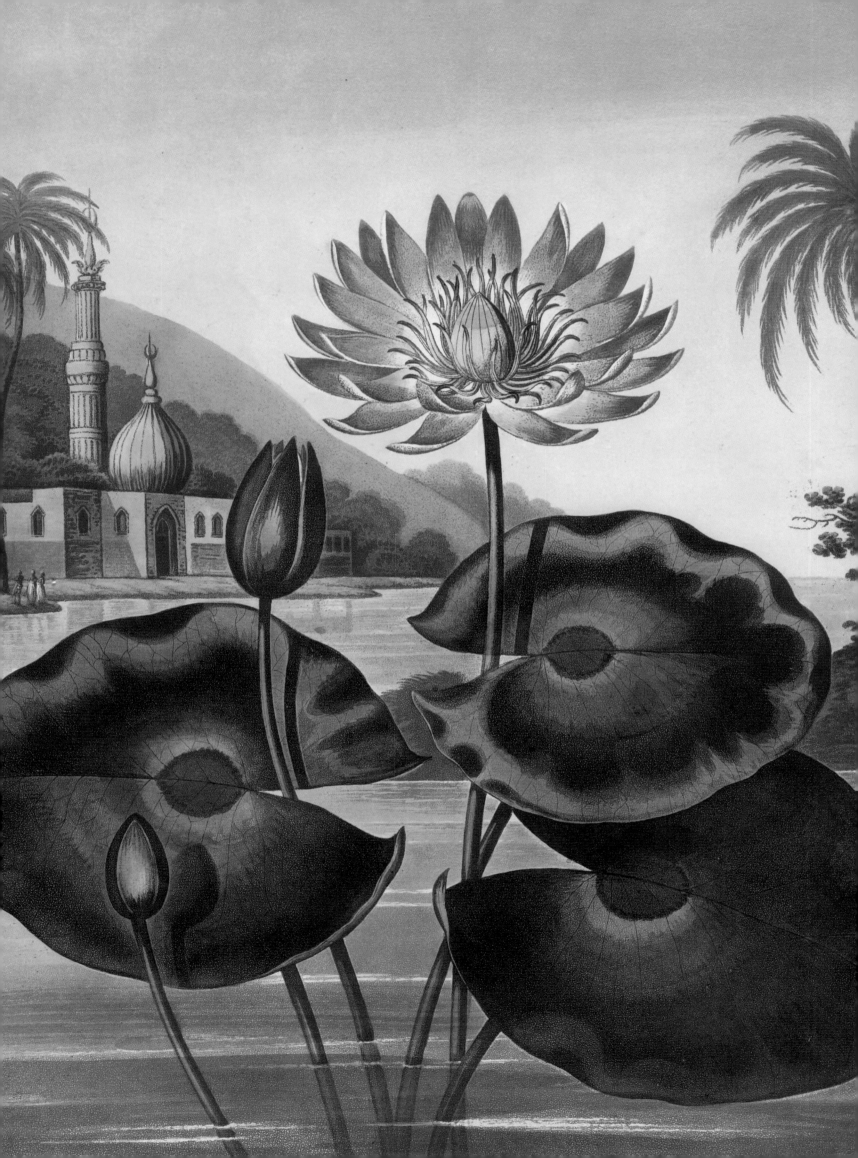

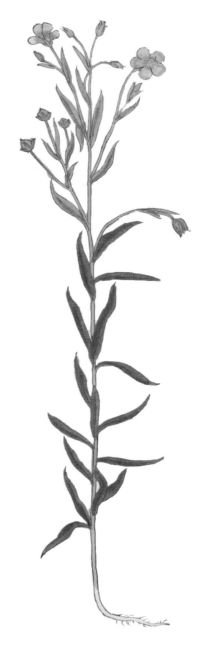

3: Ancient Egypt

FOR GENERATIONS BROUGHT UP ON THE FROZEN SMILE OF TUTAN-khamun, the idea of ancient Egypt as a dynamic, living culture may seem difficult to comprehend. We tend to see this civilisation through the mask of death—albeit richly gilt—yet in reality the Nile River provided this unpromising, arid land with gifts as rich in life as the pharaohs had in death. A little over five thousand years ago the Nile gave rise to two distinct kingdoms that clustered along its linear lifeline. To the north, the final reaches of the river sprawled from Memphis, capital of Lower Egypt, across a marshy delta before giving on to the Mediterranean Sea. Thebes, capital of Upper Egypt, sat at the midpoint of the river's arable strip, astride the Tropic of Cancer yet buffeted by hot Saharan winds and flanked by desert sands.

Unlike Sumer, where city-states gave rise to discrete concentrations of political power, ancient Egypt evolved rapidly into a unified kingdom around 3000 BCE. Authority was given to Egypt through its dynastic rulers (pharaohs), whose belief in an afterlife resulted in tombs that recorded the land and its culture with unparalleled magnificence. Agriculture contributed to this political stability, supporting numerous interlinked though decentralised marketplaces and settlements rather than isolated seats of power. Cereal crops—wheat (*Triticum aestivum*) and barley (*Hordeum vulgare*)—and protein-rich legumes and pulses—chickpea (*Cicer arietinum*) and lentil (*Lens esculenta*)—were the mainstays of ancient Egyptian agriculture. The common olive (*Olea europaea*), date palm (*Phoenix dactylifera*), and edible fig (*Ficus carica*) yielded oil and fruit. Salad plants and vegetables with local wild origins, including lettuce (*Lactuca sativa*) and onions (*Allium cepa*), were also cultivated.

Agriculture evolved along the Nile almost simultaneously with that in the Fertile Crescent, perhaps independently, perhaps learned from the Sumerians. Trade in plants as well as ideas was certainly a hallmark of the ancient Egyptian civilisation, although the beneficence of the Nile with its regular seasonal inundation contrasted with the more haphazard flow patterns of the Tigris and Euphrates. Those rivers' vagaries dictated dykes and irrigation for successful agriculture, whereas the Nile rose and fell in textbook fashion, depositing a rich crust of moist alluvium whilst also signalling seasonal operations for Egyptian farmers. The striking environment of the Nile Valley was host to plants redolent with symbolic value: the blue Nile waterlily (*Nymphaea caerulea*) appeared frequently in Egyptian art, while others, like papyrus sedge (*Cyperus papyrus*), combined ornamental qualities with utility.

Proximity to cultures in the Mediterranean, south-western Asia, and neighbouring regions of northern Africa provided a rich fusion of plants to enrich Egyptian gardens. From the margins of the Caspian Sea came the pomegranate (*Punica granatum*), its abundantly seeded fruit a symbol of fertility. From the eastern Mediterranean came the blue oriental cornflower (*Centaurea depressa*) and scarlet corn poppy (*Papaver rhoeas*). Trees such as the cedar of

Flax (***Linum usitatissimum***) was widely cultivated in ancient Egypt. Its fibres when spun yielded the fine linen cloth known from early burial sites. Flax's cultivation predates Egyptian civilisation, however, and the plant was probably domesticated in the Fertile Crescent from a wild progenitor, ***L. bienne***.

opposite: The Nile supported a distinctive flora, including the blue Nile waterlily (***Nymphaea caerulea***). From its frequent representations in ancient art and architecture, this lily became one of the most evocative of Egyptian plants.

right: The Nile—that astonishing river bisecting the deserts of Egypt—was transformed each year by flooding from its sources in the highlands of central Africa. At Memphis, the capital of Egypt's Old Kingdom, a fertile floodplain of sufficient richness to support two seasonal crops formed a wide ribbon of green and blue amidst the prevailing sandy haze.

Ancient Egyptian culture has been transmitted across the ages with wonderful clarity through the invention of papyrus. Strips of the sedge *Cyperus papyrus*, laid criss-cross and beaten to form a continuous sheet, provided a convenient medium for hieroglyphic writing. Devised in Egypt some five thousand years ago, rolled sheets of pasted papyrus inscribed with hieroglyphs formed a forerunner to the modern book.

opposite: Our knowledge of ancient Egyptian gardens is not confined to papyrus scrolls. Colourful tomb paintings, vigorous reliefs carved from stone, and preserved bouquets of dried flowers, fruits, and seeds each contribute to knowledge about the popularity of individual plants, including the oriental cornflower (*Centaurea depressa*).

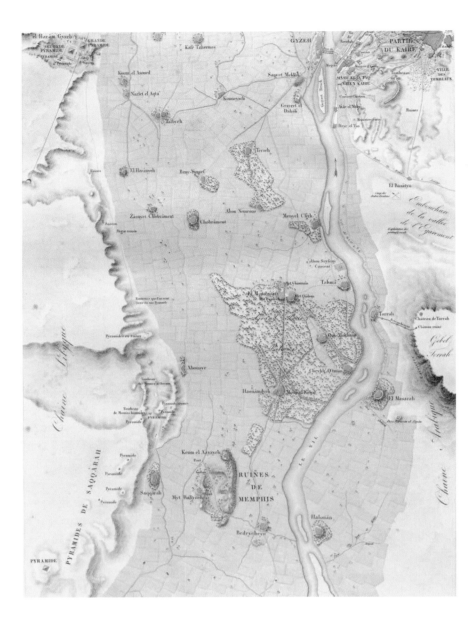

Lebanon (*Cedrus libani*) yielded timber for ship building and furniture making. From the southern Sahara came ebony (*Dalbergia melanoxylon*), its dense, dark timber used to ornament Egyptian furniture, often in the form of veneer. An array of plants provided oils, resins, and perfumes: two of these—myrrh (*Commiphora myrrha*) and frankincense (*Boswellia sacra*)—were probably cargo aboard the earliest documented plant-hunting expedition, around 1470 BCE, from Egypt to the mysterious land of Punt.

Fragrant oils, resins, and perfumes played a significant role in ancient Egyptian culture, in life and in death. Much of what we know of their use has been gleaned from relics in tombs as well as the paintings and reliefs on tomb walls. Cultivating such plants assumed great significance in preparation for the afterlife, and the raw materials were sourced from near and far. Myrrh and frankincense from the dry mountainous countries of Somalia, Yemen, and Oman were especially prized, and during the Eighteenth Dynasty, Queen Hatchepsut sent ships to Punt in search of living plants. A vivid record of this expedition was carved in relief on the walls of the Egyptian temple of Deir el-Bahari, where sequential tableaux animate the quest. Sadly, vital carved stones in the temple are missing or defaced, so we can only guess at Punt's exact position, but most scholarship places it on the Horn of Africa (present-day Somalia) or the southern

Pub by S. Curtis Glazenwood Essex June 1. 1838

Swan Sc

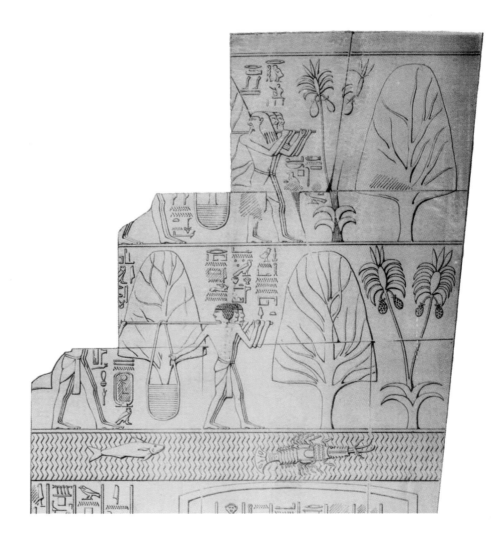

The earliest known illustrations of a plant-hunting expedition are to be found on the walls of the temple of Deir el-Bahari, dating from the reign of Egyptian Queen Hatchepsut. Travelling by boat from Egypt to the land of Punt (thought to be present-day Somalia), Egyptians worked along-side Puntites in loading the swagged trees, possibly frankincense (*Boswellia sacra*). In the top row, like some disgruntled supernumerary in a Verdi opera, a Puntite protests (hieroglyphically) that his load is heavy.

opposite: This walled garden at Thebes depicts characteristic features of ancient Egyptian gardens. Situated adjoining a tree-lined river, the approach through a large gateway leads directly to a central vine arbour. Four water basins, margined in turf and potted papyrus, and teeming with flowering waterlilies, dominate the front and sides of the courtyard. Two small temples flank a shrine, richly stocked with vases of flowers, reverential offerings honouring the god Amun.

tip of Arabia. Egyptian ships arrive, scenes of commerce are portrayed, sailors load ships with the tubbed plants, laden boats sail home, frankincense trees are planted in a garden, and the resulting heaps of incense are carefully measured.

Tensions between Egypt and neighbouring peoples of northern Africa flared periodically but it was successive invasions or occupation by Assyrians, Persians, Greeks, and Romans that ended the pharaonic way of life. Alexander the Great marched unopposed into Egypt in 332 BCE and, in his wake, Alexandria became a new centre of culture and learning, a model Hellenistic outpost. With the fall of the Eastern Roman Empire (Byzantine Empire) in 640 CE, Egypt became part of the Arab world. Gardens in ancient Egypt, such as that tended by Sennufer, gardener to Amenophis II (ruled 1427–01 BCE), show the four-fold division so characteristic of later Islamic gardens. In other ways too, the gardens and planting traditions of ancient Egypt, like those in Persia, provided models for later civilisations. Water, enclosure, shade, and symbolism all found early and sophisticated expression here, and influenced gardens of the Roman and Arab worlds, even finding their way via Islam to the Iberian Peninsula.

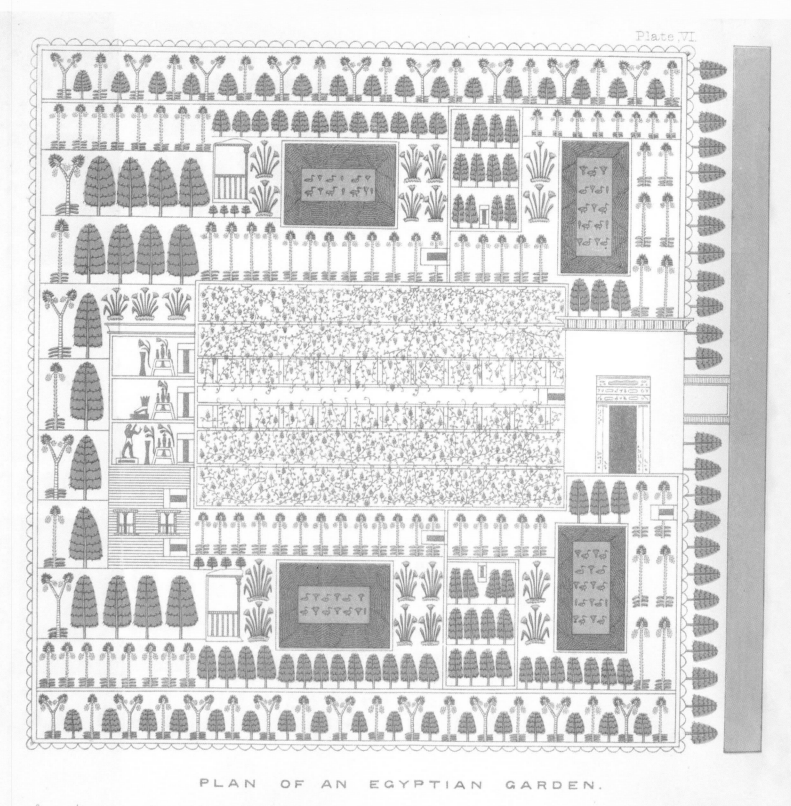

Plate VI.

PLAN OF AN EGYPTIAN GARDEN.

From Rosellini's Monumenti dell' Egitto é della Nubia, Vol. 2. Pl. 69.

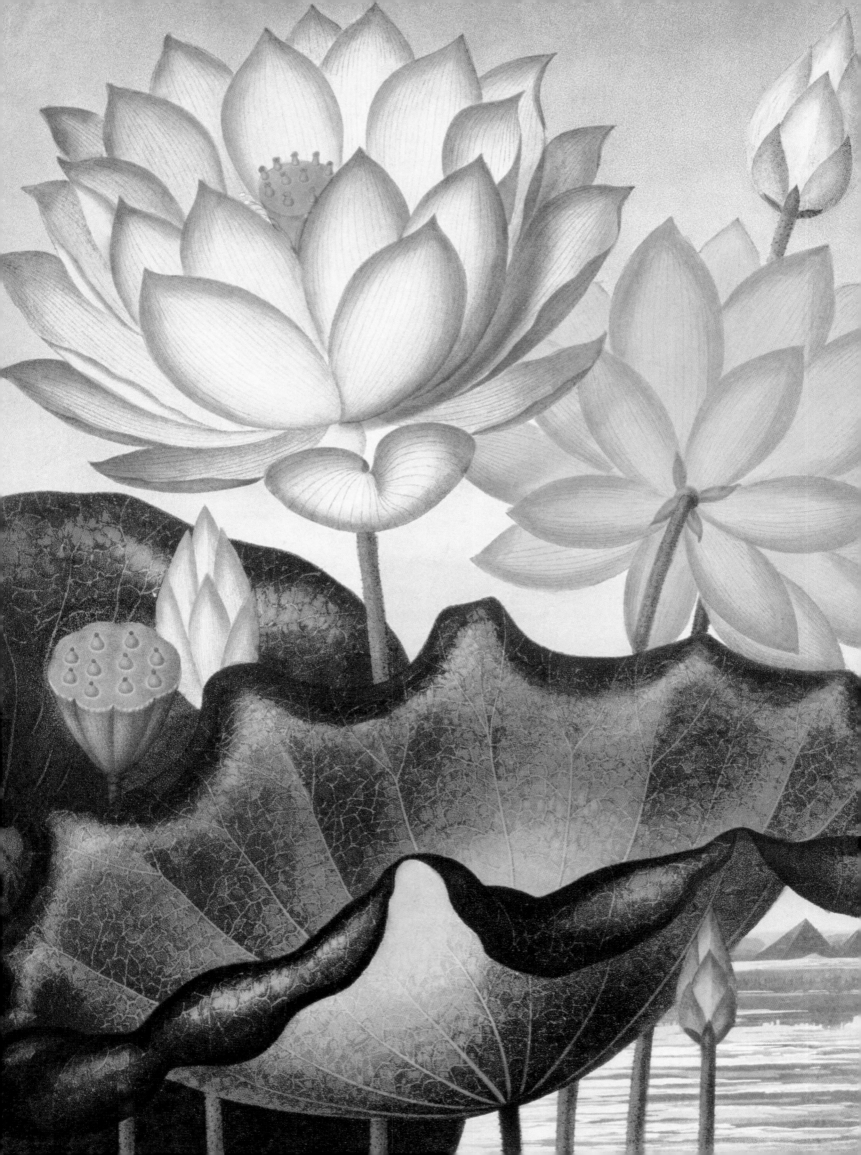

4: Ancient India

WHEN ROBERT THORNTON PUBLISHED HIS HIGHLY ROMANTICISED PLATE of India's sacred lotus (*Nelumbo nucifera*) in 1804 the flowers were depicted against the pyramid-bedecked banks of the Nile and captioned 'The Sacred Egyptian Bean'. Thornton's attribution was understandable, as this lotus had been introduced from India to Egypt perhaps as early as 525 BCE (during the Twenty-Seventh or Persian dynasty) and had acquired a long symbolic tradition in the two countries. This was coincident with the lifetime of the Buddha, whose ethical philosophy gave India and the world one of its great religions. Yet ancient Indian civilisations had emerged more than four thousand years ago in the valley of the Indus River (in present-day Pakistan), centred on the cities of Harappa and Mohenjo-Daro.

The Indus River and its tributaries, by *c.* 2500 BCE, supported a well-developed Harappan culture, which included agricultural crops of wheat and barley (varieties of *Triticum aestivum* and *Hordeum vulgare*). Like the Fertile Crescent at this date, the Harrapan people of the upper Indus Valley produced surplus grain, necessitating the construction of granaries in urban centres and providing a vital prerequisite for commerce and trade. Chickpea (*Cicer arietinum*) and lentil (*Lens culinaris*), two pulses important in Indian culinary traditions, were also known in ancient times. These crops had been domesticated in the Fertile Crescent, and their introduction was part of a well-established trade between the Indus and Euphrates valleys, which also included fruits such as the pomegranate (*Punica granatum*).

Around 1500 BCE, the Harrapan civilisation of the Indus was overtaken by that of the Aryan and other groups which had migrated from central Asia, and eventually reached the Punjab and the upper Ganges. These nomadic pastoralists brought with them oral spiritual traditions, or Vedas, that celebrated human life and its intrinsic communion with nature. The Vedic culture refocussed interest on agriculture and the philosophical beauties of rural life, turning away from the former urban focus of the Harrapan civilisation. Increasingly, rice (*Oryza sativa*) became a staple food, probably introduced from China and cultivated using flooded fields, especially along the Ganges River valley. Edible plants such as the Indian jujube (*Zizyphus* spp.) and mango (*Mangifera indica*) were mentioned in early texts, and the archaeological record reveals a wide range of legumes and cereals. Food plants assumed a heightened significance in the Indian diet after the widespread introduction of vegetarianism, especially in northern India, with a rise of religious prohibitions on the killing of animals.

The Aryans continued their spread through India, often encountering earlier cultures settled in relatively confined regions. The plains of the north have no equivalent in the south, where mountain ranges and compressed uplands dominate the topography, leaving only narrow coastal strips. Much of northern India is outside the tropics, and as it is protected by mountains from the icy

opposite: **The sacred lotus (*Nelumbo nucifera*), often taken as the national flower of India, is imbued with rich symbolism. The emergence of such a splendid flower from its murky aquatic dormancy has given rise to many allusions, mostly centred on notions of birth, purity, life, and beauty. A transfer of its sacred values also accompanied the introduction of the lotus to other cultures, particularly to Egypt.**

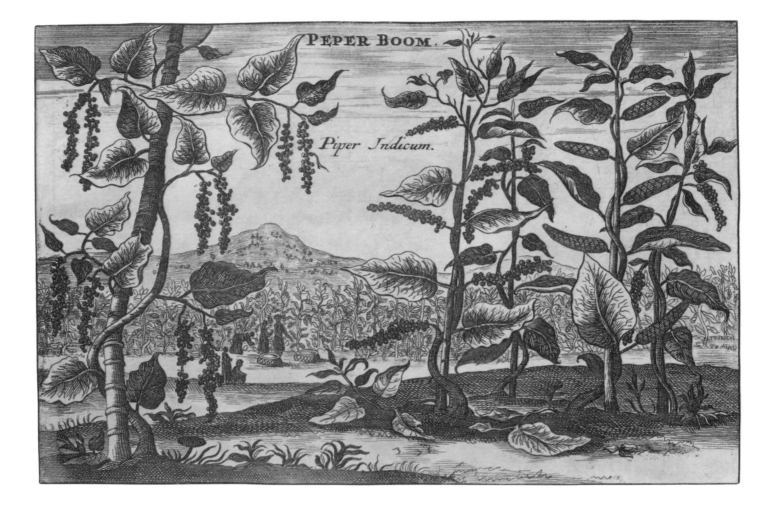

PEPER BOOM.

Piper Indicum.

Pepper was amongst the goods traded by those of the Indies with Arabs and Greeks, part of the long-established spice trade. The epiphytic climbing vine *Piper nigrum*, whose dried berries yield black pepper, once thrived in the forests of southern India and elsewhere in south-western Asia. In cultivation, poles often replaced trees as the means of support for the growing plants.

opposite: Greek trade with India was probably responsible for introducing the lemon (*Citrus limon*) to Europe over two thousand years ago. The lemon tree was common in Roman and Persian gardens, flanking courtyards and massed in orchards and groves, and its aromatic fruit provided flavour and fragrance to many foods and beverages across Asia and southern Europe.

winds of central Asia and deluged by the monsoon in the hottest part of the year, the climate was conducive to tropical plants. A range of fruits and vegetables, such as the banana (*Musa sapientum*), coconut (*Cocos nucifera*), jackfruit (*Artocarpus heterophyllus*), taro (*Colocasia esculenta*), and sago palm (*Metroxylon sagu*), were introduced from southern India and other parts of south-eastern Asia. The citrus family, another important group of Indian plants, yielded strongly flavoured fruits.

The rich and varied Indian cuisine relied strongly on the many spices found on the subcontinent and neighbouring regions of south-eastern Asia. Cardamom (*Elettaria cardamomum*), long and black pepper (*Piper longum* and *P. nigrum*), and turmeric (*Curcuma longa*) were amongst the earliest spices recorded. In southern India and Sri Lanka, cinnamon (*Cinnamomum verum*) was an important flavouring. These spices were combined with meat or vegetables, such as the brinjal or eggplant (*Solanum melongena*), to produce characteristic seasoned dishes—the English word 'curry' was a much later anglicised term derived from the Tamil word for pepper, *kari*.

Aside from the practical value of plants for sustenance, many Indian plants were also imbued with spiritual and symbolic significance. Even today, India is a haven of spiritual thought and practice, much of it ancient and enduring. Between two and three thousand years ago, Hinduism emerged from earlier Vedic traditions to give India one of its major religions. The life and teachings of Gautama Buddha (*c.* 563–483 BCE) provided inspiration for another spiritual movement, one which sat alongside other faiths.

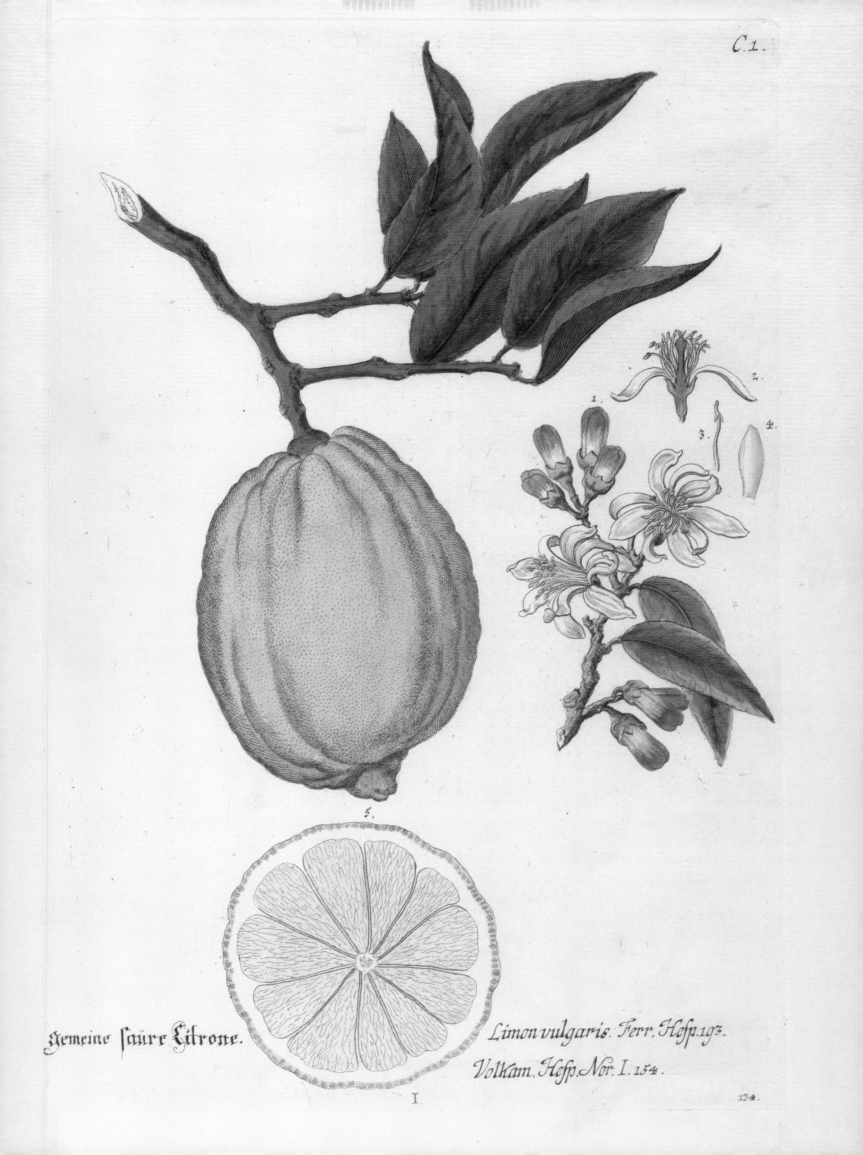

C.1.

Gemeine saure Citrone.

Limon vulgaris. Ferr. Hesp. 193.

Volkam. Hesp. Nor. I. 154.

134.

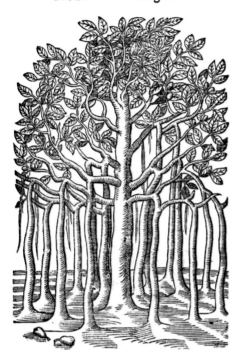

Arbor Goa, siue Indica.
The arched Indian Fig tree.

Travellers to India marvelled at the banyan (*Ficus benghalensis*), with its fibrous aerial roots that allowed the tree to establish a system of secondary trunks. Exaggerated accounts were common, but the banyan's power over the viewer's mind was matched locally by its wide range of medicinal uses.

***right:* The palm-leaf book, with its blackened script incised into leaves of the talipot palm (*Corypha umbraculifera*), trimmed and threaded with cord, represents a distinctive contribution to the history of written language, known from the 4th century CE. The fronds of the talipot, a versatile south Indian and Sri Lankan palm, were also widely used to provide materials for shelter.**

Hinduism and Buddhism both venerated nature, and many plants were sacred to both beliefs. As a link between heaven and earth, life and death, plants could provide symbols of divine birth or fuel for fiery sacrifice. Rice became a symbol of fertility in Hindu and Buddhist rituals, while turmeric possessed magical properties to ward off evil influences. The lotus was perhaps the most sacred of all. The goddess Lakshmi and other Hindu deities were often depicted on a multi-petalled lotus throne. Its flowers were widely regarded as symbol of beauty and symmetry, and to Buddhists, divine birth. Trees formed natural shelters for sages, an environment conducive to enlightenment—in some instances the trees themselves were a subject of worship. The bo tree (*Ficus religiosa*), under which Buddha is supposed to have meditated for six years, exemplifies this sacred attachment, a symbolism continued by the planting of this species beside temples.

Aryan culture and its Hindu spirituality, including the epic *Rig-Veda* collection of hymns, were based on oral traditions, but this lore was increasingly recorded in Sanskrit. We do not know with any certainty when this written record commenced, but it seems likely that Chinese traditions using incised bamboo and other plant products constituted early forms of recording language.

European knowledge of India was coloured by tales, fabulous and fanciful. Some of this knowledge was derived from Persian occupation of the Indus Valley (*c.* 515 BCE), reported by the Greek historian Herodotus. Later Greek and Roman historians incorporated accounts of the expedition of Alexander the Great, who crossed the Indus River in 326 BCE following his defeat of Darius III of Persia. Strabo noted exaggerated accounts of massive banyans (*Ficus benghalensis*), a single tree of which was said to shelter 400 men. In his natural history, Pliny the Elder noted many Indian plants and their uses, especially those of the Roman spice trade. Following the decline and fall of the Roman Empire, however, external contact with India waned until the end of the first millennium when Islamic influence began its eastern spread.

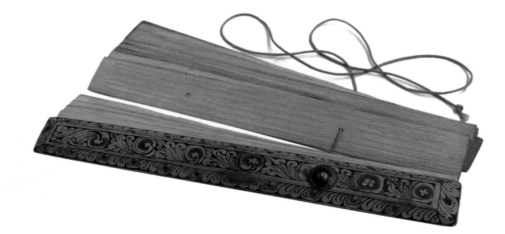

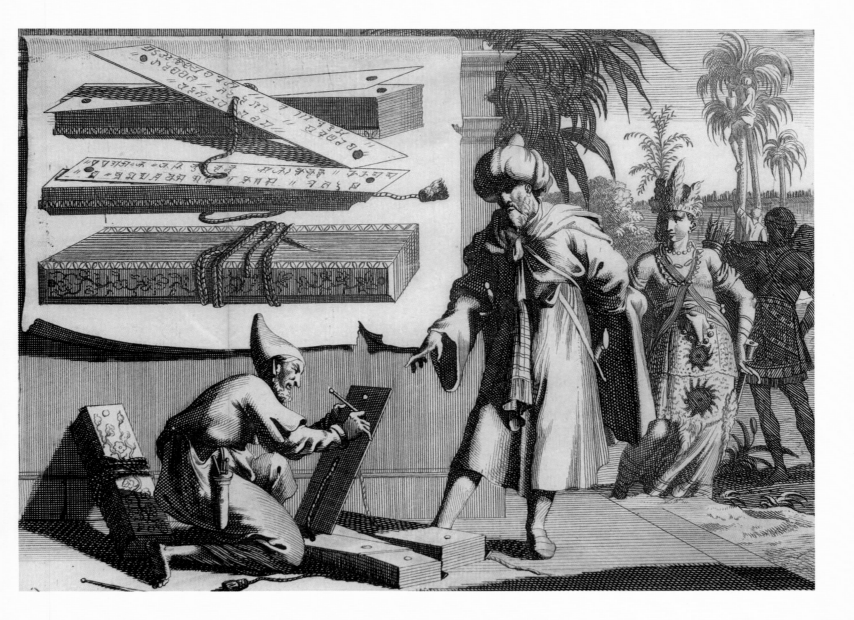

The palm-leaf book represents
a continuity of tradition found in
several Asian countries, including
China. There, before the invention
of paper in the first century CE, thin
strips of wood or bamboo were used
as a writing medium. This illustration
of a sixteenth-century Portuguese
excursion to the East Indies shows
the scribe recording on large strips
of timber, the elephant folios of the
palm-leaf genre.

Indianischer Pfeffer.

1.

3.

4.

6.

Capsicum fructu surrecto oblongo. Tournef. Inst. 153.
Capsicum caule herbacco. Linn. spec. 188. n.1.
Indianischer Pfeffer.

5: Mesoamerican and Andean Civilisations

THE EURO-CENTRIC NATURE OF WESTERN BOTANY—AND THE WRITING OF its history—means that the contribution of pre-Columbian American cultures and civilisations to the history of plant domestication has tended to be downplayed. Stress is placed on the Spanish 'discovery' of the New World and its exotic flora, yet for thousands of years vibrant cultures had existed in Mexico and Central America.

The term 'Mesoamerica' was coined in 1943 by anthropologist Paul Kirchhoff to refer to the central region of the Americas—stretching from central Mexico to Nicaragua—which was considered civilised at the commencement of the Spanish conquest in 1492. Located in a fecund tropical zone, Mesoamerica was the site of domestication of numerous important food plants, including sweet and chilli peppers, maize—or corn—and avocado. The archaeological record varies, but it is commonly accepted that agriculture was thriving in this region about 5000–2500 BCE.

The domestications of pepo squash (*Cucurbita pepo*) and the bottle gourd (*Lagenaria siceraria*) appear to have predated that of maize by several millennia. The cultivation of squash, gourds, and maize represented a ground-breaking advance over the efforts of early foragers, who relied on the collection of wild produce. Sophisticated cultivation techniques at such early dates suggest the presence of settled agricultural communities, especially in the northern areas of Mesoamerica now forming part of Mexico. Plants of upland cotton (*Gossypium hirsutum*) are known from the archaeological record, for instance, indicating domestication of this important fibre-yielding plant. Mesoamerica also included parts of present-day Guatemala, Belize, El Salvador, and Honduras, and in their low-lying areas root crops such as manioc (*Manihot esculenta*), yam (*Dioscorea* spp.), and arrowroot (*Maranta arundinacea*) were amongst the earliest domesticated plants.

The earliest civilisation of Mesoamerica, that of the Olmec, emerged on the Gulf Coast of Mexico over three thousand years ago. Its people were the forerunners of the Aztecs, and a continuum of sophisticated stone working—creating massive works of public art and architecture—distinguished the region. The Olmec lived in settled urban communities, largely dependent on agriculture. In fact, until the invasion of Mesoamerica by the Spanish in the late fifteenth century and the introduction of European crops and livestock, the staple diet was largely vegetarian, based on a balance of maize, beans, and squash. Maize (*Zea mays*) was domesticated from a primitive ancestor, a wild grass known as teosinte (*Z. mexicana*). The spread of this plant, from its origin in central Mexico, commenced perhaps eight thousand years ago and by the time of the Olmec, maize resembled the plant we know today. Likewise, various kinds of squash (*Cucurbita* spp.) and beans (*Phaseolus* spp.) were early domesticates, sometimes grown alongside rows of corn, whose stalks supported their climbing colleagues in a complementary fusion of plant architecture and nutritive value. The

Pumpkin, zucchini, and squash—all species of the genus *Cucurbita*—were amongst the earliest plants to be domesticated in Mesoamerica. Some cucurbits possessed the advantage of a hard-skinned protective shell, allowing storage throughout winter.

opposite: The genus *Capsicum* was amongst the most versatile of the early domesticates in Mesoamerica. Sweet pepper (*Capsicum annum*) provided a vegetable capable of being roasted as well as being eaten raw, while in dried powdered form it yielded the spice paprika. Chilli or red pepper (*C. frutescens*) yielded smaller and more pungent fruit, and in dried powdered form was later known as cayenne pepper, so named for the port in French Guiana where the chilli was grown and exported.

Maize or corn (*Zea mays*) is amongst
the oldest domesticated food plants of
the Americas, yet its naming in this
mid-sixteenth-century German herbal
as *Turcicum frumentum* indicates the
unfamiliarity of the plant to botanists
of the European Renaissance. This is
the earliest picture of a complete
maize plant to appear in print (1542)—
the plant had been recently introduced
to Europe from the New World—and
'Turcicum' was invoked to indicate its
foreign origin, Turkey at this date
being the quintessence of all things
exotic. Another contemporary German
writer, perhaps more wisely, called it
welschen Korn ('strange grain').

opposite: The avocado (*Persea
gratissima*) formed a nutritious
complement to the Mesoamerican diet
of grains and pulses. By the time of the
Olmec civilisation, the plant was being
cultivated in southern Mexico and
Guatemala, and soon underwent
changes by selection of improved
varieties.

common or kidney bean (*Phaseolus vulgaris*) was domesticated in a wide belt
extending from the highland valleys of Mexico to the Peruvian Andes, as was the
scarlet runner bean (*P. coccineus*).

The Mesoamerican diet was, of course, more varied than just these three
staples, and also included sweet and chilli peppers (*Capsicum* spp.), avocado
(*Persea gratissima*), and amaranth (*Amaranthus* spp.), an upright short-lived
annual that yields highly nutritious leaves and flowerheads. Storage of hard-
skinned fruits and differing cultivation techniques that prolonged the seasons of
some plants—vine-grown beans that matured over a long picking season
compared with varieties that matured evenly, for instance—also balanced diets.

As the Olmec civilisation was reaching its peak in central Mexico, a new
civilisation was emerging in the tropical rainforests of the Yucatán Peninsula,
Guatemala, and northern Honduras. The Maya flourished between the sixth and
ninth centuries CE, and like the Aztec civilisation that followed in Mexico, built
on the achievements of an earlier civilisation. Its agriculture drew on the plant
palette established by the Olmec, but the ecology of Mayan lands favoured
tropical plants unsuited to cultivation in the highlands of central Mexico. Cacao
(*Theobroma cacao*) and vanilla (*Vanilla planifolia*), which both yielded highly
important foodstuffs and flavourings, typified this new diversity. The beans of
the cacao tree—the primary ingredient of chocolate—also assumed significance
as a form of currency, as they were uniformly sized, highly valued, and
conveniently portable. Other plants from the region were domesticated: the
tomato (*Lycopersicon esculentum*), for instance, which originated in the coastal
highlands of western South America, was introduced to Mesoamerica and
cultivated by the Maya.

Indigenous agriculture in South America had many centres, but it is the
Andean highlands of present-day Peru that have yielded evidence of the most
sophisticated cultivation. Well-preserved lima beans (*Phaseolus lunatus*), sheltered
within Andean caves, have been dated to approximately eight thousand years ago.
This species was closely related to the sieva beans (also *P. lunatus*) of Mesoamerica,
and although they may have shared wild origins, both developed independently
as they became domesticated in different ecologies.

Other early domesticates for which archaeological evidence has been found
include the common bean and chilli pepper. Root crops, for example the potato
(*Solanum tuberosum*), sweet potato (*Ipomoea batatas*), and manioc (or cassava),
formed one of the principal food-plant types of South America, in widely spaced
regions including early village settlements of the Amazon and Orinoco river
basins. The grain crop quinoa (*Chenopodium quinoa*), little known outside South
America, also formed an important part of the diet in the Andes, even more
significant perhaps than maize.

The first millennium CE witnessed significant changes to the civilisations in
Mesoamerica and South America. The Mayan civilisation collapsed towards the
end of this period, and the Inca civilisation came to dominate the Andean
highlands, as the Aztec did in Mexico. Yet for all these great epochs, the European
conquest of the New World wrought changes to traditional ways of life as drastic

PLANTS OF THE ANCIENT AND CLASSICAL WORLDS

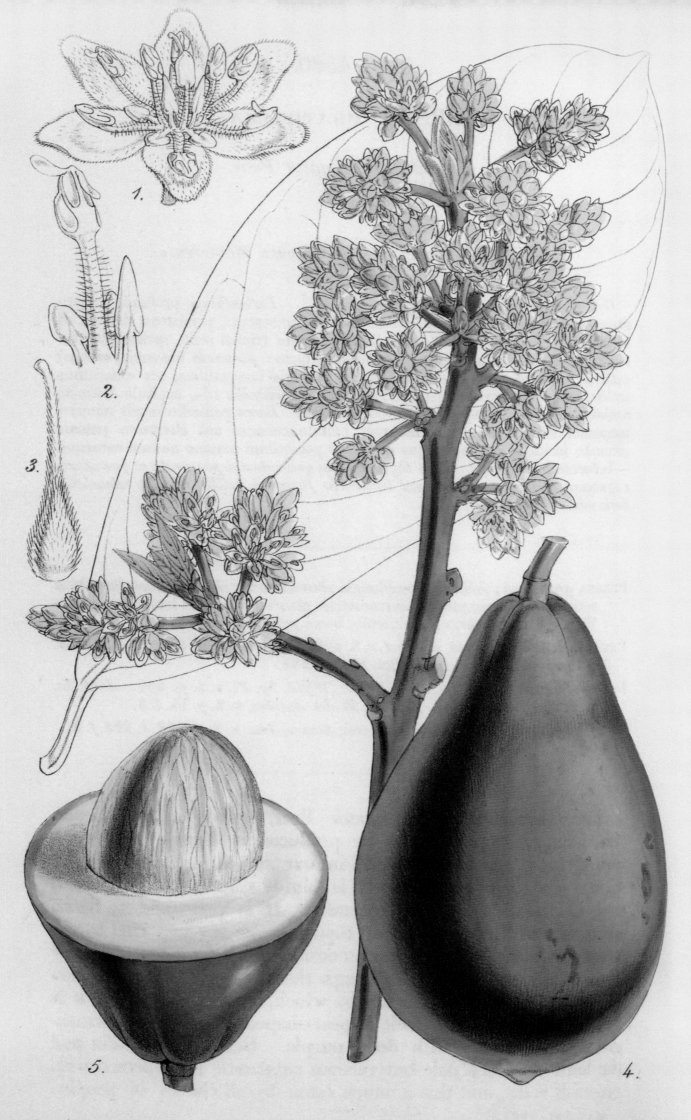

Reeve & Nichols imp

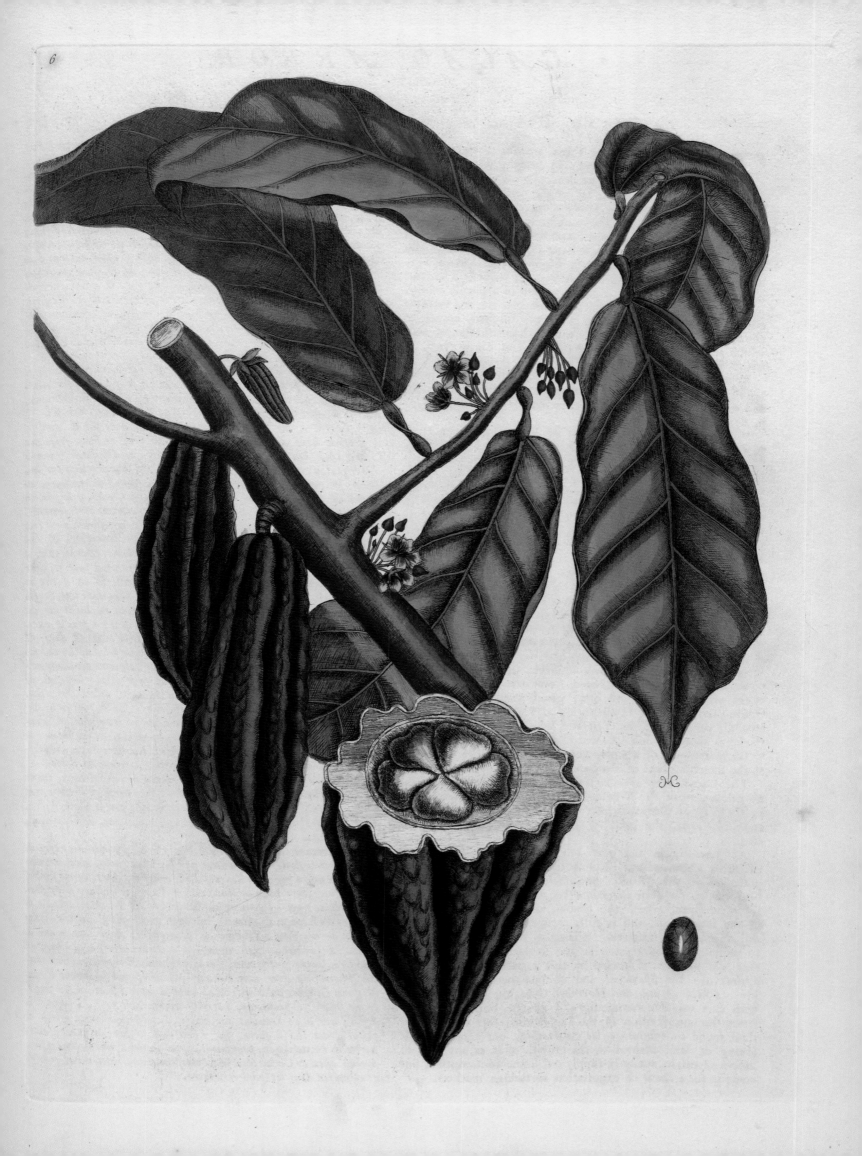

XAMPON

Much of what we know of the Mayan civilisation dates from archaeological investigations commenced in the early nineteenth century, evocatively publicised through the views of Frederick Catherwood. It was coincidently at this time that the love apple or tomato (*Lycopersicon esculentum*), a Mesoamerican staple, was being repatriated from obscurity as a food plant in northern Europe. As a member of the Solanaceae family, tomatoes had long been regarded with suspicion due to an affinity with their poisonous cousin, the deadly nightshade (*Atropa belladonna*).

as any known in the Americas. The Spanish and those who followed quickly introduced many Mesoamerican food plants to Europe and the Old World tropics of Africa and Asia, and viewed the area's rich ornamental flora with Western horticultural sensibilities. Yet the novelty of the American flora challenged early European observers. The Aztec nobility ate 'frog with green chillis; newt with yellow chillis; tadpoles with small chillis; maguey grubs with a sauce of small chillis; lobster with red chilli', wrote Friar Bernardino de Sahagun, a Spanish missionary in the early sixteenth century, his wonderment freely and deliciously spiced with hyperbole.

opposite: Although the Olmec had known of its properties, it was the Mayan civilisation of Guatemala and the Yucatán Peninsula that was the first to extensively cultivate cacao (*Theobroma cacao*). Beans from the fruit of this tropical tree were roasted and ground to form a paste, used as the basis of the beverage later known to Europeans as chocolate or cocoa.

The sweet potato (*Ipomoea batatas*) was amongst the earliest food plants domesticated in South America, with a tradition of cultivation extending back approximately four thousand years in coastal Peru.

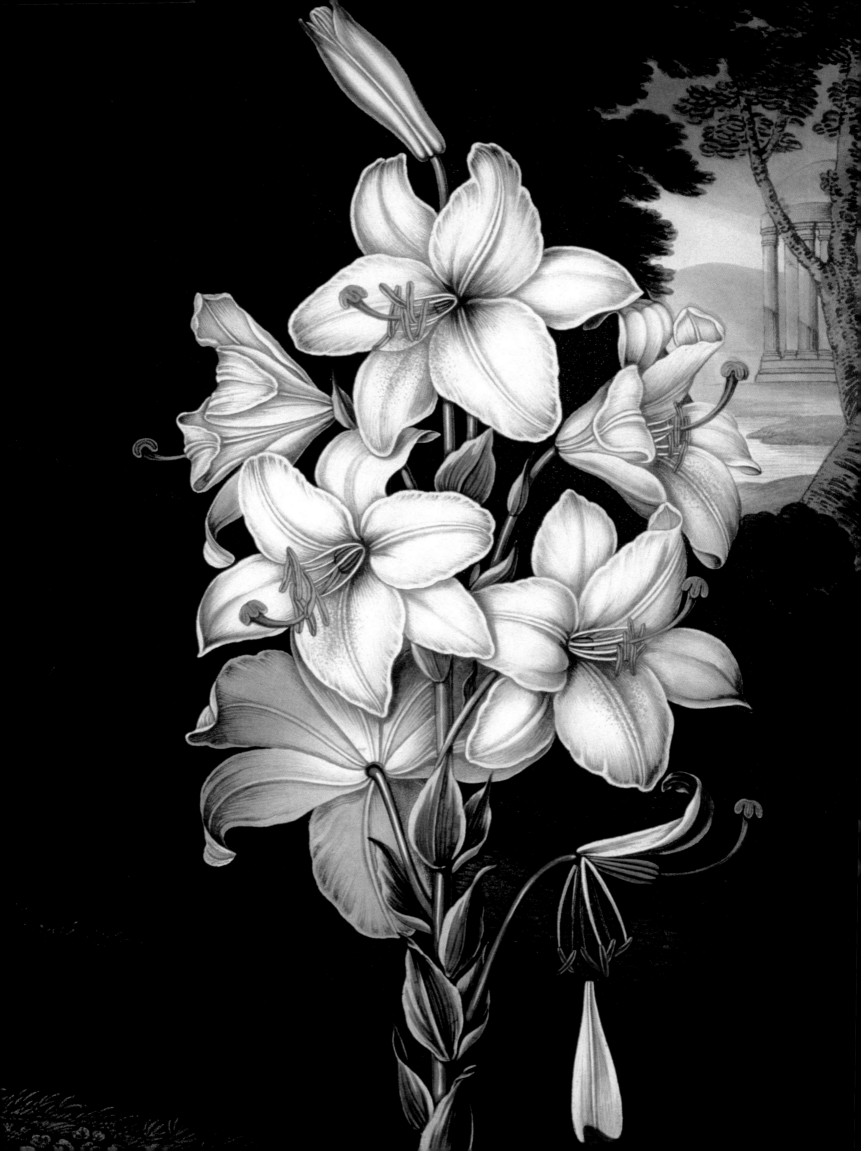

Mediterranean Civilisations

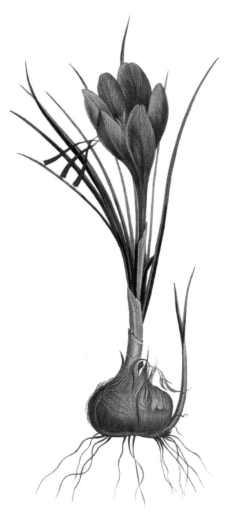

MEDITERRANEAN CIVILISATIONS OF THE ANCIENT AND CLASSICAL WORLD were—as Plato described it—like 'frogs around a pond'. The temperate waters, indented coastline, narrow coastal fringes, and often steeply rising headlands created a scenic backdrop for dramatic shifts in power and influence. Civilisations rose and sank, yet the dominant presence of the sea defined and linked disparate cultures. The climate we now recognise internationally as 'Mediterranean'—from California to Chile, and Adelaide to southern Africa—gave rise to a distinctive flora, one that could survive hot, dry summers, to be refreshed by winter rains. Common herbs such as bay laurel (*Laurus nobilis*), lavender (*Lavandula* spp.), rosemary (*Rosmarinus officinalis*), sage (*Salvia* spp.), and thyme *(Thymus* spp.) have enjoyed long use in the Mediterranean, as have the olive (*Olea europaea*) and lentil (*Lens culinaris*). Ornamental flowering plants such as the anemones,

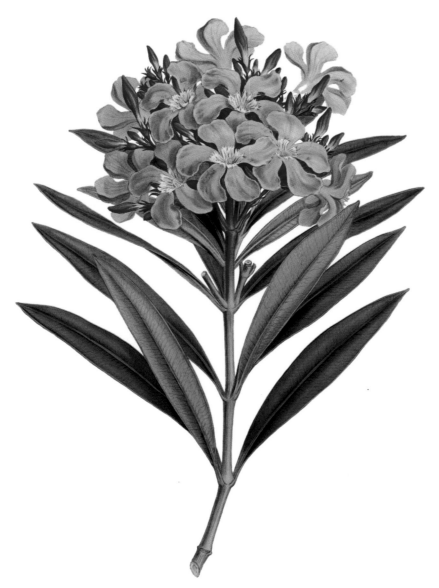

above: Saffron crocus (*Crocus sativus*), which yielded a powerful yellow dye, was featured in some Minoan art. The genus *Crocus* was widely distributed, although its strongest concentration of species was in the Mediterranean.

left: The oleander (*Nerium oleander*) enjoys a wide distribution throughout the Mediterranean region, thriving in the hot, dry summers and unforgiving stony ground of its coast. These attributes have ensured the oleander's introduction to a wide range of comparable climates.

opposite: The Madonna lily (*Lilium candidum*) formed part of the rich bulbous flora of Crete, and it was amongst the cultivated plants depicted in Minoan art from as early as 1700 BCE.

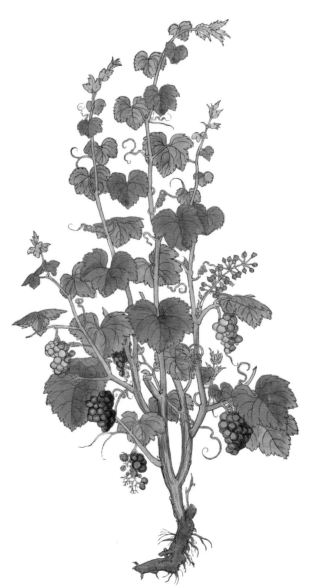

Dionysus, son of Semele and Zeus, having survived the trauma of his premature birth (Zeus's brilliance unwittingly blinding and killing Semele while simultaneously razing his own palace), discovered the culture of the vine while still a youth. Nourished into manhood by nymphs, and surrounded by satyrs, centaurs, and bacchantes, Dionysus taught the art of winemaking wherever he travelled, revelling in the productive and intoxicating powers of the grape (*Vitis vinifera*).

oleanders, and rock roses (*Cistus* spp.) characterise the coastal regions, as do such trees as the Aleppo and stone pines (*Pinus halepensis* and *P. pinaster*), the valonia and cork oaks (*Quercus macrolepis* and *Q. suber*), and carob (*Ceratonia siliqua*). In moister hilly areas, deciduous forests of beech (*Fagus sylvatica*), chestnut (*Castanea sativa*), elm (*Ulmus* spp.), and oak have yielded trees enjoying long traditions of garden use.

The early use of plants by ancient Mediterranean civilisations can be seen most clearly through the art of the Minoans. Centred on the island of Crete, Minoan culture was distinguished by the emergence of a literate people whose written script formed the basis of Greek writing. At its peak, about 1600 BCE, Minoan art displayed an unprecedented vibrancy, with frescos depicting scenes of Cretan society and its culture. Plants such as the Madonna lily (*Lilium candidum*) and saffron crocus (*Crocus sativus*) figured prominently, allowing us to appreciate commonly grown plants.

Crete possessed a rich endemic flora, as well as other species shared with neighbouring islands and mainland Greece and Turkey. Bulbs clothed her hills, arid-zone plants sharing affinities with northern African flora found a niche on hot southern and eastern coasts, while the central range of mountains was home to forests of cypress (*Cupressus sempervirens*). From its island base, Minoan civilisation depended on maritime excellence for trade and defence and its close relationship with the sea allowed influence from Near Eastern civilisations to be absorbed whilst also allowing Minoan ideas and products to be exported.

Minoan supremacy was unchallenged in the Aegean until its decline after 1000 BCE and the consequent rise of the seafaring Phoenician civilisation. From the lands of present-day Lebanon, the Phoenicians opened the full extent of the Mediterranean to trade, perhaps even venturing beyond its western bounds to the Atlantic islands. Port cities at Carthage and Utica in northern Africa and Cadiz on the Iberian Peninsula were established as components of a vast trading empire. Plants of the Middle East could be shipped to the northern and eastern Mediterranean with ease—Phoenicians, for instance, are credited with the introduction of the grape (*Vitis vinifera*) to France around 600 BCE.

Greece and the Aegean islands emerged from Minoan influence during the second millennium BCE to become a distinct Mycenaean civilisation, equalling and soon far surpassing in vitality those that had preceded it. By the fifth century BCE, from its centre in the city-state Athens, the age of classical Greek civilisation had emerged from its diffuse beginnings. The rugged countryside and distinctive flora that had shaped earlier Mediterranean cultures now cast its influence over the Athenian world. Attainments in art and architecture, mythology, literacy, philosophy, and scientific thought marked Greek attitudes to nature and to the use of plants.

An abundance of durable stone endowed Greek architecture. Temples to the gods, agoras for public assembly, and amphitheatres for drama were its set pieces, enlivened by landscape settings that invoked the *genius loci*, or spirit of the place. Trees might provide shade or honour gods, while their careful siting could reveal drama inherent in the setting, perhaps a distant view. Sculpture especially

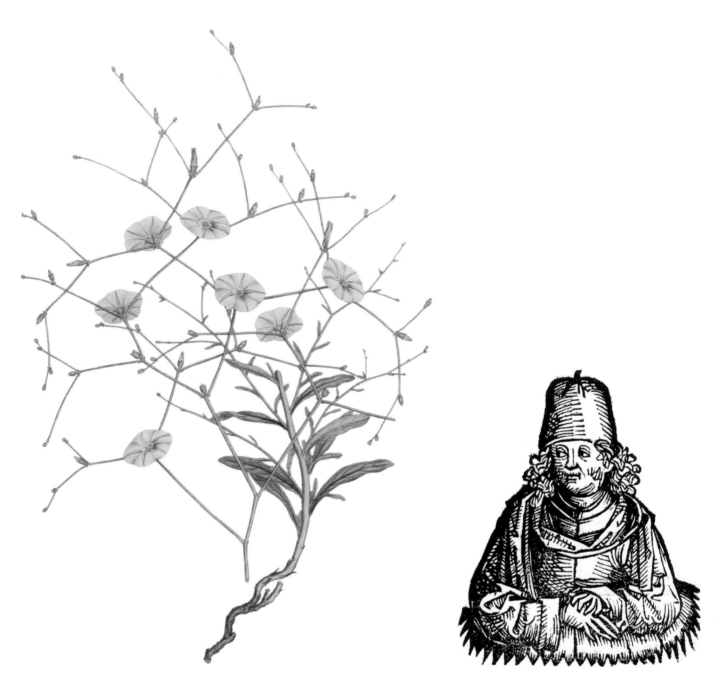

enjoyed a new naturalism, as if in response to the new-found contemplation of the universe and its nature, one in which superstition was overtaken by analysis and deductive reasoning. For all this, religion and myth still played a crucial part in day-to-day Greek culture. The pantheon of Olympian gods, supernatural yet imbued with mortal qualities, was part of the human-centred nature of the Greek civilisation. Some gods were associated with plants—Dionysus, for instance, with the grapevine—and imbued them with rich meanings, later greatly expanded by the Romans. Gods and goddesses made love in gardens, and plants healed their wounds, while Apollo's first love Daphne even turned into a fragrant bay laurel, her leaves henceforth worn as a crown of achievement.

The systematic study of plants was a key aspect in the emergence of Greek science, as was the rise of Greek as a *lingua franca* of the classical world. Aristotle of Stagira, whose observation, collection, experimentation, and categorisation of scientific data formed the basis of teachings at his Lyceum, brought these new concepts of reasoning and analysis to bear on many disciplines including the natural sciences. Aristotle had received tutelage from the Greek philosopher Plato, who in turn had been a disciple of Socrates. With such august lineage, Aristotle's followers—or Peripatetics, as they were known—were ideally placed

This fifteenth-century portrait of Theophrastus of Eresus depicts a genial scholar, the inheritor of Aristotle's Athenian Lyceum and its celebrated garden. His writings of the third century BCE, contained in the *Enquiry on Plants*, form the earliest distinctively botanical treatise.

above left: The genus *Convolvulus*, found throughout the Mediterranean, takes its name from the Latin 'to entwine'. *Convolvulus dorycnium*, found extensively in Greece, exemplifies this habit, with its convoluted branching stems punctuated at their junctions by delicate pink flowers.

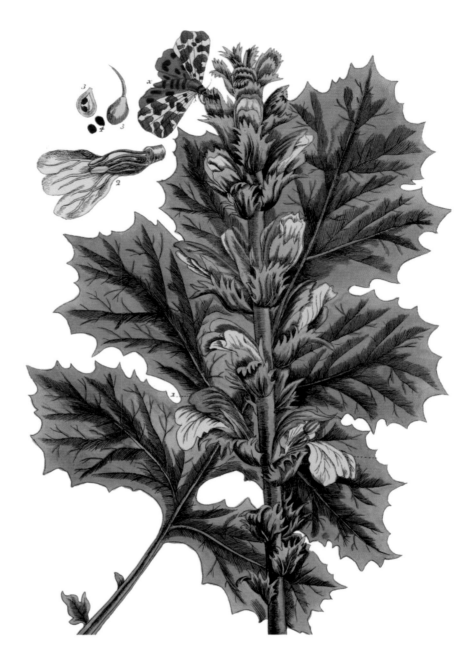

right: Outstanding engineering skills marked the Roman Empire—paved roads, for instance, gave new order to the designed landscape. Richness was also added to earlier Greek architectural traditions. The capital of the Corinthian order, which distinguished many Graeco-Roman buildings, was based on the leaf of the acanthus (probably *Acanthus mollis* or *A. spinosus*) entwined with volutes (recalling the simpler Ionic order).

An extension of European knowledge about the natural world was a major outcome of Alexander of Macedonia's expedition of conquest through Persia to the Indus Valley. On this early Alexandrian title page, hurdled livestock shelter beneath the enormous trunks and arching branches of a fig tree, perhaps intended to represent the banyan (*Ficus benghalensis*) of India.

to revolutionise botany. The mantle was passed to Theophrastus of Eresus, who maintained the Lyceum and its garden, and provided botany with two seminal treatises describing his research, *Historia plantarum* (often translated as *Enquiry on Plants*), and *De causis plantarum*, both written *c.* 320–287 BCE. Theophrastus described and classified plants according to their characteristics and differences, and identified those special to particular localities, including Egypt, Libya, Asia, the Mediterranean, the outer seas (the Atlantic Ocean, Red Sea, and Persian Gulf), and northern regions—north, that is, as far as Macedonia.

The inclusion of Asian plants in *Historia plantarum* signalled the influence of Alexander the Great, whose expedition through Persia as far as the plains of India (336–332 BCE) was a defining event of the Hellenistic age, when the centre of influence moved north from Athens to Macedonia. Like Theophrastus, Alexander had studied under Aristotle, which ensured that his military conquests were fused with a spirit of enquiry. Knowledge of Persian pleasure gardens soon influenced Greek gardens and some of the citrus fruits were probably introduced to Europe at this time.

The Greek civilisation sustained an epoch of supreme intellectual achievement. Even as Rome expanded its empire, Greek scientific scholarship remained dominant. Greek army surgeon Pedacius Dioscorides, writing in the first century CE, stands as an example of this continuing influence. Using knowledge derived from his extensive military travels, Dioscorides compiled the earliest comprehensive medical treatise, *De materia medica*, a work that provided the basis for all subsequent medical scholarship up to and including the European Renaissance.

Roman scholarship was well demonstrated by the massive compilation *Historia naturalis* (*c.* 77 CE) by Pliny the Elder. Covering the full spectrum of natural history, Pliny devoted considerable attention to plants. His discursive style left out nothing of importance, providing later scholars with a tangle of fact and fable, plausible and compelling. Plant introduction figured largely in his writings, providing a mass of information about botany and horticulture of the Roman Empire. The images of Roman gardens that were buried at Herculaneum and Pompeii following the eruption of Vesuvius—replete with palms, fruit trees, flowering shrubs, and delicate flowers—are brought to life in Pliny's *Historia*. Ironically, it was at Pompeii that Pliny lost his life. Ever curious, he rowed towards the eruption, eager to view the awful phenomenon at close hand, only to be suffocated by its sulphurous fumes.

below: **The mandrake (*Atropa mandragora*) was amongst the plants described by Greek physician Dioscorides in his *De materia medica*, the earliest surviving medical treatise. The characteristic shape of the root and leaves was often (and understandably) anthropomorphised into the human form.**

below left: **This well-known depiction of Dioscorides receiving a mandrake from the Goddess of Discovery shows not only an anthropomorphised root, but also the stiffened carcass of a dog that invariably died, having been roped to this poisonous plant to facilitate the act of pulling the root from the ground.**

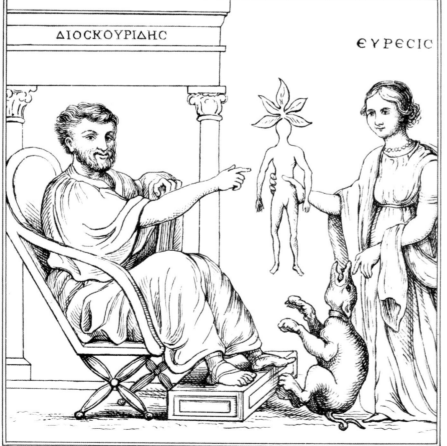

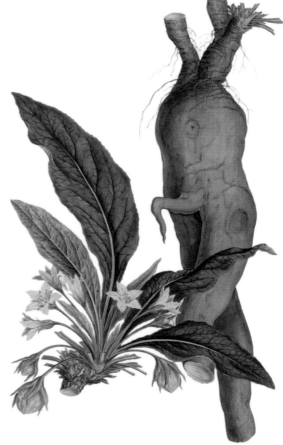

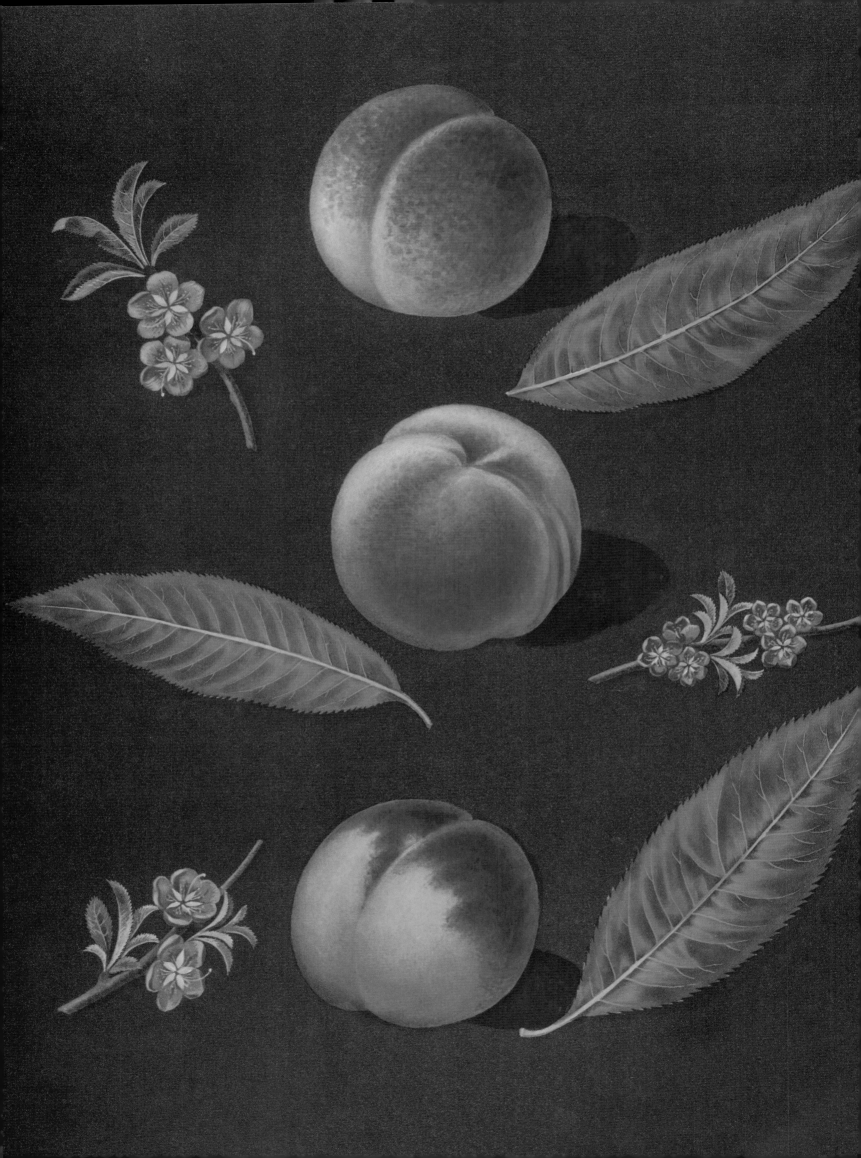

The Silk Road to Cathay and Beyond

OVER TWO THOUSAND YEARS AGO, WHEN THE RICHES OF CATHAY FIRST started to trickle west across the Silk Road, agriculture in China had already acquired a history at least as old again. Foxtail millet (*Setaria italica*) and rice (*Oryza sativa*) are known in China from archaeological evidence dating to 2600 BCE, perhaps as early as 5000 BCE. Although commonly associated with China, rice was also an early domesticate in India, and soon transferred to south-western Asia and northern Africa.

Agricultural traditions, similar to yet independent of those developing in western Asia and northern Africa, were a hallmark of the earliest Chinese civilisation—the Shang—whose culture developed along the Yellow River basin around 1800 BCE. River deltas and coastal lowlands along China's eastern coast provided a relatively benign climate suited to agriculture, especially compared with the vast arid region that extends over much of central Asia.

The Shang people developed a sophisticated society, possessing knowledge of irrigation, an ability to work bronze, and an early form of writing. Inscriptions on bone and tortoiseshell dating to *c.* 1200 BCE recorded oracular decisions, while writing with brush and ink was known as early as *c.* 1000 BCE. Writing remained a privilege of the elite, although with the invention of paper by the first century CE, its use became more widespread.

The manufacture of paper relied on plants for its raw materials, specifically the paper mulberry (*Broussonetia papyrifera*). The bark of this mulberry—later named *papyrifera* by European botanists for its link with another familiar paper-making plant—was mixed with bamboo slivers and other plant fibre, then crushed and water added. The dried pulp yielded a flat, porous, flexible medium, capable of accepting ink writing and being stored as a rolled scroll. Another form of paper was manufactured by beating the pith out of *Tetrapanax papyriferus* stems, a plant known as the rice paper tree. (Rice stalks, when added to other wood pulps, also yielded a soft paper, regarded by some historians as the earliest form of toilet paper.)

The earliest spices to reach Europe from south-eastern Asia were probably carried from the Moluccas (Spice Islands) west via sea and land through India and Arabia to Alexandria in Egypt. From the Roman Empire's busiest port, goods could then be shipped to Europe. This ancient spice trade also had a northern route, from the Moluccas to China. During the second century BCE, however, a remarkable overland route leading directly west from China to Europe was established. This 7000-kilometre network was opened following construction of the Great Wall of China, which defined the easternmost section of the Silk Road, as the route later became known. The Great Wall had been a product of the Ch'in dynasty (which gave its name to China), and served initially to protect the northern border of the newly unified nation. Caravans plied the Silk Road, carrying Chinese fruits such as apricots and peaches (*Prunus armeniaca* and *P. persica*) alongside silken products that gave the road its name. The route was a

The Silk Road—that conduit between East and West—took its name from the fine thread and fabric produced in China. The production of silk relied on an abundant supply of leaves from the white mulberry (*Morus alba*), on which the silkworms were fed.

opposite: The peach (*Prunus persica*) originated in China and Tibet, and was initially taken westwards via India and the Arabian Sea, and at a later period, overland via the Silk Road. Valued in China for its bloom as much as its fruit, the peach promised fecundity and immortality.

The planting and harvesting of rice (*Oryza sativa*) involved timeless rituals. By tradition, the Chinese Emperor planted the first seed, for the cycles of growth, harvest, and consumption were marked with spiritual as well as practical significance.

opposite above: Bamboos, woody-stemmed grasses, are one of China's most versatile plants. Their strong yet flexible canes have yielded a multitude of products, from chopsticks to scaffolding, while their great variety of form and colour has made them garden favourites. This image combines quintessential Chinese traditions of calligraphy and woodblock printing.

opposite below: Various species of banana (*Musa* spp.) were found in China's subtropical south. These yielded valuable fruits and fibres, and were also grown for the ornamental potential of their large, graceful leaves, even if the plant could not fruit in the cooler gardens of northern China.

conduit for ideas as well as goods, and trade was not all one way—precious metals and stones from Europe balanced trade with highly sought Chinese jade, lacquerware, and ceramics.

Isolated by cultural differences and distance, the indigenous and domesticated flora of China defined the country's gardens, perhaps more strongly than any other nation. Pines and other conifers from cool mountainous regions, members of the *Prunus* genus (including peach, plum, and cherry), and bamboos provided the natural ingredients of a garden culture possessing extraordinary longevity. Although the climate varied widely across such a vast country, this trio—pine, plum, and bamboo, known as the 'Three Friends of Winter'—was indispensable in Chinese gardens. Plants were especially appreciated for their symbolism and associations. The peony (*Paeonia* spp.), for instance, betokened wealth and elegance; the lotus (*Nelumbo nucifera*), an early import from India, brought with it Buddhist associations. Bamboos signified vigour, longevity, and perseverance.

The range of flowering plants was greatly expanded by careful selection, with many cultivated varieties singled out for their horticultural potential—although the long span of Chinese gardening has now obscured the origins of some plants, such as garden varieties of chrysanthemum (*Chrysanthemum* x *morifolium*). Plants from China's south—for example, bananas (*Musa* spp.), lychee (*Litchi chinensis*), and various orchids (especially *Cymbidium* spp.)—also enlivened gardens in climates where they could be grown.

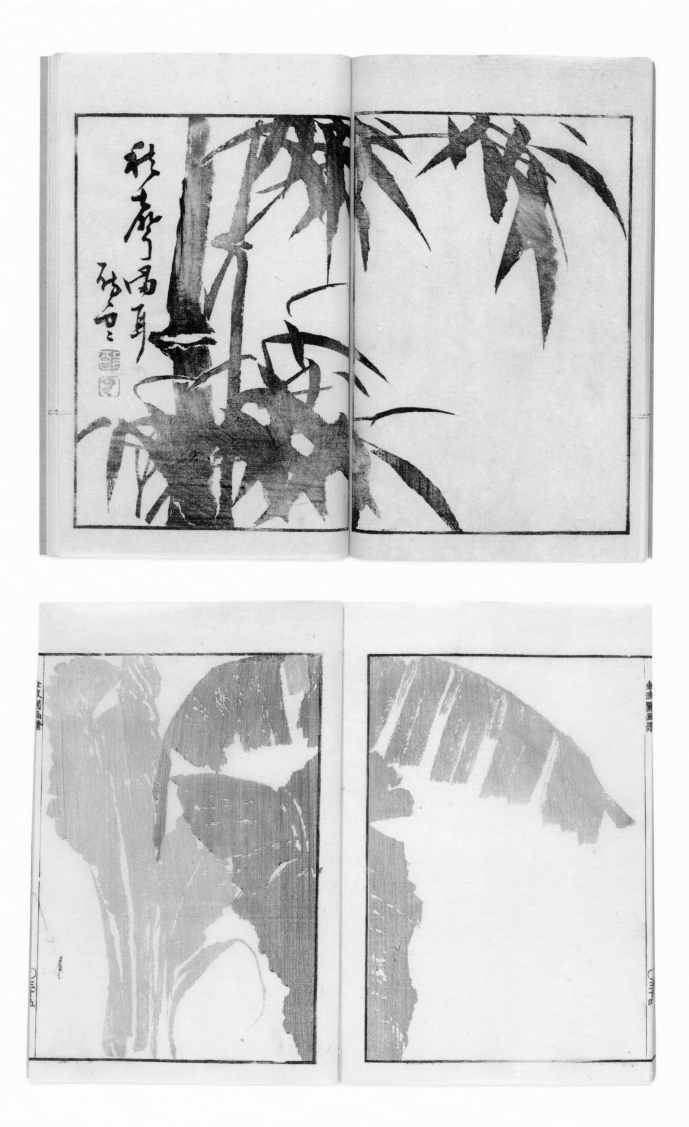

The moutan or tree peony (*Paeonia suffruticosa*) became a great favourite in Chinese gardens as early as the seventh century CE, when it was introduced from the cool mountainous regions of central China. The large size of its flowers and their variation in colour meant that many cultivars were selected and propagated, greatly increasing the range of plants available for garden use.

Pæonia suffruticosa

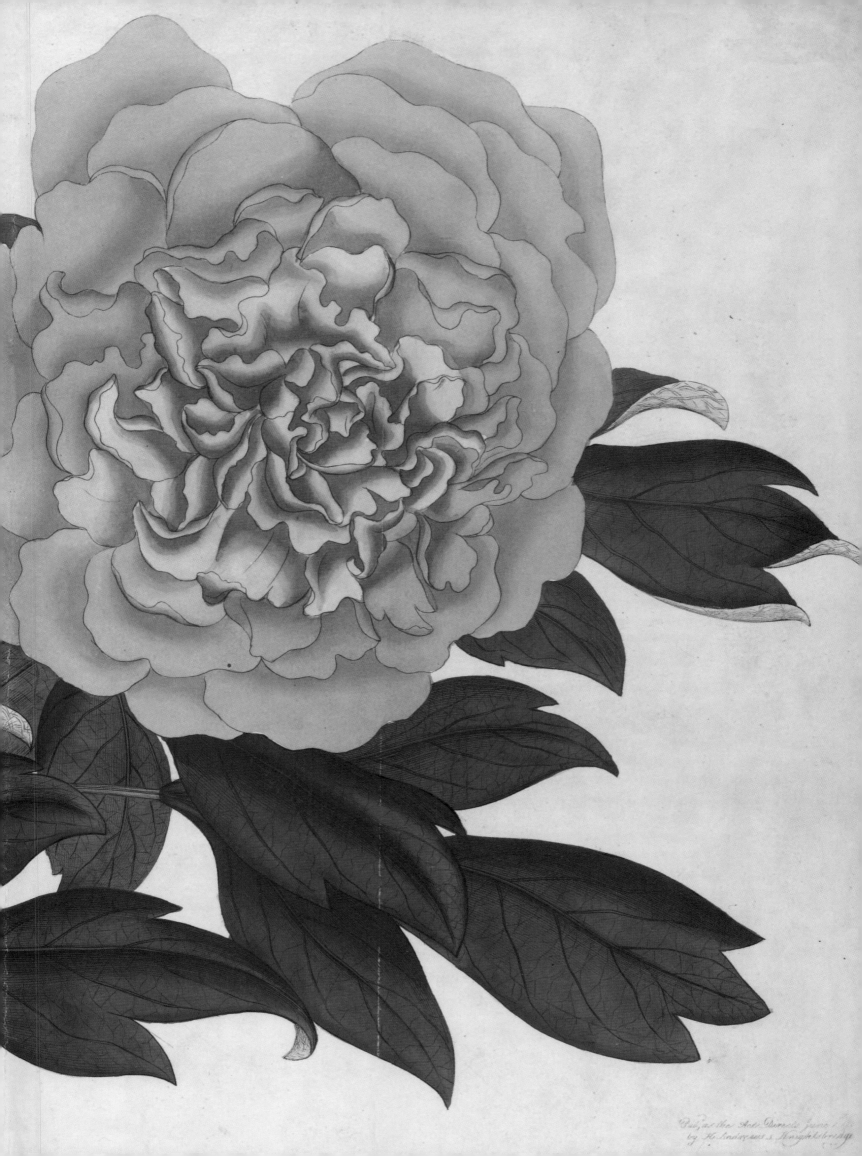

Pub. at the Art Union June 1
by H. Andrews, Knightsbridge

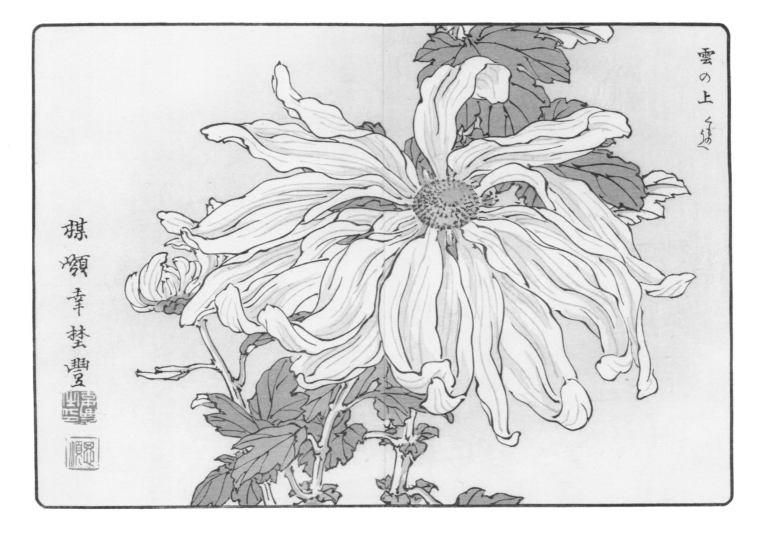

雲の上

煤頌幸埜豐

Although introduced from China, the garden chrysanthemum (*Chrysanthemum* x *morifolium*) has long held its place as the quintessential Japanese bloom, its flowers an inspiration to generations of Japanese artists.

The introduction in China of paper made from the paper mulberry (*Broussonetia papyrifera*) was later coupled with woodblock printing and moveable type. Such printed texts and images, some dated as early as the ninth century, were published hundreds of years prior to the 'invention' of printing in Europe.

This floristic richness varied across the country, from the subtropical south to the cool, arid north, and from coastal lowlands of the east to mountainous regions of the inland. China's rich flora, especially that of the north, also shared a close affinity with the plants of Korea and Japan. Such physical links were complemented by cultural interchange. From the seventh century CE, Japan increasingly adopted many aspects of Chinese culture and spirituality, including Buddhism, which overlaid local Shinto beliefs. Both stressed the beauties of nature, from the universal appreciation innate in Buddhism to the more specifically national focus of Shinto. Like their Chinese counterparts, Japanese gardeners venerated local plants and possessed an appreciation of the unfolding seasons—scented blossoms of spring, vibrant blooms in summer, richly varied autumn tints, all against a backdrop of evergreens. After the seventh century, Chinese plants increasingly enriched Japanese gardens. The chrysanthemum, peach, and tree peony (*Paeonia suffruticosa*) all found an honoured place in Japanese gardens. Indeed, some Chinese plants became so closely associated with Japan that this was later reflected in their naming by European botanists—witness the Japanese apricot (*Prunus mume*) or *Sophora japonica* (scholar tree).

The longevity of Chinese and Japanese cultures has imbued the gardens and garden plants of those countries with great symbolism. Dynastic spans of many centuries and deeply felt spiritual beliefs were influenced by and in turn enriched horticultural and landscape design traditions. Art and literature provided a means of conveying plant symbolism, reinforcing and recording it for later generations. Such enduring garden traditions bequeathed a rich harvest of plants and ideas, although it was to be many centuries before this permeated Western notions of gardening.

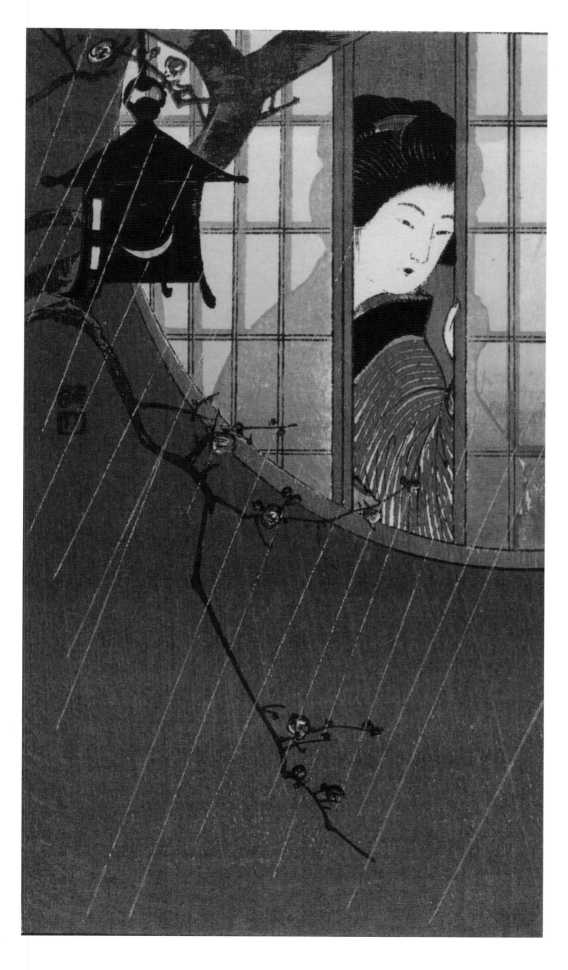

above: The root of ginseng (*Panax ginseng*), from Korea and north-eastern China, has long been regarded in Asian cultures, and China especially, as a universal tonic and cure for ailments. The resemblance of ginseng's forked root to the human form imbued the plant with symbolic importance, perhaps the cause of scepticism in Western cultures regarding claims for the plant's medicinal efficacy.

left: Many highly prized *Prunus* species were indigenous to China and Japan, where the bursting of the first spring blossoms heralded the end of winter. The Japanese apricot (*Prunus mume*), peach (*P. persica*), and Tokyo cherry (*P.* x *yedoensis*) all achieved great popularity as garden plants and were also the subjects of a vast symbolic lore.

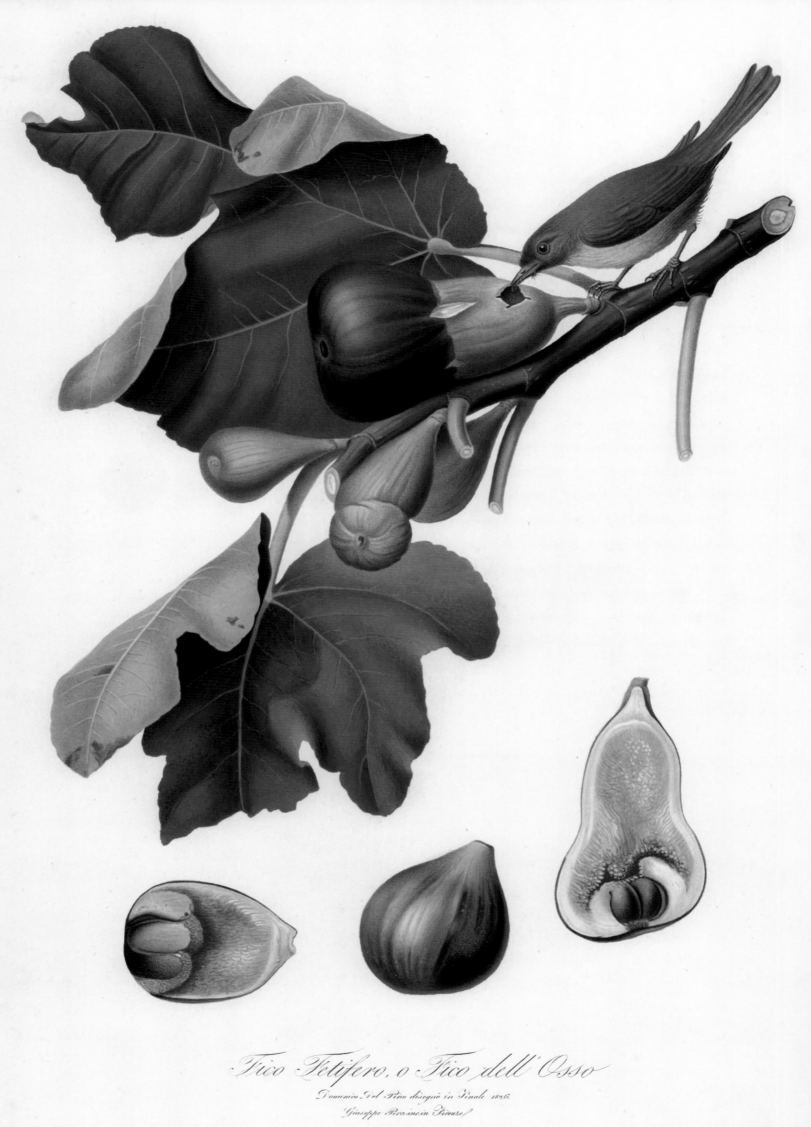

Fico Fetifero, o Fico dell'Osso

Domenica Del Pino disegnò in Finale 1826.

Giuseppe Rosaino in Firenze

The Rise of Islam

THE HARSH LANDSCAPE OF THE ARABIAN PENINSULA SEEMS AN unpromising land for plants and gardening, yet from its oases in the seventh century CE sprang a culture that expanded to rival the Roman Empire at its height. Arab trade along the Red Sea had already provided a crucial means of transporting plants to and from the Indus and Nile river valleys, as well as linking ports along the coast of the Arabian Sea with the Fertile Crescent of the Tigris and Euphrates rivers. This form of trading suited a land possessing an arid interior and a lengthy coastline dotted with small ports, yet during the sixth century the population of the inland settlements clustered around oases rose, with a corresponding rise in importance of these new cities. From Mecca to Mocha, inland routes parallel to the Red Sea coast began to dominate commerce, providing a vital new route for trade between the East Indies and the Mediterranean.

Into this world came the voice of a prophet named Muhammad, born into a clan of the Bedouin tribes centred on Mecca. Around 610, Muhammad began reciting visionary wisdom received from his god, verses that were subsequently recorded in the writings of the Koran (Qur'an). Calling on his fellow citizens to renounce all other gods and surrender their faith to Allah, Muhammad fled to Yathrib (Medina) where the new religion of Islam took hold. Followers of Islam—Muslims—pledged to submit to Allah and to order their life according to the teachings of the Koran. After Muhammad's death in 632, Islamic influence rapidly expanded throughout the Arabian Peninsula and into the northern parts of Egypt, to Syria and Iraq, and through Persia (Iran) as far as the Indus River.

The linking of Islam with older Persian traditions had a great impact on garden design and the flow of plants. Almost a thousand years earlier, the royal gardens of Persia had adopted the four-square plan form, with enclosed rectangular gardens divided by irrigation-fed rills into quadrants of flowers and shade trees. Such designs—seen in the patterns of traditional Persian carpets— were copied by the Arabians and enmeshed with the beliefs of Islam. The earthly Persian pleasure garden was transformed into the paradise promised to all Muslims by the Koran. Comfort, water, fruit, and beauty awaited the faithful after death. Palms and pomegranates, figs and roses, all were invoked in the Koran, symbolic reminders of spiritual beauty.

The writings of the Koran also depended on another Arabian accomplishment, the conversion of spoken language into written literature. Stylised floral motifs, arabesques (derived from twisting vines), and elaborate patterning complemented the calligraphic nature of Arabic script, and imbued Islamic art and architecture with great beauty. With a religious prohibition on the depiction of the human form, surface decoration evoked by the plant world contributed strongly to the splendour of this emerging style. Garden settings of buildings were also an integral part of this complementary fusion.

The political supremacy of the Arab world from the eighth to the thirteenth centuries was accompanied by active trading between the Persian Gulf and

opposite: **The teachings of the Koran stressed the unity and divinity of nature, and the duty for this to be revered and protected. Trees such as the fig (*Ficus carica*)—widely cultivated throughout the Arab Empire—provided fruit for sustenance, shade for convenience, and pleasure in its contemplation.**

Islamic art turned away from the naturalism of earlier Mediterranean civilisations, and instead developed a decorative style based on the calligraphic Arabic script and abstract patterns, often drawing on floral motifs.

MALA PVNICA.

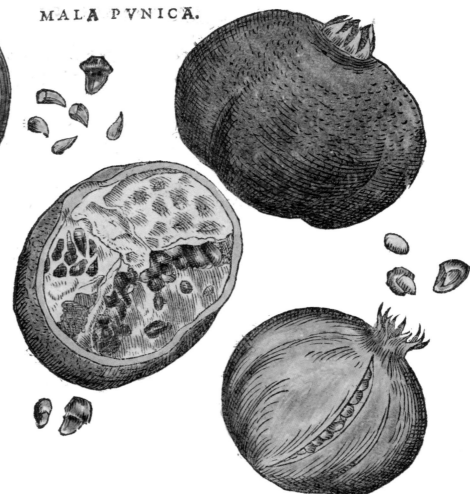

The pomegranate (*Punica granatum*), although introduced to the Iberian Peninsula earlier than the Arab conquest, was greatly favoured in the gardens of Moorish Spain. Its distinctive seeded fruit has given rise to a rich mythology—pomegranate juice mixed with snow is said (probably without foundation) to have given the iced drink 'granita' its name. With greater certainty we can attribute the name 'pomegranate' to the Latin *pome-granate*, apple with many grains (or seeds).

opposite: Although ancient Greeks and Romans knew the opium poppy (*Papaver somniferum*) and its ability to induce sleep and numb pain, it was the Arabs and Persians who monopolised its early trade. The study of the opium poppy reached new heights in the eleventh-century writings of the Arabic physician Ibn Sīnā (Avicenna), at a time when the potential of this opiate in trade as a valuable, compact, concentrated substance was also being exploited.

south-eastern Asia; this was encouraged by the fact that Islamic expansion into central Asia had restricted access along the Silk Road. During this period the Islamic hegemony not only grew east to India, but west to northern Africa and Spain. Baghdad emerged in about 750 as the capital of this expanding empire, and a centre for scholarship. Science (including pharmacology) reached a high level of sophistication in the Arab world, exemplified by the teaching and writings of Ibn Sīnā (980–1037), also known as Avicenna. Ibn Sīnā was born in central Asia (present-day Uzbekistan) and established himself as a leading Islamic scholar in philosophy, science, and medicine. In a period when medieval northern Europe was viewed as unsophisticated by the Arab world, Ibn Sīnā quickly mastered contemporary knowledge and began preparation of an encyclopaedic work whose title roughly translates as *The Cure [of Ignorance]*. In this he elaborated a broad theory of science as wisdom, and classified the natural sciences into eight principal groups, of which plants formed an important division. His writings included some of the first written descriptions of bananas and coconuts, plants of the Old World tropics accessed through the vast Arab trading network. Like earlier Islamic scholars, Ibn Sīnā drew extensively on writings of the Greeks and Romans, which were contained in vast libraries of manuscripts in Arabic translation.

Papaver somniferum.

491.

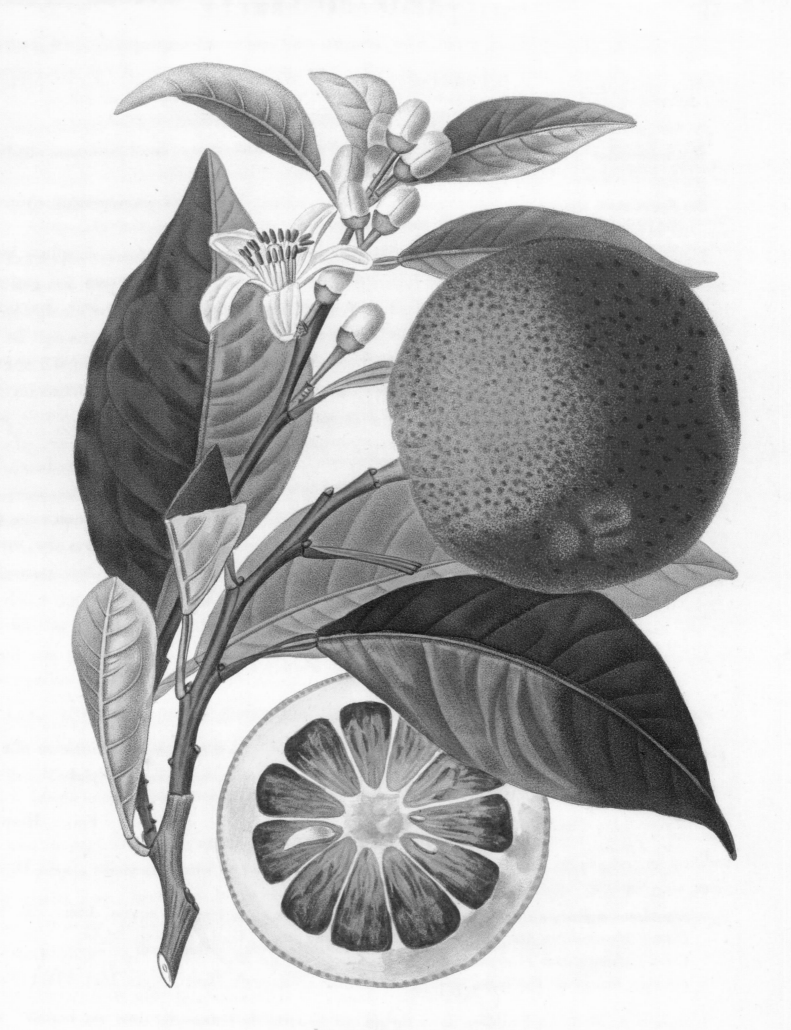

ORANGE DE MALTE.

Arancio di Malta Sanguigno.

Tab. 13.

Poiteau Pinx.^t

Gabriel Sculp.^t

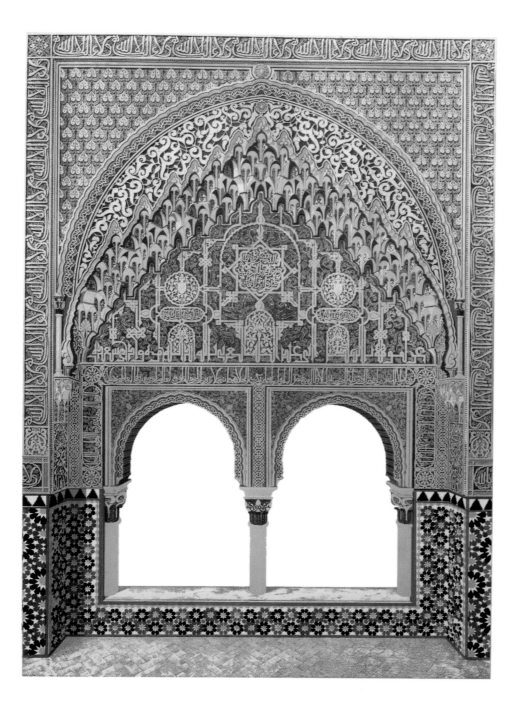

The thirteenth-century palace and gardens of the Alhambra, built in the Arab stronghold of Granada, is the best known monument of Spain's Moorish culture. Its tiled surfaces, forming abstract floriated patterns, are characteristic of much Islamic art and architecture, inspired and synthesised from the natural world.

opposite: Western expansion of the Arab Empire witnessed the transfer of citrus fruits to northern Africa and the Iberian Peninsula. The nearby Mediterranean island of Malta was subject to Arab conquest from 870 to 1090, a period recalled by this red-fleshed Maltese variety of orange, *Citrus aurantium.*

Expansion of the Arab world to northern Africa and Spain heralded a transfer of plants and also knowledge of their uses, both for medicinal and ornamental purposes. Expanding west along the north coast of Africa, Islamic influence reached Spain (or El-Andalus, as the country was known to Muslims) by the middle of the eighth century. The equable climate of the southern Iberian Peninsula—the area of greatest Islamic influence in Spain—encouraged the creation there of gardens based on the Persian model. Shaded courtyards with tubbed and potted plants, cooling channels of water, pools, and groves of trees for shade and fruit marked this phase of garden making. Plants from Persia,

The Arab world was instrumental in the transfer of plants throughout its extensive empire, which at one time stretched from India to Spain. *Melia azedarach*—known variously as the Persian lilac, Pride of India, and Chinese bead tree—stands as a characteristic example of this transfer. With a centre of origin in China and northern India, its diversity of common names hints at the widespread cultivation and naturalisation of this versatile tree.

opposite: Henna (*Lawsonia inermis*), indigenous to northern Africa and south-western Asia, was extensively grown in India as well as the Middle East. The plant yielded a deep orange dye used for personal adornment, and in India was also planted as a hedge, combining fencing with fragrance.

China, and India were grown alongside those of Iberian origin in a rich fusion of traditions. A surviving Arabic text, Ibu Bassal's *Book of Agriculture*, details this mix of plants, swelled by the many fruits grown but also including trees ranging from the Persian lilac (*Melia azedarach*) of China and northern India to the holm oak (*Quercus ilex*) of the Mediterranean.

The Alhambra, a palace of great magnificence erected in Granada in the thirteenth century, proved to be the last Moorish stronghold in Spain. With continuing opposition from Christian forces from the north, first Cordoba, then Toledo and Seville fell, and finally, in 1492, Granada. But the longevity and elasticity of the Arab world survived such setbacks, especially with increasing influence in Turkey and India. Arab traders had long visited the west coast of India and Muslims invaded the Punjab in the eleventh century, but it was the founding of the Mughal dynasty by the Emperor Babur in the early sixteenth century that gave Islam its greatest influence over India. Babur, a cultured ruler, and his grandson Akbar, were both passionate gardeners, having witnessed at first hand the magnificent gardens of Persia. Emulating these gardens in the cool mountains of Kashmir and on the hot plains of Delhi and Agra, the Mughals brought new visions of paradise to the Indian landscape.

Rungiah. Del.

Winchester. Lith.

LAWSONIA ALBA. (Lam.:)

Murthennay.

Ivenny.

Gountah.

opposite: The introduction of moveable type and the printing press in the mid-fifteenth century gave voice to the ideas of Renaissance Europe. Published books —often combining text and images — could be produced quickly and efficiently, spreading knowledge more easily and inexpensively than manuscripts.

The world map devised by Claudius Ptolemaeus of Alexandria in the second century CE encapsulated European knowledge unchanged until the Renaissance. Its printing in the *Nuremberg Chronicle* (1493) charts a key moment in world history. Although coincident with the European discovery of the New World, it was published too early to incorporate knowledge of the Americas.

THE EUROPEAN RENAISSANCE OF THE MID-FIFTEENTH CENTURY WAS literally a rebirth of human knowledge. At a time when the Catholic church effectively governed thought and action in much of Europe, profound discoveries in science and a great flowering of humanist thought challenged conventional theological teachings. The writings of earlier scholars were re-read with a mixture of reverence and revelation. Inexorably, modern knowledge was consolidated by independent thought. In painting and sculpture, astronomy and mathematics, the names of Michelangelo, Copernicus, and Kepler came to embody the new learning: da Vinci excelled in a range of disciplines embracing art and science. European knowledge of the world broadened as advances in maritime technology led to longer and more ambitious voyages of discovery. New concepts profoundly changed the way Europeans perceived themselves and their place in the world.

The printed book was the principal vehicle for Renaissance ideas. With the advent of text printed from moveable type, new ideas and discoveries could be disseminated with an ease denied earlier scholars. Coupled with illustrations printed from woodblocks, publishing houses in Germany, Switzerland, Italy, France, Spain, and England flourished from the 1470s. Advances in botanical knowledge during the Renaissance paralleled other branches of learning, and created a demand for printed herbals, specialised books that encapsulated the

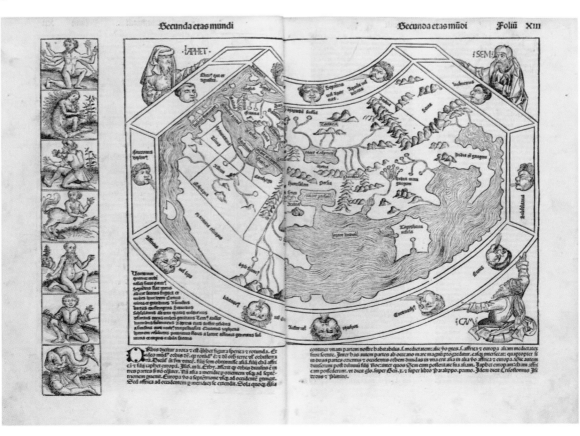

Prelū Ascensianū

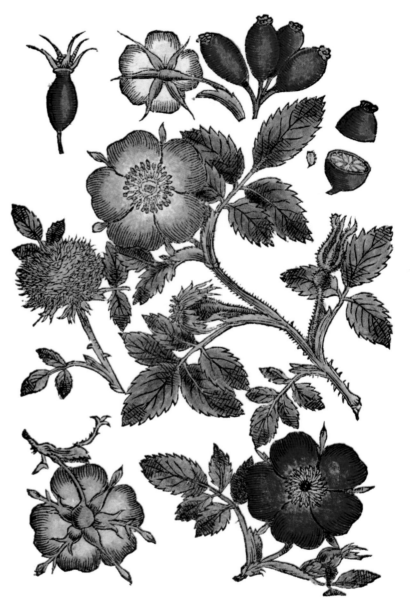

right: Franciscus Colonna's fanciful tale *Hypnerotomachia poliphili* (Venice, 1499) contained some of the earliest published illustrations of ornamental gardens. These garden views were a veritable pattern book of Renaissance bedding designs, pergolas, and other decorative features at a time when contemporary herbals mostly focussed on utility.

medicinal properties of plants. The study of plants—their native locations, constituent parts, and healing properties—was integral to the study of medicine; herbals consolidated and spread this knowledge.

The properties of plants included in Renaissance herbals were not exclusively confined to medicine. Many of the selected plants were imbued with ornamental qualities, often known from long traditions of cultivation in European gardens. Thus the rose, lily, carnation, and marigold sat alongside herbs such as santolina, lavender, and sage. Increasingly, European herbals incorporated plants from the New World and the Near East as the Renaissance garden evolved during a period of exploration. However, garden books as a distinct publishing genre were uncommon before the mid-sixteenth century, although writers and illustrators of fiction and other literary works gave occasional glimpses of contemporary garden planting and design.

In many fields of endeavour, Renaissance scholars looked back to the works of their predecessors. Key Greek, Roman, and Arabic works were known from manuscripts housed in the great European monastic libraries—although thousands of others remained unknown or had been destroyed by natural forces or human action. In the field of natural history, the works of Theophrastus, Dioscorides, Pliny, and Galen were all reprinted in Greek, Latin, and more accessible native tongues. Renaissance botanists paid particular attention to this received knowledge, and increasingly sought to reconcile the works of classical writers with scholarship of the intervening 1500 years, as well as the new plants flowing into European physic gardens from the Near East, Africa, the East Indies, and the Americas.

Reassessing earlier botanical scholarship involved a close examination of the plants in the field and preoccupied many scholars. Identifying and naming plants became a new obsession, increasingly separated from knowledge of the properties (or 'virtues') of the plants. Botanists working in Germany, for instance, were at a disadvantage in deciphering the writings of Greek or Roman authors, who generally included Mediterranean plants not found or rarely cultivated north of the Alps. Excursions to the collecting grounds of classical authors, and especially to biblical lands, formed an increasingly important part of the botanical *modus operandi*.

Botanical scholarship was galvanised in the early sixteenth century with the publication in 1530 of the first volume of *Herbarum vivae eicones*, compiled by the German physician and botanist Otto Brunfels and brilliantly illustrated by Hans Weiditz. The translated title—*Living Portraits of Plants*—provides the clue to the importance of this work. While botanical knowledge itself was little advanced by the text, the freshness and vitality of the Weiditz woodcuts effected a revolution in the portrayal of plants. The portraits were drawn directly onto the wooden printing blocks, the shapes dictated by the morphology of the living plant rather than the boundaries of the block. Earlier rigid stylisations were rejected as the plants sprang to life, closely observed, finely delineated, botanically accurate.

The Renaissance unleashed botany as an independent discipline, linked to but increasingly distinguished from medicine. Printed books gave the means of

opposite above: **Roses, including the double gallica (*Rosa gallica*) and single dog roses (*R. canina*), encapsulate widespread geographic influences stretched across many civilisations. In Babylon, Egypt, Persia, and elsewhere around the Mediterranean, rose culture flourished, as these woodcuts from Mattioli's mid-sixteenth-century herbal, *De Plantis Epitome*, illustrate. Rose symbolism also pervaded many cultures, but few examples illustrate the luxurious rose petal better than the idealised bed of roses, reputedly favoured by the ancient Sybarites of southern Italy.**

The woodcut illustrations of the *Gart der Gesundheit* (*The Garden of Health*) (Mainz, 1485) appear rudimentary to modern eyes, yet they mark an advance over earlier stylised plant portraits and were not surpassed for almost half a century. This book typifies the earliest printed herbals, illustrating, describing, and classifying plants according to their medicinal qualities.

These woodcuts by Hans Weiditz marked a new era in botanical book illustration. Drawn from living plants directly to the woodblock, the plant portraits display a vitality and veracity not previously seen in printed herbals. Published in the *Herbarum vivae eicones* (Strasbourg, 1530–32) of Otto Brunfels, this work marks the emergence of modern botany from the protective clutch of medicine.

OLEA fatiua, Græcis, Ελαία ἥμερος. Arabibus, *Zaiton, ſiue Caiton.* Italis, *Oliuo domeſtico.* Germanis, Oelbaum. Hiſpanis, *Oliuo, ſiue Azeytimo.* Gallis, *Oliuier.*

OLEA DOMESTICA.

GENERA.

Matt. Antiqui genera decem fe-
cere, noſtro autem æuo tria
tantum habentur.

FORMA.

Idem. Folia habent oblonga in
acutum definentia , craſſa,
pinguiáq;, fupernè virentia,
&infernè albicantia, ſapore
amaro, & acriuſculo ; flores
mittunt albos , racematim
dependentes, è quibus bac-
cæ prodeunt primùm viri-
des, deinde palleſcentes, &
poſtremò purpureæ prius
factæ, ſaturatè nigreſcunt.

LOCVS.

Idem. Seritur in collibus & in
campis.

QVALITATES.

Oliuæ rami quantum ha-
Gal. 6. bēt adſtrictionis , tantum &
ſimp. me. frigiditatis participes ſunt :
fructus verò, vbi rectè matu
ruerit, moderatè calidus eſt :
immaturus autē magis tum
reſtringit, cum refrigerat.

VIRES.

Colymbades tritæ, & am-
DIOSC. buſtis illitæ puſtulas gigni prohibent, & ſordida vlcera purgant. Oliua flaua, &
recēs ſtomacho vtilior eſt, & ventri difficilis : nigra autem & matura ſtomacho
auerſatur, & oculis, & dolorem capitis mouet. Arefactę autem illitu depaſcen-
tia vlcera ſiſtit, & carbuculos emarginat. Amurca in cupreo vaſe ad mellis craſ-
ſitudinē decocta adſtringit, & cæteros præbet Lycij affectus. Illinitur dentium
doloribᵒ, & vulneribus cū aceto, vino, aut mulſo. Additur in medicamēta ocu-
laria:infunditur vtiliter, ſedis, vuluæ, & genitalium exulcerationibus. Iumēto-
rum ſcabiem ſanat, cum lupinorum, & Chamæleontis herbæ decocto. Cruda,
recenſque podagricis, & articulorum doloribus auxiliatur, peruncta in villoſa
pelle, & impoſita hydropicorum tumores reprimit.

QVER-

Whilst Renaissance physicians and botanists found inspiration in the flow of new plants derived from increasingly ambitious exploration, the plant knowledge of classical European authors still formed a venerated tradition. Few fifteenth- and sixteenth-century authors did not acknowledge the canon of Theophrastus, Dioscorides, Pliny, or Galen. Here accompanying his description of the olive (*Olea europaea*), Renaissance Italian physician and botanist Pier Andrea Mattioli quotes Galen ('Gal.') and Dioscorides ('Diosc.') on its medicinal properties and 'virtues'.

spreading knowledge, in Latin to scholars, and in local languages to a general readership. Renaissance thought spread gradually from Europe, especially as scholars moved to the East Indies and the Americas. In Goa, for instance, on India's Malabar Coast, the Portuguese physician Garcia da Orta provided a finely judged example of the new botanical mood. His *Coloquios dos simples, e drogas he cousas medicinais da India* (Goa, 1563), a pioneering tropical herbal, exuded Renaissance sensibility. Cast in the form of a dialogue between the author and the fictitious Dr Ruano, da Orta provided the earliest substantial Western assessment of Indian plants. Ruano defends classical authority while da Orta counters with the evidence of his own close examination of plants, vindicating empiricism over dogma.

Woodblock illustrations of botanical subjects reached a high point in the mid-sixteenth century with these blocks by Giorgio Liberale and Wolfgang Meyerpeck. The pair reached a standard of technical and artistic excellence not exceeded until mastery in the early seventeenth century of etched or engraved metal plates. The survival of these celebrated woodblocks is almost as remarkable as their creation. Used by French botanist Duhamel du Monceau to illustrate his *Traité des Arbres et Arbustes* (Paris, 1755) after a long period of neglect, the blocks remained in his château until their sale in 1956.

right: This plate depicting the cypress (possibly the *Cupressus sempervirens* of western Asia) demonstrates the bold conception and fine cutting of the Liberale and Meyerpeck woodblocks. Their appearance here in Pier Andrea Mattioli's *New Kreüterbuch* (Prague, 1563) was merely the first of many printings, as precious suites of woodblocks were often recycled by authors and publishers.

opposite: Through his numerous publications, Flemish herbalist Rembert Dodoens was a great populariser of botany. His publications of the mid-sixteenth century were translated or re-edited into many languages, an important consideration for the general reader at a time when Latin had become the *lingua franca* of the botanical world.

PLANTS OF THE ANCIENT AND CLASSICAL WORLDS

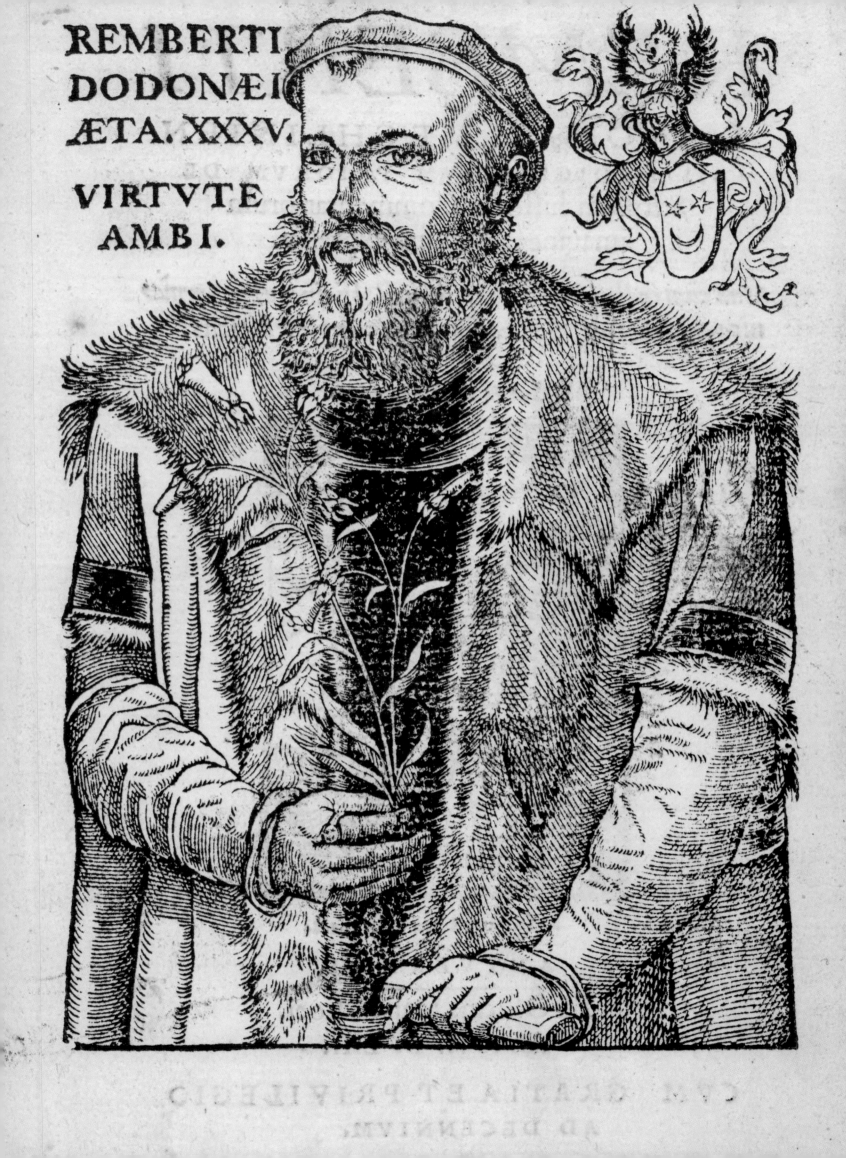

REMBERTI
DODONÆI
ÆTA. XXXV.

VIRTVTE
AMBI.

Part II

The Great Age of Maritime Exploration:

From the 1450s to the 1750s

Printed by *J.C.* for *Richard Marriott*, and are to be fold a
his Shop in *Fleet=ftreet* under the Kings-Head Tavern,
over againft the Inner Temple gate. 1665.

LONDON

JOHN

10: Empire Building
in the Golden Age

ADVANCES IN BOAT BUILDING IN THE LATE FIFTEENTH CENTURY LED TO A rapid increase in maritime exploration. Whereas small craft and coastal navigation had permitted daring forays within a limited compass, the new naval superpowers of Portugal and Spain were now able to undertake more ambitious and strategic ocean-going exploration. The English and Dutch also possessed long-distance maritime capabilities, making global empire building feasible and defensible. Arab trading monopolies were challenged by this new maritime capacity, especially after the Portuguese found a route to the Indies via the southern tip of Africa, and the Spanish stumbled on the New World en route to the same destination.

opposite: **The free-seeding sunflower (*Helianthus annus*) was an early New World introduction. Yielding edible oil, it was a plant of considerable economic significance in its native Mexico. The symbolism of its giant sun-like flower was also a recurring theme in Aztec culture, and it was valued in transplanted situations for its spectacular ornamental qualities.**

The creation of colonial empires opened the way to the importation of plants from foreign lands and differing climates, although long travel times restricted the types of plants that could be easily collected and transported. Those that could be propagated by seeds, bulbs, or moisture-laden cuttings (especially succulents) were therefore amongst the early introductions. Potted specimens and larger tubbed plants met less happy fates, but occasionally survived the vicissitudes of shipwreck, damaging salt spray, poorly understood horticultural requirements, and indifference or outright hostility by ships' captains and crew.

The self-image of nations was clearly reflected in their colonising ambitions. This was especially the case for those—such as Spain and the Netherlands—that had only recently become unified politically. Politics, although it was a critical force in empire building, perhaps had less impact on plant introduction during this phase of maritime exploration than trade. Once initial strategic goals of court or state had been achieved, it was trading companies that propelled

Despite advances in boat building during the fifteenth century, long-distance sea transport of plants was fraught with peril. The East Indiamen—the longest-haul ships of the great maritime age—were the means of successful transfer of plants to and from Europe and the East Indies. In unfamiliar territory, however, such ships were as fragile as the plants they transported.

following pages: **The great age of European maritime exploration, from the late fifteenth to the late seventeenth centuries, provided the West with a comprehensive view of the globe. A world map by Abraham Ortelius (1574) shows this phase of exploration at its mid point—the New World had been located and the southern tips of Africa and America rounded, but the Great South Land (*Terra Australis Incognita*) had yet to be satisfactorily charted.**

TYPVS ORB[...]

SE[...]

CIRCVLVS ARCTICVS.

ANIAN regnum.

AMERICA SIVE IN[...]

DIA NOVA. Ao 1492. a Christophoro.

Colombo nomine regis Castelle primum detecta.

Tolm

Tuchano
Quiuira
QVIVIRA regnu.
Cicuic
Toronte ac
Axa
Tiguex.
Totonte ac
Ceuola
Grana Marata
ta.
Marata
Cazones insula
C. del engaño.
Y de Cedri.
B. de la
Trinidad.

Calicuas.

Noua
Fran
cia.

Chilaga

Camogadi.

Tagil.

Flori
da.

Iprdru
Modano
La Bermuda
La Emperadada
Lucaio
Limana

Groclant.

Estorilant.

Terra de Baccalaur

Dobretan
Arreda
Iuan
Claudia
y de gar
ça
Santana
Iuan de
samp.
Sept cites.

TROPICVS CANCRI

Las dos
hermanos
Malabrigo
Archipelago di
Zamal
Los Boleanes
La fur sana
Restinga di
ladrones

C. del engaño.
B. de la
Trinidad.
Zalifco
Tula
Mechula
Rocca
partida
S. Thomas
Anubiada
Abreojo
R. de
caustela
R. grande
R. de los
yelos
Hispania
noua.
Panu
Ciguaaja
Acax
curla.

Sacues
B. de
culata

Cuba
Spag
nola
Iama
ica.

Boriquē

Guada
lupe
V. de S. Bº

MAR DEL
NORT

Los jardi
nos
S. Lazaro
Y de crespos
Insf. de los corales
Insf. de los reyes
J. de hombres blan
cos

Yª de los galopegos.

CIRCVLVS AEQVINOCTIALIS

apox
Ancto
riguei
Cumana
Cubao
Caribes
Auiapari.
Curo
Caribana.
Nerua

Oripana

R. de S.Vin.

R. de las
amazones

La barbada
Los Boleanes
R. de S. Augustin.

Insf. di los Tiburones.

Noua Guinea
nuper inuenta
que an sit insula
an pars continentis
Australis incertū est

MAR DEL ZVR

Casma

Insulæ
incognitæ

Tum
bes
Coran
gui
Gua
nape
Aiauari
Trapicari
Mapato
Aiauiri
ama
Picora.

Lima

Chirmos
Tisnada
Humor.

Brella
R. de S.Do
mingo

Orra
R.de S.Do
mingo
Humor.
Brasil
R. S. Fran
cisco.
R.S. Elena
P. Segur.

Insf. di S.
Pedro.

Peru.

Chicha
Margnons.
Cusco
Chicha

Amazones

Aldea

TROPICVS CAPRICORNI.

Hanc continentem
Australem, nonnulli
Magellanicam regionem
ab eius inuentore nuncupant.

EL MAR
PACIFICO

Arica
Colochi
S. Anna

B. Real

S. Catelina

Ningatas
S. Esffriens

Rio de la Plat
C. blanco
C di 3 puntas

Psaqua
Coquimbo
Copaiao
Giuru
maras
Mepe
nes

Tara
paca

Quinte
te.
Yª uistas de
lexos
Chili
P. de
palma
Lucengo
C. de
S. Maria
Chile.

Archipe
lago.
Calis

Orasfi.

Chica

Palma
res

Cordera
Chrimies.
R. de
Salinas

Estre
cho di
Magallanes

R. dolci
sino

CIRCVLVS ANTARCTICVS.

70
190 200 210 220 230 240 250 260 270 280 290 300 310 320 330 3[...]

80

C. di Ma
Steo
C. de
Signale.

Terra del Fuego.

TERRA AVSTR[...]

Cum ... priuilegio.

QVID EI POTEST VIDERI MAGNVM I[...]
OMNIS, TOTIVSQVE MVNDI [...]

OCCI[...]
[...]DENS.

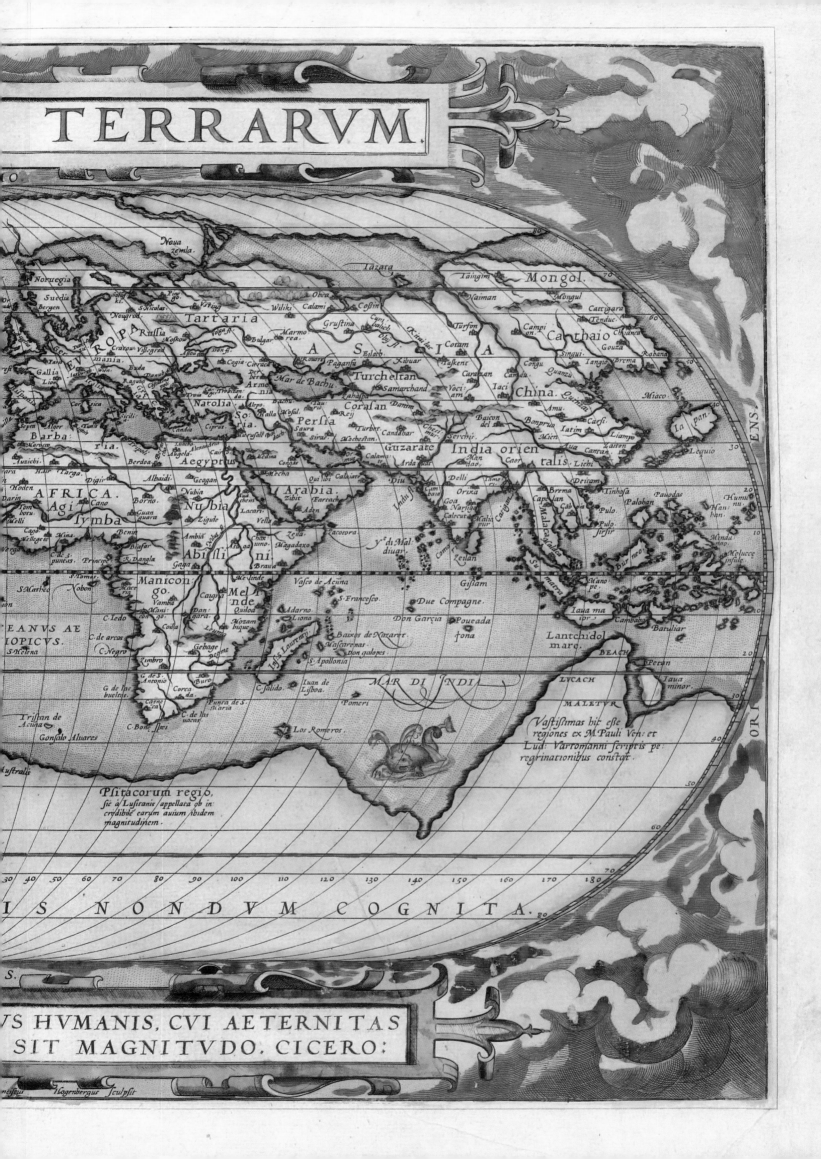

above: Chartered trading companies facilitated many plant introductions in the seventeenth and eighteenth centuries. Established in 1602 to exploit the riches of the Far East, the Dutch East India Company maintained a toehold in Japan at Deshima, a tiny artificial island in Nagasaki harbour. It was from here that specimens of lace-cap hydrangea (*Hydrangea* x *macrophylla*) and tiger lily (*Lilium lancifolium*) were packaged and transshipped to Europe.

right: The Belgic Lion—a curious map representing the Low Countries (Belgium, Luxembourg, and the Netherlands)—hints at the burgeoning self-image of this region following many years of Spanish domination. The botanist L'Obel summarised the region's increasing confidence in the late sixteenth century: 'The most extraordinary and desirable goods from across the globe are imported here in abundance over land and sea, and all the treasures of Europe, Asia and Africa are brought here together. The land is rich in brilliant talents, excellent in every art and science.'

opposite: Few plants generated as much excitement as tulips when they were first introduced from the Near East to European gardens. The Dutch brought these richly varied blooms—a great favourite of the Ottoman Turks—to new heights of cultivated novelty during the seventeenth century.

national ambition through commerce. The Dutch and English East India companies, chartered in the early years of the seventeenth century, became models for a new mode of imperial expansion. The role of these companies, and many others of similar ilk, also played a key role in the transfer of plants.

Not all plant exploration was undertaken over sea or across hemispheres. The imperial expansions of the Ottoman Turks and the Habsburg dynasty—the two brushing uneasily along the religious and political fault lines between Asia and Europe—largely involved contiguous lands. This had important implications for botanic introductions, since plants were being transported across less extreme climatic differences than those from the tropics. Differential horticultural knowledge also played a significant role in the valuing of plants. The Turks, for instance, were skilled florists who had selected naturally occurring variations with an eye to ornament and beauty. Despite many of the plants improved through such judicious selection emanating originally from Europe's Mediterranean rim, the exotic Turkish origins of cultivated hyacinths, tulips, and other bulbs imbued them with a much-sought frisson of horticultural novelty.

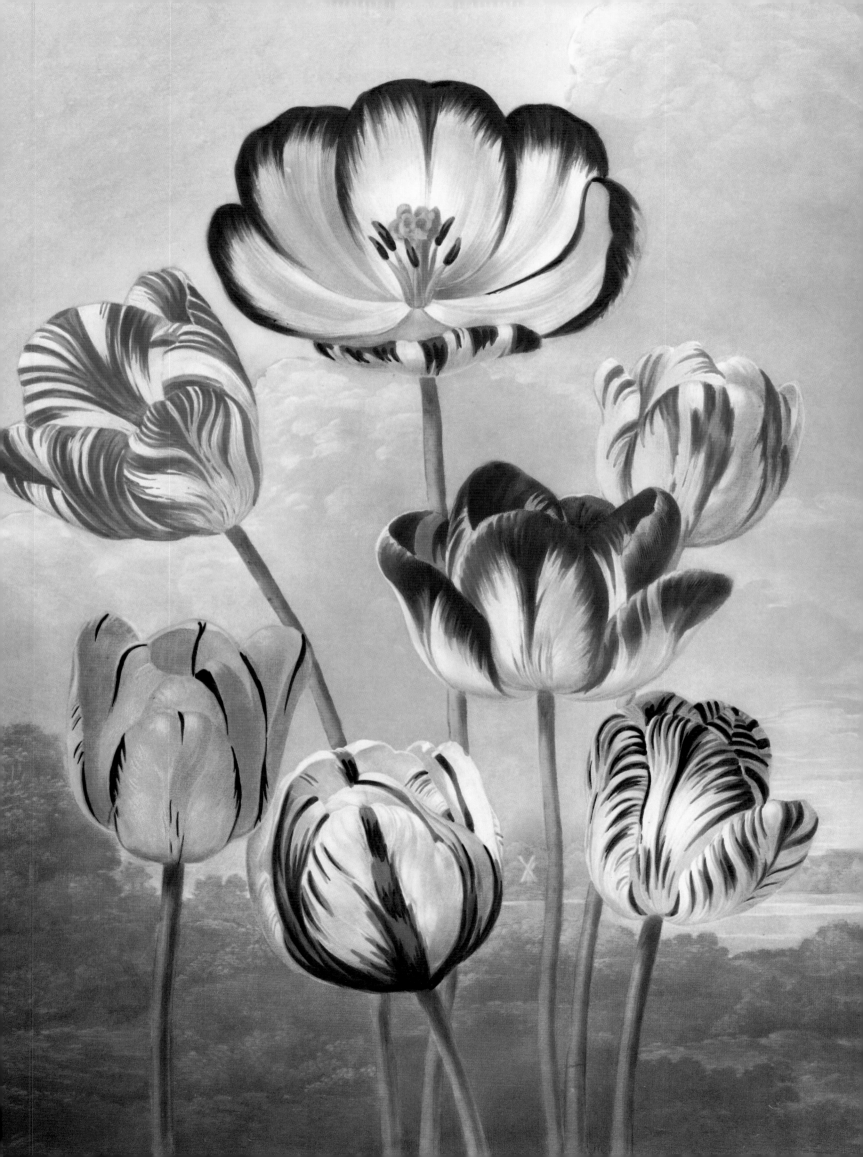

The transfer and introduction of economically useful tropical and subtropical plants is a major theme in the history of many nations. Sugarcane (*Saccharum officinarum*), cotton (*Gossypium* spp.), and tobacco (*Nicotiana tabacum*) were three of the earliest and most lucrative examples, yet all brought mixed fortunes depending where you stood in the economic cycle. Although to end users tobacco ultimately proved to be the largest killer of these three, sugar and cotton arguably brought misery to a greater number through the shameless dependence on slavery of their cultivators.

opposite: Religious conversion of Indigenous peoples formed a key adjunct to trade in the great age of maritime exploration. The passionflower of South America (here represented by *Passiflora caerulea*) symbolised the age. In *Joyfull Newes out of the New-Found Worlde* (1577), Spanish physician Nicolás Monardes epitomised its constituent parts as the passion of Christ—ten petals (the disciples present at the crucifixion), tripartite stigma (three nails, one for each hand and one for the feet), and corona filaments (the crown of thorns).

Much European colonisation was undertaken of tropical and semi-tropical lands. While Indigenous nations and peoples had cultivated their plants for numberless generations, the global reach of empire enabled European powers to subdue the peoples of one region in the cause of exploiting the plants of another. Thus the Dutch and British East India companies developed a profitable trade in food plants, spices, fibres, dyes, medicinal plants, narcotics, and other plants of economic value. Sugar and cotton relied on a wretched trade in slaves, while opium profited the few at the expense of many. Profits could be made at arm's length, metaphorically and physically.

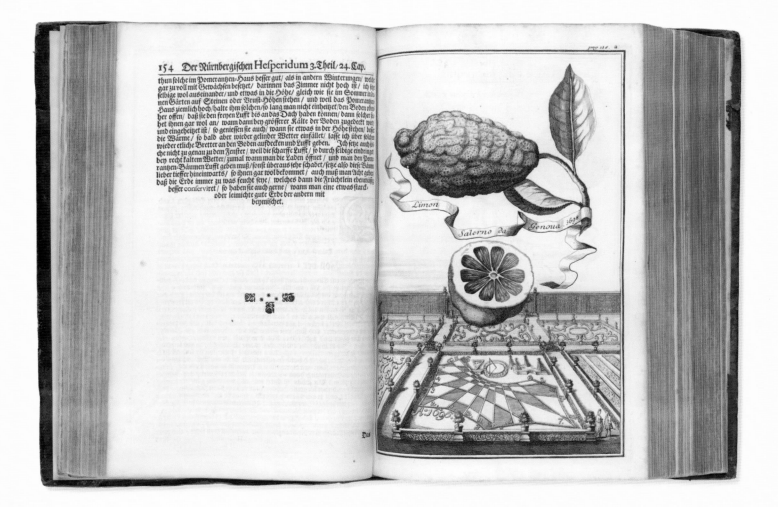

The earliest illustrated books on pomology (the cultivation of fruit) drew on Greek mythology by alluding to the golden apples guarded by the nymph-daughters of Hesperides. The favoured apples grew in the Isle of the Blest at the western extremities of the earth, and by the seventeenth century the term 'Hesperides' was closely associated with the citrus tribe, then at the height of fashion in European orangeries. Johann Volckhamer's *Nürnbergische Hesperides* (Nuremberg, 1708–12), an exuberant baroque celebration of citrus, placed fruit and vegetables in surprising juxtaposition with garden scenes. Eggplants (*Solanum melongena*) and other exotica floated across northern skies, ribbons fluttering in the breeze, but none were more bizarre than a brooding shaddock (*Citrus maxima*) hovering with Zeppelin-like menace over a moated house and garden of the German baroque.

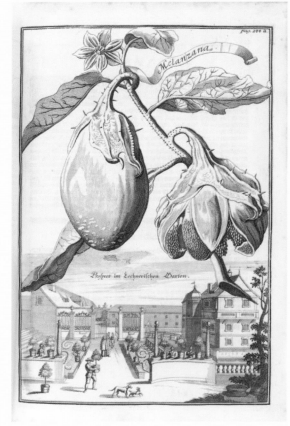

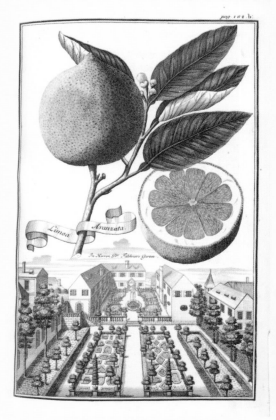

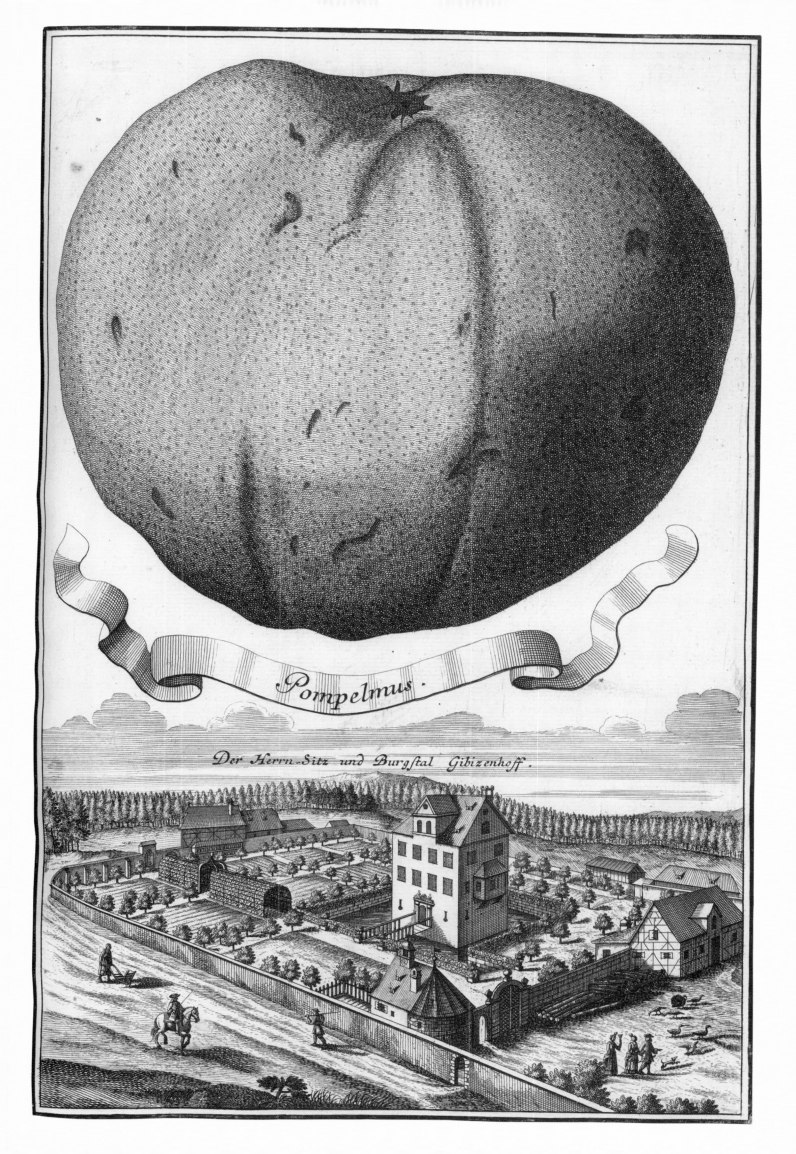

Pompelmus.

Der Herrn-Sitz und Burgstal Gibizenhoff.

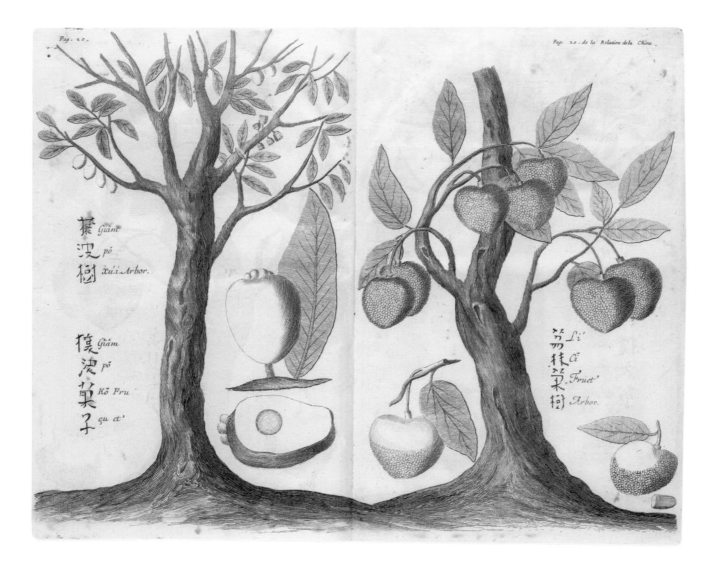

檨波樹 *Giam pó Xu'i Arbor.*

檨波菓子 *Giam pó Kŏ Fru qu et'*

茘枝菜樹 *Li Ci Fruct' Arbor.*

above: The Society of Jesus—better known as the Jesuits—formed the most widely travelled of Christian missionaries. Polish-born Michael Boym was amongst its most successful missionary-scientists, compiling the earliest European flora of China (1656). This plate, of 'Giam-pō' (possibly jambos or rose apple, *Syzygium jambos*) and 'Li-Ci' (*Litchi chinensis*), is from a contemporary French translation in Thévenot's compilation, *Relations de divers voyages curieux* (Paris, 1663).

right: A pioneer of Central American botany was Francisco Hernández, whose work in the late sixteenth century drew strongly and sympathetically on the knowledge of his local guides. He was amongst the first to describe the Mexican succulent flora and to record its indigenous names. The plant we now know as *Opuntia ficus-indica*, he recorded as 'Nochtli'. Illustrated here in the late eighteenth century, this intriguing prickly pear cactus was given its specific Latin name from the resemblance of its fruit to figs (*Ficus* spp.).

Opuntia folio minori rotundiori et com-
pressiori. Boerhaav. II. 3. p. 82.
Ficus Indica seu Opuntia folio minori
rotundiori et compressiori H. L. B. 243.

Kleine Indianische
Feigen.

Religious motives—the eager search for converts—also propelled exploration. The zeal of the Jesuits, established in 1540 with a mission to carry the Catholic faith to all parts of the world, epitomised this alternative mode of empire building. The Jesuit publishing programme, a key mode of proselytising and disseminating information, was staggering in extent and influence. Natural history was an unanticipated beneficiary of the Jesuit presses, as missionaries of scientific bent communicated their observations. Where religion was yoked to the apparatus of state—as it was, for example, in Islamic Turkey and Catholic Spain—exploration took on a powerful spiritual dimension, although censorship often hampered the advancement of knowledge.

As botany moved from its medicinal origins and increasingly embraced Renaissance scientific thought, so botanic gardens outgrew their early role as *horti medici*. Such gardens, supported by royal or state patronage, formed entrepôts for distribution of newly found plants. Public good was often supported by private initiative, as influential individuals and organisations established unofficial plant exploration and introduction networks. Botanic gardens became increasingly influential in publishing, as institutions at Leiden, Amsterdam, Paris, Vienna, and London complemented their living and dried herbarium collections with the printed word and graven image.

The flow of plants to northern Europe from the tropics encouraged experimentation in the design of greenhouses, especially their heating and glazing. The resulting 'stovehouses' marked a new horticultural era in the seventeenth and eighteenth centuries, where tropical fruits and flowers were brought to a state of cultivated perfection. Such botanical triumphs inspired suitably impressive books, where scientific accuracy was melded with artistic endeavour. The move from woodblock printing of the Renaissance to metal engraving and etching in the late sixteenth century revolutionised the art of the illustrated book, although colour remained an expensive hand-applied process until the development of lithography during the nineteenth century.

Imperial expansion was underpinned at best by official indifference for those whose lands were being invaded, with plants often afforded higher status than human life and culture. Yet there were individual examples where local knowledge was valued. This was seen most often with medicinal plants, where explorer-physicians often took great pains to seek out and transcribe traditional names, uses, and benefits. As the New World became a focus for exploration and exploitation, Indigenous plant knowledge remained a poignant and relevant means of empowering local communities.

The flow of tropical plants from the Indies was accompanied by an increasing sophistication in the glazed and heated houses required for their European reception. The European enthusiasm for growing oranges focussed attention on winter protection from frosts, and during the mid-seventeenth century *citronières*, or orangeries, became the height of fashion. Here, outside the Amsterdam 'winter-plaats' of Pieter de Wolff, we see tubbed citrus and other tender evergreen plants (hence the term 'greenhouse').

The New World

The New World challenged conventional European thinking during the fifteenth and sixteenth centuries, in map-making as much as in botany. For the cartographer, initial points of European contact provided fixed geographical observations. Towards America's extremities, however, speculation was generally needed to connect the dots of unrelated coastal sightings.

THE LURE OF A WESTERN ROUTE TO THE INDIES SPURRED ONE OF THE great epochs of European exploration. Portugal and Spain—two maritime superpowers of the Renaissance age—were the earliest to contemplate this new global route for the spice trade, one that was alive with potential. In 1492 Christian Spain had just emerged victorious from her long conflict with the Arab world, heralding a new era of conquest, commerce, and conversion. The Portuguese, secure in their newly proven route to the Indies via the southern tip

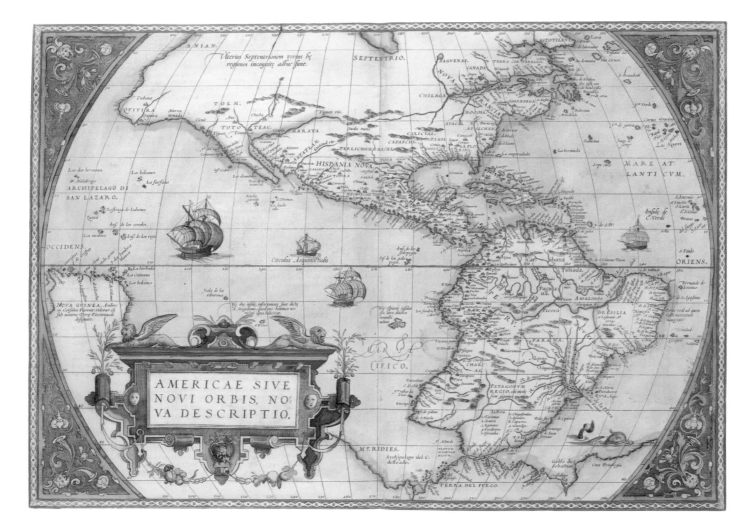

opposite: The pawpaw or papaya (*Carica papaya*), indigenous to tropical America, was amongst the earliest New World plants collected by Portuguese and Spanish sailors and transplanted to the Old World tropics, including Africa and the East Indies.

of Africa, could not match the commercial and religious hunger of Spain. So it was that backing for the first voyage of Christopher Columbus came from the Spanish court of Ferdinand and Isabella rather than King John II of Portugal.

Sailing with three small ships and a crew of ninety, Columbus passed through the Canary Islands and sailed west across the (unnamed) Atlantic Ocean. The party reached land—which Columbus named San Salvador—late in 1492. Coasting past other islands, Columbus was now accompanied by several Arawak

THE GREAT AGE OF MARITIME EXPLORATION

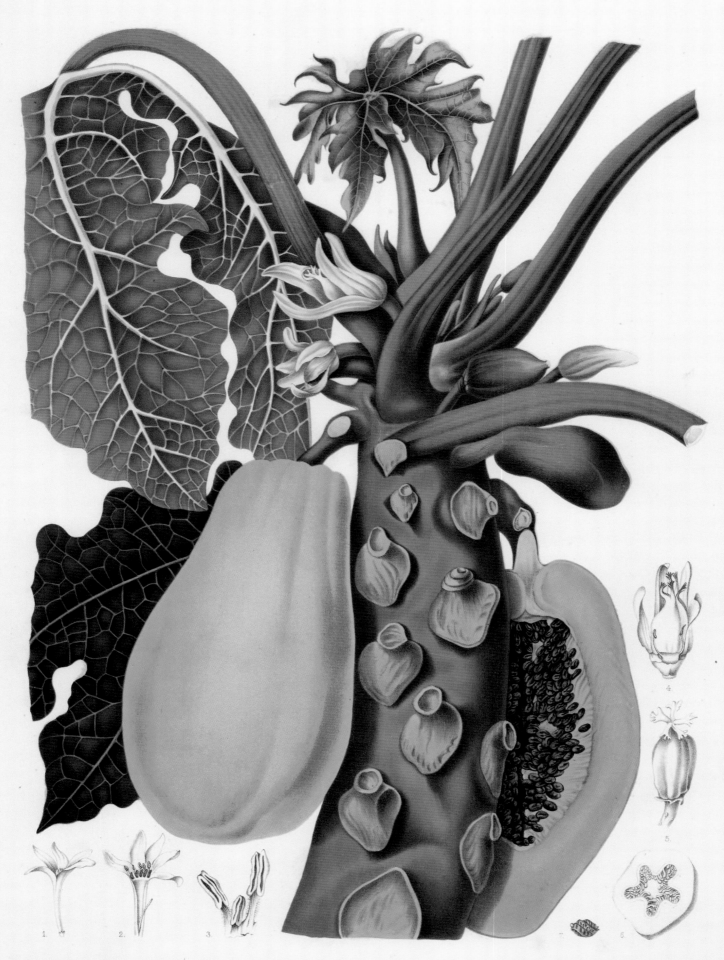

Peint d'après nature par M.me Berthe Hoola van Nooten, à Batavia.

Chromolith. par G. Severeyns Lith. de l'Acad. Roy. de Belgique.

CARICA PAPAYA. L.

Emile Tarlier éditeur, à Bruxelles.

Annatto (*Bixa orellana*) yielded a powerful red dye used by Indigenous peoples of America for colouring their skin, giving rise to the European term 'Red Indians'. In the West, its uses ranged from colouring Gloucester cheese to pigmenting cosmetic rouge.

islanders (or 'Indians' as he called them) who spoke of gold, potentially a greater prize even than spices. Believing that he had reached the Indies, Columbus left a small party at La Navidad (on present-day Haiti) to await his return with a greater fleet. In three further voyages between 1493 and 1504, Columbus explored the Bahamas and Caribbean. Errors in the calculation of longitude—at that date, an inexact science—meant that only slowly did the realisation come that the new land masses were not in the Indies but part of a New World.

The vast potential of these new lands called for bold and unprecedented measures to divide the spoils between the resourceful Portuguese crown and the ambitious, newly unified Spain. The Treaty of Tordesillas (1494) conferred on Portugal all non-European territory east of a line at 50° west, approximately 960 nautical miles west of the Cape Verde Islands, and Spain all land to the west. By papal authority, this longitudinal line thus handed Spain most of the Americas (but unwittingly excised Brazil), and Portugal parts of Africa and south-eastern Asia.

While the Portuguese colonised Brazil, the Spanish concentrated in Mexico (known as New Spain following overthrow of the Aztecs) and Santo Domingo in the Caribbean. Economic plants were the first to attract attention. The Portuguese exported timber of brazilwood (*Caesalpinia echinata*) but it was tropical and subtropical fruits and vegetables that were amongst the earliest plants to be introduced to gardens elsewhere. Pineapples (*Ananas comosus*)—a great novelty in seventeenth-century Europe—and pawpaws (*Carica papaya*) were amongst the earliest fruits to be successfully transplanted to the Old World tropics by Portuguese and Spanish sailors. The potato (*Solanum tuberosum*), from the high Andes in Peru, was introduced by the Spanish to Europe in the mid-sixteenth

above: The Central American succulent flora challenged early botanical artists, and this columnar cereus cactus is depicted with a crystalline severity born of unfamiliarity. The striking woodblock illustration (printed in 1565) is copied from the first published illustrations of cacti, contained in a natural history of the 'Indies' by the Spanish administrator Gonzalo Oviedo y Valdés (Seville, 1535).

above left: John Gerard's *Herball* (London, 1597) was perhaps the best known British herbal. Drawing on Gerard's experience as a gardener in and around London, the book included several New World plants. The novelty and promise of the humble potato (*Solanum tuberosum*)—used as a food staple for countless generations in Mesoamerica—is accentuated by the Elizabethan splendour of Gerard, who lovingly holds its leaf and flowers.

Some of the earliest books to discuss New World medicinal plants were compiled in the mid-sixteenth century by Spanish physician Nicolás Monardes. The title of his English translation, *Joyfull Newes Out of the New-found Worlde*, perfectly captured the excitement felt in the botanical world at the prospect of new drugs. Perhaps no one could have foreseen the wide-reaching effects on society 'Of the Tabaco, and of his great vertues'.

opposite: This romantic New World scene, from Thornton's celebrated *Temple of Flora* (London, 1799–1807), highlights the 'Large Flowering Sensitive Plant' (*Calliandra grandiflora*) in its native Jamaican setting. Thornton described the human figure as 'one of the aborigines struck with astonishment at the peculiarities of the plant', masking the fact that it was European botanists who struggled to contain the taxonomic complexities of a sprawling plant family containing the Madagascar flamboyant (*Delonix regia*) and Barbados pride (*Caesalpinia pulcherrima*).

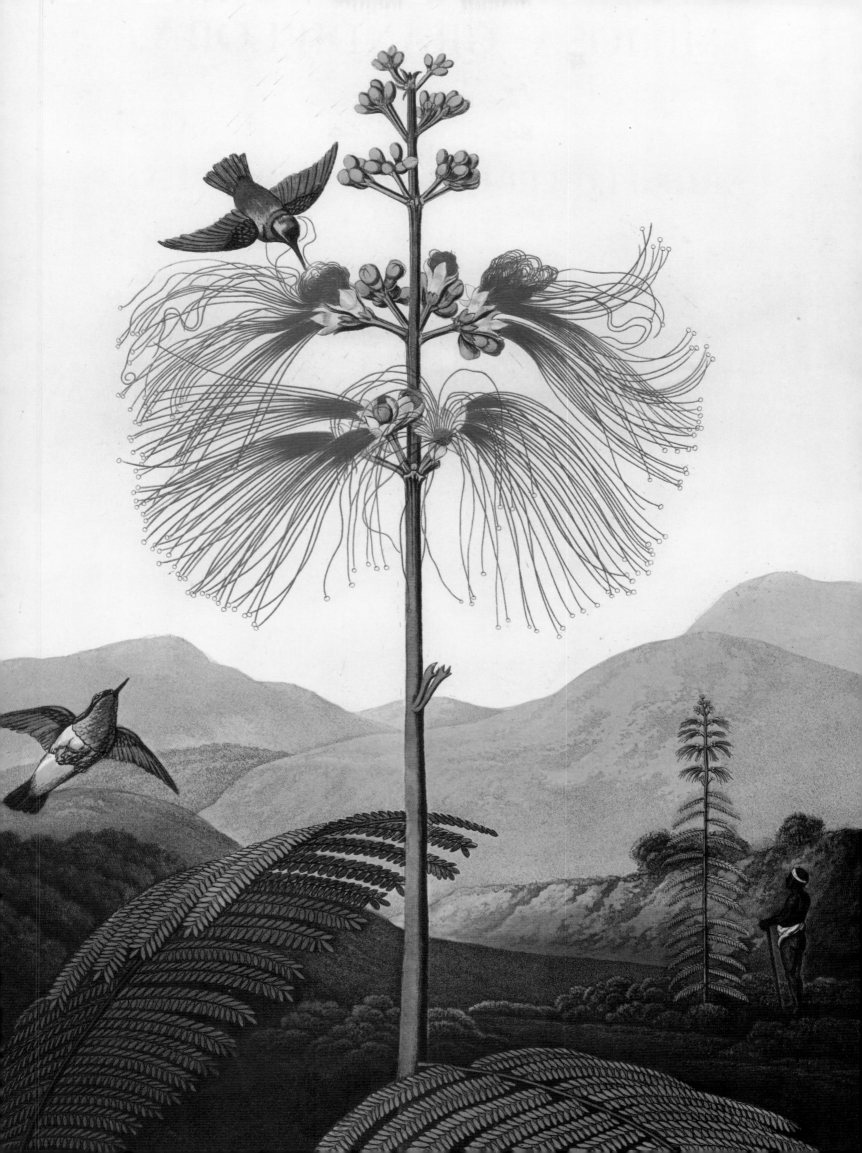

47

TAGETES
INDICA.

Indianische
negelen.

century, and soon achieved widespread cultivation. The tomato (*Lycopersicon esculentum*), on the other hand, was slow to achieve acceptance, and for several centuries was prejudicially linked in the public mind with its botanical cousins in the deadly nightshade family.

Despite widespread destruction of Indigenous gardens by Spanish conquistadors—Cortés in Mexico, Pizarro in Peru, Quesada in Columbia—local knowledge of New World plants was often noted with arrogant surprise. For the manuscript of the most celebrated Mesoamerican herbal, the so-called *Badianus Herbal* (1552), Aztec artists worked in the Catholic College of Santa Cruz to produce a document that fused their knowledge with European traditions.

The earliest published illustrations of New World plants were largely contained in travel and historical accounts, such as that written by Gonzalo Oviedo y Valdés. A Spanish administrator, Oviedo was sent to Santo Domingo in 1514 as inspector-general of trade with the New World. His *Historia general y natural de las Indias* (Seville, 1535) contained the earliest published illustrations of cacti, providing a challenge for botanical artists quite unused to such stark vegetal geometry. Botanists also struggled with the new plant introductions, often at a loss in defining differences or discerning affinities.

Medical properties of the new plant introductions soon captured the attention of European physicians and apothecaries. The Spanish physician Nicolás Monardes was amongst the earliest to illustrate tobacco (*Nicotiana tabacum*), a cultivated variety domesticated in tropical America. The plant was named after Jean Nicot, French ambassador to the Portuguese Court at Lisbon, who in 1559 had been given seeds from Brazil. By the end of the sixteenth century tobacco had become a widespread garden crop in Europe and was soon introduced to Africa, Asia, and North America (where it became a source of great wealth for the founders of Virginia).

The wide variety of climates in the New World—from the high Andes mountains and hot, dry Mexican interior through to the tropical regions of the Amazon basin and Caribbean—produced such a range of plants that introductions from it could be found to suit most parts of the globe. The early introduction of tropical fruits has already been mentioned, but no less important were ornamental flowering species that suited the warmer parts of Europe on the Iberian Peninsula and around the Mediterranean. From Mexico came the so-called French marigold (*Tagetes patula*), nasturtiums, sunflowers (*Helianthus annus*), yuccas, and the first cacti, while South America yielded cannas, passionflowers (*Passiflora* spp.), and the Marvel of Peru (*Mirabilis jalapa*), all appreciated for their striking colours and unconventional habits as much as their novelty.

As the flow of New World plants increased and their horticultural potential was realised, botanical texts devoted increasing space to their culture. Leonhard Fuchs illustrated the French marigold in his *De Historia Stirpium* as early as 1542, one of the earliest depictions of New World flora in a European publication. By 1597, when John Gerard compiled his *Herball*, the new flora was taking its place alongside the flow of plants from the East Indies and the Near East that were soon to revolutionise European gardens.

Mirabilis jalapa (Marvel of Peru) was amongst the earliest New World flowering plants introduced into European gardens. A small bushy perennial with clusters of deep pink flowers, it was praised by John Gerard and British horticultural author John Parkinson (who named it *Admirabilis* or 'The Mervail of the World').

opposite: As plants from the New World reached Europe from the early sixteenth century, their horticultural potential under northern conditions was subjected to close scrutiny. The so-called French marigold (*Tagetes patula*)—from Mexico—was probably the earliest New World ornamental plant to be grown in Europe, and was figured in the great volume of German physician and botanist Leonhard Fuchs, *De Historia Stirpium* (Basel, 1542).

Imperial Tales
of the Near East

above and opposite: **Several of the woodblocks in Pierre Belon's pioneering travel account of the Near East depict species of** *Abies, Cedrus, Larix, Picea,* **and** *Pinus.* **These illustrations were re-used in his book** *De arboribus coniferis resiniferis* **(Paris, 1553), the earliest published monograph on conifers.**

right: **The conquest of Constantinople in 1453 gave the Ottoman Empire a capital city at the juncture of its European and Asian territories, on the straits that linked the Mediterranean Sea and the Black Sea.** *Turicum Imperium*—**as Nicholas Visscher titled this early seventeenth-century map— outlined the extent of the Ottoman Empire at its height, a rich field for horticultural discovery.**

THE ORIENT—OR THE EAST—EXERCISED AN ENDLESS FASCINATION ON THE European imagination. Whether far distant Cathay (China) or the Indies, or more tantalisingly close at hand in the eastern Mediterranean, the division between Europe and Asia was not just a matter of distance or the niceties of geography, but more starkly of culture and religion. In the mid-sixteenth century, the expanding Ottoman Empire—centring on Asia Minor, or the Near East—was a European preoccupation. Oghier Ghislain de Busbecq, ambassador in Constantinople for Emperor Ferdinand I, was well placed to observe life in the Turkish capital. 'The Turks are very fond of flowers', he wrote in 1555, 'and though they are otherwise anything but extravagant, they do not hesitate to pay several *aspres* for a fine blossom'. As the Renaissance garden swept across Europe, with its richly ornamented beds blowing alongside more traditional vegetables and herbs, it was to the Near East that gardeners turned for new botanical riches.

The fall of the Byzantine capital, Constantinople, to opposing Turkish forces in 1453 had given the Ottoman Empire its new capital, one that soon glittered with the riches of Sulieman the Magnificent, Sultan of the Ottoman Turks. Working outwards from its capital, the Ottoman Empire expanded to such an extent that by the 1570s it stretched from northern Africa to the Persian Gulf. Nervously watching this imperial expansion was the neighbouring Habsburg monarchy, centred on Vienna. The Habsburg dynasty—unbroken from 1452 until World War I—ultimately extended its power over a large, contiguous swathe of central Europe. So it was, with a European Christian empire uneasily rubbing shoulders with those of a Turkish and predominantly Islamic empire, that the diplomatic Busbecq came to be appointed ambassador for the Habsburg emperor.

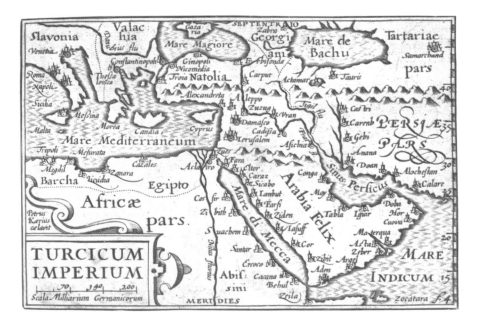

THE GREAT AGE OF MARITIME EXPLORATION

Portraict du Sapin.

Le portraict de la Suisse.

Portraict du Cedre.

Naif portraict de la Melese ou Larix.

One of the earliest scientific observers of the Near East was the French explorer-naturalist Pierre Belon. During 1546–49, Belon undertook a journey through Greece, the Aegean Islands, Egypt, Judaea, Syria, Turkey, and back to Rome, mostly within the Ottoman Empire. Belon did not collect natural history specimens, but through study with German botanist Valerius Cordus, was well equipped to observe the region's distinctive flora. Belon did much to publicise this flora through a popular account, first published in Paris in 1553. The botanical portion of his *Observations* contained the earliest depictions of several Near East plants, including the cedar of Lebanon (*Cedrus libani*), gum arabic (*Acacia* spp.), oriental plane (*Platanus orientalis*), and sycamore fig (*Ficus sycomorus*), and included descriptions of the tulip, then a popular flower in Turkish gardens. Belon also separately published his botanical observations in *De arboribus coniferis resiniferis* (Paris, 1553), the first monograph on conifers (including all cone-bearing genera then known), of which the Near East provided many important species. Belon was an early advocate for the acclimatisation of exotic plants, but sadly his career was short-lived. Only a decade after his major publications, he was murdered in the Bois de Boulogne, on the outskirts of Paris.

Belon was inspired to travel, in part, by a desire to inspect at first hand the plant-collecting fields of the classical authors. Renaissance botany had as its foundation the works of Theophrastus and Dioscorides, yet to contemporary scholars intent on codifying the properties of a venerated plant palette, and especially to gardeners who attempted to cultivate such plants, the field was strewn with confusion and misidentification. The Italian botanist Mattioli, the great commentator on Dioscorides, was appointed a physician to the Habsburg monarchy at Prague in 1555, and was thus well placed to receive plants from Busbecq. Mattioli also received botanical drawings and two manuscript copies of the writings of Dioscorides from Busbecq, who was privileged to view (and later to secure for Emperor Ferdinand I) the celebrated Juliana Anicia Codex (or *Codex Vindobonensis*), an illustrated Dioscoridian manuscript (*c.* 512) of *De Materia Medica* then housed at Constantinople. The plants forwarded by Busbecq to Mattioli included the common lilac (*Syringa vulgaris*) and horse chestnut (*Aesculus hippocastanum*); another Busbecq introduction to Vienna was the mock orange (*Philadelphus coronarius*), often confused with the lilac. These amounted to some of the most important horticultural introductions to western Europe.

The varied Anatolian climate provided a wide range of plant habitats similar to many parts of western Europe (south and north of the Alps). The Mediterranean coast, with its hot, dry summers and wet winters, contrasted with a cool temperate zone further north. The interior of the country, however, formed the western extremity of a large arid zone extending across Persia and south-western Asia to central China. From the rocky scrub of Anatolia came the crown imperial (*Fritillaria imperialis*), a large bulb with pendulous orange-red flowers borne on erect stalks, a new treasure for the imperial Habsburg gardens. The hyacinth (*Hyacinthus orientalis*) was also an early import from the Near East to Austria. A key figure in this transfer was the Flemish botanist Charles de l'Ecluse. In 1573, Clusius (as his name was often Latinised), was summonsed to Vienna by Emperor

opposite: **Pierre Belon, writing in 1553, was the first European to describe the common lilac (*Syringa vulgaris*). This deciduous bush, with its showy panicles of fragrant lilac-purple flowers, was introduced *c.* 1560 by Oghier Ghislain de Busbecq from the Near East to Vienna. Proving hardy in European winters, the lilac became a versatile mainstay of the shrubbery.**

The crown imperial (*Fritillaria imperialis*), although indigenous to Iran, Afghanistan, and northern India, was prominent in gardens of the Ottoman Turks of the early sixteenth century, and it was from Turkey that the plant was introduced to European gardens. Its earliest botanical name, *Corona imperialis*, referred to the crown-like ring of flowers and majestic habit of the plant.

opposite: The hyacinth (*Hyacinthus orientalis*) was introduced from Turkey to Europe *c.* 1560. Busbecq had admired the flowers in Turkish gardens, and by 1565 Mattioli had named and illustrated the plant. The early hyacinths bore just nine or ten flowers (as here), but in the hands of Dutch growers, double-flowered varieties soon all but ousted their simpler parents.

Maximilian II to become *Praefectus* of the imperial medicinal gardens. During his six years in Austria, Clusius received seeds and bulbs from Busbecq (still enjoying Habsburg patronage, but no longer resident in Constantinople). From Vienna, these vibrant Near Eastern plants were soon spread to gardens across Europe.

Though Turkey was the source of numerous hitherto unknown garden plants, the Ottoman Empire also yielded many neglected species indigenous elsewhere in southern Europe, especially along the Mediterranean rim. But the real revelation for European observers was the horticultural sophistication of Turkish gardeners in selecting from naturally occurring varieties. The novelty of new and desirable cultivated forms of anemones and ranunculus soon delighted wealthy garden owners across Europe. Further development of carnations, hyacinths and, above all, tulips transformed the spring aspect of gardens in the seventeenth century.

Pub. by J. Ridgway 169 Piccadilly Aug 1. 1826

The tulip, a cultivated species of ill-defined parentage, was a great favourite of the Ottoman Turks. Naturally occurring varieties suited to contemporary horticultural tastes were carefully selected, a skill continued when these blooms were introduced to Europe in the mid-sixteenth century. By 1629, when John Parkinson compiled his gardening treatise *Paradisi in sole paradisus terrestris*, he could list forty-eight cultivars of *Tulipa praecox* at a time when tulip fever amongst Dutch growers was fuelling an unsustainable speculative mania.

No plant from the Near East had greater horticultural impact than the tulip. When Clusius published his celebrated book on plants of the Iberian Peninsula, *Rariorum aliquot stirpium* (Antwerp, 1576), he hastily included an appendix describing the bulbs and tuber plants he had received from Busbecq. By then tulips, anemones, and ranunculus were attracting attention in the Netherlands, and were soon the subject of careful selection in the quest for improved varieties. Tulips, in particular, exhibited a marked tendency to variation in colour, with oddities and freakish markings being greatly prized. This aspect of novelty generated a booming market in tulip bulbs, and by the early seventeenth century prices for the most spectacular blooms were escalating alarmingly. The Dutch tulip market overheated completely in the 1630s when speculative sales took reality out of the equation. Although the 'tulipomania' bubble burst and prices were slashed, the fashion for tulips did not diminish, and they remain the most potent reminder of this early phase of Near Eastern plant introduction.

Despite widespread distribution in southern Europe, cyclamens were introduced to northern Europe from the Near East in the sixteenth century. *Cyclamen persicum* and the pink-flowered *C. hederifolium* (pictured here) were parents of the much-loved pot plant, a reputation already enjoyed by the eighteenth century.

below: John Rea's delightful book *Flora* (London, 1665) stands as an example of the new gardening book of the late sixteenth and seventeenth centuries, when the move away from herbals towards publications on ornamental plants was gathering pace.

FLORA:
SEU,
De Florum Cultura.
OR, A
Complete Florilege,
FURNISHED
With all Requisites belonging to
A FLORIST.

In III. Books.

BY
JOHN REA, *Gent.*

LONDON,
Printed by *J.G.* for *Richard Marriott,* and are to be fold at his Shop in *Fleet-street,* under the Kings-Head Tavern, over against the Inner Temple gate, 1665.

With the new wave of bulbs, including crocuses, cyclamens, erythroniums, fritillaries, leucojums (or snowflakes), and lilies, flooding into European gardens, came the need for specialist advice. A new kind of book was born—the florilegium—and with it, a new profession—the florist. The florilegium consisted largely or entirely of flower illustrations, and it fulfilled the roles of sale catalogue, compendium, keepsake, or botanical treatise, depending on the motives of the compiler, illustrator, or publisher. The earliest example was by Belgian engraver Adriaen Collaert in his *Florilegium* (Antwerp, 1590). By the early seventeenth century, when the role of the florist as a professional grower of flowers was evolving, the florilegium converged with the tradition of the herbal, and emerged as the forerunner of the modern illustrated gardening treatise.

In the Western mind, as the seventeenth century folded into the eighteenth, the Near East was gradually being repackaged as the Levant. Excursions into this volatile area, though still fraught with danger, were slowly becoming less risky,

The oriental poppy (*Papaver orientale*) was introduced from the Near East to Europe by French botanist Joseph Tournefort at the start of the eighteenth century. Its brilliant red and black-blotched flowers made a dramatic addition to the early summer border and the species was the parent of many later cultivars.

opposite: Although the common rhododendron (*Rhododendron ponticum*) was found in the Near East by Joseph Tournefort during 1700–02, it was not introduced into European gardens until the 1760s. By the time this dramatic illustration was published by Robert Thornton, in his *Temple of Flora* (1799–1807), the rhododendron was beginning to transform the landscaping of British woodlands.

and a growing market for travel accounts spawned an appetite amongst the adventurous desirous of augmenting their Grand Tour. Amongst some botanists there was an increasing interest in identifying the plants of the Scriptures, especially the Holy Lands of Palestine.

Travelling at the cusp of this change were Leonhardt Rauwolf, George Wheler and Joseph Pitton de Tournefort. Rauwolf, a German physician, travelled to the Near East during 1573–76 and, disguised as a Turkish merchant, proceeded as far east as Baghdad, botanising along the way. Wheler, travelling almost a century after Rauwolf, was more the gentleman-naturalist than buccaneering adventurer. While Rauwolf might be bracketed with Belon, the young coin-collecting antiquarian, Wheler was able to turn his scholarship into a highly successful travel account, *Journey into Greece* (1682). Wheler botanised extensively and introduced the popular yellow-flowered shrub, rose of Sharon (*Hypericum calycinum*), to Britain. Wheler's travelling companion, Dr James Spon of Lyon, also published a notable account of their travels, and thus paved the way for later botanists such as Tournefort. Appointed professor of botany at Jardin du Roi, Paris, in 1683, Tournefort is best remembered for his pre-Linnaean plant classification system. He was selected by Louis XIV 'to discover the Plants of the Ancients, and others, which perhaps escaped their attention'. Travelling in the Levant during 1700–02, one of Tournefort's most notable discoveries was the oriental poppy (*Papaver orientale*), which he introduced into European gardens.

Tournefort also saw and named the rhododendron (*Rhododendron ponticum*) and azalea (*R. luteum*). Although not introduced into European gardens for some decades, both were shrubs of immense horticultural potential. The rhododendron, in particular, was well adapted for large-scale cool temperate woodland plantings, and in the nineteenth century created effects as dramatic in their own way as the chromatic revolution Turkish flowers had initiated three centuries earlier.

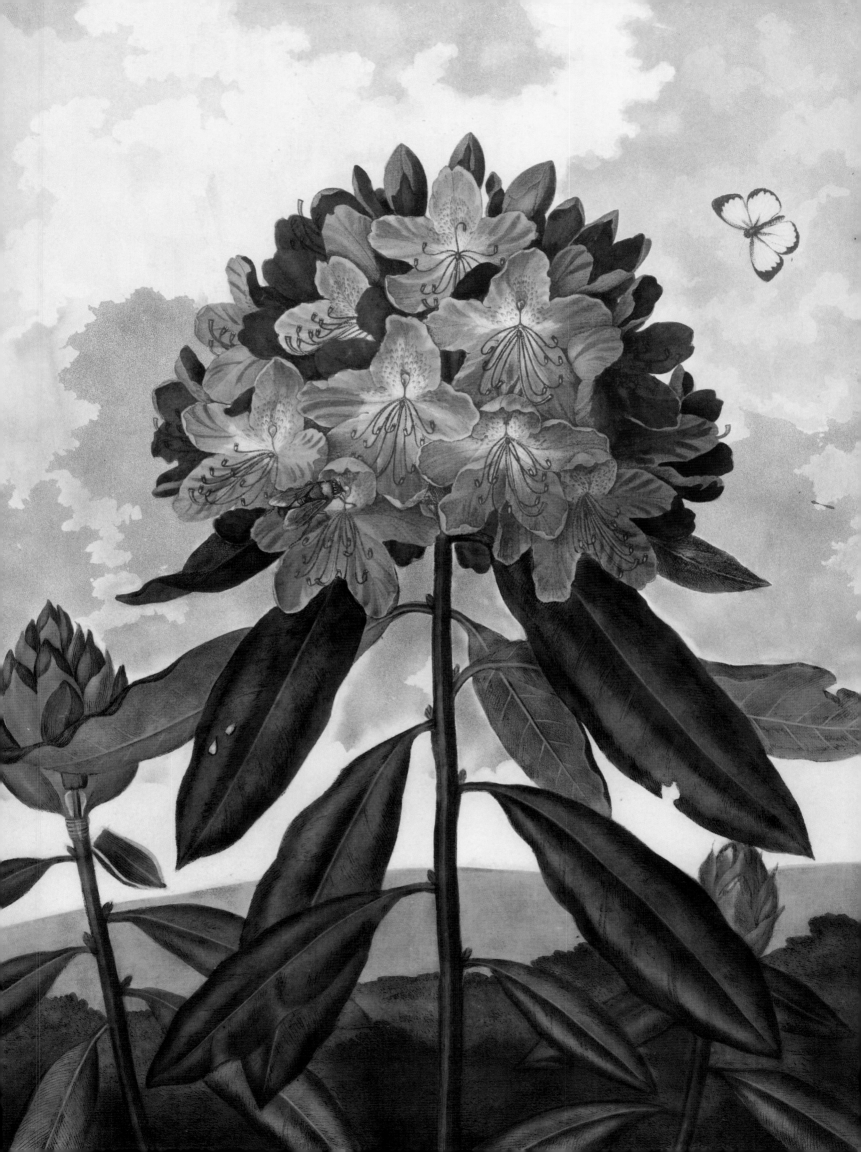

opposite: **The intoxicating thorn apple (*Datura stramonium*) is one of several *Datura* species believed by some authorities to have originated in Asia. Although illustrated here in the late seventeenth century for its ornamental qualities, in his observations of Goa in the 1580s, the Dutch explorer Jan van Linschoten revealed other uses for this powerful drug. When Indian and Portuguese women were 'disposed to bee merrie with their secrete lovers', he wrote, they plied their unsuspecting husbands with datura decoctions, allowing the lovers to slip away and 'performe their leacherie'.**

Black pepper (*Piper nigrum*) was amongst the spices that captivated the European market, and spurred maritime exploration in the late fifteenth and early sixteenth centuries. When Spanish circumnavigator Juan del Cano returned in 1522 with the remnant of Magellan's fleet (after his commander's death in the Philippines) laden with over 50,000 pounds of spices, he petitioned for a coat of arms bearing two sticks of cinnamon, three nutmegs, and two cloves.

THE INDIES HAD BEEN THE MAJOR SOURCE OF SPICES LONG BEFORE European maritime exploration of Asia. Cloves (*Syzygium aromaticum*) and nutmeg (*Myristica fragrans*) from the Moluccas or Spice Islands; black pepper (*Piper nigrum*) and cardamom (*Elettaria cardamomum*) from the Malabar Coast of India; and cinnamon (*Cinnamomum verum*) from Ceylon (Sri Lanka) were all highly prized. These were imported via Arab coastal trading networks through the Persian Gulf or the Red Sea, and then overland through Persia and the Ottoman Empire. At the close of the fifteenth century, the west's major centre of the spice trade, Venice, was also its wealthiest city-state. Europe's maritime superpowers—Portugal, Spain, and England—eyed this lucrative spice market with mercantile envy.

It was the Portuguese who pioneered the maritime route around Africa's southern tip to gain access to the riches of the East Indies, then a virtual Arab monopoly. Buoyed by favourable commercial prospects and aided by superior nautical technology, Portuguese navigator and explorer Bartolomeu Diaz sailed round the Cape of Good Hope in 1488. With the prospect of a sea route to India thus established, Vasco da Gama soon reached the Malabar Coast. Finding spices readily available, he returned with samples, and Lisbon rapidly overtook Venice as Europe's spice capital. Columbus (Spain) and Cabot (England) attempted to reach the Spice Islands by a western course but were frustratingly blocked by the Americas, the so-called 'New World'. (For some years after his landing in the Caribbean, Columbus was convinced that he had actually landed in the Indies, hence the terms 'East' and 'West' Indies.)

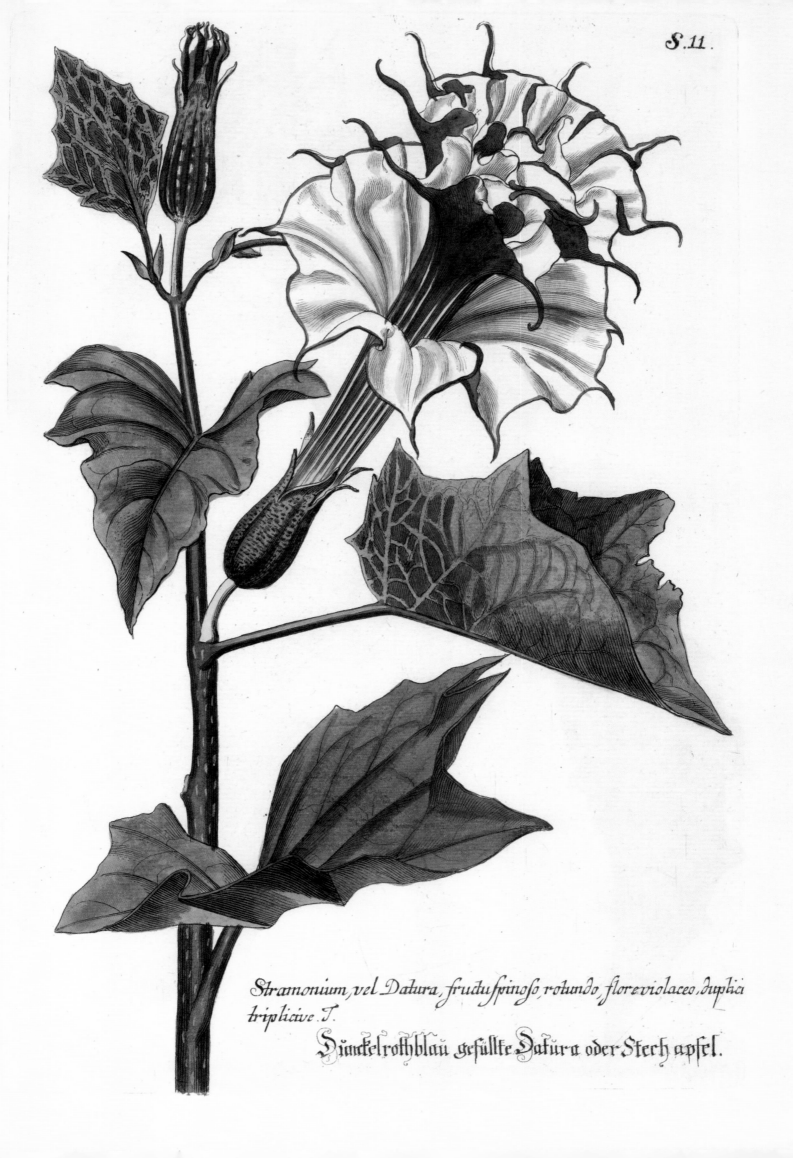

Stramonium, vel Datura, fructu spinoso, rotundo, flore violaceo, duplici triplicive. T.

Dunckelrothblau gefüllte Datura oder Stech apfel.

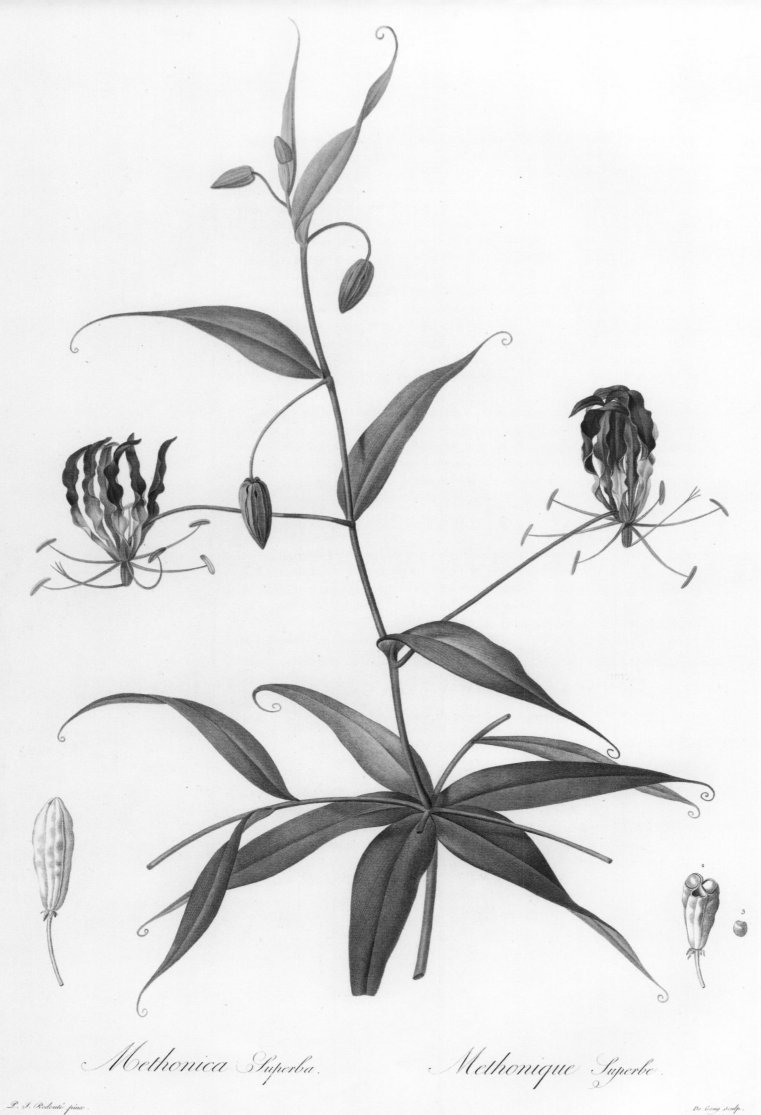

Methonica Superba. *Methonique Superbe.*

P. J. Redouté pinx. De Gong sculp.

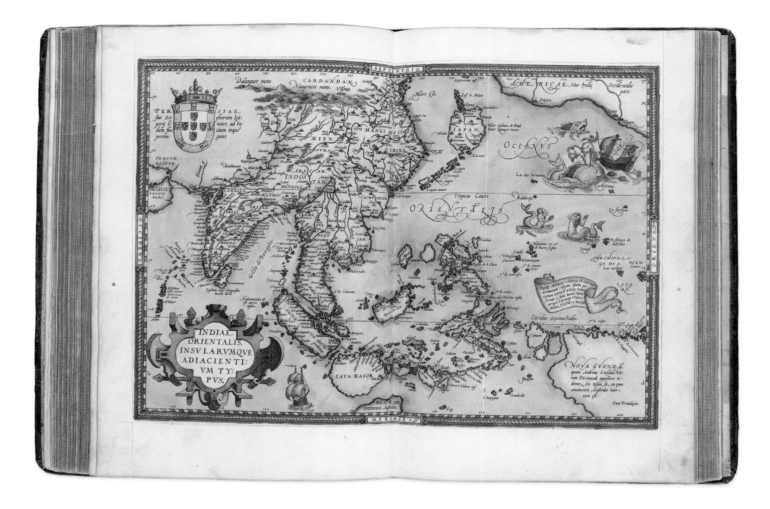

With lucrative riches beckoning, and heathen populations supposed ripe for Christian conversion, the Portuguese commenced an expansive phase of colonisation. Goa, a major port on India's Malabar Coast, was subdued in 1510 to form a Portuguese stronghold. Ceylon (Sri Lanka) was occupied in 1518, and by 1521 the Portuguese were a powerful presence in the Moluccas and Sumatra. Economic rather than ornamental imperatives governed early European study of the region's rich and hitherto unexplored flora. Apart from spices, the medicinal properties of plants attracted attention. In an era of herbals, the earliest book on the Indian flora, *Coloquios dos simples, e drogas e cousas medicinais da India* (Goa, 1563), by the Spanish botanist and physician Garcia da Orta was, fittingly, a pioneering tropical *materia medica*.

The Spanish Jesuit missionary Francisco Xavier landed at Goa in 1542—only two years after the founding in Rome of the Society of Jesus—and later visited Japan. Although he died waiting for passage to Canton on China's mainland, the influence of later Jesuits on botanical studies, especially in China, was significant. The year 1542 also marked the birth of Akbar, grandson of the Emperor Babur, founder of India's Mughal dynasty. Apart from their distinctive Persian influence, the gardens of the Mughals were noted for the richness of their plantings, and an account of Akbar's court—*Ain-i Akbari*—constitutes one of the most comprehensive contemporary descriptions of cultivated fruit, vegetables,

The East Indies, here captured in the 1570s—on the cusp of change—by Dutch cartographer Abraham Ortelius. The colonial Portuguese grasp of power in India and the Moluccas was about to slip in favour of the Dutch and English, both of whom exerted considerable maritime and mercantile might in this region from the early seventeenth century.

opposite: Gloriosa superba, a vigorous climber native to the Malabar Coast of southern India and tropical west Africa, became a favourite in European hothouses from the 1690s, where its delicate, highly coloured flowers shone with flame-like intensity.

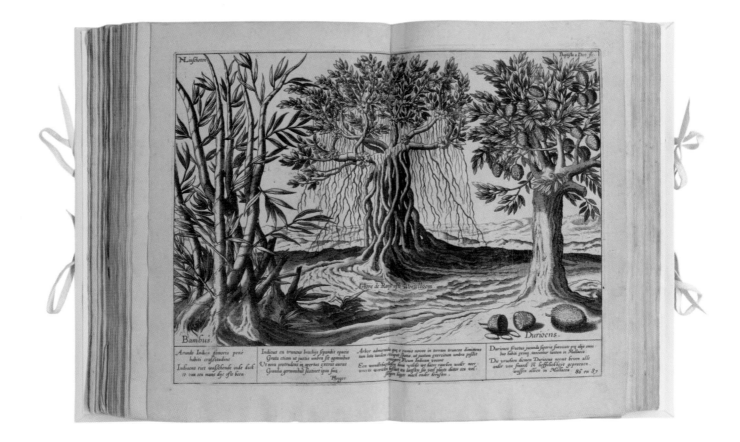

Early European travellers were attracted to the sculptural forms of south-eastern Asian flora. In the case of Dutch geographer and traveller Jan Huygen van Linschoten, it was the dramatic outlines of the bamboo, banyan (*Ficus benghalensis*), and durian (*Durio zibethinus*). The spiky fruit of the durian yielded delicious yet malodorous flesh—'it puts one in mind of persons towards whom one cannot remain indifferent', remarked one later observer.

opposite: Amongst the early plant introductions from China to the West were *Hibiscus syriacus* and *H. rosa-sinensis*. So well established became the so-called 'Syrian' hibiscus, with its characteristic dark-veined markings, that when scientifically named in the seventeenth century its origin was thought to be in the Near rather than the Far East.

and flowers in India. These two disparate cultures—that of the European merchants and missionaries, and of the adopted Islamic world of the Mughals—produced distinctive patterns of plant introductions. The Mughals imported the plants from south-western Asia—figs, grapes, pomegranates, and quinces—into their northern Indian gardens, while European travellers reversed this flow, importing many ornamental flowering plants from the Indies.

China and Japan remained for many years barred to the outside world. The Chinese had long imported spices from Ambon and India, but any flow of plants from China to the distant West was fraught with difficulties. The Portuguese obtained trading concessions at Macau (1537) and the Dutch at Deshima in Japan (1636), repulsing English advances. Trading companies and foreign governments pressed their cases through embassies, but it was missionaries who were best able to penetrate the countryside. Through their publications and global network, the Jesuits especially did much in the seventeenth and eighteenth centuries to disseminate knowledge of the Chinese and Japanese flora.

Portugal's grip on south-eastern Asia was challenged towards the end of the sixteenth century. The Dutch, looking for trading supremacy over England, saw opportunities for a bold intervention in the East Indies. Dutch geographer and traveller Jan Huygen van Linschoten travelled to India from Lisbon in the party of the new archbishop of Goa, and during his stay in the city (1583–89) proved a perceptive observer, alive to the commercial possibilities of India's rich flora. His *Itinerario* (Amsterdam, 1595–96) containing an account of his travels—soon translated into English, French, and Latin—became an essential companion for travellers to the East. As the earliest Dutch traveller to India, Linschoten's inclusion of descriptions and portraits of plants heralded a new interest by publishers in the south-eastern Asian flora, a field dominated by the Dutch until the late eighteenth century.

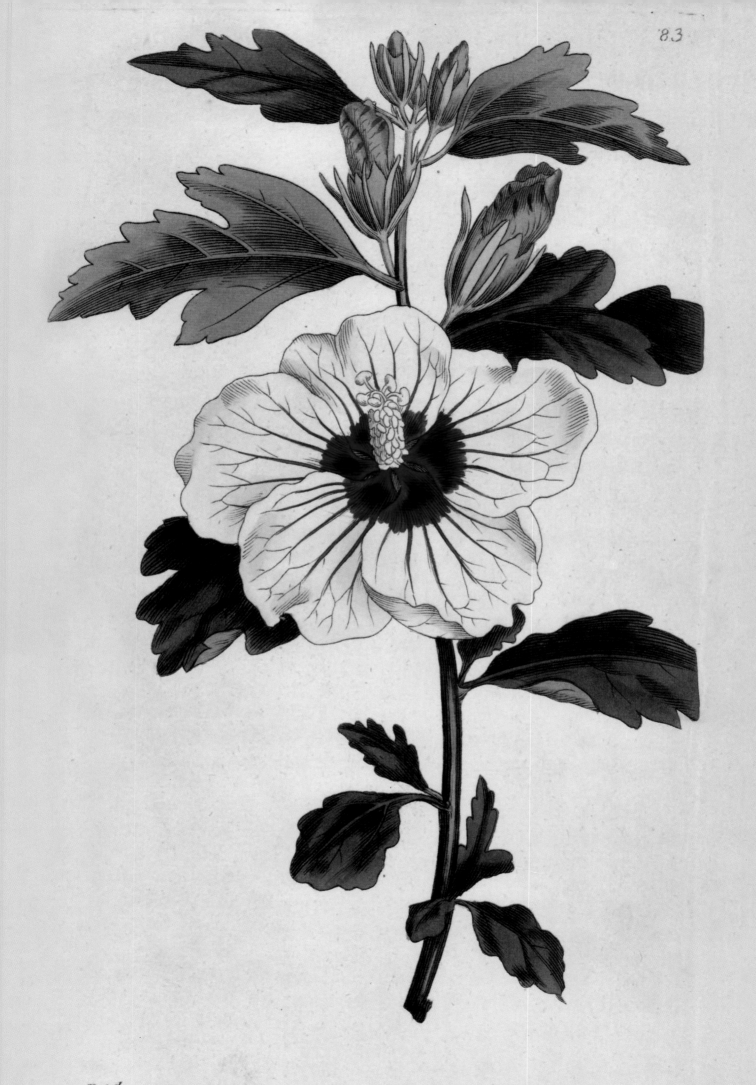

Pub.d as the Act directs, May 1.1789. by W.Curtis Botanic.Garden,Lambeth Marsh.

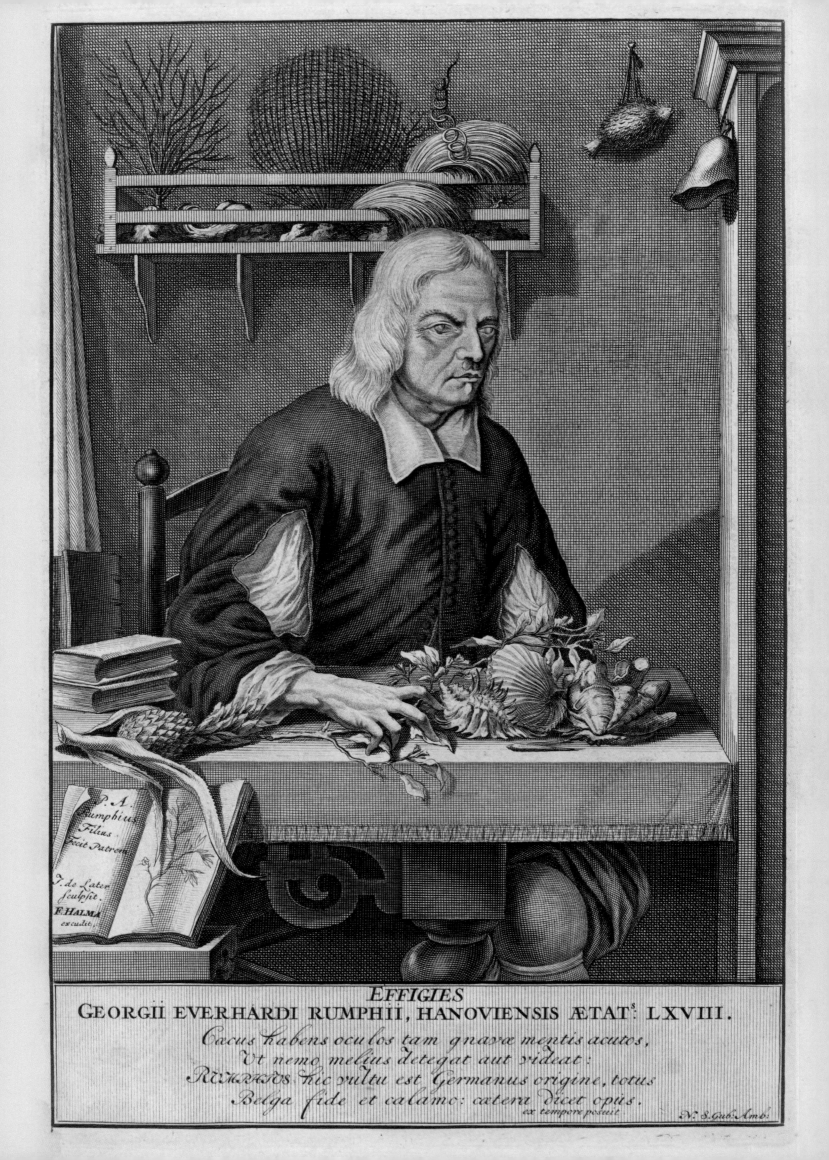

EFFIGIES
GEORGII EVERHARDI RUMPHII, HANOVIENSIS ÆTAT: LXVIII.

Cæcus habens oculos tam gnavæ mentis acutos,
Ut nemo melius detegat aut videat:
RUMPHIUS hic vultu est Germanus origine, totus
Belga fide et calamo: cætera dicet opus.

ex tempore posuit

N: S. Gub: Amb:

HORTUS
INDICUS MALABARICUS.

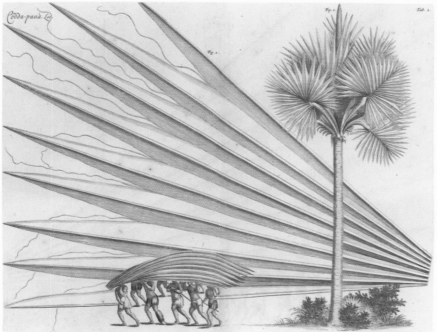

The earliest comprehensive flora of the East Indies was compiled by Hendrik Adriaan van Rheede tot Draakestein, colonial governor of Malabar on the south-western coast of India and an enthusiastic botanist. Rheede's twelve-volume *Hortus Indicus Malabaricus* (Amsterdam, 1678–93) illustrated for the first time many tropical and subtropical plants and fruits. The frontispiece (*above*) is a splendid assemblage of European imagery draped with exotica from the East, while vignettes accompanying the plant portraits illuminate the vital part played by plants in Indian society, such as the use of the massive fronds of the talipot palm (*Corypha umbraculifera*) for shelter (*below*).

opposite: Georg Rumpf, governor of the Dutch settlement on Ambon, was dogged by misfortune, and publication of his flora of the island (*Herbarium Amboinense*) took almost a century. Rumpf worked on the manuscript from 1653 to 1670, but when it was almost complete, blindness cruelly halted progress. His wife, who was assisting with writing and Dutch translation, was killed in an earthquake four years later, while a fire in 1687 destroyed the original illustrations (along with Rumpf's house and library). A final disaster, the French destroyed the ship carrying the manuscript in 1692. When a replacement copy finally reached the Netherlands in 1696–97, it sat in the archive of the Dutch East India Company for three decades until edited by Jan Burman and finally published between 1741 and 1755.

The Chinese aster (*Callistephus chinensis*) was introduced to France just as André Le Nôtre's vast formal gardens were bringing nature to heel. Yet even the grandest garden relied on floral ornamentation to colour the main promenades, and many of the new plants being introduced from China and Japan were sufficiently hardy for northern European climates.

opposite: The botanic garden established during the 1780s at Calcutta by the East India Company was the forerunner of a great imperial network of British botanic gardens that prospered during the nineteenth century. Its first salaried superintendent, the Scot William Roxburgh, compiled one of the great Indian floras, *Plants of the Coast of Coromandel*, whose publication was commenced in 1795. The drawings—by a team of unnamed Indian artists—featured many plants of economic importance to local communities, such as *Caesalpinia sappan*, which yielded a potent red dye and formed a dense thorny hedge.

It was the English who were first to formally recognise and support a trading company for the sole purpose of exploiting the riches of the East Indies. The Honourable East India Company was incorporated under royal charter in 1600, conferring sole trading rights on a company representing 125 shareholders, soon altered to the more flexible arrangement of a joint-stock company. The Vereenigde Oostindische Compagnie (Dutch East India Company) was chartered soon after, in 1602, to regulate and protect Dutch trading interests, which had greatly increased following the pioneering voyage of merchant seaman Cornelius Houtman to Java in 1598. (Like Linschoten, Houtman's published observations illustrated and described plants of economic importance such as the betel-vine (*Piper betel*), bananas (*Musa* spp.), and the coconut (*Cocos nucifera*) as an integral part of his narrative.) Although profit drove the East India companies, their directors tacitly supported interest in the south-eastern Asian flora. This was especially seen in their acquiescence to company officials who wished to pursue botanical research and their willingness to give passage to naturalists. Ultimately this support was demonstrated by the creation of colonial acclimatisation gardens for the reception of new plants.

The Dutch soon overtook the Portuguese in the East Indies, and by the mid-seventeenth century controlled important settlements in the Spice Islands, Ceylon, and southern India. The key figure in early Dutch botanical exploration of the East Indies was Georg Eberhard Rumpf. A skilled naturalist, Rumpf was governor of the Dutch colony on Ambon from 1653. In his major work, the six-volume *Herbarium Amboinense*, plants of ornamental potential such as the Chinese rose-hibiscus (*Hibiscus rosa-sinensis*), frangipani (*Plumeria rubra*), and Indian laburnum (*Cassia fistula*) sat alongside plants of purely economic importance. Even at this early date, some plants common in the East Indies—such as the frangipani, pineapple (*Ananas comosus*), pawpaw (*Carica papaya*)—were imports from the New World introduced by the Portuguese.

By the end of the eighteenth century, coloured globes highlighted the pink of British India and the orange of the Dutch East Indies. Although neither was a colony, the reach of empire shaded local cultures. The demands of empire overlaid traditional plant names with Latin nomenclature, and corralled species of potential economic benefit in botanic gardens. Despite the imposition of this framework, plants continued to enjoy traditional uses for shelter, food, and medicine. Let us leave the last word to Buddha, who spoke of the unilateral love imbued in plants. 'The forest is a peculiar organism of unlimited kindness and benevolence that makes no demands for its sustenance and extends generously the products of its life activity; it affords protection to all beings, offering shade even to the axeman who destroys it.'

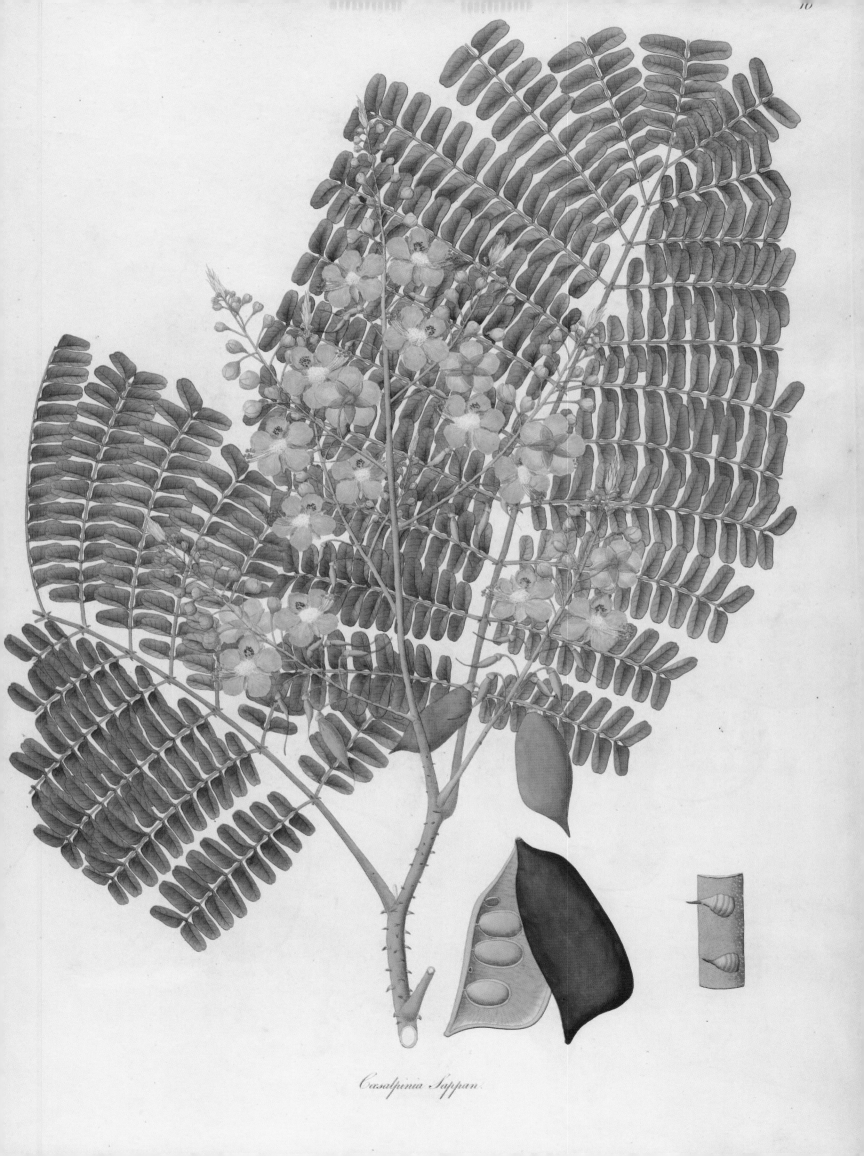

Cæsalpinia Sappan.

14: European Colonisation of the Americas

opposite above: **Few New World plants created such a sensation in Europe as the Mexican *Agave americana*. Supposed to flower only once in a century, the rapid growth and spectacular flowering habit of 'American aloes' were cause for great rejoicing. From tentative beginnings, there were many such flowerings from the mid-seventeenth century to the end of the eighteenth century, after which the flow of celebratory engravings and poems slowed, without in any way diminishing the popularity of this striking introduction.**

opposite below: **The Spanish were the first to introduce the dried flower pods of the Mexican orchid *Vanilla planifolia* to Europe. By the early seventeenth century, vanilla was esteemed in Europe's capitals for its aromatic properties—long known in Aztec culture—and its culture in the Old World tropics became a colonial imperative. Yet it was not until 1841, on the island of Bourbon, that the secret of fertilisation was discovered, and commercial exploitation of the plant could be undertaken with any certainty.**

right: **The New World moistened European lips but, having no land access to the Old World, posed logistical problems for those transporting plants. Here we see furrowed brows all round as seventeenth-century Dutch map-maker Nicolas Visscher and his associates contemplate the cartographic hurdles facing would-be colonisers of the Americas.**

THE EUROPEAN IMAGINATION, ALTHOUGH EXCITED BY DISCOVERY OF A New World, still dreamt of a western sea route to the Indies. Ferdinand Magellan, having fallen from favour with the Portuguese court, finally sailed round the southern tip of America and then west across the Pacific in 1519–22, providing Spain with the long-sought gateway to the Indies as well as a means of consolidating its colonisation ambitions. From New Spain (later Mexico), Spanish settlements were made in Florida, Santa Fé (New Mexico), and along the Baja Peninsula (California). This western territory was largely arid, and its rich succulent flora aroused great curiosity, especially *Agave americana*, which was first flowered in Europe in 1583.

To challenge the Portuguese and Spanish monopolies, other European powers sought a north-west passage—through icy polar regions—to the Indies, and also to lay claim on new lands. The French, after an abandoned attempt to settle Florida, eventually obtained a toehold in the north at New France (later part of Canada). The English explorer Francis Drake, following Magellan's route around America's southern tip, explored north as far as Vancouver before heading west across the Pacific—his claim of New Albion (now in California) for England was, however, thwarted by Spanish dominance and geographic isolation. Tentative English settlements had been made on North America's mid-east coast in the 1580s but it was not until the formation of the Virginia Company in the early seventeenth century that these could be sustained.

Formed to promote settlement and trade, the Virginia Company colonised an area on Chesapeake Bay sufficiently temperate in climate to enable plant exchanges with northern Europe. Amongst the Company's members (from 1617) was John Tradescant, an English gardener and horticulturist with impressive patronage. Tradescant used the Company as a vehicle for many plant introductions

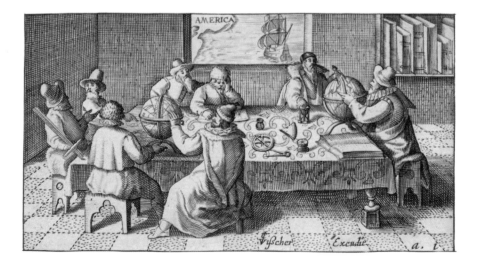

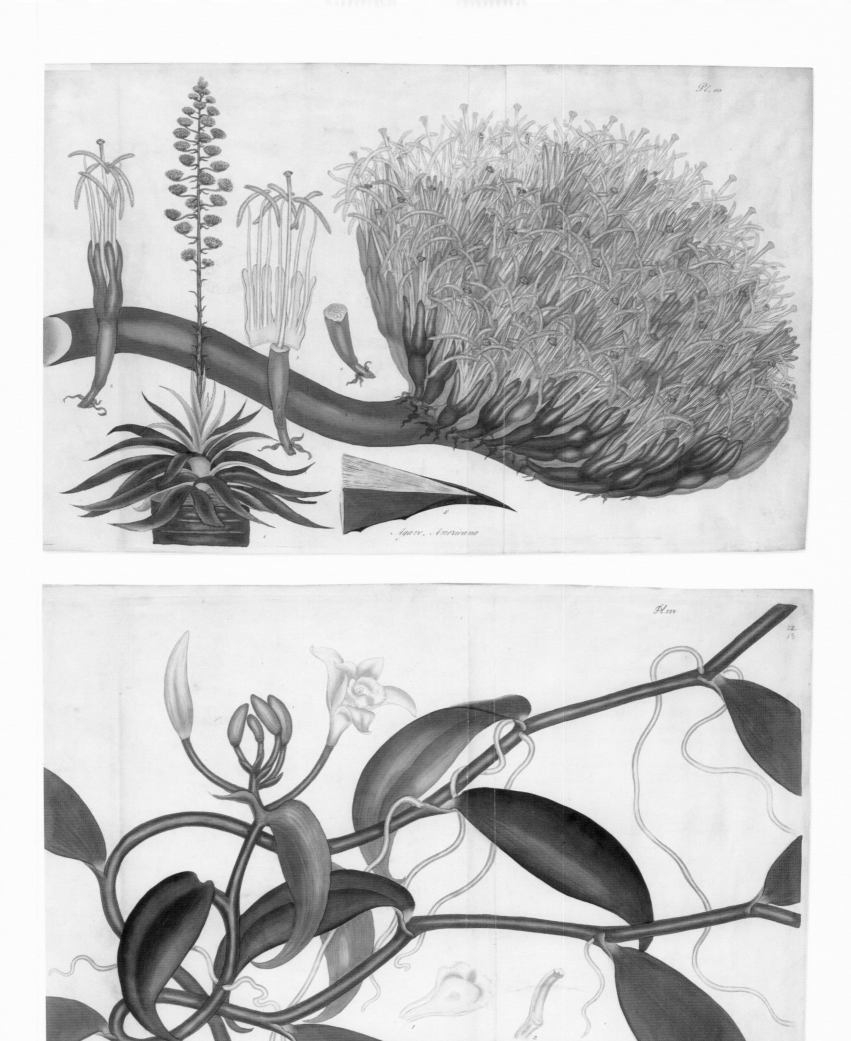

Pl. 112

Agave Americana

Pl. 553

Vanilla planifolia

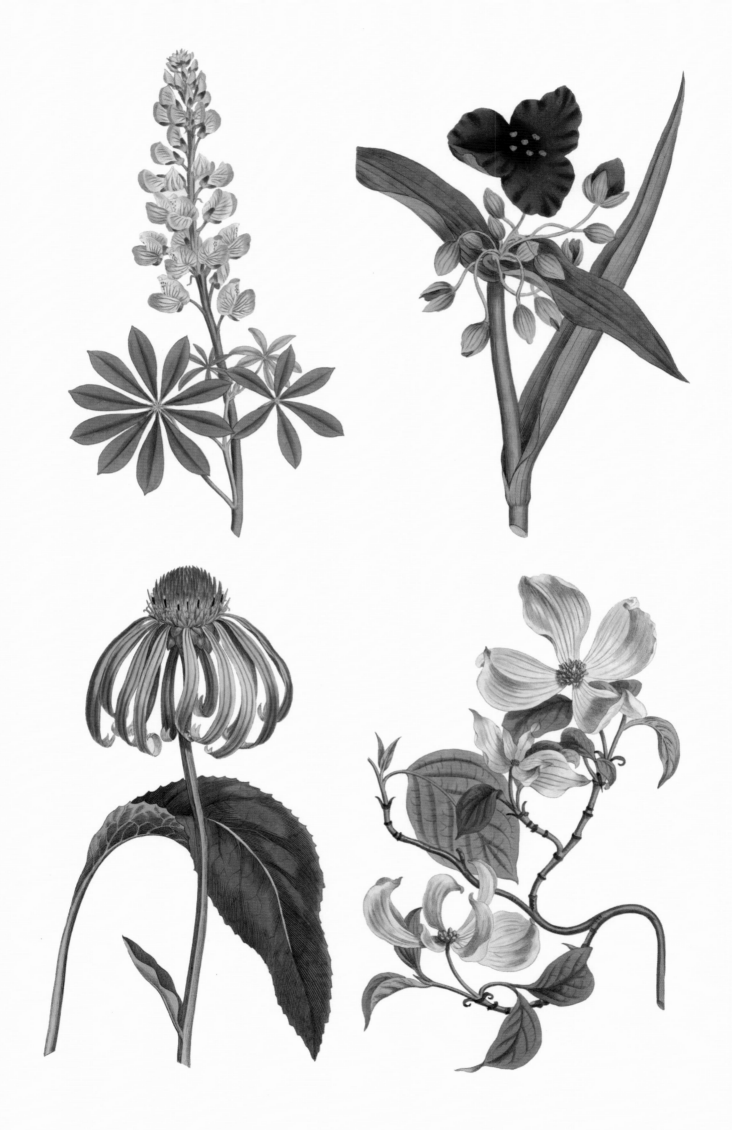

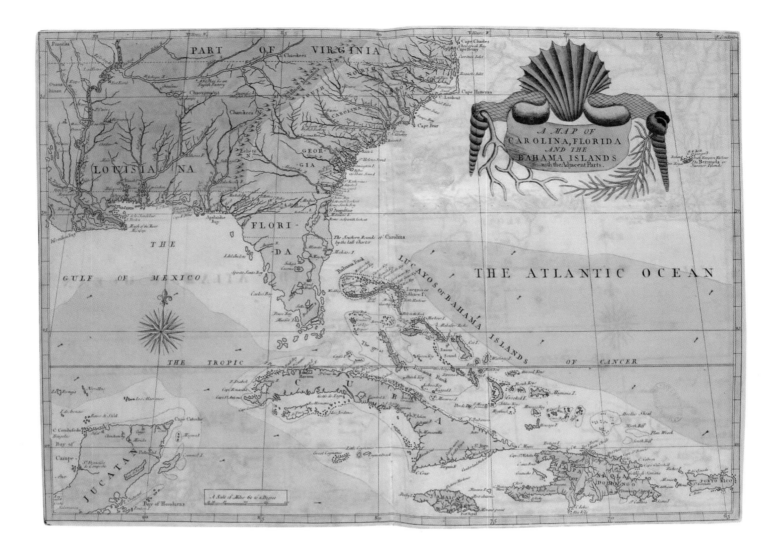

whose names recall this history—*Tradescantia virginiana* (spiderwort) and Virginia creeper (*Parthenocissus quinquefolia*) for example. John Tradescant the younger followed his father's calling, and the fame of their London garden (at Lambeth) rivalled that of contemporary botanic gardens. During the 1630s–50s, Tradescant the younger made three trips to Virginia, introducing many new plants to English horticulture. Along with plants from New England and Maryland, which had been colonised in the mid-seventeenth century, the North American flora made a distinctive contribution to gardens of temperate latitudes. Initially, flowering perennials and shrubs were the principal novelties, but by the turn of the eighteenth century it was the turn of ornamental trees to be recognised for their horticultural potential.

The establishment in 1621 of the Dutch West India Company followed the success of that country's East India Company. Dutch trading interests in the Old and New worlds facilitated the movement of plants between tropical America and the East Indies, as had Spanish and Portuguese trade a century earlier. Like the French and English, the Dutch were keen to gain a foothold in the New World. Its interests invaded sparsely populated Portuguese Brazil in 1630 and also attacked Portuguese strongholds in West Africa, giving access to slaves for sugar plantations, then rapidly being established in tropical America. Unlike the earlier Dutch settlement of New Amsterdam (1624, on the later site of New York), its Brazilian capital, Recife, was more fully developed, including several large gardens emulating European ideals. The gardens of Count Johan Maurits van Nassau-Siegen, administrator from 1637, exemplified the concern of the Dutch to collect and display indigenous and exotic plants as a microcosm of

The southern and eastern states of North America were the earliest to be colonised by European settlers, with Spain (yellow), Britain (pink), and France (green) each represented in the seventeenth and eighteenth centuries by substantial territory.

opposite: **Many of the early seventeenth-century introductions from North America were ornamental flowering plants, suited to temperate European climates. These ranged from perennials such as (*left to right*) *Lupinus perennis*, *Tradescantia virginiana*, and *Echinacea purpurea*, to a limited range of shrubs and trees such as the dogwood (*Cornus florida*). In common with many North American plants, new forms and greater adaptability came with later breeding.**

The pineapple (*Ananas comosus*) was amongst the earliest tropical American plants to arouse European curiosity, yet its widespread introduction had to wait until the development of appropriate hothouses in the seventeenth century—surprise and delight accompanied its successful fruiting in the 'pinery'. Imported pines from South America sometimes also occasioned surprise when the giant Surinamese spider flew in all its evil splendour from the packaging, despatching small birds in a single leap.

opposite: Of all the tropical American food plants, few are as intriguing in their fruiting as the cashew nut (*Anacardium occidentale*). This native of northern South America produces an enlarged and richly coloured fruit stalk—the sweet-tasting fruit is edible, and at its apex sits the small but highly esteemed nut in its protective shell.

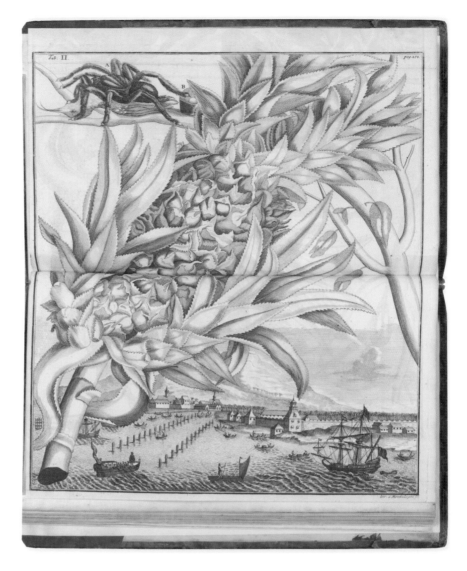

The sweetsop or custard apple (*Annona squamosa*), a native of the West Indies and tropical South America, yielded delicious sweet flesh 'much esteemed by many of the fair sex'. Its introduction and acclimatisation in the East Indies during the sixteenth century was so complete that even the eminent botanist and plant collector Sir Hans Sloane, who had travelled in Jamaica during the late seventeenth century, could not discern its origins with any certainty.

natural history. The court of Maurits extended patronage to many naturalists and artists, resulting especially in the publication of *Historia naturalis Brasiliae* (Leiden and Amsterdam, 1648), whose pioneering volume on Brazilian medicinal plants was compiled by Dutch physician William Piso.

The Dutch withdrew from Brazil in 1654 and moved to new territory, further north, at Surinam (Dutch Guiana). Here, the artist Maria Sibylla Merian produced one of the most astonishing books of any tropical flora. In 1699, she and her daughter sailed for South America with the intention of studying and painting insects and the plants upon which they lived. The resulting volume, *Metamorphosis Insectorum Surinamensium* (Amsterdam, 1705) and its several translations, highlighted the vegetable productions of tropical America as never before, in vivid colour and with striking naturalism. Here were the annatto (*Bixa orellana*), cashew (*Anacardium occidentale*), frangipani (*Plumeria rubra*), guava (*Psidium guajava*), nipple fruit (*Solanum mammosum*), pawpaw (*Carica papaya*), pineapple, and sweetsop, all early introductions from the New to the Old World tropics, where many became highly valued food crops.

As Spain's grip on the Caribbean basin loosened during the seventeenth century, the English, French, and Dutch all made further territorial inroads. The English captured the island of Jamaica in 1655—adding to existing Caribbean settlements—and soon consolidated sugar plantations as a crop of major economic importance, made viable through the blinding attraction of slavery.

The rich Caribbean flora possessed considerable horticultural potential. Hans Sloane, whose collections later formed the nucleus of the British Museum, spent fifteen months in the West Indies collecting and cataloguing local plants. He gave patronage to plant collectors who followed—including Mark Catesby,

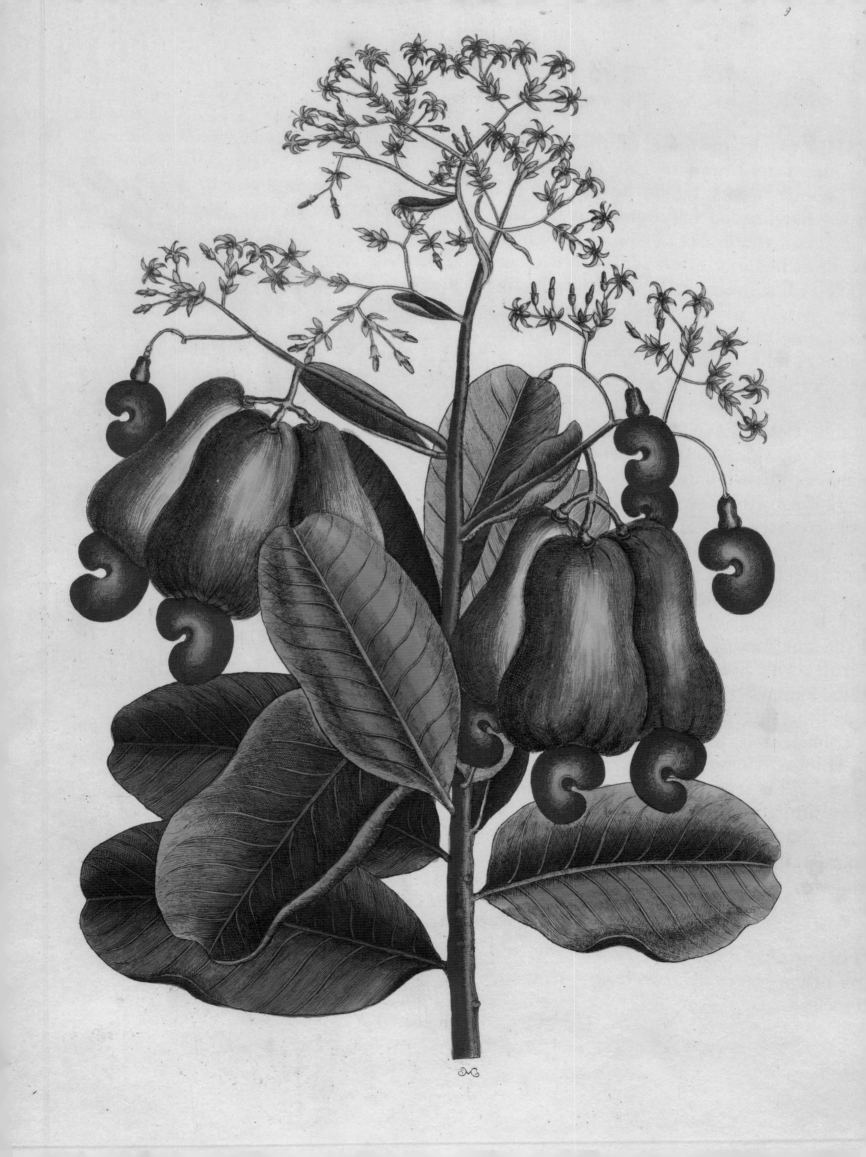

Books can tell many stories—sometimes, unexpected ones. Peter Collinson's handwritten draft of an obituary for plant collector Mark Catesby has been neatly tipped in to the copy of Catesby's *Natural History of Carolina, Florida and the Bahama Islands* (3rd edn, London, 1771) owned by nineteenth-century mycologist Dawson Turner. Collinson, a Quaker merchant and naturalist, was one of Catesby's English patrons in England, and this warm assessment of his protégé lends a poignant air to the volume.

Styrax Arens fol...

Arbor Tulipifera.
The Tulip Tree.

Icterus.
The Baltimore Bird.

Willow Oak.

Platanus Occidentalis.
The Western Plane-tree.

Muscicapa Rubra.
The Summer Redbird.

Largest White Bill'd Woodpecker.

Catesby's *Natural History* is arguably
one of the most delightful floras, its
plates enlivened by the inclusion of
interacting fauna. The lilium named
for Catesby (*Lilium catesbaei*)
competes for attention with the
blue-skinned wampum snake
(*opposite*) while the sweet gum
(*Liquidambar styraciflua*) disguises
an American chameleon (*top left*).
Catesby was a pioneer of North
American ornithology, and many
of his plates include birds, their
contrasting plumage giving the splash
of colour often provided in botanical
illustrations by flowers. This small
selection (from 220 plates) includes a
Baltimore oriole nesting in a tulip tree
(*Liriodendron tulipifera*); a sycamore
or western plane (*Platanus
occidentalis*) enveloping the red-
plumed summer tanager; and the
willow oak (*Quercus phellos*), host
to an ivory-billed woodpecker.

Like numerous fruits and vegetables, many ornamental flowering plants of tropical America acclimatised so successfully in the Old World tropics that their geographic origins became masked. The sweetly fragrant frangipani (*Plumeria rubra*), a native of the West Indies, was widely planted in the East Indies and became known as the pagoda tree or temple flower, from its frequent planting near Buddhist temples.

opposite: The introduction of flowering shrubs found in peaty swamps of eastern North America, such as azaleas and rhododendrons, magnolias, and kalmias—including the sheep laurel or narrow-leaved kalmia (*Kalmia angustifolia*)—encouraged the planting of such species according to their geographic origin. The popularity of these American plants led to their grouping in Britain as separate collections, often known as American gardens.

John Bartram, and William Houston—and supported the work of Philip Miller, curator of the Chelsea Physic Garden, then a major centre for English plant introduction. Houston, an English physician, sent the West Indian orchid *Bletia purpurea* to a Quaker merchant and plant collector, Peter Collinson, in London, where it was flowered in 1733, one of the earliest tropical orchids to be successfully cultivated. Sloane's French contemporary was the botanist and monk, Charles Plumier, who botanised extensively in the French Antilles and elsewhere in Central and South America. He named several tropical American genera, including *Fuchsia* and *Lobelia* (after the botanists Fuchs and L'Obel), and *Begonia* and *Magnolia* (after the French promoters of botany, Michael Begon and Pierre Magnol).

By the early eighteenth century, the first great wave of horticultural interest in North American plants was drawing to a close. British interests still dominated plant introductions, with a circle centred on Sloane and Collinson in London, but as the century progressed, the nascent colonial nursery trade expanded, simultaneously creating and meeting new demand.

The English botanist John Banister travelled as a missionary in Virginia during 1678, forwarding to his grateful bishop, Henry Compton, many ornamental garden trees, including balsam fir (*Abies balsamea*), box elder (*Acer negundo*), honey locust (*Gleditsia triacanthos*), sweet gum (*Liquidambar styraciflua*), and scarlet oak (*Quercus coccinea*). The new magnolias from North America also attracted his attention, with the swamp bay (*Magnolia virginiana*) amongst his introductions, and the earliest to be cultivated in England. Mark Catesby, the first professional plant collector in North America, travelled throughout Virginia, the Carolinas, Georgia, Florida, and the Bahamas during two visits in 1712–26. His second visit was sponsored by Sloane and other members of the Royal Society, and this resulted in his splendid folio volumes on the *Natural History of Carolina, Florida and the Bahama Islands* (London, 1730–47). His most significant introduction to Britain was the bull bay (*Magnolia grandiflora*), a magnificent species which soon shaded its earlier rival. The bull bay had been introduced independently to France several years earlier, the French by then having considerable territory along the Mississippi River in Louisiana.

The years leading up to American independence—and the federation of the eastern colonies as the United States—were significant in laying the foundations for a distinctively North American style of gardening and horticulture. John Bartram, who established America's first botanic garden and nursery, at Philadelphia in the late 1720s, soon exchanged plants within Britain's elite horticultural circles. Peter Collinson and Philip Miller both benefited from Bartram's skill as a plant collector, and amongst the plants he forwarded were the Turk's cap or scarlet lily (*Lilium superbum*) and the showy, large-leaved rhododendron (*Rhododendron maximum*). Like Collinson, Bartram was a Quaker, possessed of a great sensitivity to the natural world. In 1765—through Collinson's influence—Bartram was appointed botanist to George III. The appointment was partly in recognition of his immense contribution to British horticulture, although as the new American nation emerged in the 1780s, Bartram's contribution to his native country was arguably the greater honour.

Guernsey-Lily

G. D. Ehret pinx.

30.

J. M. Seligmann excud. Norimbergae.

The Cape Unveiled

THE ESTABLISHMENT OF A PERMANENT DUTCH COLONY AT THE CAPE OF Good Hope in the mid-seventeenth century consolidated an unfolding botanical exploration of southern Africa. With the backing of the Vereenigde Oostindische Compagnie (V.O.C. or Dutch East India Company) came the adjuncts to successful horticultural exploitation of the Cape's rich endemic flora—regular shipping movements to European ports, scientifically inclined governors who could facilitate inland exploration, and a permanent Company garden. Yet by this date, southern African plants had already been grown in Europe for some time.

Two-pronged voyages of discovery had gradually charted the African coast, with Arab mariners venturing down the east coast from the eighth century and Portuguese down the west coast from late fifteenth century. As these voyages punched further south, culminating in the rounding of the Cape by Bartolomeu Diaz in 1488, the Indian Ocean—once supposed to be landlocked, accessible only via the Red Sea or Persian Gulf—soon formed a new sea route from Europe to the East Indies. The Cape of Good Hope, with Table Mountain as a majestic beacon, provided a strategic halfway house, 'where the vices and follies of the East meet and shake hands with those of Europe'.

Early trade at the Cape was haphazard, as eager masters guided their East Indiamen towards distant destinations or impatiently returned, laden with exotic riches. Not surprisingly, seeds and plants that were robust and easily transportable were the first to be collected. The Cape bulbs, such as species of *Agapanthus*,

opposite: The Guernsey lily (**Nerine sarniensis**) was known in Europe from the early seventeenth century and given its common name from its discovery on the Channel Island, Guernsey. Speculation that it was of Japanese origin—from the cargo of a shipwrecked Dutch vessel returning from Japan—persisted until British collector Francis Masson discovered the bulb on Table Mountain in the late eighteenth century, conclusively establishing it as a native of the Cape.

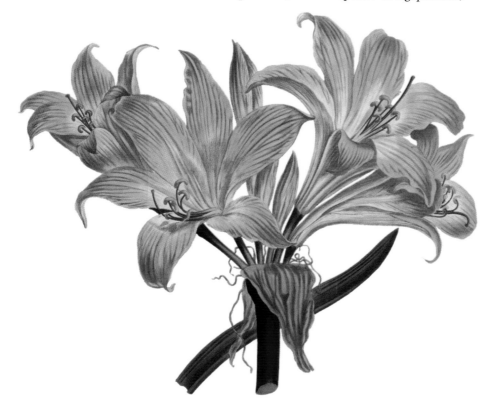

The belladonna (**Amaryllis belladonna**) was amongst the earliest of the Cape bulbs to be introduced to Europe. It flourished around the Mediterranean and on the Iberian Peninsula, presumably introduced by Portuguese mariners of the early sixteenth century. The bulb was also grown extensively on Madeira, an early site for sugarcane culture, hinting at close links between European maritime networks, the African slave trade, and the distribution of plants.

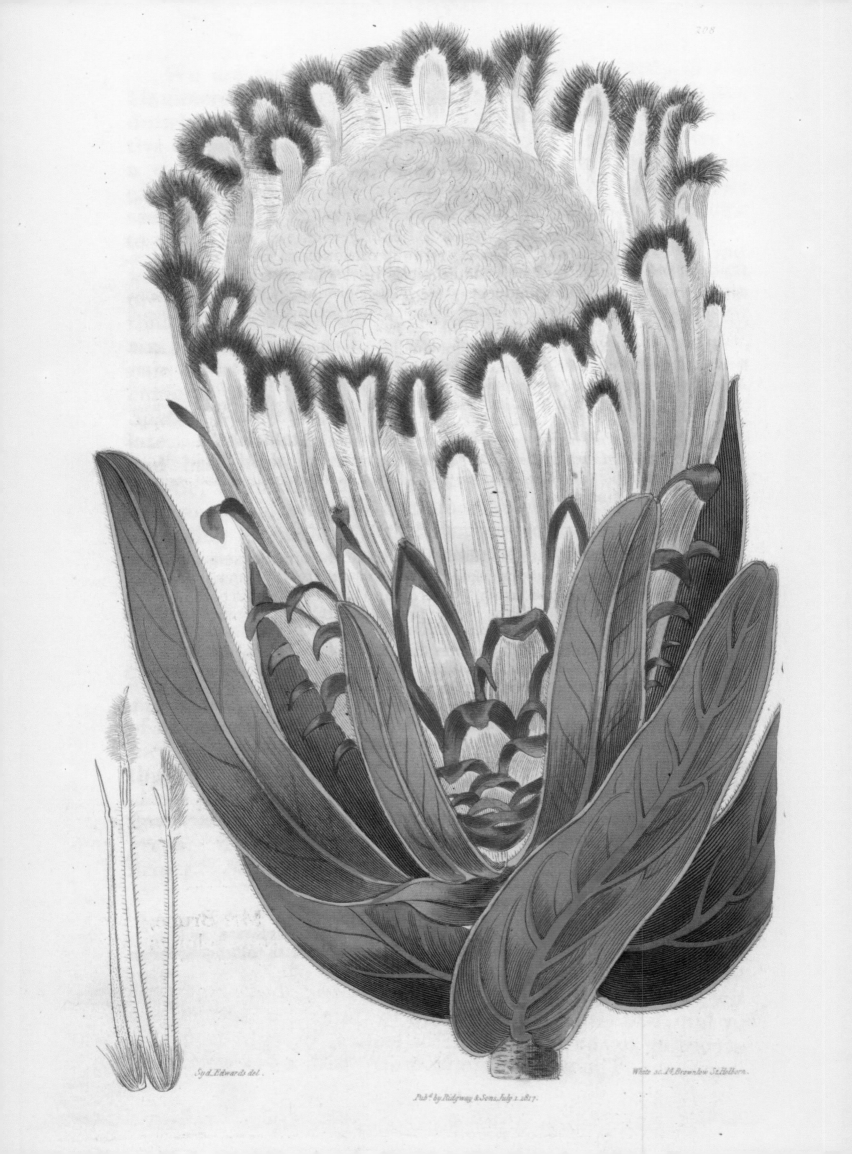

Syd. Edwards del.

White sc. 1st. Brownlow St. Holborn.

Pub.d by Ridgway & Sons. July 1. 1817.

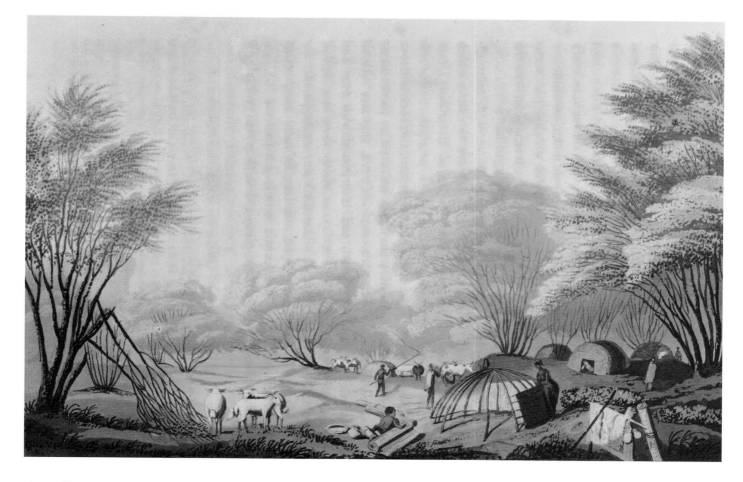

Amaryllis, *Brunsvigia*, *Haemanthus*, *Narcissus*, and *Nerine* were early acquisitions in European hothouses and herbaria. In 1605, botanist Mathias de L'Obel related the story of Gonarus de Keyser, who two years earlier had dug up and returned with Cape bulbs for his brother, a wealthy merchant in Wiesbaden. The story of de Keyser—the first named plant collector at the Cape—was illustrated by woodcuts of bulbs now identified as the striking red-flowered *Haemanthus coccineus* and the less well-known *H. rotundifolius*. Nomenclature in this period was often still vague, with most unidentified bulbs labelled 'Narcissus' or 'Hyacinthus' until their taxonomic marshalling by later botanists.

The Dutch East India Company established a fortified base and victualling station at Table Bay in 1652, midway between Europe and the East Indies. The resultant settlement, Cape Town, grew into a colonial outpost of considerable strategic importance. A garden, managed by a succession of Dutch-trained gardeners, was quickly established. This doubled as an acclimatisation ground, especially for local plants of potential economic significance. Willem (Wilhelm) ten Rhyne, physician for the V.O.C., visited the Cape in 1673 en route to Java, sketching and collecting plants as he explored the environs. Ten Rhyne praised the Company's garden. 'It was a lovely sight with its plantations of lemons, citrons and oranges, its close hedges of rosemary and its laurels, equal in height to a tall tree, all fragrant in the sun … It is the very essence of greenness set in the midst of thorns and barren thickets.' By 1681, a master gardener, three under-gardeners, and seventy-five slaves, tended the site.

Such slaves were generally not drawn from the Indigenous population, but from more distant Angola and Mozambique, or other parts of tropical Africa. For the Khoikhoi (or Khoekhoen), who had lived in southern Africa for 30,000 years, the establishment of a permanent European settlement at the Cape had disastrous

William Burchell's early nineteenth-century sketch of a Khoi encampment on the banks of the Gariep (or Orange) River demonstrated a rare sensitivity towards the Aboriginal herders of the Cape. Traditional huts of acacia branches and rush matting of the grass-like sedge, *Cyperus textilis*, demonstrate the lightness of touch that the Khoikhoi brought to life in the semi-desert conditions of the Karoo.

opposite: The novelty of the Cape flora was evident in the rush to name its many unfamiliar plants. In 1605, celebrated botanist Charles de L'Ecluse published the first known illustration of *Protea neriifolia*, describing it as an 'elegant thistle'. L'Ecluse was director of the botanic garden at Leiden, and this plant was amongst the earliest examples of the Cape's rich proteaceous flora to be collected by the Dutch. By the time of Sydenham Edwards's illustration pictured here (1817), the Cape flora was at the height of its European popularity.

JOANNIS BURMANNI,
Med. Doct. & in Horto Medico Amstelaedamenst Botanices Professoris,

RARIORUM AFRICANARUM
PLANTARUM,
Ad vivum delineatarum, Iconibus ac descriptionibus illustratarum

DECAS PRIMA.

AMSTELÆDAMI,
Apud HENRICUM BOUSSIERE.
MDCCXXXVIII.

Johannes Burman's *Rariorum Africanarum plantarum* (Amsterdam, 1738–39), which described and illustrated many recently introduced southern African species, exemplified the close botanical links between the Netherlands and the Dutch Cape Colony. Burman, who did not visit Africa, relied on illustrations by Hendrik Claudius, who had accompanied Simon van der Stel on an expedition to Namaqualand during 1685–86.

consequences. The Khoi (or Khoe) peoples—known to the Dutch as Hottentots—were herders, and for at least 2000 years had tended sheep and, later, cattle, an attractive inducement to reprovisioning European ships. Resistance was ruthlessly thwarted. Colonisation drove the Khoi from their traditional lands, herds were stolen, and during 1711–13 a smallpox epidemic decimated the population. The San peoples (the Bushmen), hunters living off the wild game animals and bush foods of the deserts north of the Cape, fared little better as the colonisers drove further and further into the interior of southern Africa. Generations of adaptation to the land and its products received scant recognition. Empathic accounts by colonial botanists and travellers usually highlighted native medicinal uses of plants—in 1649, for instance, the ulcerated limbs of sailors were successfully treated by local Khoi herders using unnamed plants, an event recorded with gratitude by the French merchant-adventurer, Jean-Baptiste Tavernier.

Some of the Cape plants, such as grasses and daisies, had a familiar look to the colonists, but others were of strikingly novelty. Ten Rhyne likened the landscapes of Saldanha Bay, north of Cape Town, to 'rich gardens ... a vision of the Elysian fields in the midst of a wilderness', yet of other areas he was less lyrical. This was understandable, as European eyes often regarded the very un-Elysian semi-desert conditions of the Karoo and the vast, open savanna grasslands across the Orange River with a fear emblematic of the Styx.

A very large proportion of the Cape's plant species were endemic, that is, they were not known in the wild in any other locations. This was especially true in the species-rich *fynbos* (literally, 'fine bush' in Dutch) which formed a spectacular coastal belt from Cape Town to Port Elizabeth, where heaths, proteas, and rush-like herbs proliferated. To the north lay the Karoo and Namaqualand, a semi-desert buffer between the coast and the Kalahari Desert. In this buffer land dwarf, drought-tolerant shrubs and a few scattered trees contrasted with an intriguing succulent flora. Here leaf succulents such as aloes and crassulas, and stem succulents such as euphorbias, were common. So too were the 'mesembs' of the Aizoaceae family. Bulbs, corms, and rhizomes—which provided underground nutrient storage for many smaller plants—thrived, resulting in a colourful display of *Haemanthus*, *Oxalis*, and *Babiana* species.

The establishment of the Dutch Cape Colony coincided with a period of great prosperity in the Netherlands, a golden age that linked church, commerce, and culture. Botanic gardens were a key part of this satisfied self-image. The scholarly centre of Leiden had established a *Hortus Botanicus*, attached to its university, in 1587. This botanic garden, intended for the benefit of medical students, received its greatest boost from the early 1590s when Charles de L'Ecluse was appointed *Praefectus Horti*. A well-travelled botanist, L'Ecluse was a pioneer of bulb culture in the Netherlands. Drawing on his wide network of contacts, L'Ecluse swelled the collection with the plants from the Near East that were then revolutionising European gardens, and soon used his influence with the newly established V.O.C. to encourage ships' captains to collect seeds and plants in the East Indies and en route. Critical to the introduction of tropical and semi-tropical plants was the

The Cape silver-tree (*Leucadendron argenteum*) was amongst the earliest of the leucadendrons grown in Europe, yet it rarely flowered under hothouse cultivation. Johannes Commelin, who in 1701 published the earliest illustration of this species, relied on a living plant supplied to Amsterdam's *Hortus Botanicus* by Simon van der Stel. In this later illustration, published in the *Botanical Register* (1826), the silvery-green colouring that contributes to the common name is clearly evident—a 'strong but agreeable contrast' to the normal greenery of the hothouse (according to the magazine's editor).

Geranium Africaum, arborescens malvæ fo-
lioplano, lucido, flore elegantissimo Hermesino.
Boerhaav. I. 4. 262. Martijns. Hist. Pl. rar.
Dec. I. Tab. 2.

Geranium Africanum arborescens, malvæ folio
pingui, flore coccineo Dill. Elth. Tab. 118. fig. 151.

Africanischer, baumartiger Storchschnabel
mit den Pappelblat und scharlachfarber
blume.

development of special glass-fronted plant houses, heated to protect their contents from the cold and frost of northern climates. Such hothouses, first developed for wintering citrus trees, led to an indoor gardening revolution—tubbed trees were increasingly shielded by flanks of flowering plants, requiring the attainment of new horticultural skills.

As the eighteenth century progressed, the Dutch port city of Amsterdam prospered beyond the wildest dreams of its inhabitants. Jan Commelin, whose successful pharmacy and spice-handling business was commenced in 1652—the year in which the Dutch Cape Colony was established—was the founding director of Amsterdam's *Medicyn-Hof*. Unlike Leiden, this botanic garden was run by the city, and Commelin's mercantile acumen was turned to the service of botany and horticulture. Like L'Ecluse a century earlier, Commelin drew on an extensive network of correspondents, including Simon van der Stel, the botanically inclined governor of the Cape Colony, appointed in 1685. Commerlin's nephew Caspar succeeded his uncle at the Amsterdam garden in the early eighteenth century; notable successors rounding out the century were father and son Johannes and Nicolaas Laurens Burman. All were well placed to bridge the divide between botany and horticulture by describing and distributing newly discovered seeds and plants from the Cape, complementing the work of professional florists and wealthy amateurs.

Under the watchful eye of Simon van der Stel (and his son Willem Adriaan, who succeeded him as governor in 1699), the Company's garden at the Cape was expanded and transformed into a botanic garden. The successive appointments of skilled horticulturists, Heinrich (Hendrik) Bernard Oldenland (*c.* 1692) and Jan Hartog (1697) to the post of master-gardener facilitated this process as well as the garden's role in the exchange of seeds and plants, especially to the Commelins at Amsterdam. Simon van der Stel's governorship also coincided with a great reorganisation and expansion of the garden at Leiden by Paul Hermann, its director from 1680 to 1695. Hermann alone of the Dutch botanic garden directors had visited the Cape. Ashore for several days in 1672, Linnaeus records that Hermann collected over 800 new plants, including proteas, ericas, and leucadendrons—notably the Cape silver-tree, *Leucadendron argenteum*.

During expeditions north to Namaqualand, Simon van der Stel and his entourage identified several new succulent plants, while on an eastern excursion in 1689, Oldenland collected *Aloe humilis*, a plant with considerable horticultural novelty. The Cape's rich succulent flora was eagerly sought—seeds and smaller specimens were collected, transported, and transplanted with relative ease. Such was the popularity of Cape plants that the first book on succulents, Richard Bradley's *Historia plantarum succulentarum* (London, 1716), included more African than American species. Bradley—who in a letter to his friend and patron, James Petiver, once signed himself 'Your most humble and disincornufistibilated servant'—invented some fanciful succulent names, including fig-marigolds (mesembryanthemums), torch thistles (*Cereus* species), and melon-thistles. Bradley's research had included lengthy visits to the Netherlands to consult specimens held at Amsterdam and Leiden, which by the early eighteenth century were home to peerless collections of cultivated succulents.

opposite: Seeds of the pelargonium (then known as *Geranium africanum arborescens*) sent from the Cape by Willem Adriaan van der Stel were raised in Amsterdam in 1700, the forerunners of today's zonal pelargoniums. This illustration, bearing the same name, depicts the brilliant red-flowered *Pelargonium inquinans*, a closely related horticultural introduction from the Cape.

Like bulbs, the rich succulent flora of the Cape was transported with relative ease and eagerly sought by wealthy plant enthusiasts. The refined European sensibilities imbued in this pot contrast exquisitely with the untamed habits of its occupant, the maggot-bearing stapelia (*Stapelia hirsuta*), one of the Cape's many endemic species.

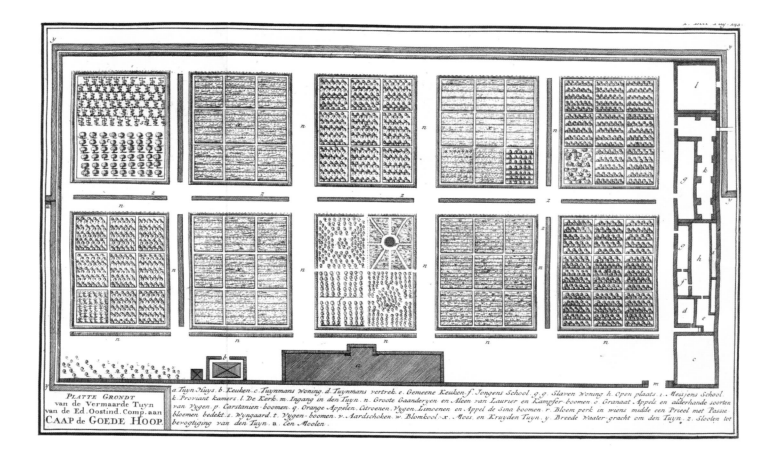

PLATTE GRONDT
van de Vermaarde Tuyn
van de Ed. Oostind. Comp. aan
CAAP de GOEDE HOOP.

a. Tuyn-Huys. b. Keuken. c. Tuynmans woning. d. Tuynmans vertrek. e. Gemeene Keuken. f. Jongens School. g.g. Slaven woning. h. Open plaats. i. Meisjens School.
k. Proviant kamers. l. De Kerk. m. Ingang in den Tuyn. n. Groote Gaanderyen en Aleen van Laurier en Kampfer-boomen. o. Granaat Appels en allerhande soorten
van Vygen. p. Carstanien-boomen. q. Orange Appelen. Citroenen. Vygen. Limoenen en Appel de Sina boomen. r. Bloem-perk in wiens midde een Prieel met Passie
bloemen bedekt. s. Wyngaard. t. Vygen-boomen. v. Aardschoken. w. Blomkool. x. Moes, en Kruyden Tuyn. y. Breede Waater-gracht om den Tuyn. z. Slooten tot
bevogtiging van den Tuyn. a. een Moolen.

By the end of the sixteenth century, numerous Cape species had been described and illustrated, and by the mid-seventeenth century many were in cultivation in European gardens. While most of the Cape flora required glazed and heated protection, some varieties proved hardy in the Northern Hemisphere. Others remained as curiosities. The white arum lily (*Zantedeschia aethiopica*), for example, described and illustrated as early as the 1640s, had to wait until the late eighteenth century to be widely introduced into European gardens.

At the Cape itself collecting continued, especially under the mid-eighteenth century governorship of Rijk Tulbagh. Tulbagh, an intellectual who corresponded with Linnaeus (in Latin) and sent plants to him at Uppsala, died in 1771. Only a year later, the British collector Francis Masson and Linnaean disciples Carl Thunberg and Anders Sparrman arrived at the Cape, heralding an unprecedented horticultural enthusiasm for the Cape flora.

During the 1690s, the garden of the Dutch East India Company at Cape Town was greatly expanded. This reflected the continuing role of the port for the reprovisioning of ships with fresh food as well as the increasing botanical and horticultural significance of the Cape's flora. In this engraved plan of the early eighteenth century, the ordered rows of beds hint at the productive nature of the garden but so too do they reflect the colonisers' imposition of order on nature.

Taking Stock

Advances in the emerging science of botany transformed the classification of plants and their ordered representation in books. The earliest published botanical texts, such as John Gerard's *Herball* (illustrated here in its revised edition of 1633), were arranged according to the medicinal properties of plants, a tradition dating from classical times.

THE GREAT AGE OF MARITIME EXPLORATION YIELDED MANY THOUSANDS of plants new to Western knowledge. From all quarters of the globe—but especially from the New World and the Old World tropics—the newcomers flooded into European gardens. Whereas ancient botanical authors—whose work formed the basis of Renaissance plant knowledge—could distinguish perhaps 500 or 600 plants, by 1700 French botanist Joseph Tournefort could enumerate over 10,000. This great explosion in plant numbers left botanists floundering. Renaissance botany had focussed on medicinal uses of plants, and this underpinned the arrangement of most botanical texts. Yet the need to distinguish between the uses of plants (economic botany) and the plants themselves (taxonomy or systematics) became an urgent task as botanists took stock of shelves now groaning with new specimens, and gardens (and especially their plant houses) filled to overflowing with untold botanical riches.

The Swiss Bauhin brothers (later honoured by the genus *Bauhinia*) undertook a crucial post-Renaissance plant inventory with the publication of *Pinax theatri botanici* (1623) and *Historia plantarum* (1650–51), describing some 5000 plants. These books were amongst the earliest to incorporate the system of genera and species that Linnaeus codified a century later. Rival classification systems, however, gave rise to great confusion, as the same plant might be ascribed two or more quite different names. Even when there was general agreement, lengthy strings of descriptive Latin bedevilled a popular understanding of botany—*Anemone oenanthes folio florae violaceo hexaphyllo*, even coming from Gaspard Bauhin, was hardly likely to excite those who grew the garland anemone in their garden.

Different botanists championed different classification systems, each generally based on close comparative examination of constituent plant parts such as roots, stems, and leaves. At the fringe were those who clung to the doctrine of signatures, a conviction that plants resembled the ailment they were supposed to cure—the resemblance of a walnut to the human brain, for instance, was taken as a sign it could cure ailments of the head. Astrological botany, perhaps best known from the works of seventeenth-century English physician Nicholas Culpeper, linked plants with corresponding star signs in a plausible and immensely popular fusion. Enter science. The advent in the mid-seventeenth century of the compound microscope (using two or more lenses) heralded a new era of botanical classification. Botanists could now closely examine parts of plants not visible to the naked eye, experiments first described by English scientist Robert Hooke in his revolutionary work *Micrographia* (London, 1665).

The new scientific approach inherent in Hooke's work, where long-held beliefs were challenged or overturned by cool rationality, was also mirrored in the garden. Botanic gardens, whether funded by the state or private enterprise, had now progressed from being gardens of medicinal plants to living textbooks of the plant world. Historian John Prest gives a beguiling reading of early botanic

The compound microscope, consisting of multiple ground-glass lenses, was invented in the late sixteenth century. However, it was not until the middle of the seventeenth century—when use of the instrument by English scientist Robert Hooke led to the discovery of plant cells and other biological breakthroughs—that its scientific use became widespread.

right: By the eighteenth century the botanic garden had outgrown its origins as a 'physic' or medicinal garden. Increasingly—as at Leiden, depicted here in allegorical garb—it was a centre of research, classifying and explaining the vegetable kingdom with the aid of living collections, herbaria of dried specimens, and an associated library.

below: The artificial system of classification devised by Swedish naturalist Carl Linnaeus, first expressed in his *Systema naturae* (Leiden, 1735), revolutionised the natural sciences. Plants were grouped according to their reproductive organs, stimulating an enhanced understanding of plant morphology (in order to identify affinities or differences between plants). In its subsequent refinement, binomial (two-part) names—generic and specific—then further distinguished individual plants, replacing earlier and often confusingly lengthy nomenclature.

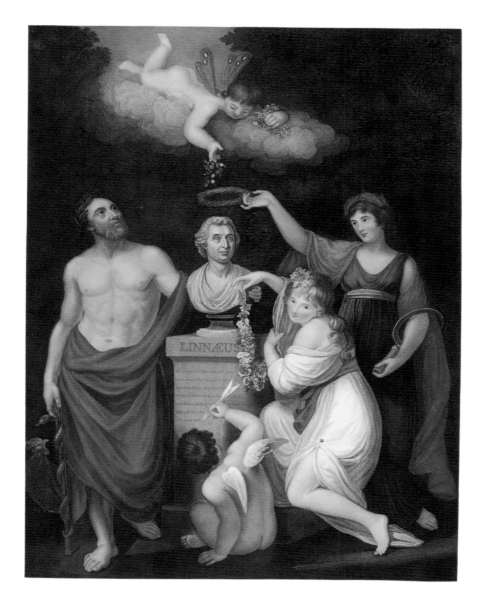

Homage to Linnaeus came in many forms, but few were as sentimental as this tableau to taxonomy in Robert Thornton's *New Illustration of the Sexual System of Carolus von Linnaeus* (London, 1799–1807), better known as *The Temple of Flora*. Here Thornton elevates his hero to the pantheon, honoured by Aesculapius, Flora, Ceres, and Cupid (respectively the deities of medicine, flowers, agriculture, and love).

gardens, tracing an Edenic genesis to their humanist flowering in an age of maritime discovery. Useful and ornamental plants from the four known continents were arranged in squared formations to be read like leaves from a book—the European discovery of the New World having so recently enabled this quadrilateral perfection. From garden beds to book leaves is perhaps not such a fanciful allusion, since botanic gardens and their directors were now at the forefront of a burgeoning publishing industry.

Botanic gardens had also become the taxonomic clearing-houses of the eighteenth century. The facility to examine dried herbarium specimens in close proximity to living plants gave botanic gardens an edge denied the solo traveller or desk-bound scholar. One young naturalist who was greatly influenced by botanic gardens was Carl Linnaeus. Born in Sweden in 1707, Linnaeus undertook higher study at Uppsala, where the institution possessed a fine botanic garden. He made particular study of flowers and reproductive techniques of plants. This was consistent with contemporary interest in plant sexuality, long postulated but only verified in the late seventeenth century. Travelling then in the Netherlands to undertake his doctorate, Linnaeus came into contact with a circle of eminent botanists including Hermann Boerhaave, professor of medicine at Leiden (and therefore in charge of the botanic garden). Amongst the circle of scholars centred on Leiden were Johan Gronovius, a keen amateur botanist, and Isaac Lawson, a Scottish doctor. Here the pair came into contact with Linnaeus, and upon seeing

Wanzen

PVNAISES

The flora, in the sense of a descriptive catalogue of plants from a particular geographic area, had its origins in the mid-seventeenth century. Sibthorp's *Flora Graeca* (London, 1806–40) is generally reckoned as amongst the rarest and most lavish. The ten volumes were produced seemingly without regard to cost, using the finest illustrators and botanists of the age. Such was its expense and duration of publication that only twenty-five subscribers completed their original subscriptions to the work. John Sibthorp had died before publication commenced, and the descriptions had to be completed by others. Even in the field, tragedy befell the project when Sibthorp's assistant Joseph Borone (for whom the Australian genus *Boronia* was named), sleepwalked to his death off the balcony of his Greek hotel.

opposite: The Linnaean system of nomenclature applied equally to animals and minerals, as to plants. The garlanded frontispiece of Caspar Stoll's book on the world's insects (*Wantzen* in Dutch, *Punaises* in French), published in Amsterdam in 1788, highlights this inter-relation of the natural world.

his unpublished tabulation of the natural world, funded its publication. Printed in only a very small number—fewer than thirty are known to survive—*Systema naturae* (Leiden, 1735) effected a revolution in the study of the natural world.

The great genius of Linnaeus was in his elegant means of describing plants using a two-part (or binomial) system. Some toyed with rival naming systems, but the works of Linnaeus—especially his elucidation of plants in *Species plantarum* (Stockholm, 1753)—achieved rapid acceptance and are now accepted as the starting point of modern botanical nomenclature. The Linnaean system of nomenclature consisted of a single name to distinguish generic groupings (genus) followed by a descriptive specific epithet (species). Thus, in his hands, the garland anemone became *Anemone coronaria*, providing botanist and gardener alike with a simple Latin name that drew on the resemblance of the flower to a crown (*coronaria*) or garland.

Once a system of nomenclature was widely accepted it could be applied to a variety of plant groupings. This formed the basis of specialised publishing ventures, with the two most common such groupings being geographic area and plant group. The earliest use of the term 'flora' to distinguish a regional plant survey was probably the *Flora Danica* (Copenhagen, 1647), a survey of Denmark's flora by Simon Paulli. Whilst such usage predated the works of Linnaeus, the Linnaean system sparked a new interest in the production of regional floras. These were often intrinsically linked to political or national prestige in their sponsorship, a theme that effectively translated to imperial ambitions in the eighteenth and nineteenth centuries.

ROBINIA *altagana* ROBIN. *pygm.* ROBIN. *ferox* BERBERIS. *radix* BERBER. *lign.* MESP. *cotoneast.* AMYGDAL. *nana* RHAMNUS *erythroxylon*

BETULA *Alnus* 9 BETULA *incana* 10 TAXUS *baccata* 11 TAMARIX *gallica* 12 POPULUS *balsamifera* 13

SORBUS *aucuparia* 14 ELÆAGN. *angustifol.* 15 IUNIPERUS *Sabina* 16 IUNIP. *Lycia* 17 CUPRESSUS *sempervirens* 18

CRATÆGUS *sanguin.* 19 PYRUS *Malus* 20 ULMUS *pumila* 21 PAL. *Pterococcus* 22 LONICERA *tatarica* 23 PRUNUS *sibir.* 24

LIGNA *Russica colorata*

Amongst the more unusual floras was Ettinghausen and Pokorny's *Physiotypia plantarum Austriacarum* (Vienna, 1856–73). This Austrian flora utilised nature printing, where the impression of plants was transferred to a soft metal plate (a nineteenth-century refinement of the original technique using direct impressions on paper from plants).

opposite: The economic potential of plants—such as these timbers depicted in *Flora Rossica* (St Petersburg, 1784–88) by Russian botanist Peter Pallas—provided a great stimulus to imperial ambition dressed in the guise of botany, a theme that resonated in a period of great geo-political upheaval.

Plant groups based on families or genera also formed the basis for a renewed interest in botanical publishing in the post-Linnaean age. Flowering plants were the key to the Linnaean system of classification and often resulted in magnificent illustrated monographs, such as Redouté's *Les liliacées* (Paris, 1807–16). Even fungi and seaweed received close attention in the quest to bring order to the natural world. The Linnaean system depended on close observation of minute parts of plants, and consequently many older botanical book illustrations became obsolete.

Depictions of fruit also inspired many lavish books, leading to a specialised type of publication known as the 'pomona'. In eighteenth-century Europe, fruit gardening was at the pinnacle of the horticultural world, and this was reflected in the sumptuous books it inspired. Classification of fruit had always been rather problematic, and in the pre-Linnaean era many liberties were taken. The apple, for instance, known in Latin as *Malus*, formed the basis for much fruit nomenclature merely because other spherical or ovoid fruit were deemed to be types of apple, and the trees thus labelled as different species of *Malus*. So the peach, apricot, quince, orange, and even pomegranate were grouped together in Renaissance botanical texts. Even the Linnaean treatment of fruit did not meet with complete satisfaction from pomologists, especially as one species might have many hundreds of named varieties.

opposite: The classification of fruits
has long bedevilled botanical authors
since most variation occurs in varieties
of individual fruits rather than in
the range of different fruits. Indeed,
some fruits still resist precise
classification, or at best rely on an
uneasy nomenclatural truce between
factional leaders. The pomona—a book
specifically devoted to fruit, such
as Johann Knoop's *Pomologia*
(Nuremberg, 1760)—developed as a
specialised publishing genre from
the sixteenth century, and reached
lavish heights during the late
eighteenth and early nineteenth
centuries.

Pierre Bulliard's *Herbier de la France*
(Paris, 1780–1809) utilised colour-
printed engravings, a similar technique
to that developed by Redouté for his
most lavish publications. These plates—
drawn, engraved, and probably printed
by Bulliard—capture the essence of
the plants with an accuracy and
sensitivity often found wanting in
less capable hands.

Yet for all the recognition Linnaeus received, his classification system based
on the reproductive organs of the plant still produced highly artificial groupings.
Many other authors grappled with this problem, and the major alternative
during the late eighteenth and early nineteenth centuries was the so-called
natural system. Successive members of the Jussieu family in France and John
Lindley in Britain, amongst others, promoted such a system. The natural system
took into account the whole plant, seeking to compare all points of resemblance
rather than just the sexual organs. Ultimately, neither system proved entirely
satisfactory. This posed a dilemma for botanic garden directors, who often
arranged beds of living plants according to the classification system enjoying
prevailing favour. Books might be revised but gardens took longer to respond.

Tab. V.

N.° 43. Bergamotte grise d'Ete reif zu
Ende Sept.
gewogen
4 Loth

N.° 44. Muscateller Birn
oder Marcipan Birn
reif zu Ende
Sept. gew:
4½ L.

N.° 46. Kleiner Isenbar
reif zu Anf. Oct.
gew: 8 L.

N.° 45.
Robine
reif
zu Ende
Sept.
musquee
gew. 2½ L.

N.° 47.
Lieb Birn
reif zu End Sept
gew. 8 Loth

N.° 48.

N.° 49. Groser Isenbar
reif zu Anfang Oct.
gewogen 16. Loth

N.° 50. Beure grise reif zu Anf.
Oct. gewogen 11 Loth.

Bergamotte grande
d'Automne
reif zu Ende Oct.
gew. 10 Loth

N.° 51.
Paul Kochs Birn
reif zu Anf. Oct.
gew: 16. Loth

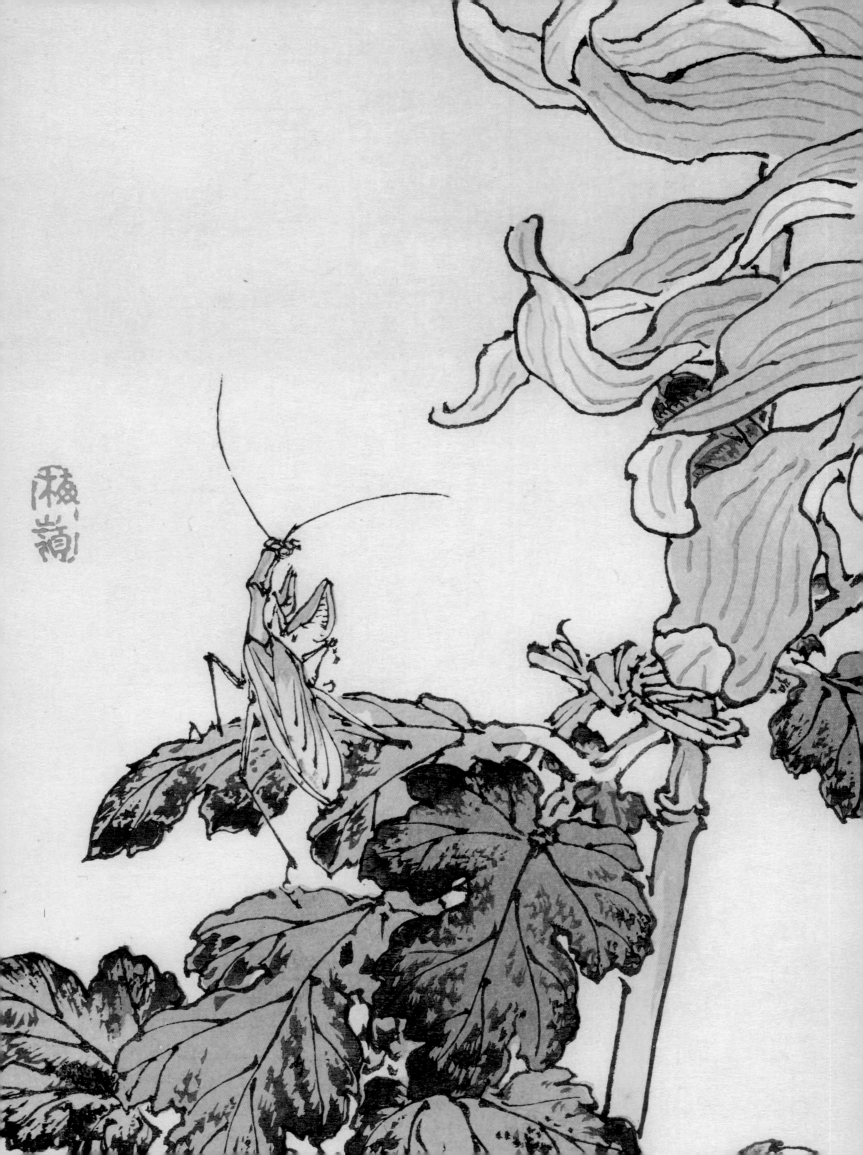

Printed for T.B for Humphrey
Motley at the Primrose from in Paul
[s Church yard, 25, 1842]

Part III

Scientific Imperialism and Exotic Botany:

From the 1750s to the 1900s

車遊し
くら海か

轆轤
蜋
かま
くり

The Reach of Empire

opposite: **The breadfruit (*Artocarpus altilis*) became a staple food in central and eastern Oceania following its domestication from the tropical region centred on Papua New Guinea. To the British, the tree appeared a bountiful source of food, and its transfer from Tahiti to the West Indies in the 1790s is amongst the best-documented examples of plant introduction.**

THE LATE EIGHTEENTH CENTURY WAS COINCIDENT WITH THE AGE OF Enlightenment. Rational thought was changing the way people perceived themselves and the world they inhabited. A move from private gain to public good now underpinned enquiry on many fronts. Collectors especially could no longer rest content with cabinets of curiosity: science demanded human advancement and enrichment of nations from natural history. This came through exploration, collection, and classification, as comprehensive as the means available. Many key figures of the Enlightenment were amateurs of independent means, typified by Joseph Banks, a wealthy British landowner and gentleman-scientist. Enlightened political leaders also embraced the new mood of science, with Thomas Jefferson its leading advocate in America.

The Linnaean classification system, and especially the rationalised basis of nomenclature promoted by Linnaeus, placed botany on a more universally scientific basis. The Linnaean revolution (1735–53) brought new scientific discipline to plant taxonomy and stimulated publication or revision of books to bring them into line with the new but widely accepted nomenclature. Linnaeus also encouraged and assisted his students to travel. 'Apostles'—students who had studied under an illustrious mentor—such as Peter Kalm in North America, Daniel Solander in the South Pacific, and Carl Thunberg in southern Africa and Japan all brought Linnean methods to bear on diverse floras.

Imposing order on the world of nature also became a national preoccupation—especially in Georgian Britain and Napoleonic France—increasingly linked to imperial economic ambitions; in the realm of plant collecting, the move from individual travellers to those sponsored by court, state, or national institutions gathered speed. In London, Joseph Banks sat at the hub of an international network of plant collectors, promoting, directing, and cajoling anyone who might assist the royal garden and its collections. London's Kew Gardens was revolutionised by Banks following his return in 1772 from Cook's first voyage to the South Pacific, transforming this royal pleasure garden into a scientific centre. East India Company captains were pressed to give passage to plant collectors and to transport their collections; individual collectors (such as Francis Masson at the Cape of Good Hope) were sponsored to collect for Kew; and the work of empire in its manifold aspects gained a new champion. It was Banks, for instance, who designed the facilities for transferring the breadfruit (*Artocarpus altilis*) from Tahiti to Jamaica in the 1790s. Captain William Bligh, in charge of the breadfruit transfer, articulated the new mood of economic botany: 'The object of all the former voyages to the South Seas, undertaken by the command of his present majesty, has been the advancement of science, and the increase of knowledge. This voyage may be reckoned the first, the intention of which has been to derive benefit from those distant discoveries.'

2869.

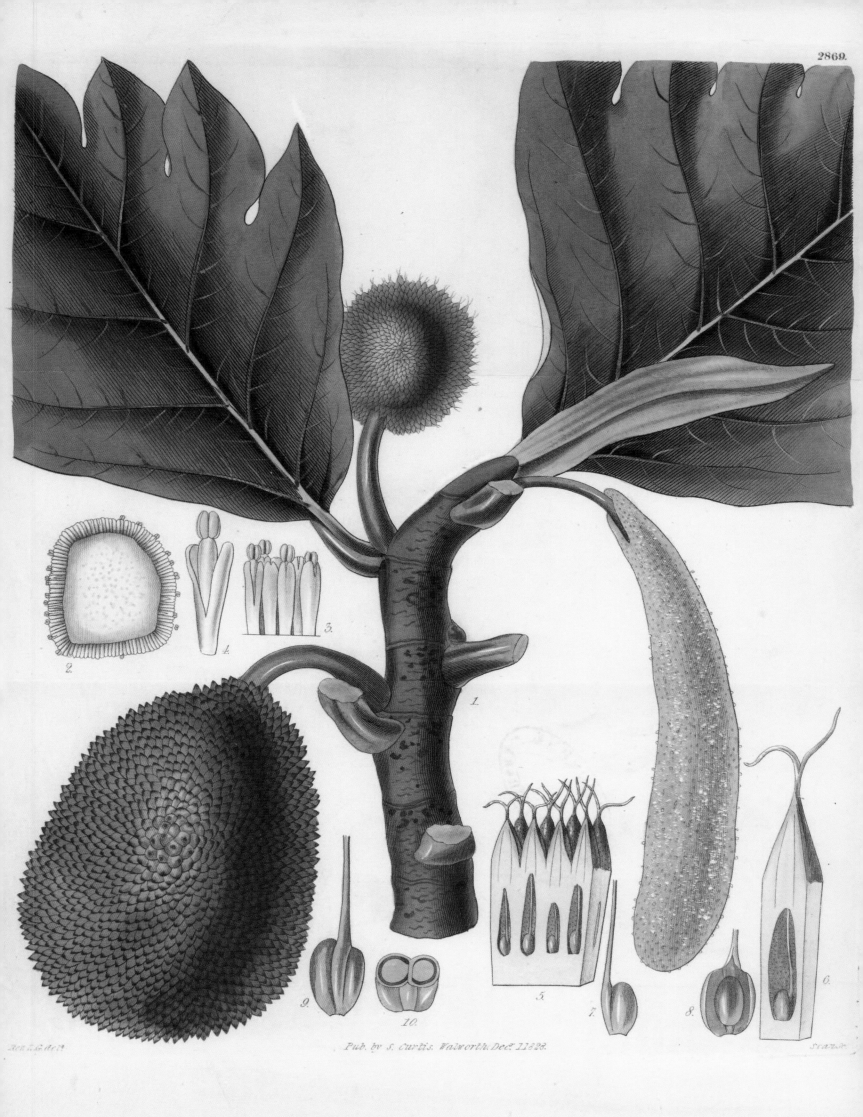

Pub. by S. Curtis. Walworth. Dec.r 1.1823.

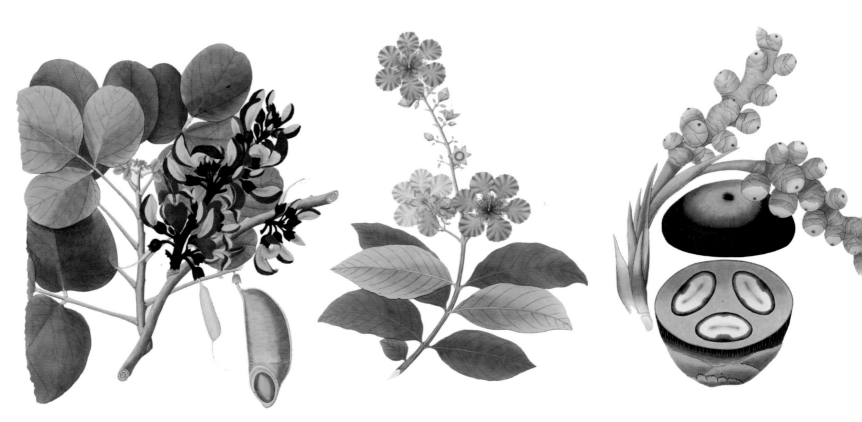

above and opposite above: Official interest in botany was well demonstrated by the ambitious publication of *Plants of the Coast of Coromandel* (London, 1795–1819). This Indian flora by William Roxburgh was sponsored by the British East India Company and published with the imprimatur of Joseph Banks, scientific adviser to George III.

right: The voyage of the *Bounty* in 1787–89, undertaken under the direction of William Bligh, was notable for the manner in which the vessel was outfitted to facilitate transport of breadfruit plants. Constructed to the specification of Joseph Banks, the great cabin between decks was transformed into a 'garden' of potted plants. The voyage ended in a mutinous fiasco, however, with the plants cast overboard, and the transfer was ultimately undertaken aboard the *Providence* during 1791–93 when Bligh was also able to return with West Indian plants for Kew Gardens.

Scientific imperialism and exotic botany came together in the creation of colonial botanic gardens. The Cape Town garden of the Dutch East India Company has previously been mentioned, and in the 1780s the British East India Company established a comparable institution at Calcutta. In fact, the British and Dutch colonial trading networks encouraged the creation of important botanic gardens as widely spaced as the Caribbean island of St Vincent (1765), Sydney (1816), and Colombo (1821) under British rule, and Bogor (1817), on Java in the Dutch East Indies. Such gardens formed useful depots for plant collecting as well as a focus for local and regional botany.

The conditions encountered by plant collectors in the late eighteenth and early nineteenth centuries were testing, and often beyond the imagination of those at home. In India, Joseph Hooker wrote of mosquitoes maintaining

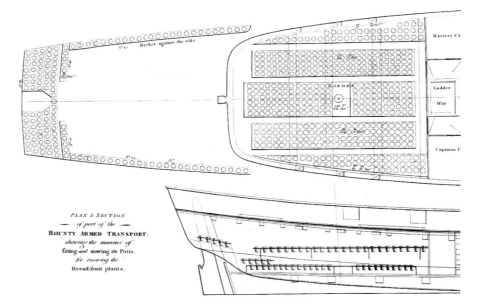

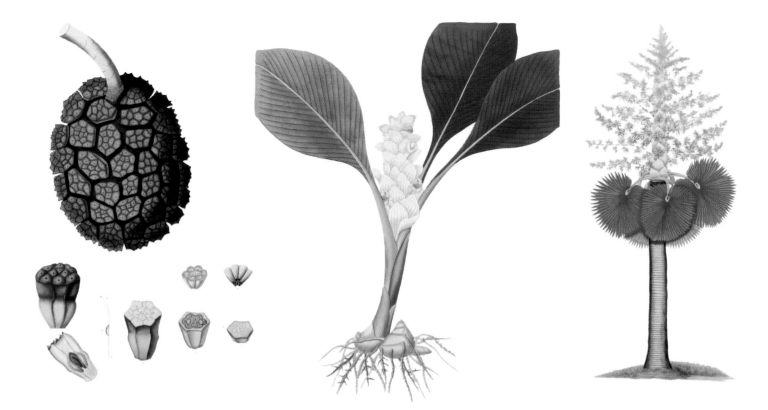

'a constant guerilla warfare'. Climatic extremes, personal privations, and encounters with Indigenous peoples hostile to intruders all ensured plant collecting was an unforgiving business. Once plants were safely acclimatised at botanic gardens, or secure on the wharf, the task of securely transporting them to home ports was paramount. This was a major undertaking, although by the early nineteenth century, special plant cases had been successfully trialled on long sea voyages. William Roxburgh and Nathaniel Wallich—both highly experienced in Anglo-Indian horticulture—wrote on the subject of transporting living plants, and each broadly followed earlier advice: adequate light and ventilation, protection from salt spray, watering in moderation, and frequent examination for signs of insect pests. Stout boxes of timber or metal guarded against rough handling, but nothing could replace the superintendence of an attentive captain.

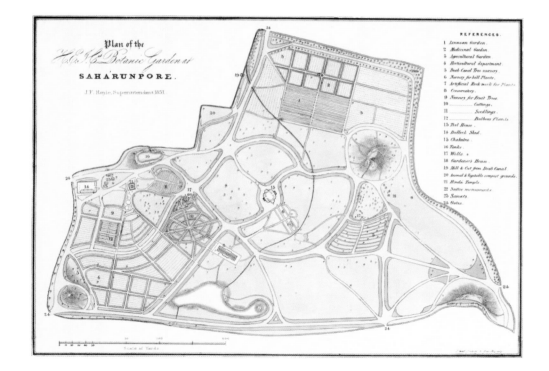

Colonial botanic gardens, like this facility at Saharunpore (Saharanpur) in northern India, served many roles. Part nursery, part experimental station, and part recreational pleasure ground, such botanic gardens were generally established in the eighteenth century by trading companies, coming more directly under government management only in the nineteenth century.

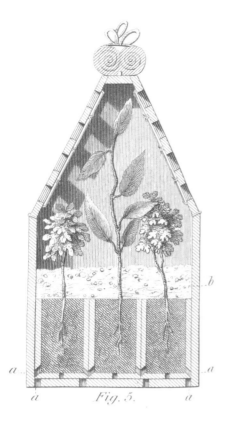

Fig. 5.

Fig. 1.

Losses in transit of plants, especially from tropical ports, gave rise to debate over the best methods of transport. Until the invention of the Wardian case in the 1830s, timber boxes with glazed, shuttered, and hinged tops ('sloped off like a penthouse' according to John Lindley, inventor of this design) were the norm in the early nineteenth century.

opposite: French interest in Australia was manifest in successive voyages of exploration, strategic and scientific in conception. New plants flooded into French gardens, especially that of Empress Joséphine, whose estates at Malmaison and Navarre formed a horticultural focus in Napoleonic France. Joséphine's gardener Aimé Bonpland, noted for his South American explorations with Humboldt, showcased these riches in his lavish book, *Description des plantes rares cultivées à Malmaison et à Navarre* (Paris, 1813). This highlighted newly introduced species—such as the showy Australian shrub, *Callistemon glauca*—which were depicted in magnificent colour-printed stipple engravings after paintings by Redouté.

Highlighting this, the Horticultural Society of London presented medals to nine ship's captains in 1820 for their exemplary care in transporting plants from China. The major breakthrough in plant transport came in the 1830s, however, with the successful trialling of the tightly glazed Wardian case.

The French were another nation that successfully yoked science and imperial ambitions. The Jardin du Roi in Paris had become a centre of scientific thought in Enlightenment France: its director from 1739 was George-Louis Leclerc, Comte de Buffon, author of the celebrated encyclopaedic *Histoire naturelle* (Paris, 1749–89). Buffon looked beyond the artificial classifications of Linnaeus, and through his interest in evolutionary theory—of which he was a founder— gave natural history an intellectual framework only eclipsed by the revolution that Darwin unleashed in the mid-nineteenth century. Buffon also greatly enlarged the Jardin du Roi, which like most European botanic gardens was reaping the benefits of botanical exploration. Under royal patronage, expeditions to the South Pacific from the 1760s exemplified the French interest in natural history. Like Cook, Louis-Antoine de Bougainville's voyage to the South Pacific had the new interests in geographic and scientific exploration at its heart, as did the voyage of Jean-François de La Pérouse (1785–88), which effectively combined traditional military strategic interests with the newer imperatives of science and natural history.

As La Pérouse was preparing for his voyage, two influential figures in French history were commencing their careers. The fifteen-year-old Napoléon Bonaparte had unsuccessfully applied for a berth aboard the voyage at the commencement of his military career, just a few short years before the French Revolution. Elsewhere in Paris, Pierre-Joseph Redouté was perfecting his botanical artistry, having just met the amateur botanist Charles-Louis L'Héritier de Brutelle, who commissioned the young artist to illustrate his books. The pairing was a productive one, and led to Redouté meeting Gerard van Spaëndonck, a Dutch flower painter who filled the post of professor of flower painting at the Jardin

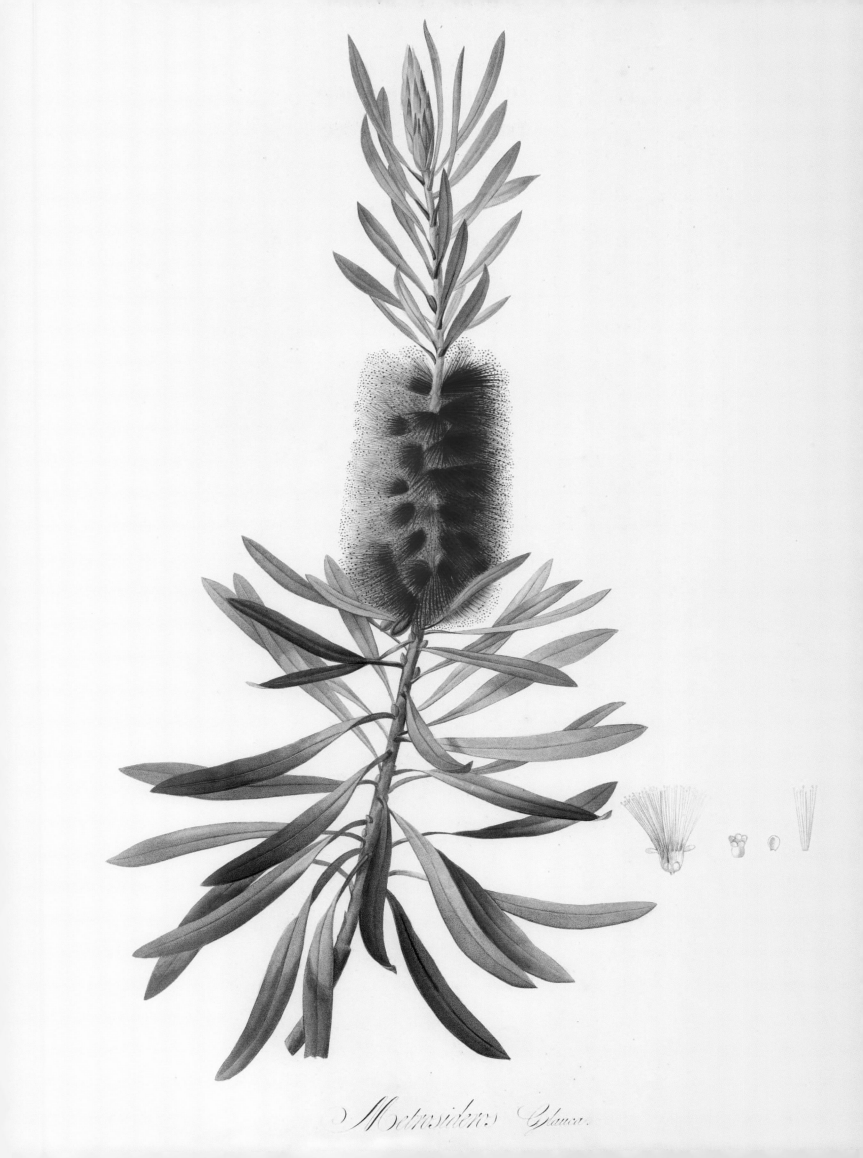

Metrosideros Glauca.

Redouté named the spectacular southern African lily, *Amaryllis josephinae* (now *Brunsvigia josephinae*), for the Empress Joséphine and illustrated it in his lavish *Les liliacées* (Paris, 1807–16), both fittingly splendid commemorations of dazzling patronage.

Amaryllis Josephinæ.

P. J. Redouté pinx.

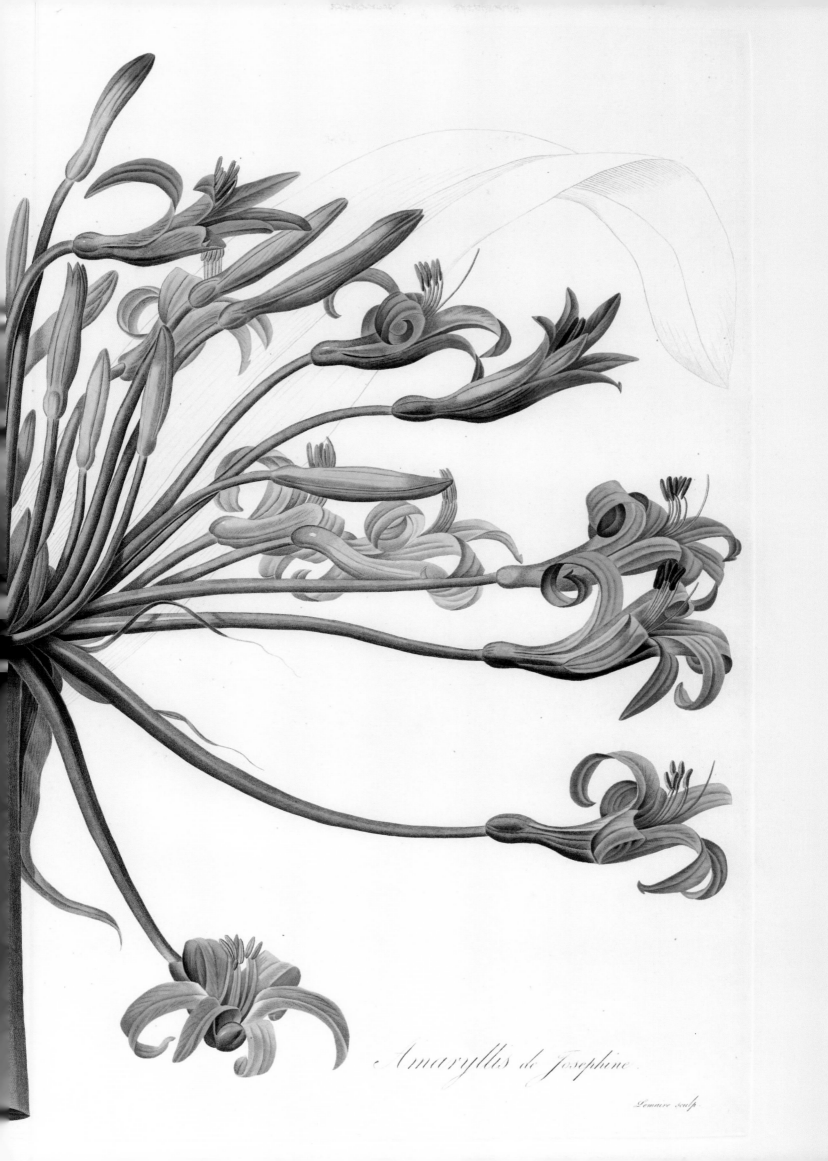

Amaryllis de Josephine.

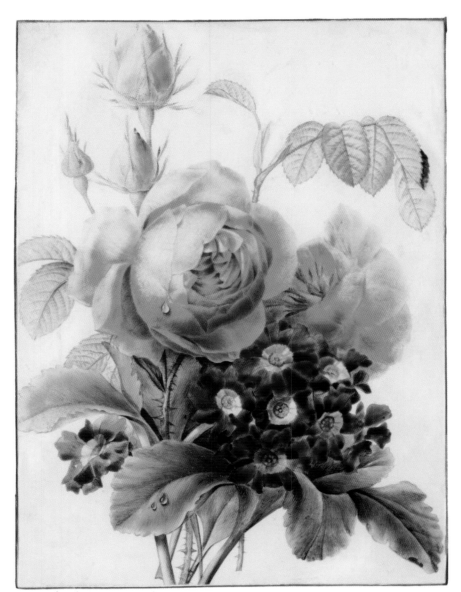

P. J. Redouté a son ami Balzac.

'The flower painter fails if a works lacks beauty, the botanical artist fails if it lacks accuracy', observed Wilfrid Blunt and William Stearn (*The Art of Botanical Illustration*). Pierre-Joseph Redouté was no less celebrated as a flower-painter than as a botanical artist, and his late works provide a fusion of both disciplines. Here the aging artist allows sentiment to intrude in the form of a tear-like droplet in this bouquet drawn *à son ami Balzac* ('to his friend Balzac').

opposite: In the 1820s William Roscoe was amongst the first to produce a botanical book using the newly invented printing technique of lithography. Relying on waxy impressions drawn onto a polished stone or metal plate, lithography heralded a relatively inexpensive printing process. When coupled with mechanised presses later in the century, the new technique revolutionised the art of book printing. Roscoe's *Monandrian Plants of the Order Scitamineae* (Liverpool, 1824–28) featured plants grown at Liverpool Botanic Garden, including *Hedychium gardnerianum*, which had recently been introduced from India.

du Roi. It was van Spaëndonck who taught Redouté the rudiments of stipple engraving, who in turn combined this with colour printing to produce books of abiding beauty under the patronage of Napoléon and especially his wife Joséphine. The garden of Malmaison provided the Empress Joséphine with an estate of renowned splendour, and a nursery for the new plant introductions flooding into Europe from Australia, the Cape, and the Americas.

Despite the on-going war between France and Britain, a spirit of scientific cooperation suffused botanical exploration. The newly constituted Jardin des Plantes in Paris (the Jardin du Roi of the *ancien régime*), for example, benefited by the intervention of Joseph Banks to ensure the repatriation of naturalist Jacques-Julien Labillardière's specimens, seized by the Dutch in the East Indies. The French, on the other hand, did much to publicise the flora of Britain's newest colony, New South Wales. With the death of Banks in 1820, however, botany lost an international champion, and the garden at Kew, over which he had presided for almost half a century, went into decline.

If the royal garden at Kew was faltering, the early nineteenth century was a golden age in Britain for privately funded botanic gardens. Such gardens,

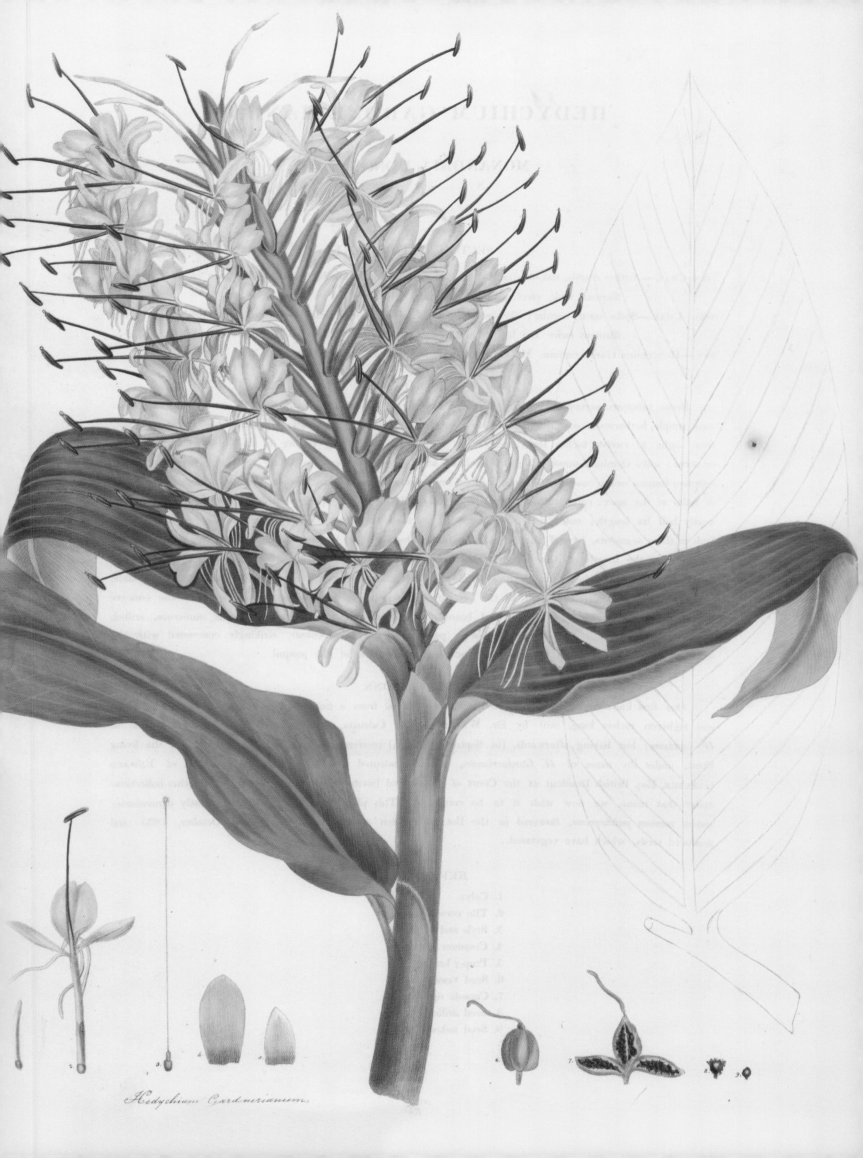

Hedychium Gardnerianum.

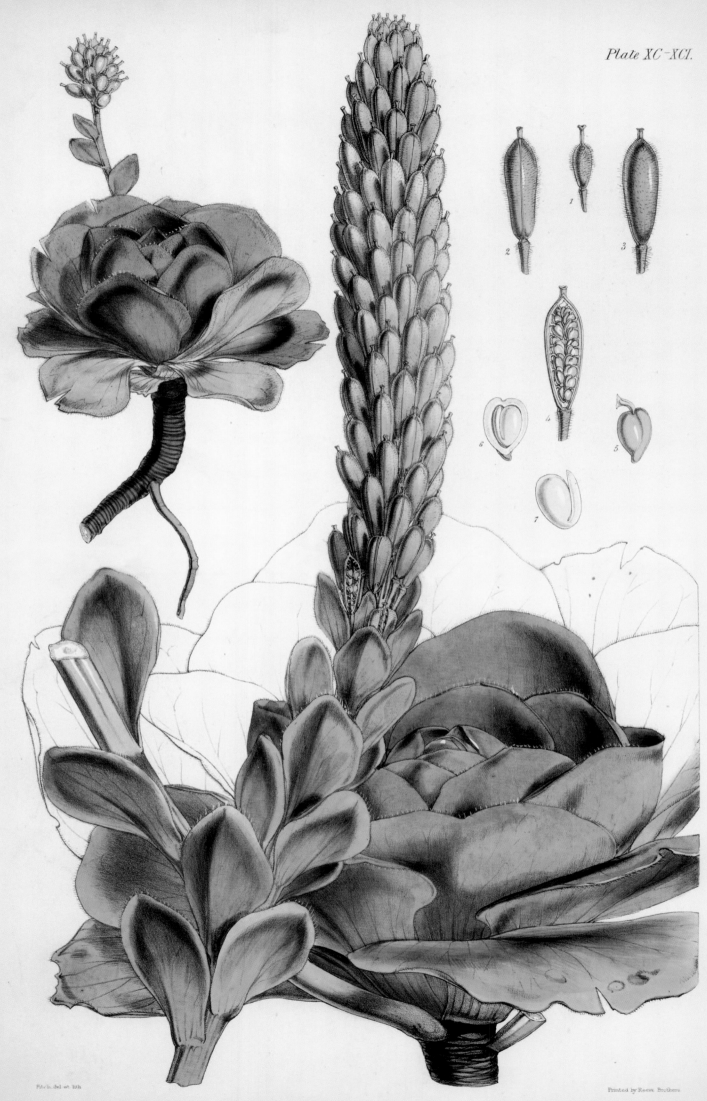

Plate XC-XCI.

Fitch. del. et lith.

Printed by Reeve Brothers

Pringlea antiscorbutica, *Hook. fil.*

established by subscription at Liverpool, Birmingham, and Sheffield, and in London at Chiswick and Regents Park, provided a new focus for horticulture, and complemented the commercial display gardens of the major nursery proprietors. At Liverpool, for instance, a specialty was made of the Scitamineae order. These bulbous tropical plants including species of *Curcuma*, *Hedychium*, and *Zingiber*, formed showy additions to the hothouse, and were publicised by the garden's founder, William Roscoe, in a lavish folio volume, *Monandrian Plants of the Order Scitamineae* (Liverpool, 1824–28). Just as the seventeenth century had seen a move from woodblock printing to metal engraving and etching (often hand-coloured), so the nineteenth century saw a move towards lithography, which Roscoe was amongst the first to exploit for a botanical book.

Kew Gardens regained its central role from the early 1840s when it was reconstituted as the Royal Botanic Gardens, Kew. Now answerable to the elected government instead of the hereditary monarch, successive directors, father and son, William and Joseph Hooker, made Kew a focus for imperial objectives in the Victorian age through their powerful support of economic botany. Rubber, tea, cinchona, fibres, and crops—all came within Kew's global reach, aided by a network of colonial botanic gardens. Kew was not alone in this support of economic botany, merely the best-documented example. From St Petersburg to Rio de Janeiro, directors of botanic gardens were increasingly called upon to support state agricultural and horticultural programmes.

Capturing a country's flora between the pages of a book was a powerful expression of control, and Kew was at the forefront in publishing colonial floras. Amongst the earliest of the new-look floras were those by Joseph Hooker, published following his circumpolar voyage (1839–43). Kew botanist George Bentham recognised that each botanist would impart different diagnostic skills: 'The aptness of a botanical description, like the beauty of a work of imagination, will always vary with the style and genius of the author'. Joseph Hooker's genius, like that of his colleague Charles Darwin, was to use the discipline of natural history as a springboard for wider philosophical and scientific thought.

Just as the publication of Linnaeus's *Systema naturae* had commenced a new era in the natural sciences, so too did Darwin's book *The Origin of Species* (London, 1859), but with wider and more dramatic results. As Hooker was collecting his first specimens in the Antipodes, Darwin was contemplating the results of his *Beagle* voyage to the Galapagos Islands. Both were coming to the same conclusion: that species had evolved over long time periods, far longer than commonly thought. At a time when most Christians believed that the world had had its genesis in less than a week—in 4004 BCE, according to contemporary theological scholarship—the idea of evolution was radical and heretical. Biblical catastrophists were aghast, and the campaign of denial they launched still reverberates.

opposite: Scurvy, a chronic vitamin deficiency, bedevilled long-distance mariners. On his Antarctic voyage, JD Hooker discovered *Pringlea antiscorbutica* on the sub-Antarctic Kerguelen Island, his naming honouring both physician John Pringle and the antiscorbutic properties of the Kerguelen cabbage.

Sydney Parkinson's published journal (London, 1773) is a poignant reminder of the hazards of botanical exploration. Travelling with Banks and Solander on Cook's first voyage to the Pacific (1768–71), Parkinson worked feverishly to sketch and annotate the natural history specimens collected and observed. With an overwhelming workload and little chance of completing any paintings of the Australian flora, Parkinson died at sea off Batavia in 1771, the crew by then racked with dysentery and malaria.

right: A bay to commemorate botany, and a promontory for each of the botanists aboard Cook's first voyage to the Pacific. Such was the reach of imperial science in the late eighteenth century.

opposite: The kowhai tree (*Sophora tetraptera*) was introduced to Britain in the early 1770s, one of the earliest New Zealand introductions resulting from Cook's voyage. Praised by contemporaries for the 'peculiar richness' of its golden yellow flowers, kowhai is now the national flower of New Zealand.

THE GREAT SOUTH LAND—TERRA AUSTRALIS INCOGNITA—LAY TANTALIS-ingly close to Dutch settlements in the East Indies. While Spanish and Portuguese voyages had quashed the notion of a fiery equatorial belt—supposed since classical times to separate the Antipodes from Europe—it was probably ill fortune rather than determined seamanship that caused Dutch ships to touch on antipodean shores. The Dutch mapped significant stretches of New Holland's coastline during the early seventeenth century, although their estimation of the land and its productions was low. The English adventurer William Dampier landed on the north-west coast in 1699, and provided more favourable—though still far from glowing—reports of the grasses, heaths, and low-growing trees. Dampier made the first recorded collections of Australian plants by a European: his specimens, now housed at the University of Oxford, included a species of *Dampiera* (named for him) and the Sturt desert pea (*Swainsona formosa*).

Turn now to the eastern coast of the continent almost a century later. As the French circumnavigator Louis-Antoine de Bougainville headed west across the Pacific towards the north-east coast of Australia in 1768, the presence of a great but treacherous coral reef formed a barrier to the coast, and his party changed course for north towards the better-charted waters of New Guinea. Two years later, the first voyage of Captain James Cook to the Pacific (to observe the transit of Venus from Tahiti) touched on the east coast of New Holland, which he claimed for the British crown and named New South Wales. Bougainville missed

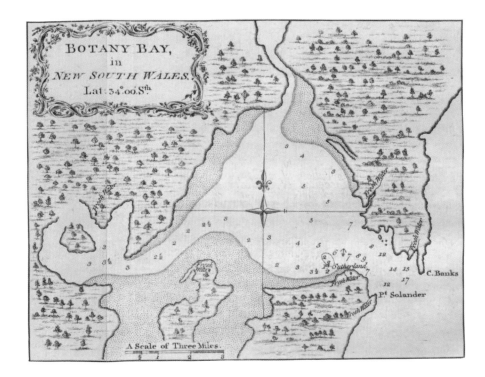

S. Featon

BOCK & COUSINS, CHROMO-LITHO.

YELLOW KOWHAI——Sophora tetraptera.

M. Hart. del. Pub. by J. Ridgway 169 Piccadilly Ap.l. 1. 1830. S. Watts sc.

an opportunity of staking a French claim on New Holland, however French interest in the South Pacific continued apace. With Britain and France in conflict during the eighteenth century, the rival powers had prestige at stake in this unlikely theatre.

Cook's voyage (1768–71) with botanists Joseph Banks and Daniel Solander yielded a rich herbarium of dried and pressed plant specimens but few viable seeds. And although artist Sydney Parkinson's sketches resulted in the preparation of copper plates for a magnificent publication of the Australian flora the work was never completed—the plates were published in black impressions in 1900–05 and finally in colour during 1981–88 as *Banks' Florilegium*.

Further voyages by Cook with botanist Johann Forster (1772–75) and gardener David Nelson (1776–79) led to the collection and naming of additional Australian plants, including the genus *Eucalyptus*. Cook's voyages also did much to advance European knowledge of the distinctive New Zealand flora. New Zealand flax (*Phormium tenax*) attracted attention for its boldly sculptural foliage and flowers as well as the economic potential of the strong fibres it yielded. The red-flowered pohutukawa (*Metrosideros excelsa*) became well known as the New Zealand Christmas tree, enlivening the antipodean summer Christmas season.

opposite: The dominance in Australian botany and horticulture of Joseph Banks—explorer, botanist, and patron—is fittingly recognised in the genus *Banksia*. Coined in 1782 by Carl Linnaeus, son of the great botanist, the distinctive cylindrical inflorescences of banksias have given these plants an enduring horticultural value.

The showy red waratah (*Telopea speciosissima*) was featured in many early botanical books and periodicals, including the earliest separate flora of Australia—*A Specimen of the Botany of New Holland* (London, 1793–95). In this, the noted botanist-author James Edward Smith relied on paintings by convict artist Thomas Watling as well as dried herbarium specimens. The much less common illustration reproduced here is from the *Naturalist's Pocket Magazine* (London, 1798), anonymously compiled but perhaps also derived from Watling's original paintings.

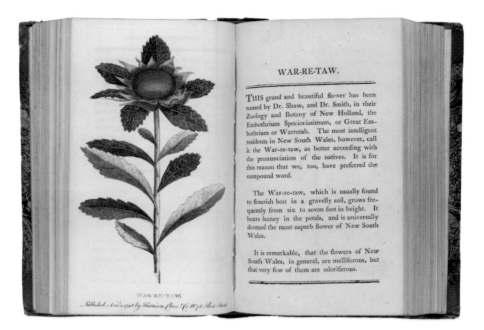

opposite: The Norfolk Island hibiscus (*Lagunaria patersonia*) was introduced to Britain in 1792 from seeds despatched by Colonel William Paterson. A showy tree in warm climates, in Europe it was a tender subject for the greenhouse. Paterson, who came to Australia as a captain in the New South Wales Corps, was keenly interested in natural history and took every opportunity to botanise in his new environment, as he had at the Cape some years earlier.

Australasian plants had become available through the British nursery trade from the early 1770s, but it was the arrival of the First Fleet and British colonisation of Australia from 1788 that provided the critical impetus for a two-way flow of plants. The late eighteenth century also witnessed a fascination for southern Africa's ericaceous and proteaceous flora, and its requirements in the Northern Hemisphere for the dry heat of the stovehouse also suited the flora of New Holland. As more and more 'New Holland exotics' were introduced to Europe, so too did their illustrations increasingly appear in published works. William Curtis and Henry Andrews both figured many Australian plants in their respective periodicals, the *Botanical Magazine* and *Botanist's Repository*, and during 1793–95 English botanist James Edward Smith published *A Specimen of the Botany of New Holland*, the first monograph on the Australian flora. These and other early hand-coloured publications vividly highlighted species of *Banksia*, *Eucalyptus*, *Grevillea*, and a host of lesser-known genera, all glowing with horticultural potential.

Although shaded by British colonisation, the French persevered with their exploration of the South Pacific. Notable botanists included Jacques-Julien Labillardière, who sailed with Joseph-Antoine d'Entrecasteaux (1791–93), and Jean-Baptiste Leschenault de la Tour, who sailed with Nicolas Baudin (1800–03). A small walled garden, established by the French in 1792 at Recherche Bay in Van Diemen's Land, remains an early and tangible legacy of the d'Entrecasteaux expedition. Returning with seeds and plants, the French soon outshone the British in their publications depicting the Australian flora.

The earliest—*Sertum Anglicum* (Paris, 1788–92)—was intended as an expression of gratitude for the hospitality extended by Banks and others to its author, Charles-Louis L'Héritier de Brutelle, on his visit to Kew. The books of Labillardière, including his *Novae Hollandiae plantarum specimen* (Paris, 1804–06), were based directly on his botanical voyages. Yet others depicted Australian plants growing in important French gardens, such as those of the Empress Joséphine at Malmaison and Navarre, the Paris garden of botanist JM Cels, and in the state-run botanic garden, the Jardin des Plantes. These books fortuitously coincided with the career of Pierre-Joseph Redouté and the great age of French stipple engraving, producing coloured impressions of great subtlety and beauty.

Pl. 226

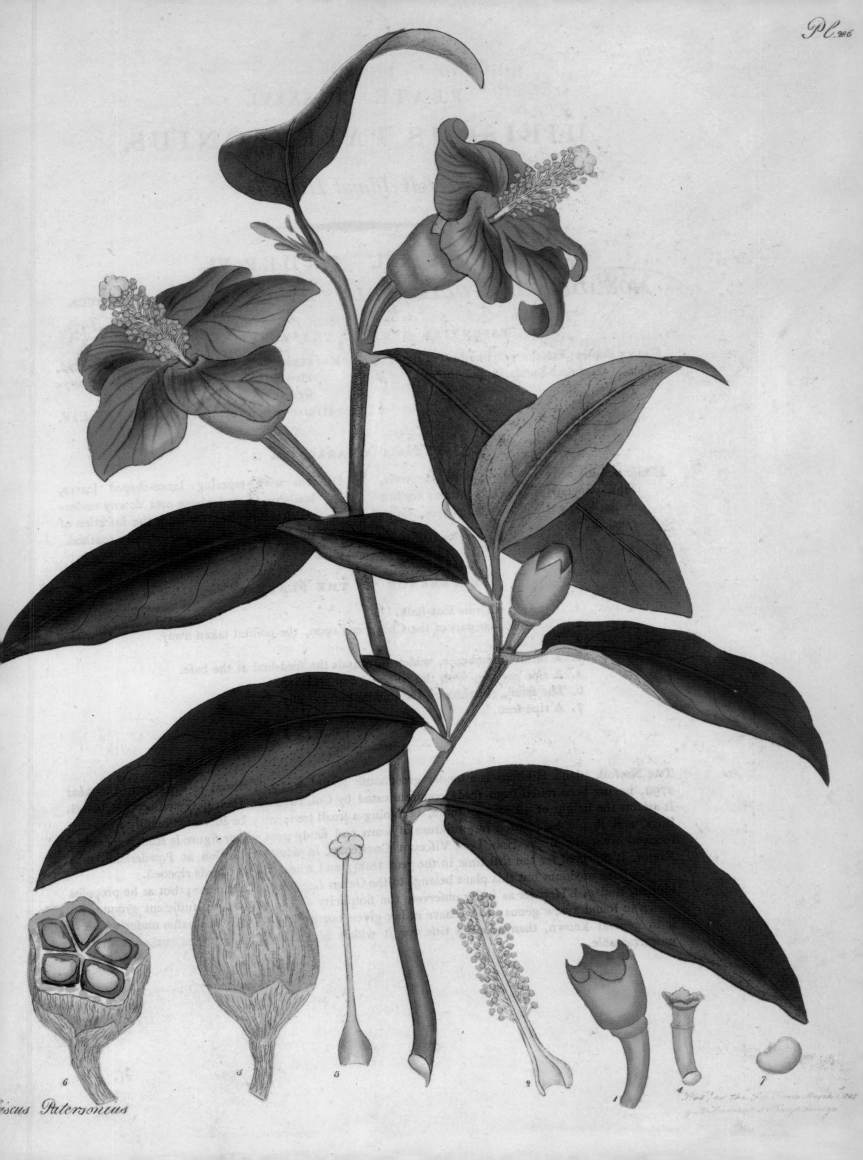

Hibiscus Patersonius

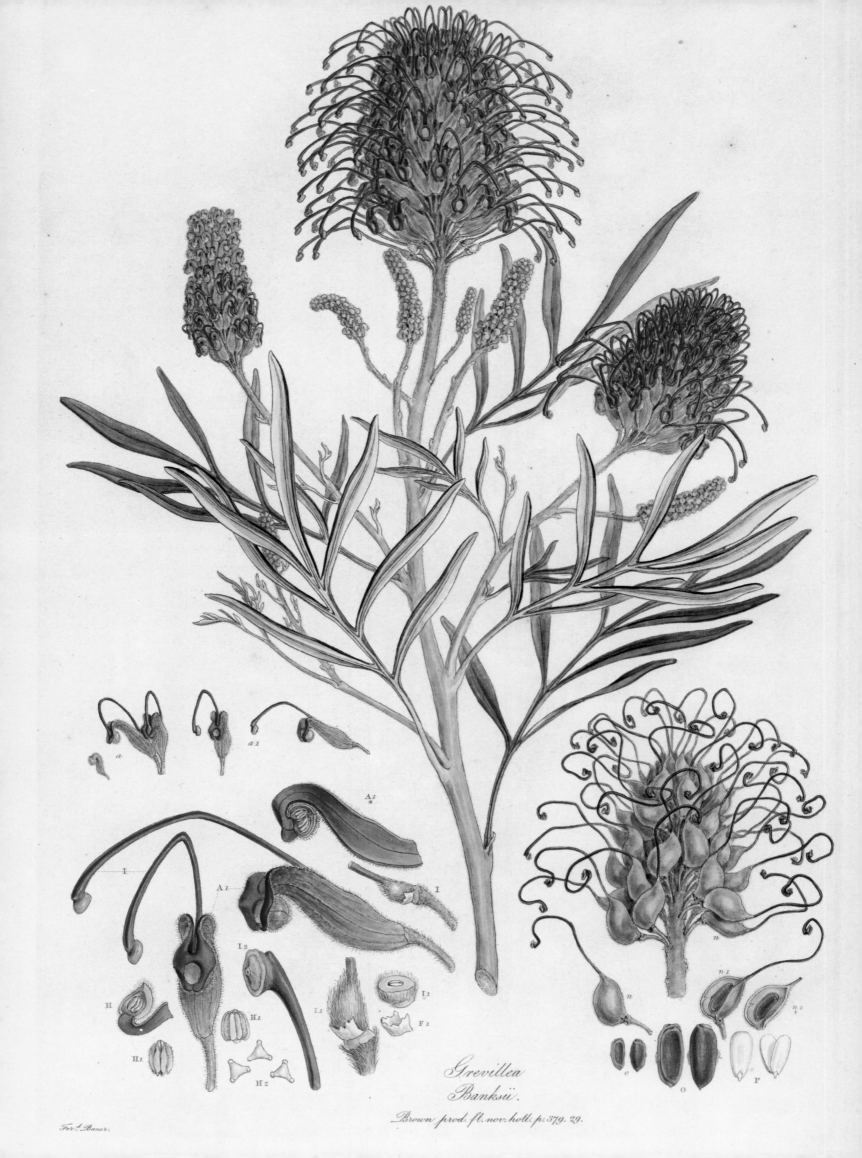

Grevillea
Banksii.

Brown prod. fl. nov. holl. p. 379. 29.

Fer.^d Bauer.

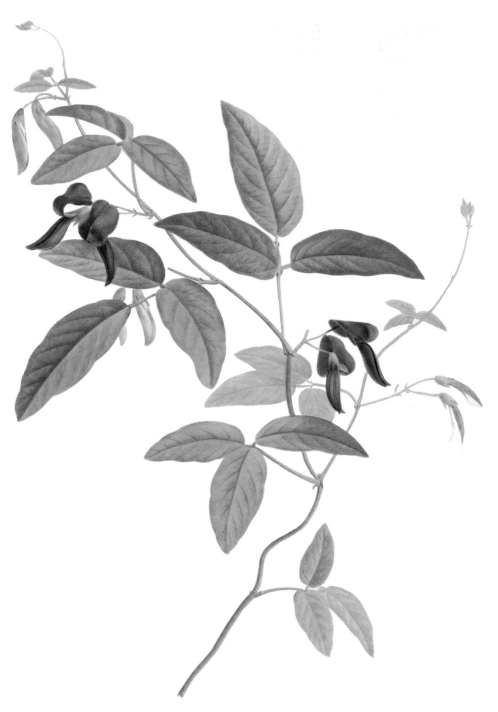

Continuing British exploration—including coastal mapping by Matthew Flinders that led to adoption of the name 'Australia'—yielded further plants of ornamental potential. Collaboration between botanist Robert Brown and artist Ferdinand Bauer, who travelled with Flinders (1801–03), resulted in Brown's unillustrated *Prodromus* (1810) and Bauer's *Illustrationes florae Novae Hollandiae* (1813), resplendent with magnificent hand-coloured plates.

Despite the botanical riches depicted in these French and British florilegia, botanists were gloomy in their assessment of the economic potential of the Australian flora. A perceived lack of edible plants was commonly cited, yet this belied the rich array of 'bush tucker' plants that had sustained Australia's Aboriginals for thousands of years. So it was that Australia's earliest colonial gardens focussed on sustenance, importing European agricultural and horticultural traditions along with familiar fruits and vegetables. Indeed, Australia's earliest botanic garden, at Sydney, had its origin as a productive garden supplying the governor's table.

Although Britain gained the crucial ascendancy in colonisation of Australia, it was the French who first classified for the scientific world many icons of her flora and fauna, including the eucalypt tree, wombat, platypus, and emu. The publishing programme of Napoleonic France resulted in sumptuous natural history publications, several of which included the earliest coloured illustrations of distinctive Australian plants. The dusky coral pea (*Kennedia rubicunda*), a vigorous climber from eastern Australia, was illustrated by Redouté in 1803 from plants growing in the Empress Joséphine's garden at Malmaison.

opposite: The exploration of Matthew Flinders during 1801–03 brought new detail to many parts of the Australian coast, just as the work of his botanist, Robert Brown, brought a great advance in knowledge of the Australian flora. Yet it was the published work of the voyage's artist Ferdinand Bauer, *Illustrationes florae Novae Hollandiae* (London, 1813), that highlighted the horticultural potential of this flora. Many of the plants depicted honoured the greats of contemporary British horticulture—*Grevillea banksii*, for instance, commemorated Joseph Banks and Charles Greville, one of the founders (in 1804) of the Horticultural Society of London.

Despite a shift towards South American and other tropical plants, Australian plants continued to be grown in Europe during the mid-nineteenth century, especially in botanic gardens. *Eucalyptus macrocarpa* was raised at Kew in 1842 from seeds sent by James Drummond—a long-standing correspondent of William Hooker—from the fledgling Swan River Colony, on Australia's western coast.

below: Robert Sweet's *Flora Australasica* (London, 1827–28), one of the best known British works on Australian plants, was published towards the end of the European fashion for growing this complex exotic flora. It was an expensive business, requiring a suitable hothouse and finely honed horticultural skills. The proteaceous flora—such as *Dryandra longifolia* (introduced in 1805)—required dry heat and was quite unsuited to the moist atmosphere generated by steam and hot water heating of the plant houses then revolutionising exotic horticulture.

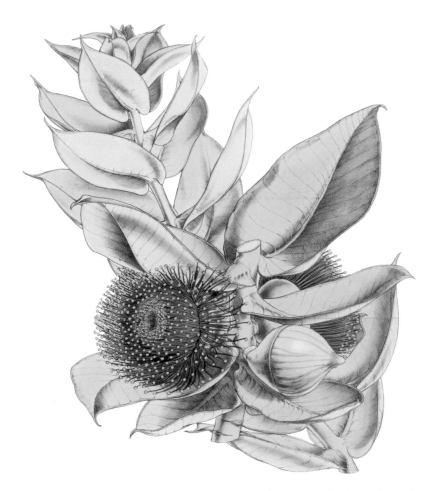

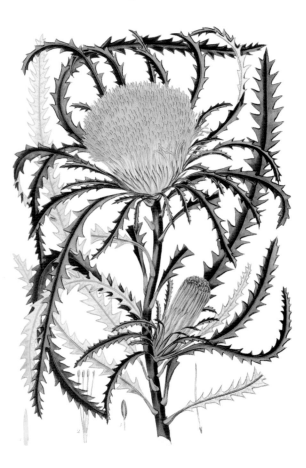

By the 1820s, the Sydney Botanic Garden was the centre of a flourishing plant exchange network with botanic gardens around the world. Thouin in Paris, Hooker at Glasgow, and Wallich at Calcutta all enriched the Sydney garden—and themselves were the recipients of Australian plants from directors Charles Fraser and brothers Richard and Allan Cunningham. The burgeoning plant-nursery trade, led by Lee and Kennedy of Hammersmith, Loddiges and Sons of Hackney, and other London-based firms, also traded with colonial botanic gardens, with plants from the Cape and Australia enjoying a period of immense popularity. Yet the fashion for Australian plants was relatively short-lived. Fickle horticultural tastes and the growing interest in tropical plants from the Americas, Africa, and Asia led to a decline—although not a complete halt—in their cultivation in European stovehouses. It was Henry Andrews who best captured the contemporary mood: 'To New Holland we export criminals for our convenience and safety, and from thence import furs for our covering and flowers for our amusement. So far the balance of trade is in our favour.'

The pages of the various botanical periodicals, and part-works such as Robert Sweet's *Flora Australasica* (London, 1827–28), continued to feature Australian flora, although in comparatively fewer numbers than during the late eighteenth and early nineteenth centuries. *Eucalyptus macrocarpa*, for example, was promoted in Britain in the 1840s for its bold bluish foliage as well as its striking flowers. The Sturt desert pea (*Swainsona formosa*)—seen and figured by Dampier—was collected by many mid-nineteenth-century botanical explorers, and achieved horticultural prominence when exhibited in 1858 by the Veitch nursery. This was coincidently the decade when colonial horticulture made its greatest strides, fuelled by the wealth from gold rushes. By the decade's end, each of Australia's colonial capitals possessed a botanic garden, and a vigorous local publishing industry was producing botanical and horticultural works suited to local needs and budgets.

Clianthus dampieri (now *Swainsona formosa*) was named to honour explorer William Dampier, who saw the plant in 1699 on the dry sandy islands of Dampier's Archipelago in north-western Australia. It was through seed collection during the great age of inland exploration in the first half of the nineteenth century, however, that the species was brought into horticulture. By 1858, when the Horticultural Society of London awarded a silver medal to Messrs Veitch and Sons for a flowering specimen, the celebrity of the plant was firmly established.

Fitch del. et lith.

Vincent Brooks Imp.

19: Erica-mania

THE CAPE OF GOOD HOPE AND ITS HINTERLAND WERE A BOTANIST'S dream. Botanists working principally from Leiden and Amsterdam had laid the foundations of botanical taxonomy for southern Africa in the seventeenth and early eighteenth centuries. The best-stocked stovehouses of Europe could already boast choice examples of the Cape's rich succulent flora, as well as showy members of the narcissus family, and a limited selection of other bulbs and perennials. As the eighteenth century drew to a close, however, the Cape increasingly became seen as a horticultural wonderland, and it was the Cape heaths (*Erica* spp.) that sparked the new frenzy of interest. Dubbed 'erica-mania', the craze for heaths reached its greatest heights in Britain, through a mix of institutional, commercial, and private initiatives.

European species of the genus *Erica* had been introduced into cultivation during the mid-eighteenth century but the seemingly endless varieties of Cape heaths established 'the celebrity of that superb collection at Kew, which for many years, with unrivalled lustre, far outshone all others'. Scottish-born Francis Masson was working at Kew Gardens when he was selected by its superintendent to visit the Cape for an extended period to collect plants and bulbs. Qualities that had long characterised Scottish gardeners—perseverance, reliability, and a keen eye—marked Masson as the ideal candidate for Kew's first official plant-collecting expedition. Based in Cape Town, Masson commenced his forays into the interior during 1772. He introduced many heaths and other examples of the southern African flora to Kew—the importance and novelty of his introductions was reflected in the erection of a dedicated 'Cape House' at Kew in 1792.

opposite: The king protea or honeypot sugarbush (***Protea cynaroides***) was amongst the wealth of proteaceous flora introduced to Kew Gardens in the 1770s by its resident collector in the Cape, Francis Masson. The large sculptural inflorescence of this species made a dramatic addition to European hothouses, and in warmer parts of the world, a striking addition to the open border.

Fashionably-train'd and velvet-bedeck'd, a lady and gentleman of the English upper middle classes inspect their ericaceous treasures, while their frock-coated gardener nips and preens in this frontispiece to *The Heathery* by Henry Andrews, a charming evocation of 'erica-mania'.

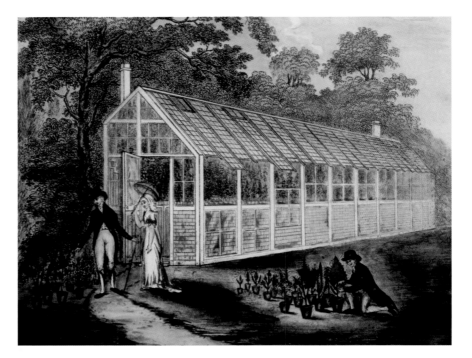

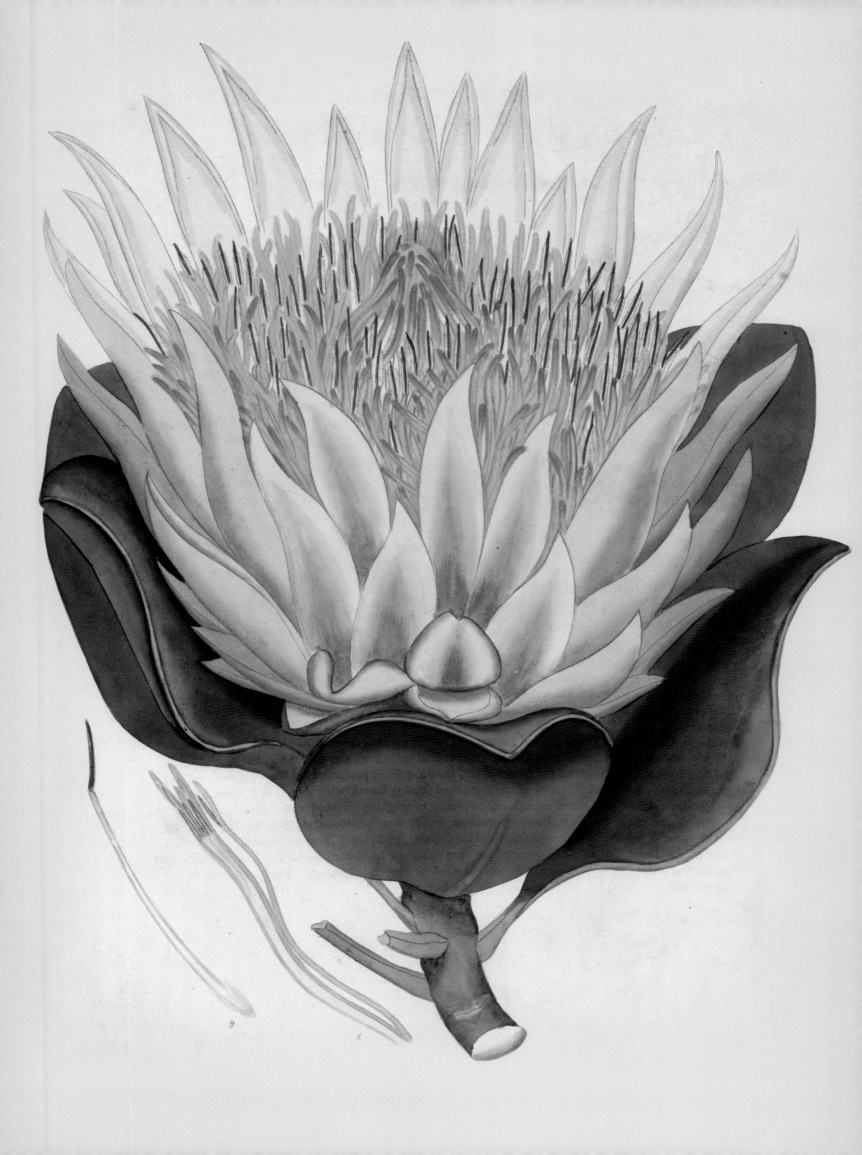

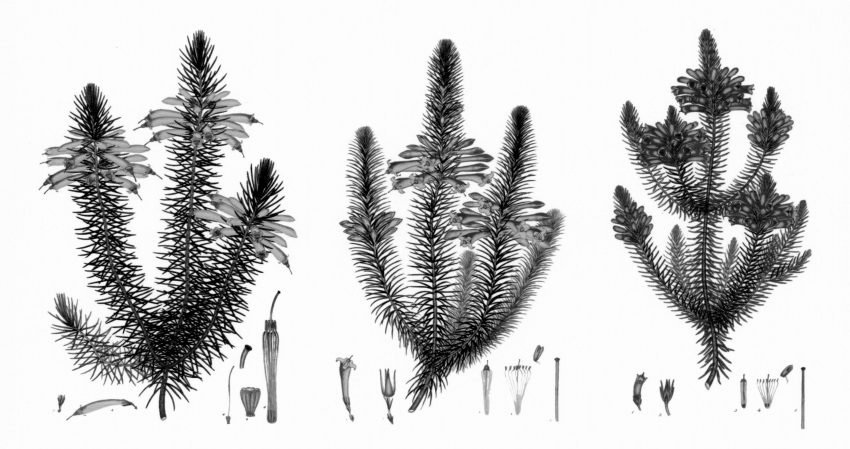

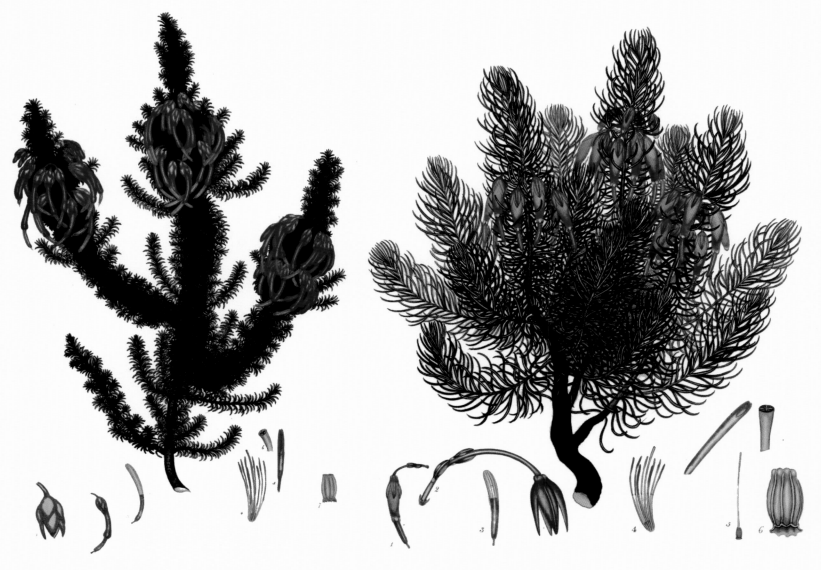

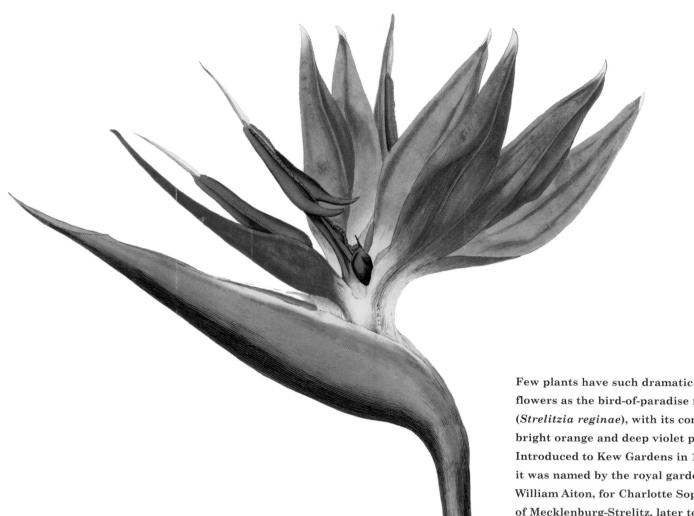

The high praise of Kew's collection was penned by Henry Andrews in his lavish folio publication *Coloured Engravings of Heaths*. Through his publications, especially the periodical *Botanist's Repository* (1797–1815), Andrews was a great promoter of Cape species. Private collectors, such as George Hibbert, who possessed an outstanding collection of botanical exotica at his Clapham residence in London's south, also coveted the Cape flora. A wealthy merchant with business interests in the West Indies and one of the 'great encouragers of exotic botany', Hibbert's garden provided many of the plants illustrated in Andrews' *Botanist's Repository* and also his monograph on geraniums (1805). Two of the plants grown by Hibbert, the bird-of-paradise flower (*Strelitzia reginae*) and king protea or honeypot sugarbush (*Protea cynaroides*), went on to became garden favourites, and emblematic of the rich southern African flora.

From the foregoing it might appear that the new interest in Cape plants was exclusively a British affair, but this was merely its most enthusiastic and best-publicised reception. In France, the new Cape plants were also eagerly sought by discerning collectors: London nursery proprietors Lee and Kennedy forged close links with the Empress Joséphine at Malmaison through the provision of plants and advice. In Vienna, Nikolas Jacquin, director of the Imperial Botanic Garden of Schönbrunn, built an enviable collection of exotic plants. When a severe frost destroyed many of its tropical and subtropical plants, two gardeners were sent to Mauritius and southern Africa to collect replacements. Dutch collecting was aided by the work of Swedish botanist Carl Thunberg, who spent three years at the Cape en route from Amsterdam to Japan for the Dutch East India Company. His compatriot and fellow pupil of Linnaeus, Anders Sparrman, also journeyed to the Cape in 1772.

Ixia Columnaris
Var: grandiflora

Collaboration between the Swiss
botanist Augustin-Pyramus de Candolle
and the botanical artist Pierre-Joseph
Redouté resulted in the spare beauty
of the folio *Plantarum historia
succulentarum* (Paris, 1798–1805),
widely regarded as one of Redouté's
masterpieces, and a book that sits at
the pinnacle of the succulent literature.
For this work, Redouté perfected the
technique of stipple engraving,
enhanced by printing in coloured inks
and hand-finished with watercolour.
The Cape flora was well represented,
including many popular garden
subjects such as *Aloe arborescens*
and *A. ferox*.

Thunberg traversed country that had not been explored by European botanists, and his seeds and bulbs enriched collections in Amsterdam and Leiden, as well as Sweden. Apart from collecting, the published accounts of such plant collectors included much information about the indigenous vegetation and its uses. Sparrman, for instance, carefully noted traditional economic uses of plants, such as *goree-bosch* or aloes, which yielded medicinal gum aloe, used as a salve for wounds. Occasionally, collectors shared the joys and hardships of travel. Thunberg, for instance, joined Masson on the latter's second expedition (1773–74). The pair could not have been more different, a point borne out by comparison of their respective published narratives. Masson's quiet industry was reflected in his terse prose. By contrast, the ebullient Thunberg boasted in his *Travels*: 'I met the dangers of life ... I prudently eluded ferocious tribes and beasts, and for the sake of discovering the beautiful plants of this southern Thule, I joyfully ran, sweated and chilled.'

Collectors found a horticulturally rich and visually exciting succulent flora at the Cape—the area was especially rich in aloes, crassulas, euphorbias, mesembryanthemums, and stapelias. In 1811, English naturalist Wiliam Burchell was astonished to discover that 'a curiously shaped pebble' seen on rocky ground was a plant, later identified as a species of *Lithop*, the first of this curious succulent genus to be identified. Yet succulents teased and confounded botanists— their high moisture content and unconventional plant morphology meant this

opposite: Flowering bulbs, such as
species of *Ixia*, were easily collected
and transported to distant ports. Yet
other valuable southern African plants
posed greater challenges, especially
as ships became increasingly crowded
with passengers returning from the
East Indies. Bulky succulents were a
particular problem—'how I shall get
them home, God only knows' despaired
Francis Masson.

The Cape Wagon was a specialised vehicle developed to suit the needs of overland travel in southern Africa of the eighteenth and nineteenth centuries. Stoutly constructed yet highly manoeuvrable over uncertain terrain, it remained an essential aid to the natural historian and plant collector.

Plumbago capensis was collected during the 1770s and initially grown in European hothouses, but like Cape honeysuckle (*Tecomaria capensis*), this bushy climbing shrub became better known as a hedging plant in warm temperate and subtropical climates.

intriguing flora was ill adapted to storage as dried and pressed herbarium specimens. Here botanical art came to the rescue, as the illustrated page could, paradoxically, demonstrate typical characteristics with greater veracity than preserved samples of the actual plant. In the rare and starkly beautiful book *Plantarum historia succulentarum*, commenced in 1798, Pierre-Joseph Redouté demonstrated his new enthusiasm for stipple engraving, a technique involving etching or engraving by use of dots or stipples rather than lines. It was Redouté's mastery of perspective and botanical exactness—according to historian Wilfrid Blunt—that made his depictions of succulents so impressive, and rarely had the Cape flora been treated with such artistic distinction. Succulent historian Gordon Rowley, using hyperbole commensurate with this incongruous plant group, christened Redouté 'Raphael of the Succulents'.

In his *Flora Capensis* (1823), Thunberg usefully listed exotic species that had been introduced into southern African gardens in the century and a half since European settlement. Yet the era of botanical discovery around the turn of the nineteenth century also witnessed the uncertain beginnings of an appreciation of the Cape flora by local gardeners. The turbulent 1790s had been crucial in strengthening British interests in southern Africa, and with this came a change of emphasis in colonial gardening. William Burchell, the son of a botanist who owned London's celebrated Fulham Nursery, was the quintessential nineteenth-century natural history polymath. Writing of his stay in Cape Town, Burchell noted: 'It may be naturally supposed, that, in a country abounding with the most beautiful flowers and plants, the gardens of the inhabitants contain a great number of its choicest productions'. But 'such is the perverse nature of man's judgement', he added, 'that whatever is distant, scarce, and difficult to be obtained, is always preferred to that within his reach, and is abundant, or may be procured with ease, however beautiful it may be'. He listed many exotic trees and shrubs that had been introduced—a mix of Mediterranean, Chinese, Japanese, and south-eastern Asian species—and yet, he observed, 'a small number of the more remarkable indigenous plants are sometimes admitted to the honour of a place in their gardens'. Amongst these Burchell noted Cape chestnut (*Calodendrum capense*), with its scented lilac-pink blossom; kaffirboom (*Erythrina caffra*), bearing brilliant scarlet flowers on its thorny branches; two species of gardenia— the fragrant night-flowering *Gardenia thunbergia* (stompdoorn) and less common

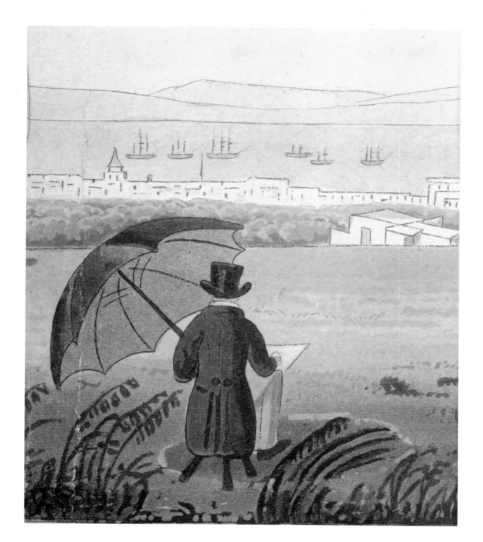

G. rothmannia; the prickly stemmed tall nightshade (*Solanum giganteum*), having delicate pale violet flowers; and the pink-flowered *Virgilia capensis*. The sculptural forms of the fan aloe (*Aloe plicatilis*) and bird-of-paradise flower (*Strelitzia reginae*) grew amidst bulbous species such as the striking orange- and green-flowered *Cyrtanthus obliquus*.

The southern African bulbous flora was perhaps the most widespread product of this intensive period of plant exploration and introduction. Whereas many of the Cape genera required the heat of a stovehouse in Europe, some plants required only the protection of a greenhouse, while a few, such as nerines, kniphofias, and zantedeschias, proved hardy outdoors. But there was a more widespread and long-lasting horticultural benefit from these Cape introductions than as hothouse plants, and that was in climates approximating that of southern Africa. In Australia, for instance, Cape bulbs and perennials, and the succulent flora were at home in rapidly developing gardens. Potted aloes decorated verandahs, and in open ground became a drought-tolerant mainstay of the shrubbery, particularly *Aloe arborescens*. The strelitzia flowered profusely. Plumbago and tecoma grew rapidly to form thick hedges. Bulbs such as ixias, sparaxis, and nerines graced the colonial flower garden, with the belladonna lily (*Amaryllis belladonna*) especially prominent. By 1844, Superintendent Charles La Trobe—whose father had botanised at the Cape two decades earlier—could write from Melbourne to English friends: 'pray send us occasionally a few of the rarer seeds … [and] a box of Bulbs', noting approvingly, 'Cape bulbs we have in abundance'.

opposite: Rhododendron arboreum—now the national flower of Nepal—was the earliest Indian rhododendron to be introduced to England, raised from seeds collected and liberally distributed by an amateur natural historian, Thomas Hardwicke. His sketch of the flower formed the basis for the illustration in JE Smith's Exotic Botany (London, 1804). This was in turn copied by an unknown but contemporary amateur artist: the rhododendron depicted here did not flower in England until the 1820s.

INDIA IN THE LATE EIGHTEENTH CENTURY REPRESENTED A RICH FUSION of cultures. To the north and west, the Himalayas and the Indus River separated the Indian sub-continent and its peoples from other Asian civilisations. Fiercely independent peoples in Kashmir, Nepal, and Bhutan clung to elevated strongholds, their botanical riches shielded from Western eyes. A series of independent states bestrode the Indian plains, along the coastal hinterland, and stretched between the uplands of the eastern and western Ghats. Colonial trading outposts—such as Portuguese Goa—remained from earlier times, although the dominant influence of the British and Dutch East India companies was waning. In 1784 the British government orchestrated a major shift in its Indian policy, establishing a government bureaucracy and installing a governor-general, and throughout the nineteenth century Anglo-India rose in prominence.

Botanical research was hindered by the dual lack of a comprehensive and convenient guide to the Indian flora, and a botanic garden in which to observe and trial plants under cultivation. However, Calcutta soon became a centre for British investigation of Indian's natural history. The foundation there in 1784 of the Asiatic Society provided a focus for amateur research at a time when those with professional scientific backgrounds were scarce. William Roxburgh, a Scottish-born surgeon employed by the East India Company, was among those who found time to botanise and experiment with plantings of potentially useful crops. In 1794 Roxburgh was appointed as the first paid superintendent of the newly formed Calcutta Botanic Garden. With drawings of Indian plants by local artists, he prepared a lavish three-volume work, *Plants of the Coast of Coromandel* (1795–1819). The plates were imbued with a vivacity that distinguished the work from the two earlier Indian floras (produced under Dutch patronage), and proudly connected European botanical objectivity with instinctive local traditions.

Amongst the most significant additions to British gardens from India were plants from the north, found on cool mountainous slopes of the Himalayas. The Indian tree rhododendron (*Rhododendron arboreum*) was amongst the first Indian examples of its rich genus to be described, and whose hardiness in cool temperate climates soon gave them such deserved popularity. The enthusiasm for hothouses in northern Europe also ensured that the Indian orchids, including species of *Dendrobium*, *Phaius*, and *Vanda*, were early favourites amongst those wealthy collectors smitten by orchidomania. One such was William Cavendish, better known as the sixth Duke of Devonshire, whose tropical houses at Chatsworth in England's midlands boasted one of the most impressive collections in cultivation. The Chatsworth conservatories—whose ribbed glass roofs formed a prototype for the design of London's Crystal Palace—were enriched by specimens collected in India in 1835 by John Gibson, one of the duke's gardeners. An inspiration for this visit was the illustration and description of *Amherstia nobilis*, a graceful Burmese tree whose virtues had been extolled by Nathaniel Wallich.

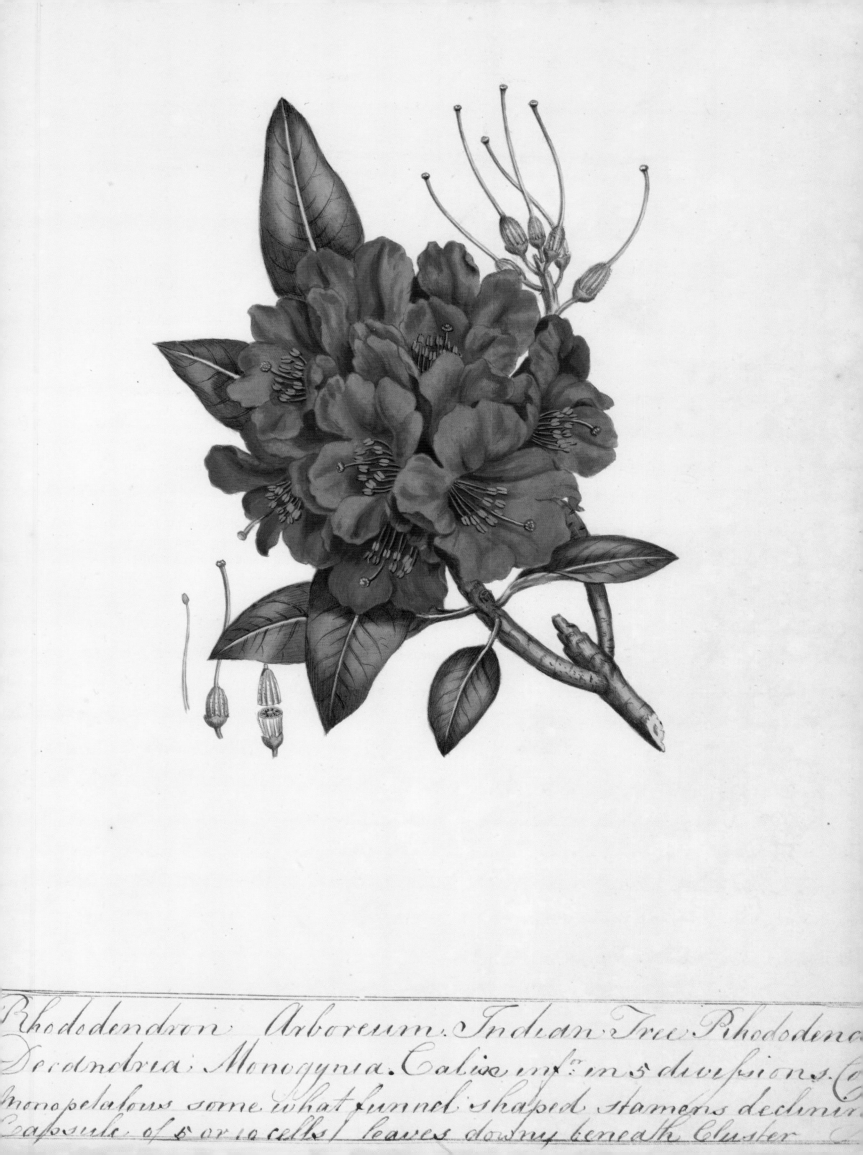

Rhododendron Arboreum. Indian Tree Rhododend
Decandria. Monogynia. Calix inf.º in 5 divisions. Co
Monopetalous some what funnel shaped Stamens declinir
Capsule of 5 or 10 cells/ leaves downy beneath Cluster

PLANTÆ
ASIATICÆ RARIORES;

OR,

DESCRIPTIONS AND FIGURES

OF A SELECT NUMBER OF

UNPUBLISHED EAST INDIAN PLANTS,

BY

NATHANIEL WALLICH, M.&PH.D.

KNIGHT OF THE ROYAL DANISH ORDER OF DANNEBROG; FELLOW OF THE ROYAL SOCIETIES OF LONDON AND EDINBURGH; CORRESPONDING MEMBER OF THE ROYAL INSTITUTE OF FRANCE; FELLOW OF THE LINNEAN AND GEOLOGICAL SOCIETIES OF LONDON; MEMBER OF THE ROYAL SOC. OF SCIENCES, AND THE ROYAL MEDICAL SOC. OF COPENHAGEN; THE ACAD. NAT. CURIOS. OF BONN, THE SOC. OF COPENHAGEN; THE SOC. OF LONDON; THE SOC. NAT. CURIOS. OF MOSCOW; FOREIGN MEMB. OF THE PHYSIOGRAPH. SOC. OF LUND; OF THE WERN. SOC. OF LONDON; CORRESPONDING MEMB. OF THE MED. BOT. SOC. OF PARIS; OF THE ACAD. OF THE SCIENC. OF BERLIN, THE SEC. OF ARTS AND SCIENCES OF BATAVIA; THE LINN. SOC. OF THE PHILIPPINES; HONORARY MEMB. OF THE HELVETIC SOC. OF NAT. SCIENC.; THE ROYAL BOT. SOC. OF RATISBON; THE LIT. SOC. OF MADRAS; THE AGRIC. SOC. OF ST. HELENA, &c. &c.

IN THE BENGAL MEDICAL SERVICE OF THE HONOURABLE EAST INDIA COMPANY, AND SUPERINTENDANT OF THE BOTANIC GARDEN AT CALCUTTA.

VOL. I.

CONTAINING

PLATES I.—C.

LONDON:

TREUTTEL AND WÜRTZ, TREUTTEL JUN. AND RICHTER, FOREIGN BOOKSELLERS TO THE KING, 30, SOHO SQUARE:
PARIS; TREUTTEL AND WÜRTZ, RUE DE LILLE: STRASBURGH, TREUTTEL AND WÜRTZ, GRANDE RUE.

1830.

Aleburites exilce

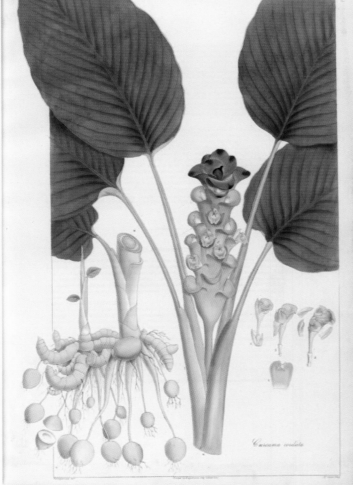

Curcuma oedala

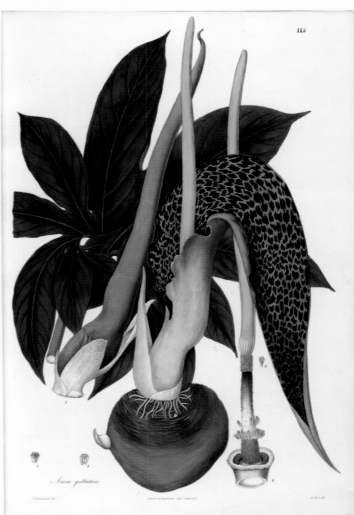

Arum guttatum

Wallich had been appointed superintendent of the Calcutta Botanic Garden in 1817, and like his predecessor, William Roxburgh, produced a sumptuous three-volume Indian flora—*Plantae Asiaticae rariores* (London, 1829–32). The Duke of Devonshire was greatly impressed by the work, which did much to promote the horticultural merits of the Indian flora. Much of its charm was derived from the superb hand-coloured plates, lithographed in England from drawings executed in Calcutta by accomplished local artists—one, Vishnupersaud, had also contributed to Roxburgh's earlier Indian flora. Wallich also sent many plants to botanic gardens around the world, although transporting live plants was a cumbersome and risky business. The prospect of steamships serving India was thus welcomed by Wallich in 1833, although it was not until 1842 that a regular monthly service to Britain via the Cape was initiated, cutting a journey of months to just six weeks.

To India's south-east lay the archipelago which now constitutes Indonesia, central to the early spice trade and of crucial strategic importance as a gateway to China and Japan. On the verge of bankruptcy in 1799, the Dutch East India Company had transferred its business affairs to the Dutch state. However, despite the strong Dutch presence in the East Indies, the on-going British conflict with France threatened this interest, and during 1811–16 the British seized Dutch possessions in the rich agricultural lands of Java to forestall French territorial ambitions. After restoration of this land (1816–17), the Dutch again became a major geo-political force in the region, and with the exception of Singapore— seized from the Dutch by the British in 1819 to guard its India–China shipping route—British India and the Dutch East Indies coexisted until Indonesian and Indian independence in the 1940s.

Amongst Dutch botanists to explore the region was Karl Ludwig Blume. In 1817, German-born Blume was appointed as the first superintendent of Buitenzorg Botanic Garden in Bogor, south of the original Dutch settlement at Batavia in eastern Java, The fertile volcanic soil and equatorial location supported a rich tropical flora, which was eagerly collected. Over a productive lifetime, Blume published three major books on the East Indian flora, his last highlighting the many splendid orchids which increasingly graced conservatories in Europe and North America. Palms too were an important horticultural export from the East Indies, along with numerous curiosities that satisfied a burgeoning taste at home for the grotesque and bizarre. These prodigies of the vegetable world— such as the monstrous and malodorous *Rafflesia arnoldii*—only added to the reputation of the Indies as a place of wonderment and danger, much appreciated on the printed page but best left to the intrepid or foolhardy.

The foetid tropical jungles of Java and Sumatra were matched in danger to the plant collector by the treacherous slopes of the Himalayas. This vast chain contained a remarkable flora, rich in plants from lofty conifers to jewel-like alpine perennials. Until the 1830s, little was known of this flora in Europe outside the handful of accounts from travellers and botanists such as Wallich, and the few plants—such as *Rhododendron arboreum*—already in cultivation. J. Forbes Royle, who superintended the East India Company's botanic garden at

German-born Dutch botanist Karl Ludwig Blume travelled and worked extensively in Java and neighbouring islands, becoming in 1817 the first superintendent of Buitenzorg (now Keybun Raya) Botanic Garden at Bogor. Styling himself Rumphius, Blume assumed the mantle of his illustrious predecessor Georg Everhard Rumpf (himself known as *Plinius Indicus*) in describing and depicting the archipelago's rich tropical flora.

opposite: The plates in Nathaniel Wallich's *Plantae Asiaticae rariores* (London, 1829–32) depict a selection of previously unpublished plants of the East Indies, including Pride of Burma (*Amherstia nobilis*) and the voodoo lily (*Sauromatum venosum*). The drawings upon which the hand-coloured lithographs were based highlight the accomplished circle of Indian artists employed at Calcutta Botanic Gardens. Although perhaps discomforting to English sensibilities, the freedom of the drawing—*Curcuma cordata*, for example, runs provocatively out of captivity and off the page—produced a book of great vitality.

The European discovery of *Rafflesia arnoldii*, the world's largest known flower, encapsulates a nineteenth-century love of the bizarre. Discovered in 1818 by Joseph Arnold, an assistant to Sir Stamford Raffles, governor of the East India Company's establishment at Sumatra, the metre-wide flower aroused enormous interest. The plant—now exceedingly rare in the wild—was pollinated by flies. Reporting the find to Sir Joseph Banks, Arnold wrote, '[it] was truly astonishing. My first impulse was to cut it up ... It had precisely the smell of tainted beef.' This illustration, from Karl Ludwig Blume's *Flora Javae* (Brussels, 1828), perfectly captures the flower's putrid fascination.

RAF

IA patma.

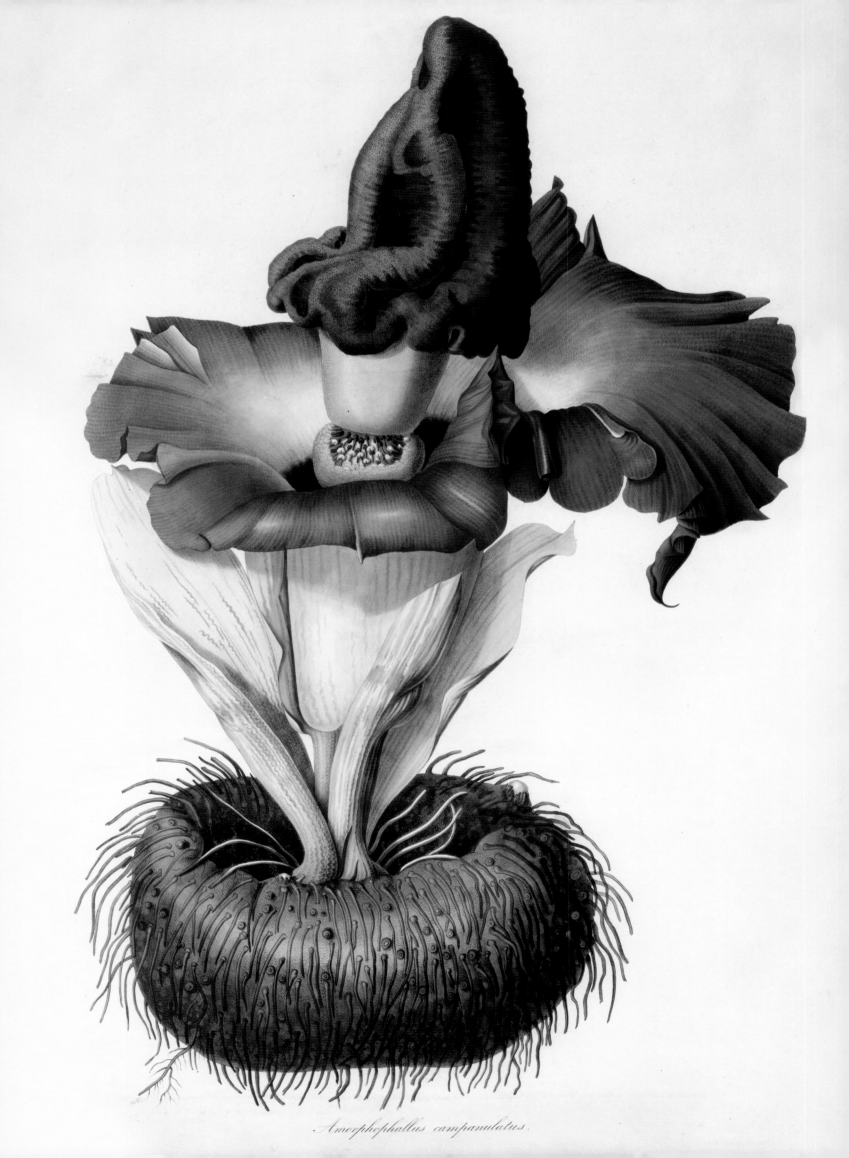

Amorphophallus campanulatus.

Saharanpur, in far north-west India, was well placed to investigate the flora as far north as Cashmere (Kashmir). Like Wallich, Royle relied heavily on local collectors. Returning from the Punjab to England, Royle published *Illustrations of the Botany and other Natural History of the Himalayan Mountains, and of the Flora of Cashmere* (London, 1833–40). This provided one of the earliest glimpses into the horticultural world of an alpine and sub-alpine flora well suited to gardens of the Northern Hemisphere. Already the deodar (*Cedrus deodara*) had created a stir in British gardening circles, and other Himalayan conifer species of *Abies*, *Picea*, and *Pinus* were rapidly finding favour in the pinetum.

In the eastern Himalayas, the botanising of Joseph Hooker during 1847–51 led to more spectacular plant finds. Armed with experience from his Antarctic travels—and with his father, William, now director of the revived Royal Botanic

opposite: The discovery in Sumatra of *Amorphophallus titanum* by Italian botanist Odoardo Beccari (1878) and its subsequent flowering at Kew is the stuff of botanical legend. Less well known are earlier discoveries in this genus, such as *A. campanulatum*. Although lacking the massive erect purple spadix of *A. titanum*, in his flora of Java, Karl Ludwig Blume milked this grotesque aroid for all its scrofulous splendour.

The leaves of the purple-coned fir (*Pinus webbiana*) have a long tradition of medicinal use in India, particularly for ailments of the throat and stomach. Found in the Himalayas, the plant was introduced into the British pinetum in the 1820s primarily for its striking purple cones. Specimens were sent by Nathaniel Wallich to Aylmer Lambert, who illustrated the new species in his *A Description of the Genus Pinus* (London, 1832).

The botanising of Joseph Hooker during his visit to India and its northern neighbours yielded many important plants, especially rhododendrons from the eastern Himalayas. Hooker's sketches and observations were quickly published as *The Rhododendrons of Sikkim–Himalaya* (London, 1849–51). The frontispiece, drawn by long-time collaborator Walter Fitch, depicts the epiphytic *Rhododendron dalhousiae* amid rugged mountain scenery.

opposite: Begonia rex, found in Assam in the eastern Himalayas, was first raised in French greenhouses in the 1850s. Valued for its foliage rather than its flower, breeding further enhanced the size and decorative markings of the leaves.

Gardens, Kew—Hooker was well placed to bridge the gap between botany and horticulture, collecting plants for Kew while simultaneously investigating the botanically unexplored state of Sikkim. Working from Darjeeling, which the British had occupied since 1835, Hooker undertook increasingly ambitious forays into the mountainous—and politically unstable—heights of Nepal, Sikkim, and Assam. Ferns, orchids, and arums soon attracted his attention, along with new rhododendron species, such as the epiphytic *Rhododendron dalhousiae* with its deliciously sweet-scented white flowers. Hooker secured permission to visit Nepal, where, fortified by yak butter and other local staples, he marvelled at hitherto unseen conifers, and additional hardy rhododendrons. The rajah of Sikkim was less accommodating than his counterpart in Nepal, and mid-travel Hooker was imprisoned while his companion Campbell (for whom Hooker had named *Magnolia campbellii*) was tortured in the cause of territorial rivalry. Diplomatic troubles aside, Hooker marvelled at the massive rhubarb-like *Rheum nobile*, and continued his comparative study of alpine flora, augmenting his earlier polar travels. *Primula sikkimensis* was amongst Hooker's lasting introductions from this trip.

Hooker was in a position to benefit from the introduction of the Wardian case for the most valuable of his live plant exports from India to Kew. Introduced in the 1830s, the tightly glazed case was also extensively used by commercial collectors. Thomas Lobb, who collected in the East Indies for the famous Veitch nursery in the early 1840s, made extensive use of the Wardian case for the

5101.

W. Fitch, del. et lith.

Vincent Brooks, Imp.

OUVRAGE DÉDIÉ A SA MAJESTÉ LA REINE DE HOLLANDE

FLEURS, FRUITS

FEUILLAGES CHOISIS

DE LA

FLORE ET DE LA POMONE

DE L'ILE DE JAVA

Few plants created more of a sensation in European hothouses than the insectivorous genus *Nepenthes*. With a centre of distribution in Borneo (now Kalimantan), the pitcher plant was an exacting but exalted horticultural companion to the orchid.

tropical plants then eagerly being sought as horticultural novelties for the hothouse and conservatory. Such was the insatiable taste for novelty that, in the 1870s, Messrs Veitch sent collector Frederick Burbidge to Borneo primarily to collect new species of pitcher plants (*Nepenthes* spp.).

Plants from the East Indies were not only exported to Europe. Direct introductions were also made, for example, to Australia. Nathaniel Wallich generously endowed colonial botanic gardens, as did his colleagues George Thwaites (and later Henry Trimen) from Peradeniya Botanic Gardens in Colombo. Baptist missionary James Smith, after convalescence in Australia, sent deodars (*Cedrus deodara*) from India to Ferdinand Mueller at Melbourne Botanic Gardens, who then acclimatised this stately conifer in Victoria's public parks and gardens. And there were alternative plant trajectories, outside the bounds of horticultural convention. From at least the eighteenth century, fishermen from Makasar (Ujung Pandang) on the island of Celebes (Sulawesi) had sailed to Australia's north coast in search of trepang for the Chinese market. Makasan words entered Australian Aboriginal languages and trading networks ensured that south-eastern Asian plants such as tamarind (*Tamarindus indicus*) became part of the local diet. When George Watt prepared his massive, officially sanctioned six-volume *Dictionary of the Economic Products of India* (Calcutta, 1889–93), similar indigenous economic uses of plants were duly noted but went otherwise unremarked, for they were not really the stuff of empire.

opposite: Fleurs, fruits et feuillages choisis ... de l'Ile de Java (Brussels, 1863–64), produced by Berthe Hoola van Nooten, is amongst the most vibrant of the works on the flora of the Indonesian archipelago. The book is also unusual amongst large-format botanical works in being addressed particularly to women: 'Its object, its tendency, its entire scope, all mark it with the special seal of our sex'. In a preface heavy with emotion, the recently widowed Madame Hoola van Nooten explained to her sister readers the need to address 'pecuniary obligations' following 'one of the heavy blows which blight our existence'. Having tasted 'the bitterness of exile', she cathartically chronicled the Javanese fruit and flowers—indigenous and introduced—in bold lithographic prints and appealing prose.

PLATE. CIII.

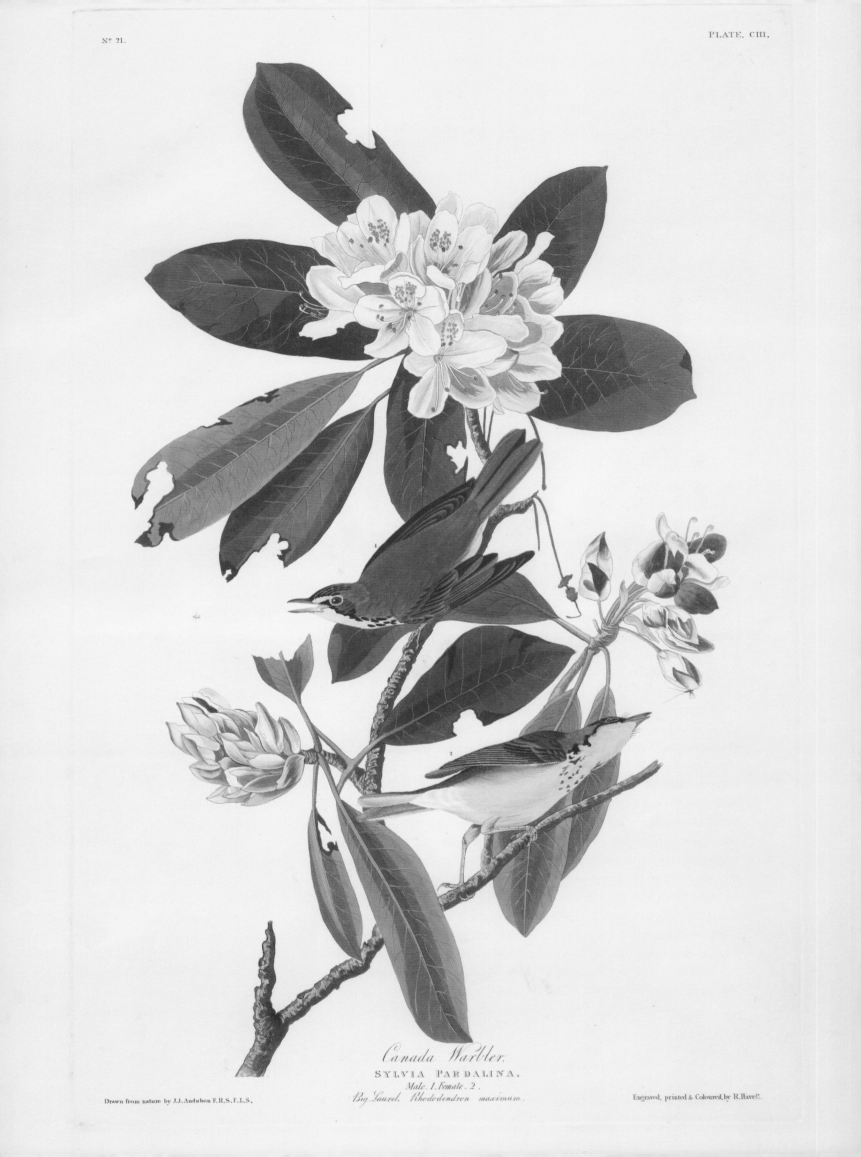

Canada Warbler.
SYLVIA PARDALINA,
Male. 1. Female. 2.
Big Laurel. Rhododendron maximum.

Drawn from nature by J.J. Audubon, F.R.S., F.L.S.

Engraved, printed & Coloured by R. Havell.

21: North America's Western Frontier

WHEN THE FRENCH BOTANIST ANDRE MICHAUX WAS SENT BY HIS government to collect plants in the United States in 1785, knowledge of its flora was largely confined to the eastern seaboard. Through the agency of state-sponsored expeditions, trading companies, and individual enthusiasts, this flora had been received into European herbaria, botanic gardens, and wealthy estates for over two centuries. In the wake of the 1776 American Declaration of Independence from Britain, Michaux's collecting of timber trees and other plants of economic value had a symbolic importance beyond botany and horticulture, as the French had supported the newly independent United States in the American Revolutionary War. Michaux established nurseries in New Jersey and at Charleston, South Carolina, and through these, he and his son François André are credited with the introduction of a host of plants such as *Azalea indica*, *Camellia japonica*, *Ginkgo biloba*, *Melia azedarach*, and *Rhododendron luteum* to the United States. Michaux introductions from North America to France were, by contrast, adversely affected by the vicissitudes of the French Revolution.

British domination east of the Mississippi lessened as the new American nation emerged in the late eighteenth century. With the purchase of Louisiana from the French in 1803, the United States more than doubled her size, and gained a springboard from which to facilitate an overland route, linking the Atlantic seaboard with Spanish territory to the west, that did not require crossing the Rocky Mountains.

The potential of the Pacific coast and its hinterland as a source of new conifers had been confirmed by the observations of Scottish surgeon-naturalist Archibald Menzies, sailing with the George Vancouver's British expedition in the early 1790s. Menzies had described magnificent forest trees, such as the Douglas fir (*Pseudotsuga menziesii*) and western red cedar (*Thuja plicata*) found on Vancouver Island. Further north he had noted the Sitka spruce (*Picea sitchensis*). To the south, at Monterey Bay, Spanish authorities had permitted Menzies to undertake limited inland exploration—at Santa Cruz he observed the towering coast redwood (*Sequoia sempervirens*).

In the wake of the Louisiana purchase, the expedition of Lewis and Clark successfully crossed the continent from the Missouri to the Pacific (1804–06). This government-sponsored expedition was primarily strategic, although natural history was favoured by many discoveries, including several plants of horticultural potential. The genera *Lewisia* and *Clarkia* were named for the pair, but like Menzies before them, new species such as the Oregon grape (*Mahonia aquifolium*) and flowering currant (*Ribes sanguineum*) observed by Lewis and Clark had to wait for introduction by later collectors. Botanical investigation in the American West was, however, greatly stimulated by the expedition.

opposite: John James Audubon's sumptuous and justly famous book *The Birds of America* (London, 1827–38) may seem an unlikely inclusion in a book concerned with botanical riches, yet Audubon lavished the same care on his depictions of North American plants as he did with its birds. Although published before the plant wealth of America's West was common in European horticulture, the illustrations of eastern species, such as *Rhododendron maximum*, provide a glorious record of these earlier introductions.

A VIEW OF THE SCENERY OF THE AMERICAN PLANTATIONS.

Gardeners in temperate climates with the space and taste for an American Garden formed a receptive audience for the new conifers from America's western frontier. The inclusion of conifers by the 1820s in the 'American plantation' at Fonthill Abbey (Wiltshire, England) suggests a change in emphasis from the American Garden towards the pinetum, then gaining popularity in large gardens.

opposite: The flowering currant (*Ribes sanguineum*) typified many plants from the American West in the delay between initial botanical description and subsequent introduction to horticulture by professional plant collectors. In this case, the plant was observed by Lewis and Clark on their 1804–06 expedition in search of a transcontinental route, but not widely introduced until the energetic collecting of David Douglas in the 1820s–30s.

Liverpudlian printer turned plant-collector Thomas Nuttall was one who undertook considerable botanical exploration during the early decades of the nineteenth century, including travels with John Bradbury, collector for the Liverpool Botanic Garden, which had been established during 1800–03 under the energetic direction of William Roscoe. Nuttall collected the osage orange (*Maclura pomifera*), which he saw growing in a St Louis garden in 1818—this tree became popular in both North America and Australia closely planted and trimmed as a hedge, although its popularity waned with the rise of barbed wire in the 1840s. He also collected stolons of buffalo grass (*Buchloe dactyloides*), a vigorous creeping grass that was found to endure great climatic vicissitudes: it should, commented the prescient *Gardeners' Chronicle*, 'be looked after by our Australian friends'. Nuttall's crossing of the Rocky Mountains in 1833 yielded the Pacific dogwood (*Cornus nuttallii*), one of several North American species that proved popular in garden cultivation.

Yet for all the territory traversed by Nuttall and Bradbury, they and their fellow collectors in the American West were eclipsed by the introductions of a single collector, David Douglas. Here was the epitome of the nineteenth-century plant collector. A Scot of humble origins, Douglas exhibited those qualities that marked him out for success in his chosen profession: insatiable curiosity, extraordinary stamina, and a discriminating botanical eye. Feted during his lifetime, his haul of plants came to symbolise a golden age of plant introduction, seldom matched and perhaps never surpassed. Even in death—at the foot of a bull pit trap in Hawaii—Douglas was hailed as a martyr to the cause of botanical exploration and horticulture. When in 1881 the *Gardeners' Chronicle* dryly observed, 'Of all the deadly occupations this is surely the most fatal', the shadow of Douglas loomed large.

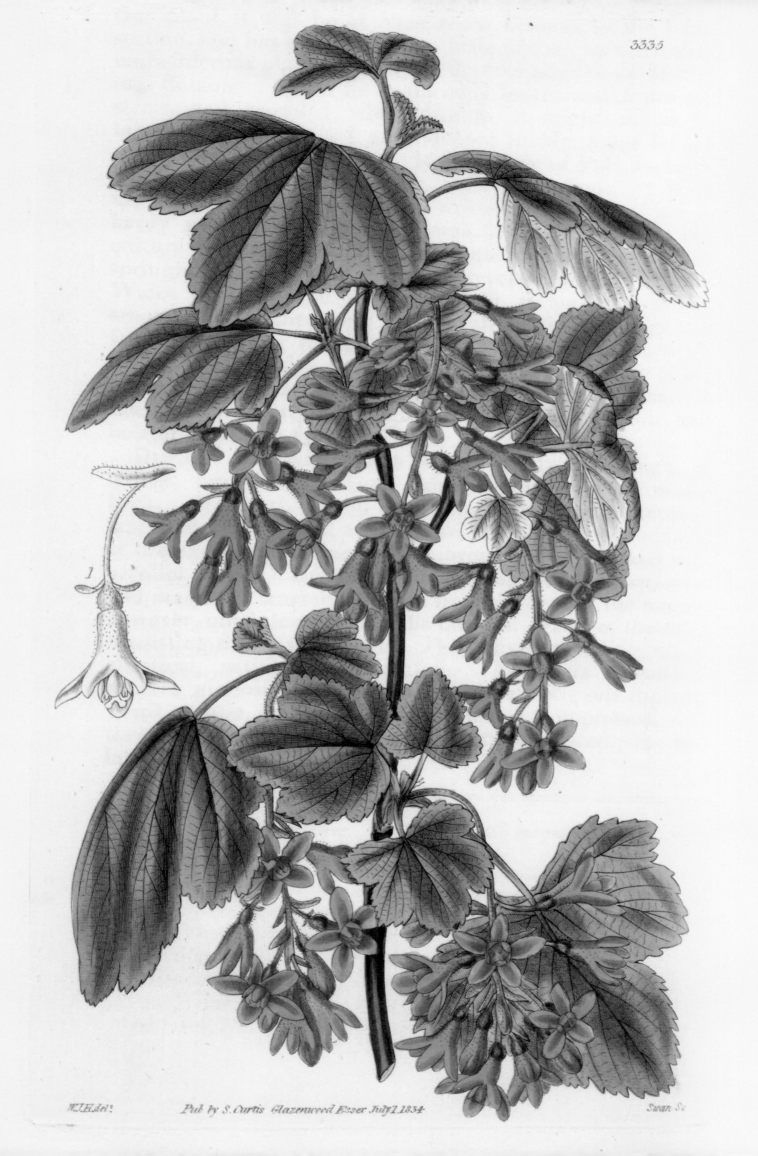

W.J.H.del. Pub by S.Curtis Glazenwood Essex July 1.1834. Swan Sc

PINUS INSIGNIS.

MENDECINO CALIFORNIA.

W. Richardson, del et lith.

Day & Son, (Limited) Lith. London.

Through the efforts of David Douglas and Irish botanist Thomas Coulter—who met by coincidence in California in the mid-1820s—the big-cone pine (*Pinus coulteri*) was introduced into cultivation by the Horticultural Society of London.

Douglas had been selected in 1823 to act as plant collector for the Horticultural Society of London. Recommended by William Hooker, the young gardener sailed for New York to commence his task. Having scoured upstate New York and the Great Lakes, he returned in 1824 for a second expedition, this time to America's north-west coast, aboard the annual supply ship of the Hudson's Bay Company. On his arrival at the mouth of the Columbia River, Douglas immediately recognised a tree earlier seen by Menzies, and subsequently named *Pseudotsuga menziesii*, the Douglas fir. Perhaps no more fitting monument could be found, for as a rapidly growing forestry species, this fir perfectly fulfilled the wish of the Horticultural Society to find species of economic value. Soon Douglas came upon another 'truly grand tree' that he named *Pinus lambertiana* (sugar pine) after Aylmer Bourke Lambert, the noted British author on the pine tribe. 'I rejoice to tell you of a new species of *Pinus*', Douglas wrote to Hooker in 1826, 'the most princely of the genus, perhaps even the grandest specimen of vegetation'. By then Hooker was formulating plans for a new flora of North America, incorporating the novel taxa of Douglas and his compatriot Thomas Drummond, then botanising in Hudson Bay territory east of the Rocky Mountains. As a finale to his second trip, Douglas made the arduous trip from the Pacific east to Hudson Bay, and on to richly deserved acclaim in London.

opposite: Although here looking far from its glamorous and youthful best, this mature Monterey pine (*Pinus radiata*) demonstrates one of David Douglas's most valuable introductions. As an ornamental tree, its glossy green needles and symmetrical habit enhanced the lawn or border; as a windbreak, its value has long been recognised; and—masquerading as radiata pine—it still forms the backbone of the softwood timber industry in the Southern Hemisphere.

David Douglas is best remembered
for conifers, yet many flowering
plants also recall his outstanding
North American plant introductions.
Although it was known in Europe
from dried specimens collected in
the 1790s, it was Douglas who in the
late 1820s introduced the brilliant
yellow California poppy (*Eschscholzia
californica*) and the vigorous
flowering currant (*Ribes sanguineum*),
both outstanding garden plants.

E.W.C. del.

Eschscholtzia californica.

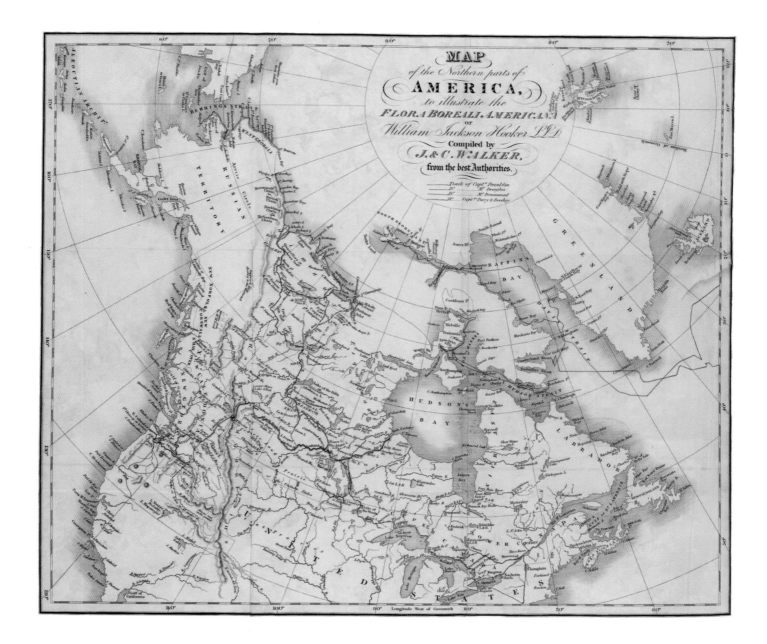

Douglas set sail for a third trip in 1829, to California, still on the Horticultural Society's payroll but by now somewhat aggrieved at the modest financial return he was receiving for such arduous work. (As his biographers quietly observe, he was receiving less than the porter at the Society's London headquarters.) With his pet Scotch terrier, Billy, a double-barrelled shotgun, and other instruments of his trade, Douglas eventually arrived at his destination, but not before a long wait on the Columbia River, where he collected seed of the blue-green foliaged noble fir (*Abies procera*) and grand fir (*Abies grandis*). Douglas reached Monterey, California, in early spring, where he met Thomas Coulter, who for some years had been collecting further south in Mexico. (It was about this time that Coulter discovered the plant named for him, *Romneya coulteri*, the Matilija poppy.) With the resignation of Joseph Sabine as Secretary of the Horticultural Society in 1832 (for whom Douglas had named *Pinus sabiniana*, the digger pine), Douglas too cut his links with the Society and thereafter sent his plants direct to William Hooker at Glasgow. A canoeing accident amid rapids, where he lost his precious diary and many plant specimens, broke his strength and spirits. Abandoning long-cherished plans to visit Alaska and Siberia, he travelled instead to the Hawaiian Islands. Here Douglas met a mysterious end—perhaps trampled, perhaps murdered—during his exploration of Hawaii's spectacular volcanic mountains.

William Hooker's flora of the northern parts of 'British America'—or, to use its Latin title, *Flora Boreali-Americana* (London, 1833–40)—drew heavily on the northern travels of David Douglas, as well as those of fellow Scot, Thomas Drummond (for whom the popular Texan annual *Phlox drummondii* was named). Hooker's text was able to incorporate the major new west-coast discoveries, demonstrating great advances since the previous flora of similar ambit, by his predecessor François André Michaux (Paris, 1803).

W. Fitch, del. et lith.

Vincent Brooks, Imp

In all, Douglas collected the seeds of more than 800 plant species, of which over a quarter were new introductions. That many of these proved hardy in Britain—then the major centre in world horticulture and garden design—ensured that the name of David Douglas lived long after his melancholy death in 1834, aged just thirty-five.

Much plant collecting was conducted in the United States as part of government expeditions, and many botanical reports appeared as part of the official records of such exploration. For example, the United States and Mexican Boundary Survey, undertaken in 1848, resulted in a substantial haul of new cacti that were examined by German-born physician George Engelmann. A founder of the St Louis Academy of Science and early proponent of the Missouri Botanic Garden, Engelmann published widely on cacti, including the many newly collected Mexican species. The steel engravings that accompanied his reports formed outstanding examples of their craft, at once economical of line yet with a precision suited to their demanding subjects.

Another who contributed to the botanical results of the border survey was John Torrey, a Harvard-based botanist and collaborator with Asa Gray. The work of Torrey and Gray, in publications such as the *Flora of North America* (1838–43) and Torrey's *Flora of New York* (1843) ushered in a new phase of botanical publication, written by and for Americans. Such botanical works complemented a new wave of local horticultural and garden design publishing, such as Robert Buist's *The American Flower-Garden Directory* (1832) and AJ Downing's

The poinsettia (*Euphorbia pulcherrima*) was introduced into North American cultivation through the agency of Robert Buist of Philadelphia, who in 1834 sent the plant to James McNab at Edinburgh Botanic Garden. The plant, discovered in Mexico in 1828 by American diplomat Joel Poinsett, found initial favour in stovehouses but by the mid-twentieth century had become a Christmas favourite in the Northern Hemisphere, valued for its showy red petal-like bracts.

opposite: The Rocky Mountain columbine (*Aquilegia coerulea*) was introduced into cultivation in the mid-nineteenth century. Within a few decades, hybridists had incorporated its distinctive long spurs with desirable attributes of earlier species, producing now-familiar garden varieties.

The horticultural world adores giants. Whether it be *Rafflesia arnoldii* or *Amorphophallus titanum* from Sumatra; the giant redwood (*Sequoiadendron giganteum*) of California; or a venerable multi-trunked banyan (*Ficus benghalensis*) sufficient to shelter an imaginary army; the saguaro cactus (*Carnegiea gigantea*) of Arizona is at home amongst the titans. In 1848 German émigré George Engelmann described this 16-metre species, with a long tradition of Amerindian use and known to the Spanish by repute from the sixteenth century, to an astonished botanical world.

opposite: The naming of California's giant redwood (*Sequoiadendron giganteum*) highlighted Britain's fading sway in North America. John Lindley, to whom Veitch had entrusted the plant for classification, honoured the recently deceased Duke of Wellington in the name *Wellingtonia gigantea*. American sentiment was outraged and a new genus *Washingtonia*, honouring the first United States president and undisputed war hero, George Washington, was proposed. Eventually the botanical affinity of the tree to the coast redwood (*Sequoia sempervirens*) settled the overheated rhetoric.

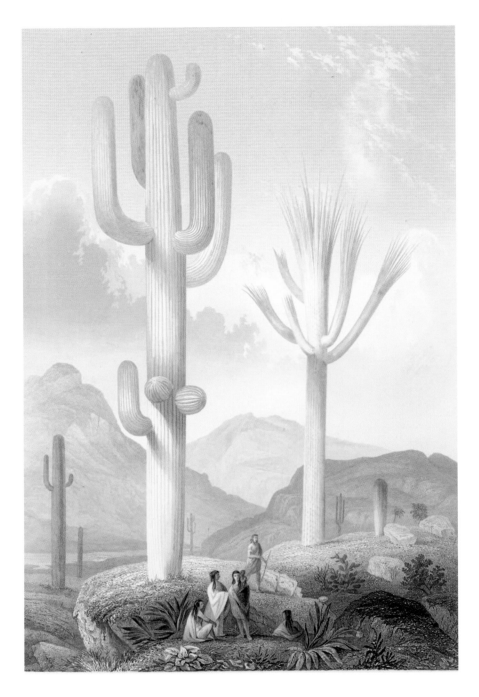

A Treatise on the Theory and Practice of Landscape Gardening, Adapted to North America (1841). Yet this energy was still mostly directed to those on the eastern seaboard.

Mexico ceded California to the United States in 1846, and the gold discoveries there in 1848 unleashed a wave of optimism and opportunism unlike anything yet seen in North America. The signature plant of this gold-rush era was the Wellingtonia or giant redwood (*Sequoiadendron giganteum*) of the Sierra Nevada. Collected for the Veitch Nursery by William Lobb in 1853, seedlings were put on the market in the following year to great acclaim. Even in the far-off Victorian goldfields of Ballarat, the tree made its impact—an avenue in the local botanic garden, now with massive tusk-like branches, still delights visitors. It also highlights the close horticultural links between Australia and the American West that developed in the gold-rush period, an age when traditional trading patterns were rapidly becoming decentralised.

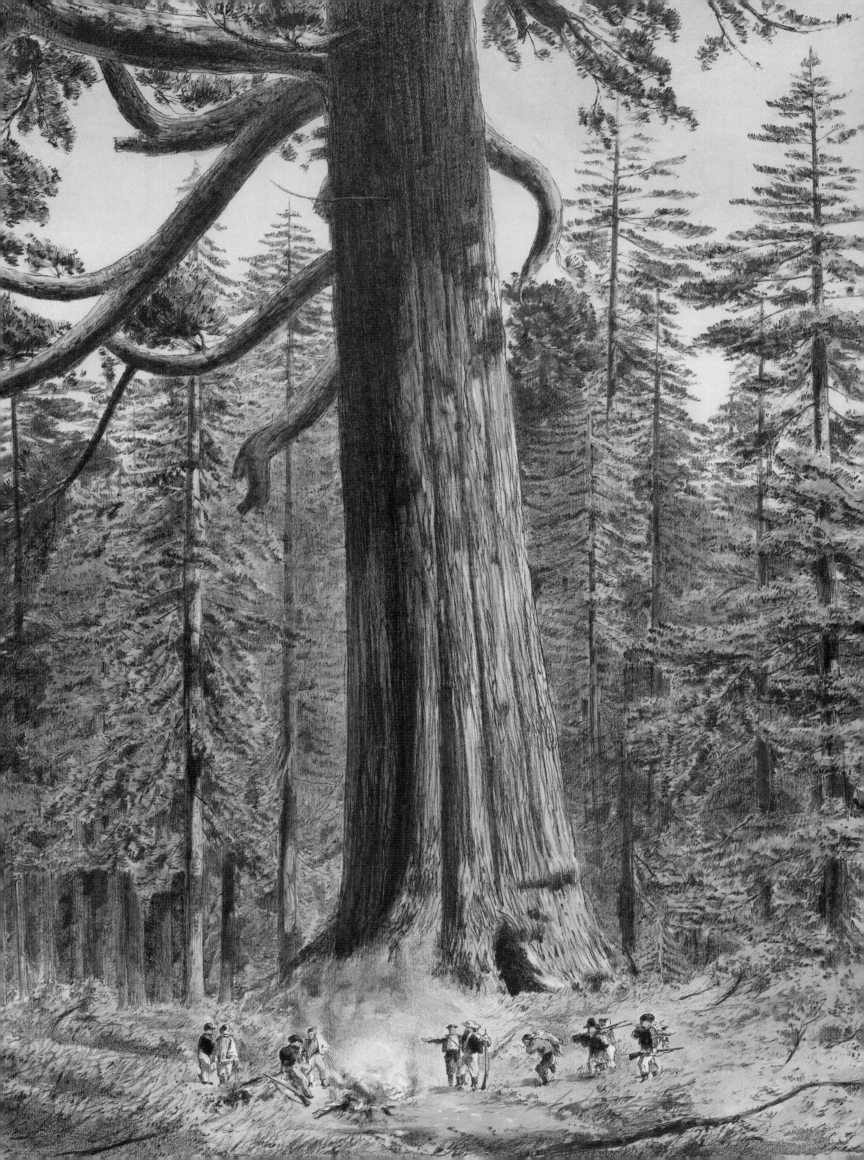

Central and South America

opposite: The first dahlia to reach Europe was described in 1791, only two years after seed reached the Royal Botanic Gardens in Madrid. Named by Spanish botanist Antonio Cavanilles, to honour his Swedish colleague, Anders Dahl, *Dahlia pinnata* was soon joined by a host of other Mexican and Central American species from this showy genus.

WHEN ARMY OFFICER JG STEDMAN PUBLISHED HIS *NARRATIVE, OF A FIVE years' expedition … on the wild coast of South America* (London, 1796), he illustrated the work with a revealing allegorical view, of Europe supported by Africa and America. Elsewhere, the book highlighted coffee and cotton: if Stedman had been writing earlier, it might have been tobacco and sugar; or later, quinine and rubber. These vegetable products—some local, some introduced—and the means to cultivate them were at the heart of European interest in the Americas. Although Stedman's illustration was symbolic, its truth was evident for those who would acknowledge it.

Although the floristic richness of Central and South America had long been recognised, European botanists were still grappling with its complexities, especially as a steady stream of new taxa was still entering Old World botanic gardens and herbaria. The region's dominant Spanish presence ensured that Madrid was well supplied. The botanising of Lopez and Pavón in Chile and Peru (from 1777), and Sessé and Mociño in Mexico, Central America, and the Caribbean (from 1788) heralded a renewed interest in natural history by the Spanish court, under Charles III. Although few publications resulted, botanical exploration in Spain's American dominions resulted in the introduction of several new plants of considerable horticultural potential, including the earliest dahlia (*Dahlia pinnata*), from Mexico, and species of *Fuchsia* and *Zinnia*. Another Mexican flower, cosmos (*Cosmos bipinnatus*), was introduced via Madrid's Royal Botanic Garden in the 1790s.

The power of the Andean tree *Cinchona officinalis* to cure 'fever' was long known to the Spanish, and the virtual monopoly of quinine by the Society of Jesus led to the plant becoming known as 'Jesuits' bark'. Named *Cinchona* by Linnaeus after the wife of the Spanish viceroy of Peru, the Countess of Chinchon—who was supposedly cured of malaria in 1638 by a cinchona decoction—the plant was eagerly sought by the British and the Dutch. The bark was harvested in Colombian and Peruvian forests, but it was not until the 1870s that cinchona was successfully grown outside South America in marketable quantities—in Java, by the Dutch.

SCIENTIFIC IMPERIALISM AND EXOTIC BOTANY

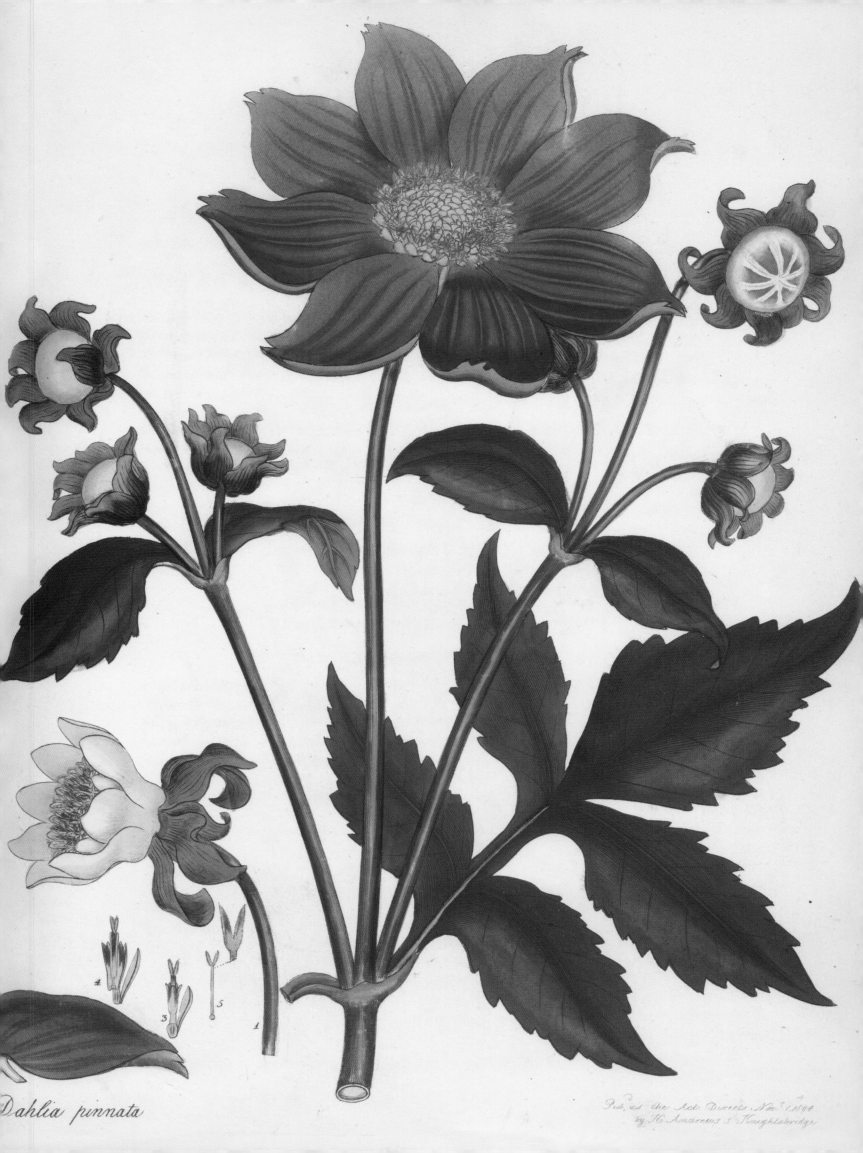

Dahlia pinnata

Pub. as the Act Directs Nov.r 1.1804
by H.s Andrews s Knightsbridge

Although known to botanists early in the eighteenth century, fuchsias were not generally introduced to European cultivation until the 1780s. *Fuchsia magellanica*, for instance, from the moist Andean regions of Chile and Argentina, was first grown at Kew Gardens in 1788. The graceful pendulous flowers of the fuchsia were greatly popularised from the mid-nineteenth century by extensive breeding.

opposite: Heliconias have become the quintessence of horticultural tropicalia. The wild plantain or lobster claw (*Heliconia bihai*), a denizen of tropical Central and South America, is closely related to the *Musa* and *Strelitzia* species. This affinity suggested its generic name to Linnaeus, derived from Helicon (the mountain of the Muses), and linked through a botanical in-joke playing on the similarity of *Musa* and Muses. Instead of cringing, the inconspicuous bisexual flowers hide their modesty behind sculptural, highly coloured bracts whose charms have proven irresistible to the breeders' hand.

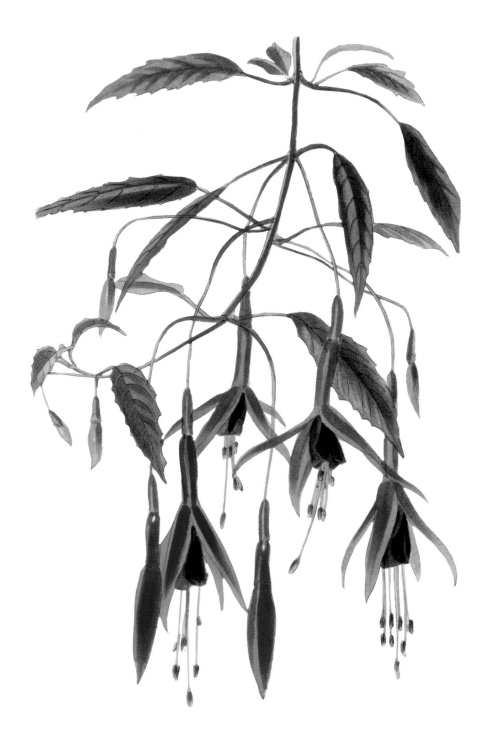

The British and the French also retained considerable interests in the West Indies. In the Lesser Antilles, French settlements on Guadeloupe and Martinique were augmented in the early nineteenth century by territorial expansion in French Guiana (whose capital, Cayenne, gave its name to the pepper). British interests were more widely spread, and included the Bahamas, Jamaica, and later British Guiana (now Guyana). All were rich fields for plant collectors, and through science and commerce many new plants found their way into cultivation. Kew Gardens and the Jardin des Plantes provided the states with breeding grounds for new introductions, while amongst the nursery trade, the London nursery of Lee and Kennedy was at the forefront of the West Indian introductions, including new species of dahlia and fuchsia.

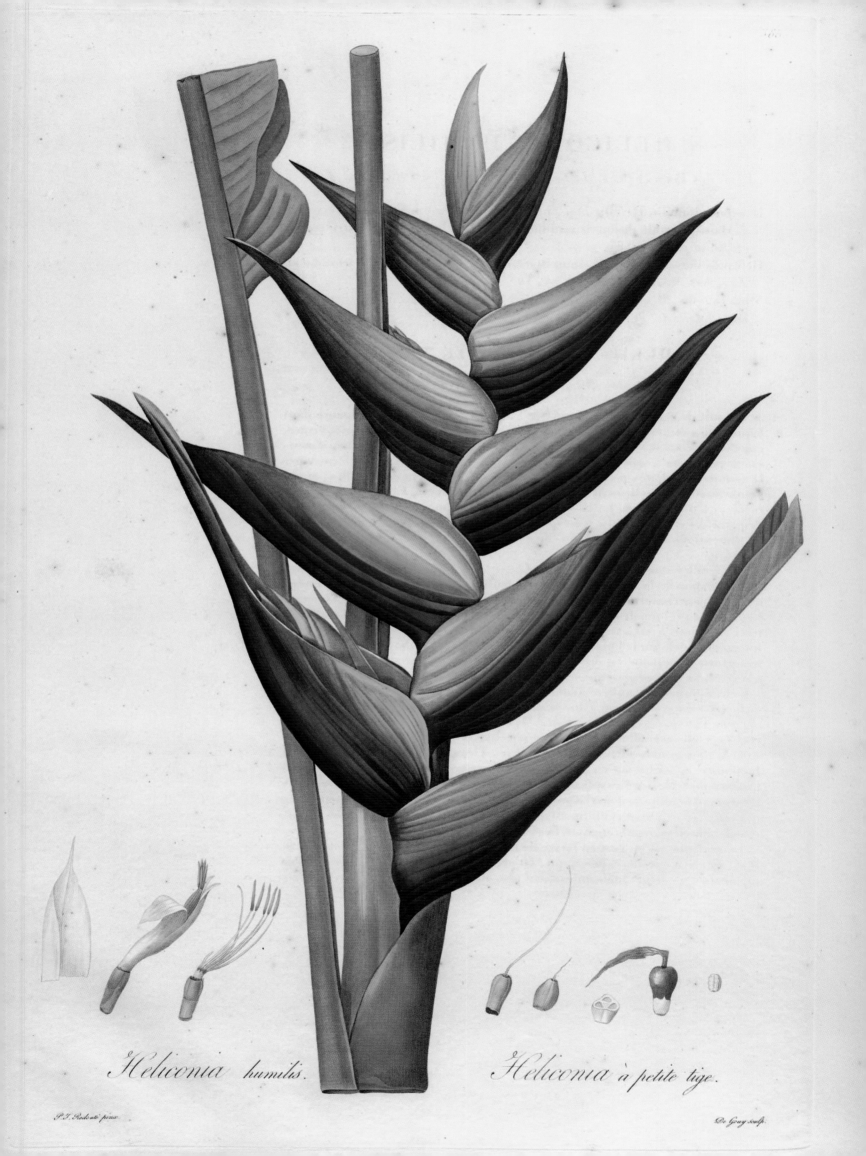

Heliconia humilis.

Heliconia à petite tige.

P.J. Redouté pinx.

De Gouy sculp.

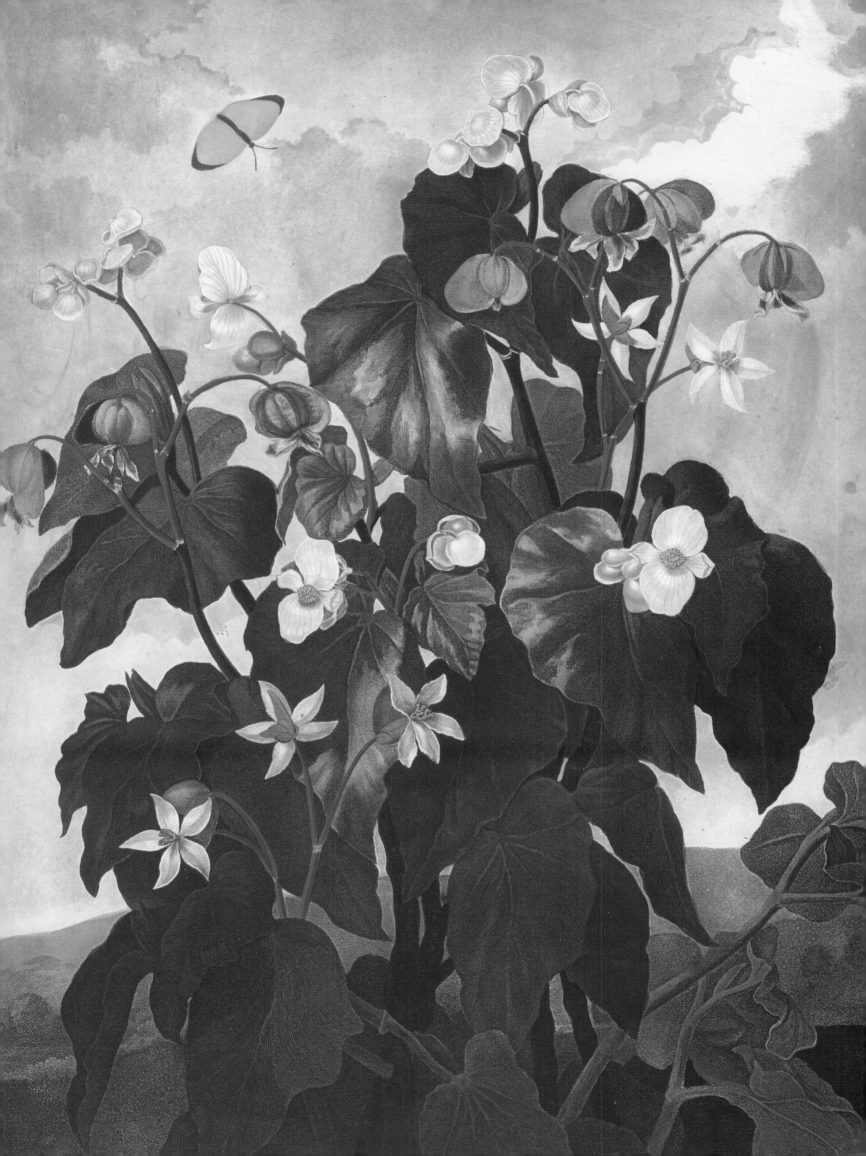

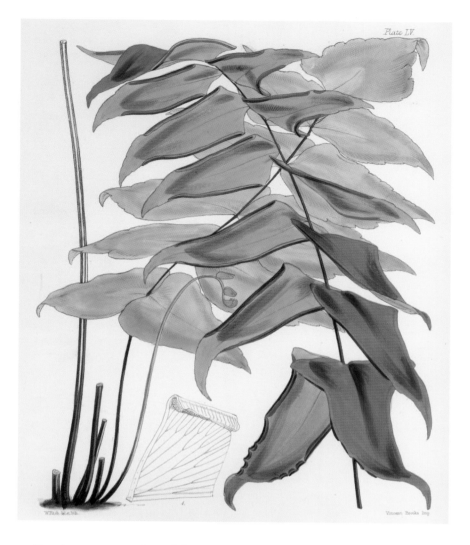

The juvenile reddish-pink fronds of *Adiantum macrophyllum* were widely admired in Regency conservatories, as was the contrast between its foliage and glossy black stems. This fern was sourced initially from Jamaica—from where it was sent to Kew Gardens in 1793 by William Bligh (following his mission to introduce breadfruit to the West Indies from Tahiti)—but has a distribution throughout the West Indies, Central America, Brazil, Bolivia, and the Galapagos Islands.

opposite: Begonia minor was introduced to Kew Gardens from Jamaica in 1777. The interplay between flowers (in some species, inconspicuous) and foliage (often larger and gaudier) in Philip Reinagle's drawing captures the delicately balanced charm of this species, the earliest introduction of its genus.

Despite our perception of the West Indies as a tropical paradise—you know the travel slogan 'You won't need your pyjamas in the Bahamas'—in the late eighteenth and early nineteenth centuries, the region was no place for the casual traveller. Islands and nations still seethed with territorial ambitions and political unrest, ensuring that botanising, much less the collecting of live plants, was viewed with suspicion. Portuguese-controlled Brazil had long been closed to outside interests, and the best most travellers could gain was a tantalising glimpse of the port city of Rio de Janeiro. Those best placed to observe were those with official sanction and firm resolve.

In 1799, through diplomatic connections with the Spanish court, German geologist and physicist Alexander von Humboldt gained the necessary permission to travel in Spain's American territories. Joined by Aimé Bonpland, a French surgeon and keen botanist, the pair embarked at Venezuela amid tropical vegetation that most botanists might only see in their dreams. 'We have been running about like a couple of fools' remarked Humboldt, 'for the first three days we could settle to nothing, as we were always leaving one object to lay hold of another … Bonpland declares that he should lose his senses if this state of ecstasy were to continue.' The pair travelled by large canoe in mosquito-infested waters of the Orinoco, and following Bonpland's recovery from malaria, travelled through the Caribbean and eventually arrived in Mexico. After many trials, the travellers sailed triumphantly for Europe with a bountiful haul, even stopping for three weeks with American President Jefferson at Monticello. While Humboldt inspired a generation with his published scientific accounts, Bonpland settled for horticultural glory, superintending the Empress Joséphine's gardens at Malmaison and Navarre. Here he was able to grow several newly discovered dahlias, and two *Lobelia* species (*L. fulgens* and *L. splendens*) collected during his travels in Mexico.

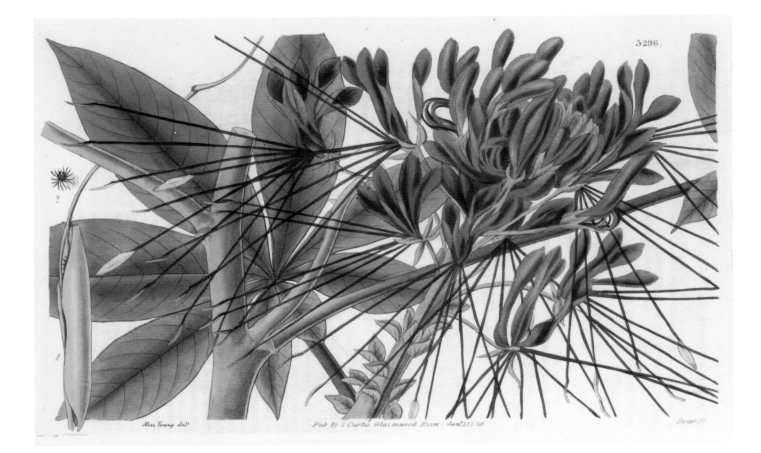

Miss Young del. *Pub by S Curtis Glazenwood Essex Jan 1 1834.* *Swan Sc*

The *Botanical Magazine*, through its longevity and the excellence of its illustrations and text, forms a barometer to plant introductions and horticultural trends. A rise of interest in Central and South American plants is evident, especially in the 1820s–50s. So too, does this magazine chart the role of women artists, whom Curtis and others frequently featured. In 1834, Miss Young rendered the spider plant (*Cleome* sp.) from Brazil with economical clarity, complete with its namesake lurking to the left.

opposite: The giant Amazon lily or Victoria Lily (*Victoria amazonica*) was encountered in tropical South America by many explorers during the early nineteenth century, all of whom remarked on the majesty of the plant. It was the descriptions of Robert Schomburgk, exploring in British Guiana for the Royal Geographical Society of London in 1837, however, that sparked a frenzy to flower the 'Queen of Aquatics' in cultivation. Soon its giant ribbed leaves and ephemeral flowers were seen in specially constructed 'Victoria houses' from Amsterdam to Adelaide.

Plant introductions to Europe and North America increased once restrictions on exploration were relaxed by Spanish and Portuguese authorities in the early nineteenth century. This enabled renewed French and British collecting at a time when steam, and soon, hot-water heating of hothouses provided ideal conditions for tropical plants. Many of these were great novelties, and interest was maintained as new species were successively introduced. Plants suggestive of exotic locations, such as the spider plant (*Cleome* sp.) of Brazil or the Mexican tiger lily (*Tigridia pavonia*), were praised in the burgeoning popular horticultural press. Enhancement of flowers and foliage by commercial plant breeders also fuelled highly specialised manias for begonias, caladiums, calceolarias, dahlias, fuchsias, and hippeastrums, to name just a few of the most popular plants of Central and South American origin. However, no plants surpassed the mania from the 1830s for orchids.

Orchids had been known in cultivation since the mid-eighteenth century, but it was the flowering in England of the butterfly plant (*Psychopsis papilio*) in the early nineteenth century that sparked widespread interest in this highly decorative plant group. Successive introductions soon graced the pages of the illustrated botanical journals and increasingly impressive monographs. No book—on this or any other plant group—surpassed the magnificence of James Bateman's *The Orchidaceae of Mexico & Guatemala* (London, 1837–43). Bateman relied on a network of collectors employed at his own expense, or the agency of expatriate merchants such as George Ure Skinner in Guatemala (after whom *Cattleya skinneri* was named). Bateman's huge elephant folio, principally illustrated by Sarah Drake and Augusta Withers, was of importance in depicting Central American orchids but also marked the advent of cool orchid cultivation. Hitherto, many American orchidaceous genera such as *Odontoglossum* had fared poorly in European hothouses due to excessive humidity: Bateman's experiments proved that many species thrived in cool temperatures and dry air, and therefore suited the means of those who could not afford to maintain a heated orchid house.

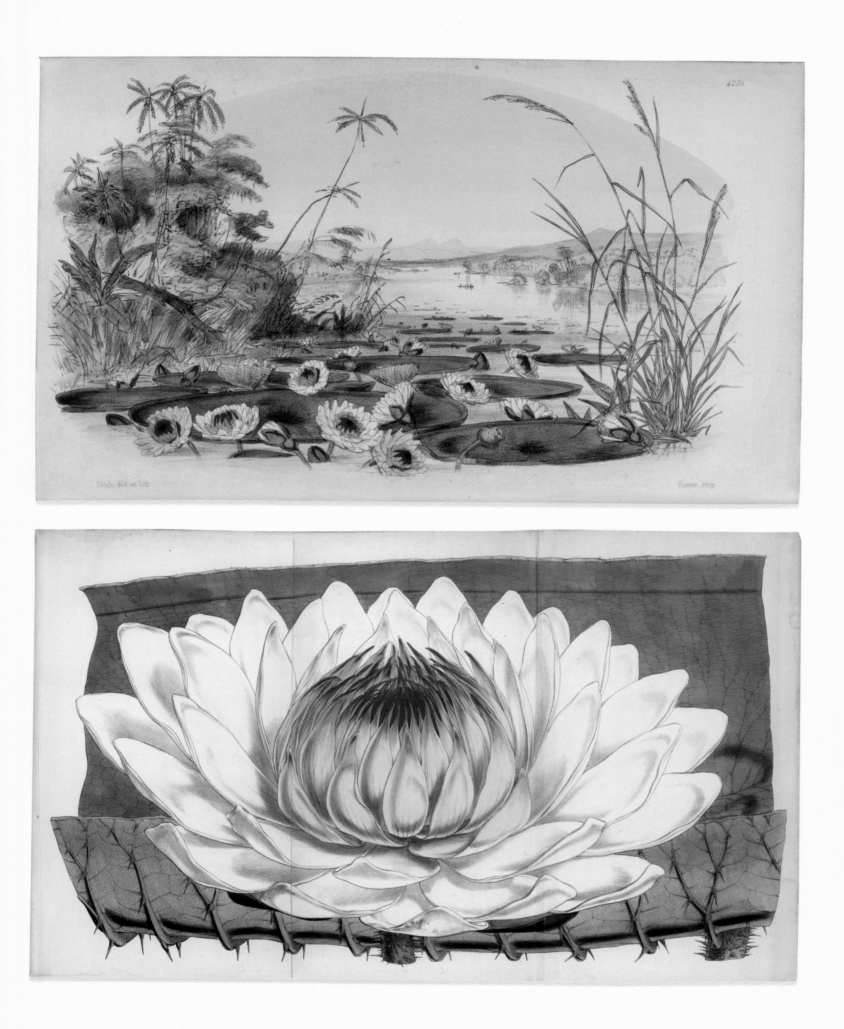

4275

"............ curramus præcipites, et
" Dum jacet in ripâ, calcemus Cæsaris hostem."
 JUVENAL.

The fascination of tropical orchids
is clearly evident in their beautiful
depictions in James Bateman's
*The Orchidaceae of Mexico &
Guatemala* (London, 1837–43).
The huge hand-coloured lithographs
have a counterplay in charming
engraved vignettes, including
George Cruickshank's amusing
depiction of cockroaches escaping
from an orchid consignment.

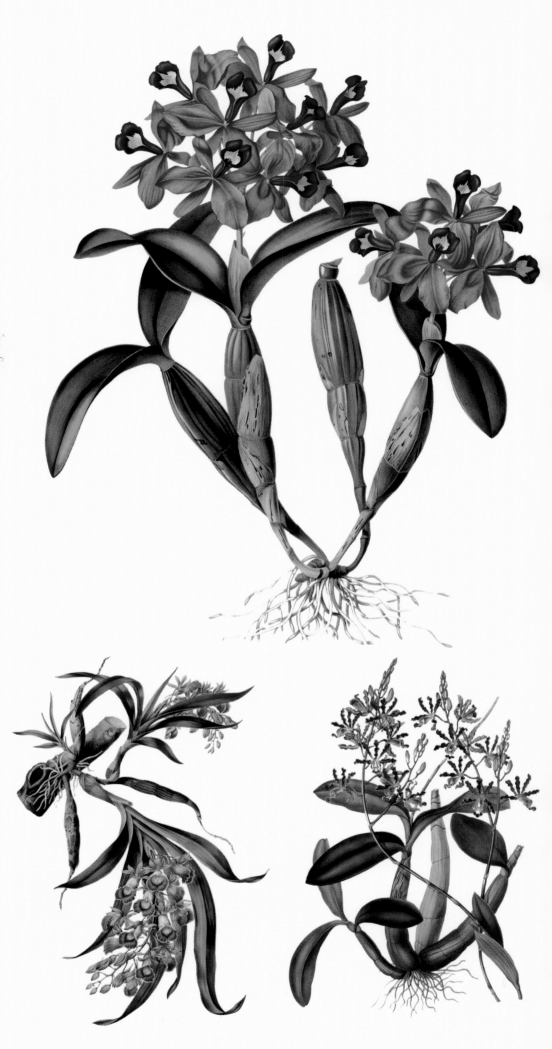

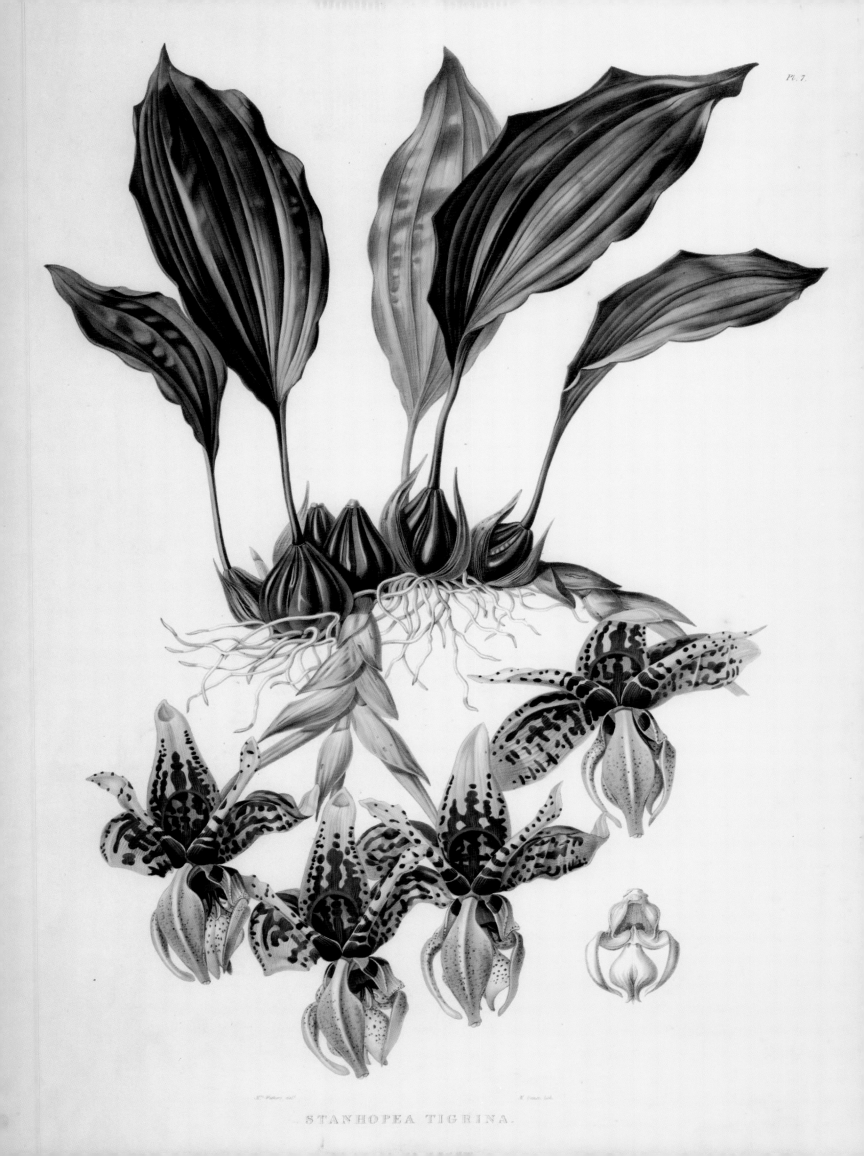

Pl. 7.

STANHOPEA TIGRINA.

The Chilean fire bush (*Embothrium coccineum*) was collected in 1846 by William Lobb and introduced in Britain by the Veitch nursery. The striking flowers had similarities to members of the Australian proteaceous flora, just as species of *Araucaria* were found in both Chile and Australia. Later discoveries in plate tectonics and continental drift led to the conception of Gondwana, a massive conjoined landmass that provided a ready explanation to these and many other botanical affinities.

opposite: Seed of the monkey puzzle tree (*Araucaria araucana*)—so-named in England for its sharp, twisted foliage—was collected in the late eighteenth century by surgeon-naturalist Archibald Menzies whilst in Chile. Although it excited some botanical interest, it was not until the importation of seed in quantity in the 1840s by William Lobb, professional plant collector for the Veitch Nursery, that this distinctive conifer was popularised in cool temperate gardens.

Orchids and South America were also central to the experimental research of Bateman's contemporary, Charles Darwin, but in isolation rather than conjoined. Travelling aboard the *Beagle* (1832–36), Darwin's voyage culminated with a visit to the Galapagos Islands, astride the equator off the Ecuadorian coast. The voyage profoundly shaped his theory of evolution and the specimens he collected filled a lifetime. Although botany was not Darwin's strongest suit—he was pleased to be guided by John Henslow, professor of botany at the University of Cambridge, and Joseph Hooker—his researches relied strongly on plants. In this context, orchids assumed considerable importance, especially in his writings on plant fertilisation. With their luridly coloured petals and bizarre forms, in Darwin's perceptive hands orchids proved to be more than just the voluptuous playthings of (mostly) male fanciers.

Darwin's travels in South America benefited from a new mood of cooperation that had spread through the continent in the wake of the Napoleonic Wars, seen especially in the process of self-determination amongst former colonial strongholds. Although British, Dutch, French, Portuguese, and especially Spanish influence remained strong, the rise of new independent states during the second and third decades of the nineteenth century diffused entrenched European colonial interests. Brazil, for instance, attracted the attention of German-born botanist Carl Philipp von Martius, whose multi-volume *Flora Brasiliensis* (1840–1906) gave the country's botany a comprehensive foundation. Relaxation of restrictions on travel also paved the way for increased plant collecting, by botanic gardens and the nursery trade alike. William Lobb, travelling in Brazil and Chile in the 1840s for his employer Veitch, collected and introduced many plants suited to temperate climates, such as *Berberis darwinii* (seen earlier on the *Beagle* voyage), *Embothrium coccineum*, and the colourful climber *Tropaeolum speciosum*. Most importantly, in 1844 Lobb introduced seeds of the monkey puzzle tree (*Araucaria araucana*) in quantity, capping an era of conifer discovery in the Americas which gave horticulture some of its choicest specimen trees.

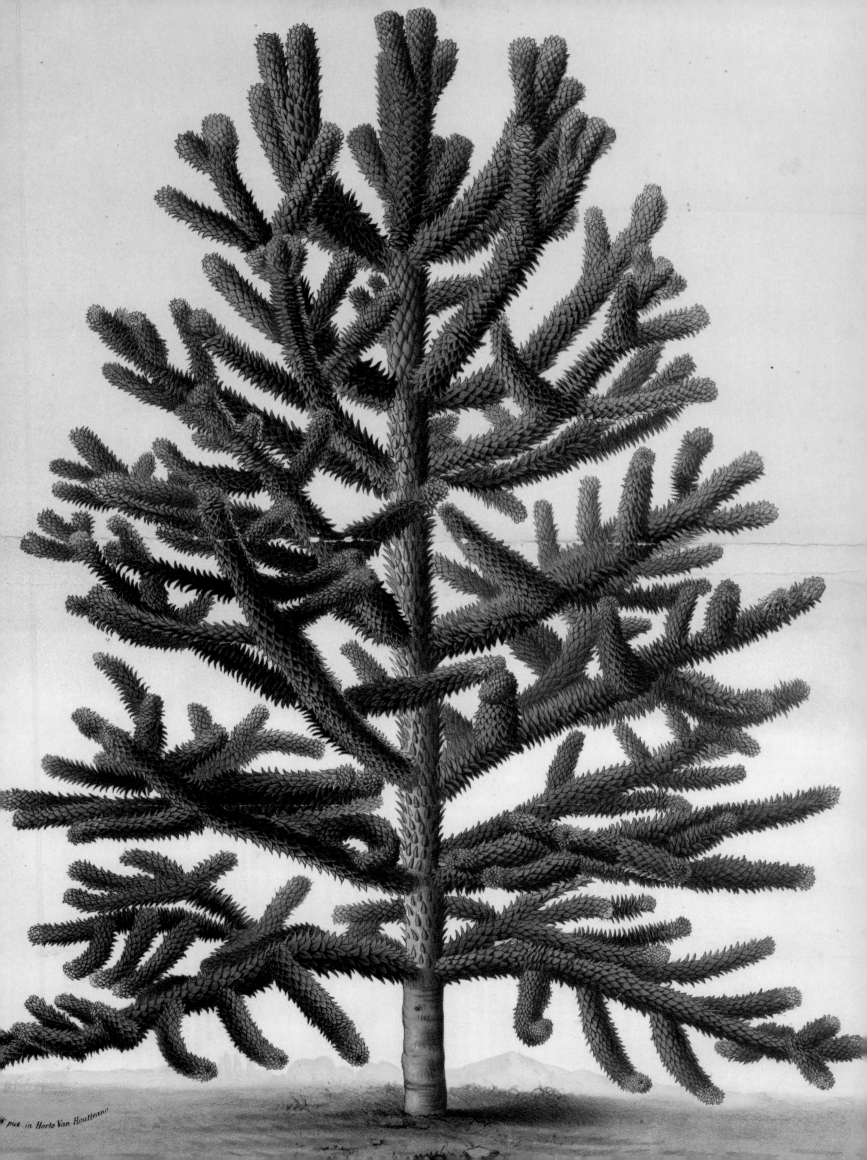

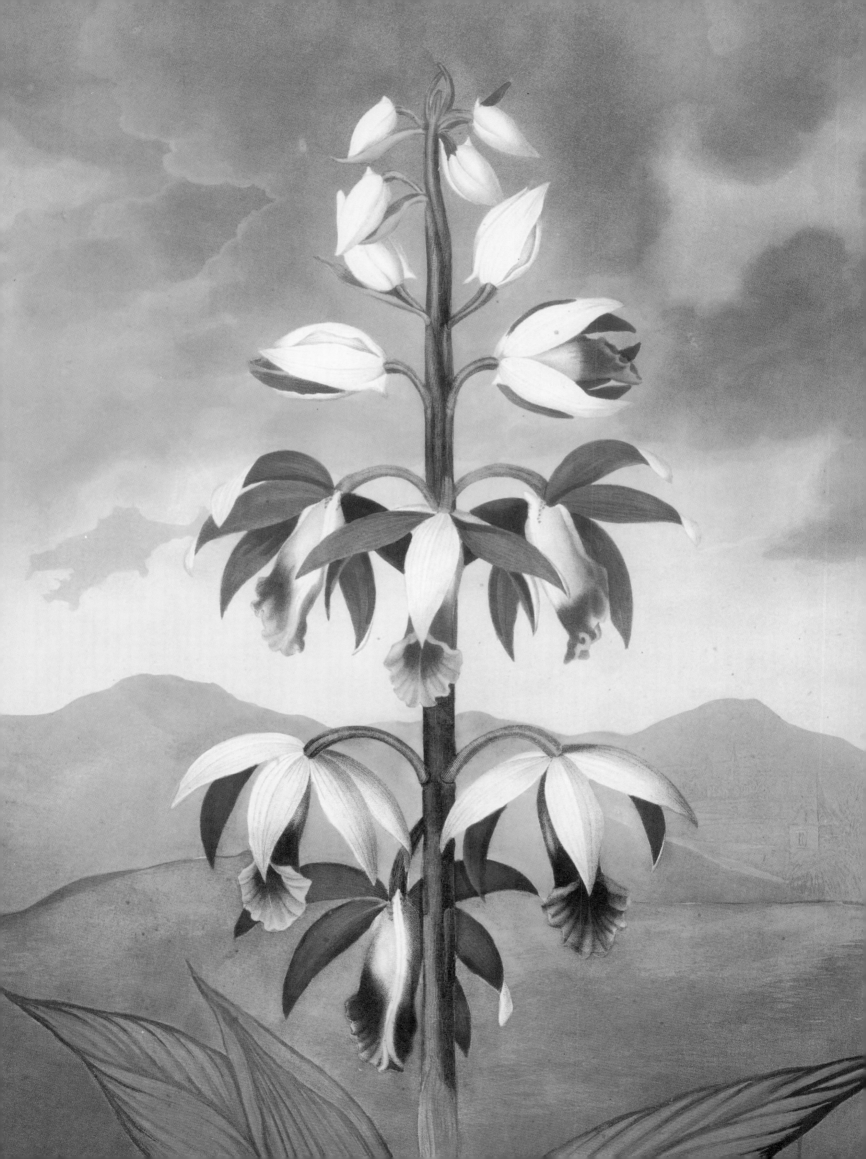

23:

Piercing the
Oriental Armour

FOR MOST PEOPLE IN THE EIGHTEENTH AND NINETEENTH CENTURIES, THE
Orient lived only in their imagination. Accounts by travellers painted a picture of
exotic peoples and ancient customs in lands where Europeans had always been
uncomfortable visitors. Eastern and Western civilisations shared a mutual
distrust, based on prejudice and misunderstanding. Yet by the mid-eighteenth
century, despite tightly veiled cultures, some plants of Chinese and Japanese
origin had found their way to the West via the Silk Road and through the trading
ventures of the Portuguese and Dutch. Citrus species were early Chinese
introductions to Europe, as were the peach and apricot (*Prunus persica* and
P. armeniaca). Ornamental flowering plants such as the Chinese *Hibiscus syriacus*
had also become popular. Eighteenth-century botanical naming invoking Persia,
Armenia, and Syria betrayed widespread misunderstanding about the Orient and
the long history of its plant introductions.

It was a French Jesuit, Pierre d'Incarville, who pioneered a new intensive
phase of plant collecting in China in the mid-eighteenth century. Gaining
imperial favour through plant exchanges, d'Incarville was able to send the golden
rain tree (*Koelreuteria paniculata*) overland to Paris with a Russian caravan,

opposite: **Dr John Fothergill, a
colleague of Joseph Banks and
Peter Collinson, funded numerous
plant-collecting forays to enrich his
garden outside London. The Chinese
limodoron (*Phaius tankervilliae*),
introduced in 1778, was one of his
many introductions, and amongst
the earliest Asiatic orchids cultivated
in Europe.**

**Trading companies facilitated many
plant introductions during the
seventeenth and eighteenth centuries,
especially from those countries
where access was severely restricted.
Benjamin Torin, stationed at Canton
for the East India Company, was
amongst those who responded to
requests for plants. One of his
shipments in 1770, sent to Joseph
Banks at Kew Gardens, included the
sweetly fragrant shrub *Daphne odora*,
long a favourite amongst Chinese
(and Japanese) gardeners.**

Japan yielded many plants adapted to cool European climates, including the hortensia hydrangeas (*Hydrangea macrophylla*), introduced to Britain in the late eighteenth century.

and later sent seeds of the oriental thuja (*Platycladus orientalis*) and tree of heaven (*Ailanthus altissima*). Employees of the British East India Company also played an increasingly significant role in plant importations, even though their access to China was severely restricted. Benjamin Torin, based at Canton (now Guangzhou) in southern China, consigned plants to Kew Gardens in 1770, including daphne (*Daphne odora*) and *Osmanthus fragrans*, fragrantly flowered shrubs both new to British gardens.

British diplomatic overtures to China in the 1790s yielded additional plants new to European horticulture. The embassy of Lord Macartney (1792–93) included two gardeners and a naturalist, who successfully introduced Macartney's rose (*Rosa bracteata*), one of the earliest Chinese roses to be grown in Europe. The introduction of roses from China effected a revolution in rose breeding in the early nineteenth century. Varieties of *Rosa chinensis* became a mainstay, valued especially for their delicacy and quality of remontancy (repeat flowering in the same season). Even rose breeders could go too far, however—'turning a Greek goddess to the stoutest of matrons' British garden writer Mrs Earle lamented much later in the century, a sentiment vigorously endorsed by today's enthusiasts for 'old fashioned' roses.

Many garden plants were found widely distributed across China, Korea, and Japan. Often this was due to similarities in climate and geography, but it also reflected the early introduction of plants from one country to another, spanning perhaps two millennia. The region ranged across extremes from north to south, and over large distances from coast to interior. The southern parts of China, including the ports of Macau and Canton, shared much in common with the tropical East Indian flora. Shanghai and the southern tip of Japan enjoyed a subtropical climate, while northern China and the northern islands of Japan shared similar latitudes to northern Europe. Whilst many early introductions had been made between tropical areas, it was the ability of northern and inland areas to yield plants suited to cool temperate European climates that made China and Japan such an enticing horticultural focus.

The Chinese flora was afforded sporadic attention by European botanists of the seventeenth and eighteenth centuries, with several attempts to produce a *Flora Sinensis*. For many years, Japan also remained elusive to European botanical authors, although tentative steps towards a *Flora Japonica*—including the earliest, by Linnaean pupil Carl Thunberg (1784)—did produce a work of great magnificence in the mid-1830s. German surgeon, Philipp Franz von Siebold, was posted to Japan with the Dutch East India Company in 1826, where his skill attracted favourable attention from his hosts. Travelling beyond the confines of the Dutch concession of Deshima, Siebold was able to collect a wide range of Japanese natural history specimens and goods. Collaborating with compatriot Joseph Zuccarini, Siebold's *Flora Japonica* (Leiden, 1835–70) highlighted plants with horticultural potential. Amongst the plants described and illustrated by Siebold was the royal paulownia (*Paulownia tomentosa*), named for Anna Paulowna (daughter of Czar Paul I of Russia and wife of William II of the Netherlands), and introduced to Europe in the 1830s. (So rapid was its growth that, according to Chinese legend, a tree planted on the birth of a daughter yielded timber sufficient for a wardrobe as part of her dowry.) Others such as the ginkgo (*Ginkgo biloba*) and loquat (*Eriobotrya japonica*) had also enjoyed long cultivation in Japan (and China). Siebold sent plants back to Europe, including in 1830 the beautiful pink-throated *Lilium speciosum*, long a favourite of Japanese artists, and known in the West since its description by Dutch East India Company physician–botanist Engelbert Kaempfer in the 1690s.

Siebold's *Flora Japonica* was by no means the only contemporary coloured illustrations of the Chinese and Japanese flora. The illustrated botanical journals published by Curtis, Andrews, Edwards, and others contained many illustrations of new plants, particularly those introduced as a result of professional plant-collecting expeditions. In 1803 gardener William Kerr was sent by Joseph Banks to China on behalf of Kew Gardens. He stayed eight years, although he did not travel far outside Canton and Macau. His reputation was marred by (unsub-stantiated) suggestions of opium addiction—a drug that the British were actively

A wide range of plants encountered in Japan by Western plant collectors were Chinese in origin yet had a tradition of Japanese cultivation stretching back many centuries. The veneration of the Japanese cedar (*Cryptomeria japonica*) is evident in this print 'Great Cryptomeria at Mishima Ko' (after the celebrated Japanese artist Hokusai). Robert Fortune sent seeds of this conifer from Shanghai to London in 1844.

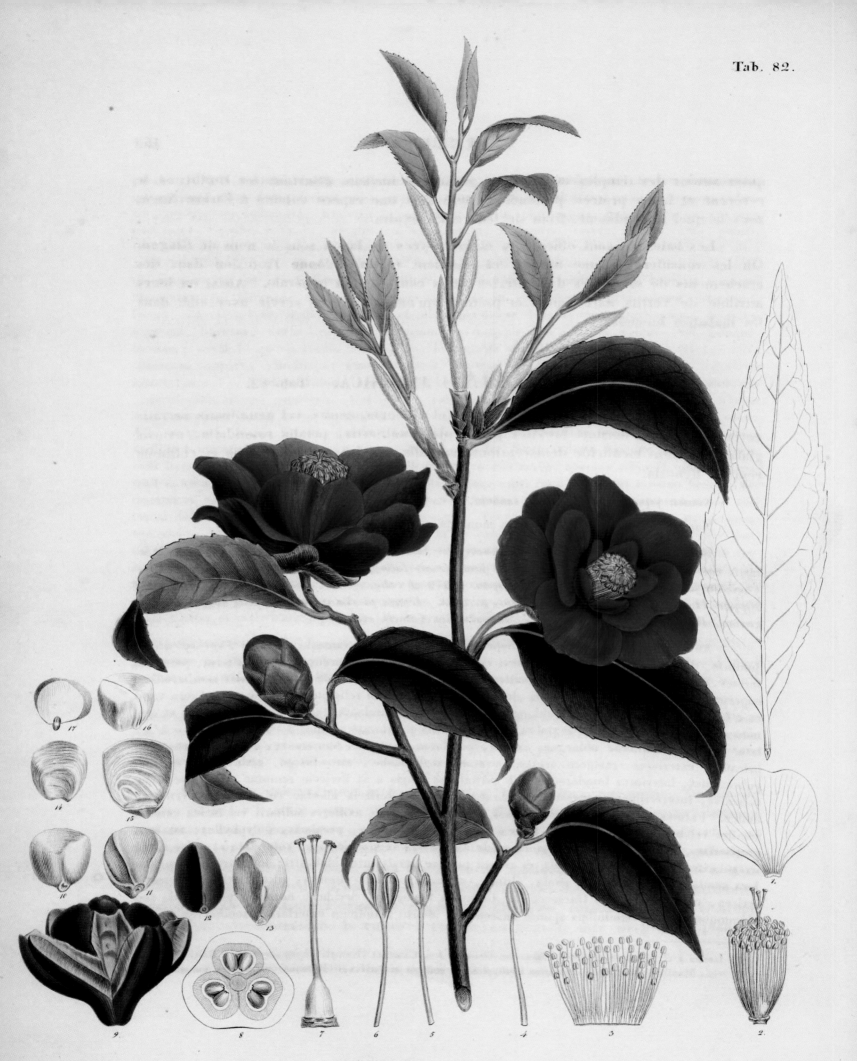

Tab. 82.

CAMELLIA *japonica* .

Tab. 136.

SALISBURIA adianthifolia.

FLORA JAPONICA

SIVE

PLANTAE,

QUAS IN IMPERIO JAPONICO COLLEGIT, DESCRIPSIT,
EX PARTE IN IPSIS LOCIS PINGENDAS CURAVIT

Dr. PH. FR. de SIEBOLD,

SECTIO PRIMA

CONTINENS

PLANTAS ORNATUI VEL USUI INSERVIENTES.

DIGESSIT

Dr. J. G. ZUCCARINI,

CENTURIA PRIMA.

LUGDUNI BATAVORUM
APUD AUCTOREM
1835.

With its magnificent large-format, hand-coloured lithographic plates, Siebold's *Flora Japonica* (Leiden, 1835–70) was the earliest comprehensive European depiction of Japan's botanical riches. Many of the plants were of Chinese origin, but their inclusion reflected long traditions of garden cultivation in Japan. Outstanding gardening introductions include the Japanese camellia (*Camellia japonica*), maidenhair tree (*Ginkgo biloba*), royal paulownia (*Paulownia tomentosa*), and loquat (*Eriobotrya japonica*).

Tab. 10.

PAULOWNIA imperialis.

ERIOBOTRYA japonica.

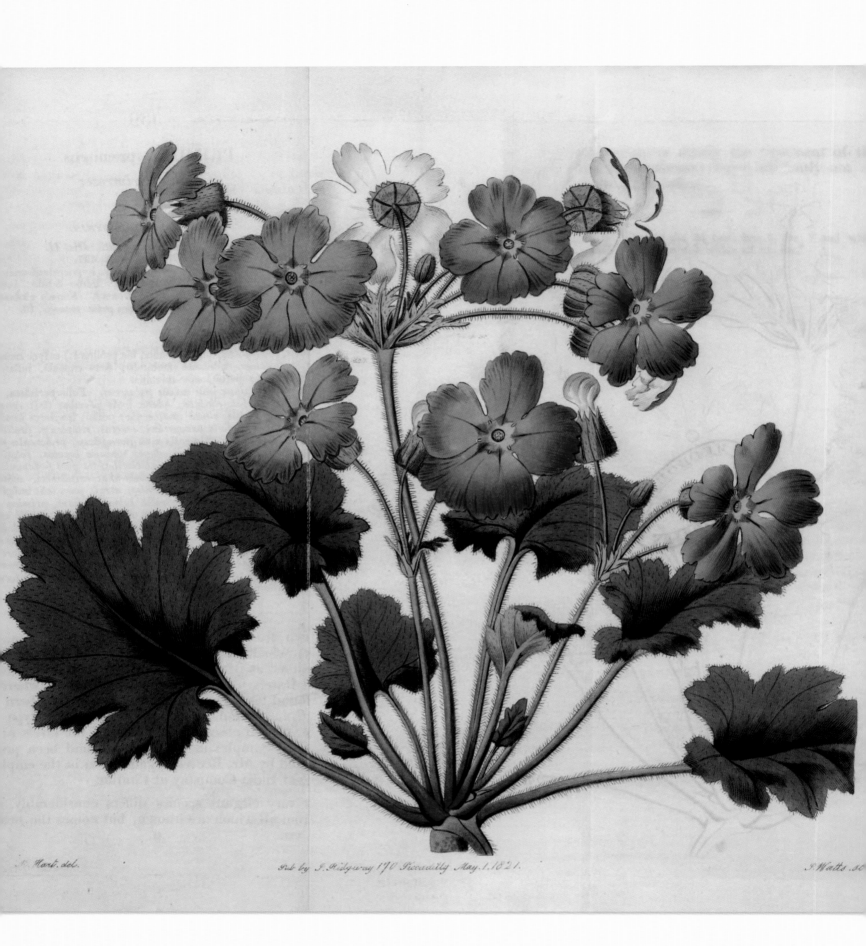

N. Hart. del. Pub by J. Ridgway 170 Piccadilly May.1.1821. J. Watts. sc.

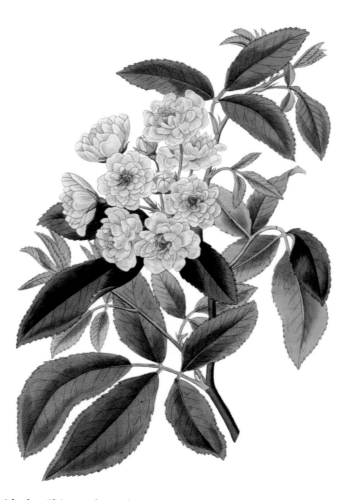

trading with the Chinese through a system of private traders sanctioned by the East India Company—yet Kerr was responsible for a fine haul of new plants. These included heavenly bamboo (*Nandina domestica*), the white-flowered Banksia rose (*Rosa banksiae*), and the striking orange and black-spotted tiger lily (*Lilium lancifolium*)—so successful was this last that by 1812 William Aiton had propagated and distributed 10,000 bulbs from Kew.

As Kerr was commencing his work in China, influential gentlemen of the British garden world were meeting to form the Horticultural Society of London, forerunner of the Royal Horticultural Society. Within twenty years, the Society had established a garden at Chiswick, in London's west, adjacent to the villa of the Duke of Devonshire. The garden acted as a depot for newly introduced plant varieties (especially fruit), where they could be trialled, propagated, and inspected by members. The Society's collection of Chinese plants soon swelled, and in 1820 following the offer of a berth, Chiswick gardener John Potts was selected to undertake the collection of additional plants. His brief stint in China was promising, although a major collection of chrysanthemum cultivars was lost on the voyage home. A second expedition to China, this time organised at the Society's behest, was undertaken during 1823–24 by John Parks. His collecting yielded new varieties of chrysanthemum and *Camellia japonica*, the double yellow Banksia rose, and *Aspidistra lurida*, which became a staple of the indoor gardener. Parks also returned with *Camellia reticulata*, then known in the West only from a variety collected several years earlier by Captain Richard Rawes (who had also introduced the Chinese primrose, *Primula sinensis*).

Potts and Parks were both ably assisted by John Reeves, a Canton-based tea factor with the East India Company. Reeves had returned briefly to London in 1816 with a collection of potted plants from his garden on Macau, and was commissioned by the Horticultural Society to obtain a collection of plant

The double yellow variety of Banksia rose (*Rosa banksiae*) was amongst the Chinese plants introduced to European horticulture as a result of plant collecting sanctioned by the Horticultural Society of London. Perhaps even more important was the arrival in England during this period of the earliest tea roses from China. These were soon crossed with European varieties, uniting the new colours and scents of the repeat-flowering Chinese roses with the hardiness and vigour of traditional European stocks.

opposite: The genus *Primula* enjoys a wide distribution, especially in Europe where it has long been a garden favourite. The earliest Asiatic species to be introduced, the Chinese primrose (*P. sinensis*), was sent from Canton to London in the early 1820s, part of an increasing flow of plants from China in the early nineteenth century.

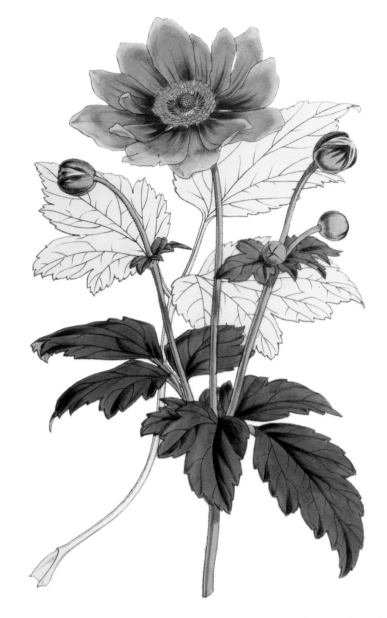

The Japanese anemone (*Anenome hupehensis* var. *japonica*), introduced by Robert Fortune as a result of his plant collecting for the Horticultural Society of London, was amongst the most valuable of his garden introductions. This striking perennial had been described in the late eighteenth century by Swedish botanist Carl Thunberg, and in 1844 Fortune found the plant in Shanghai, profusely flowering in the local cemetery.

portraits by Chinese artists (of the so-called Company School). These drawings depicted many of the plants then being introduced from China, including *Camellia reticulata* and the Chinese wisteria (*Wisteria sinensis*), both sent to England through the agency of Reeves. Another source of plants was the nursery of the celebrated Fa Tee Gardens at Canton, which specialised in traditional Chinese favourites—much to the chagrin of visiting plant collectors, rare or novel plants were accorded a low priority. In an era when travel by foreigners to interior regions was still largely prohibited, this nursery was a vital depot.

Apart from his support of the Horticultural Society, Reeves was actively involved in the transfer of plants, including their introduction to many other centres. With his friend and neighbour on Macau, Thomas Beale, Reeves was responsible for sending more than thirty plants to Charles Fraser at the Sydney Botanic Garden during the 1820s, for instance, including *Ginkgo biloba*, *Camellia japonica*, *Hibiscus rosa-sinensis* and *H. mutabilis*, and several of the citrus tribe. Reeves also urged the Horticultural Society to send out additional collectors, and the opportunity came in 1842 with the signing of the Treaty of Nanking. Britain had been at war with China over the importation of opium from India, which the Chinese unsuccessfully resisted. Through the Treaty, the British were able to establish consular facilities, and gain much-desired access to Chinese ports. The Horticultural Society was ready, and its Chinese Committee (chaired by Reeves) drew up detailed instructions for collector Robert Fortune.

The British predilection for tea (dating from the early eighteenth century) and a desire to break the Chinese monopoly on its trade fuelled the quest to introduce plants of the parent *Camellia sinensis* from China to Anglo-Indian plantations in the Himalayas. Early efforts failed, but using the latest technology of glazed and sealed Wardian cases, Robert Fortune managed to transport many thousands of germinated seedlings in the late 1840s and early 1850s, thus establishing the Indian tea industry.

Fortune's name was a good omen. He arrived in Hong Kong—which the Chinese had ceded to Britain—in 1843, armed with instructions and assisted by the sons of Reeves and Beale. Plants that would be hardy in British conditions were of paramount importance—'the value of the plants diminishes as the heat required to cultivate them is increased' instructed the Committee. On his outward journey, Fortune had travelled with Wardian cases of plants destined for the new British settlement at Hong Kong. This mode of transport had only been trialled a decade earlier, and was instrumental in the success of Fortune's introductions on the return leg. Although he undertook only limited inland travel and was therefore often reliant on plants found in gardens, Fortune reaped a fine harvest. Amongst his introductions were the Japanese anemone (*Anemone hupehensis* var. *japonica*), bleeding heart (*Dicentra spectabilis*), winter jasmine (*Jasminum nudiflorum*), Japanese snowball bush (*Viburnum plicatum*), and the Chusan palm (*Trachycarpus fortunei*). The success of Fortune's collecting was immediately compared with that of fellow Scot David Douglas, in north-west America—both had introduced plants suited to outdoor garden cultivation rather than the restricted preserve of the heated glasshouse. Fortune's reputation was also enhanced by the success of his book *Three Years' Wanderings in the Northern Provinces of China* (London, 1847), which conveyed his travels in vivid prose to an eager audience.

Fortune returned to China in 1848 on a much increased salary and now under the auspices of the East India Company. His primary objective was to obtain Chinese tea plants (*Camellia sinensis*) as well as 'native manufacturers and implements' to establish British plantations in the Himalayas. His use of Wardian cases to transfer tender seedlings under the noses of his hosts was a great success, and the establishment of a tea industry in India is a ripping yarn of the British Empire. The Second Opium War (1856–60) further opened China to the West, and followed hard on the heels of the Treaty of Kanagawa (1854), which had established diplomatic relations between Japan and the United States. Walls of suspicion and antagonism had been breached, and although China and Japan (and Korea for that matter) remained elusive to the Western grasp, the plants that had for so long enriched local gardens and embroidered folkloric traditions were now a global commodity.

A plant of ancient origins, the Japanese umbrella pine or parasol pine (*Sciadopitys verticillata*) was introduced to Europe and North America in the mid-nineteenth century. Unlike many other conifers of unkempt habit, the whorled architecture of this pine has an expressive quality perfectly suited to the quiet joys of Japanese aesthetics.

A PLAN OF THE BOTANIC GARDEN AT BROMPTON.

The botanic garden of William Curtis, established at Brompton in the late eighteenth century and continued by his successors, heralded a new style of plant display. Here in inner London the scientific dimension of botany was blended with the needs of commerce. Curtis was a pioneer in botanical periodicals, often illustrating plants from his own garden in the *Botanical Magazine* (established in 1787 and still in publication).

opposite: From its base in Birmingham, *The Floral Cabinet, and Magazine of Exotic Botany* was amongst the plethora of illustrated botanical magazines that appeared in the early nineteenth century. The enticing frontispiece to the first volume (1837) clearly signalled the intention of its publishers to favour horticulture over botany.

24: Commerce and the Insatiable Taste for Novelty

FEW CORNERS OF THE WORLD WERE LEFT UNEXPLORED BY THE MID-nineteenth century. 'Nurserymen to the world', a slogan later used to describe the British nursery trade, telegraphed the expansive mood of the early nineteenth century and its implications for global trade. Urbanisation of major metropolitan centres in the wake of the Industrial Revolution, the consequent rise of a middle class seeking to embellish their villas with gardens, an era of relative peace in Europe, and the flood of new plants, all fuelled the rise of the nursery trade. Those in the business of selling plants unashamedly promoted new horticultural specialisations, and their publications were at the forefront of disseminating new trends.

When William Curtis published the first number of his *Botanical Magazine*, in 1787, he established a new publishing genre. Issued in regular parts containing several hand-coloured engravings and accompanying botanical text in letterpress, Curtis's magazine tapped into a new market of subscribers sufficiently affluent to purchase a journal but perhaps unable or unwilling to subscribe to more expensive books. His new magazine soon had competition, most notably from Henry Andrews, who established the *Botanist's Repository* in 1797. The insistence by Andrews of featuring only rare and newly introduced plants ensured that the *Repository* was well placed to capitalise on the flood of horticultural arrivals from areas such as the Cape ahead of his more conservative rival Curtis.

Nursery proprietor John Kennedy wrote many of the descriptions in the early volumes of the *Botanist's Repository,* and the commercial acumen of Andrews saw a close and strategic relationship develop with the Hammersmith nursery of Lee and Kennedy, London's major depot for the burgeoning trade in new plant imports. Other nursery proprietors also saw the benefits of publishing a magazine to promote the plants they were selling—Loddiges in London, van Houtte in Ghent, and Meehan on the east coast of the United States were amongst those who published or edited journals that yoked botany with commerce. Each brought a slightly different slant, and in a concentrated field, plagiarism was rife. Louis van Houtte's *Flore des serres* was notorious for copying plates that had first appeared in the British journals, and even made a feature of the practice. The title of van Houtte's journal also signalled the apogee of the glasshouse (or *serres* in French), that by the mid-nineteenth century had reached a mass market.

The care of tropical plants had long bedevilled gardeners. Cool temperate climates in Europe and North America precluded the growth outdoors of many new plant introductions, and hothouses were affordable only by the wealthy. Experiments in the late eighteenth century with piped steam heating—instead of the more cumbersome and unreliable system of hot-air flues—paved the way for a revolution in glasshouse design. The breakthrough finally came almost two decades into the nineteenth century, when the natural circulation of hot water in pipes was found to suit the heat requirements of tropical plants. By trial and error, artificial climatic conditions were optimised, although the costs involved

THE

FLORAL

CABINET.

Nomenclature may have changed, but 'Getting a Brazilian' meant something very different to hothouse devotees of the nineteenth century. Who among Eve's Victorian daughters would not have been tickled by the tropical American splendour of *Cypella caerulea* (also known as *Marica caerulea* and *Morea northiana*). In this delicately water-coloured plate from Edwards' *Botanical Register*, the short, curly, black-striped inner petals of this showy bloom have been painstakingly picked out by hand.

still placed a heated glasshouse beyond the reach of the average gardener. Similar though less intensive investigations in tropical and subtropical climates sought to perfect lathed shadehouses where plants from the temperate world might flourish. Favourites from 'home' were just as much a dilemma for the colonial gardener in Sydney or Cape Town as showy tropical plants were in the Northern Hemisphere.

Two further revolutions in glazing awaited horticulture. The first was the invention of the Wardian case. The second was the repeal in 1846 of the tax on glass that had inflated prices of horticultural buildings in Britain. The Wardian case had its origins in the late 1820s, when English physician and naturalist Nathaniel Bagshaw Ward chanced upon the growth of small plants in a bed of mould at the bottom of a stoppered glass jar. Observing the principles of transpiration in this microenvironment, he set about constructing a tightly sealed, glazed case which, when protected with timber strapping, afforded a sufficiently robust environment for the protection of living plants during sea voyages of several months. The London nursery firm of Conrad Loddiges and Sons trialled the Wardian case in 1833 with a successful consignment of plants destined for Sydney Botanic Garden, then refilled with Australian plants for the return leg. This innovation facilitated introductions of a host of new plants to Europe, including ferns, orchids, and aroids, and the dispatch of stock to colonial nursery proprietors and botanic gardens. Journal descriptions and Ward's own book, *On the Growth of Plants in Closely Glazed Cases* (London, 1842), popularised the use of the case for transporting plants, as well as its more decorative use for growing plants indoors. Coupled with advances in wrought-iron glazing bars and prefabrication of glasshouses, the greater affordability of such structures led to an unrivalled demand for plant houses, large and small.

above: The myriad glasshouses and boiler chimneys of the Van Houtte nursery in Belgium demonstrate the intensive cultivation required for fashionable hothouse plants in mid-nineteenth century Europe.

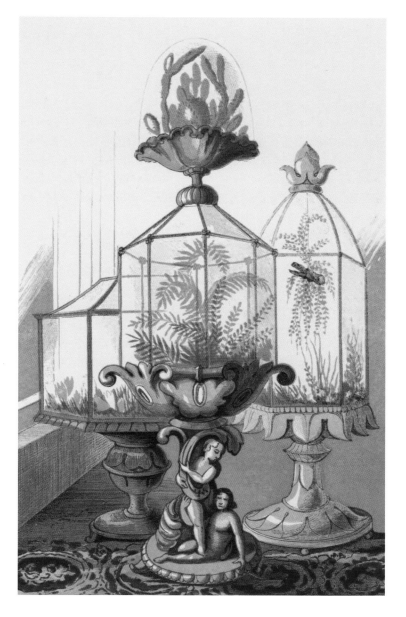

From its introduction in the 1830s, the Wardian case—a tightly sealed, glazed plant case—had many benefits for horticulture. Its enclosed self-sustaining environment allowed plants to be transported by sea with far greater chance of survival than previously, encouraging a flow of plants between distant ports. For the indoor gardener in gas-lit, fume-ridden parlours and polluted industrial cities, the Wardian case took on a decorative manifestation belying its utilitarian beginnings.

Botanist William Curtis originally had no intention of illustrating cultivated varieties of plants in his *Botanical Magazine*, yet soon bowed to subscriber pressure to figure the occasional florist's novelty, such as this bizarre carnation (*Dianthus caryophyllus* 'Franklin's Tartar'). These 'monsters', and their corresponding lack of descriptive botanical text, reduced the magazine to a mere 'drawing book for ladies' (according to *The Temple of Flora* author Robert Thornton).

opposite: The Queen of the Night cactus (*Selenicereus grandiflorus*) was a great favourite of the humid tropical stovehouse of the 1830s and 1840s. This celebrated illustration from Thornton's *The Temple of Flora* shows the moonlit clock at a minute past midnight, appropriate for this shy nocturnal bloomer and suggestive of assignations between patron and painter, breathlessly recounted by some later imaginative botanical writing.

The work of the hybridist came of age in the nineteenth century. Plant breeding had traditionally relied on judicious selection of naturally occurring variations (or 'sports'), but with the recognition during the eighteenth century of sexual reproduction in plants, a new horticultural era was dawning. Artificial breeding enabled the selective enhancement of plants, especially in the size, marking, and colouring of flowers and foliage. The powerful cocktail of commerce and novelty which had manifest itself in 'tulipomania' during the early seventeenth century, now created a similar demand for novel varieties of auricula, calceolaria, carnation, pansy, and ranunculus. Idealised properties of the most popular 'florist's flowers' were set down in precise terms, bringing new interest in competition amongst plant enthusiasts. With competition came the continual quest for new varieties, and novelty began to overwhelm the nursery industry. Profits were maximised by the rapid sale of novel varieties: each year brought a new 'sensation' to the covers and centre spreads of nursery catalogues, as the retail trade came to rely on this annual boost to supplement sales of traditional stock.

Apart from new cultivated varieties of plants, the never-ending stream of new plants from the Cape, the East Indies, the Americas, and Australia during the nineteenth century provided new specialisations for plant enthusiasts and gardeners. No longer was a large garden required to satisfy horticultural urges: a collection of plants could now be formed in the artificial confines of the glasshouse or modest yard. Ferns were an early favourite amongst collectors and horticultural decorators, especially after the widespread introduction of the Wardian case. A comparable, though less sustained interest, was seen in the fascination for cacti and other succulents. Bold-foliaged plants, such as begonias, bromeliads, caladiums, and crotons, were increasingly valued in the conservatory, and their subsequent cultivation outdoors in Europe led to a fashion for

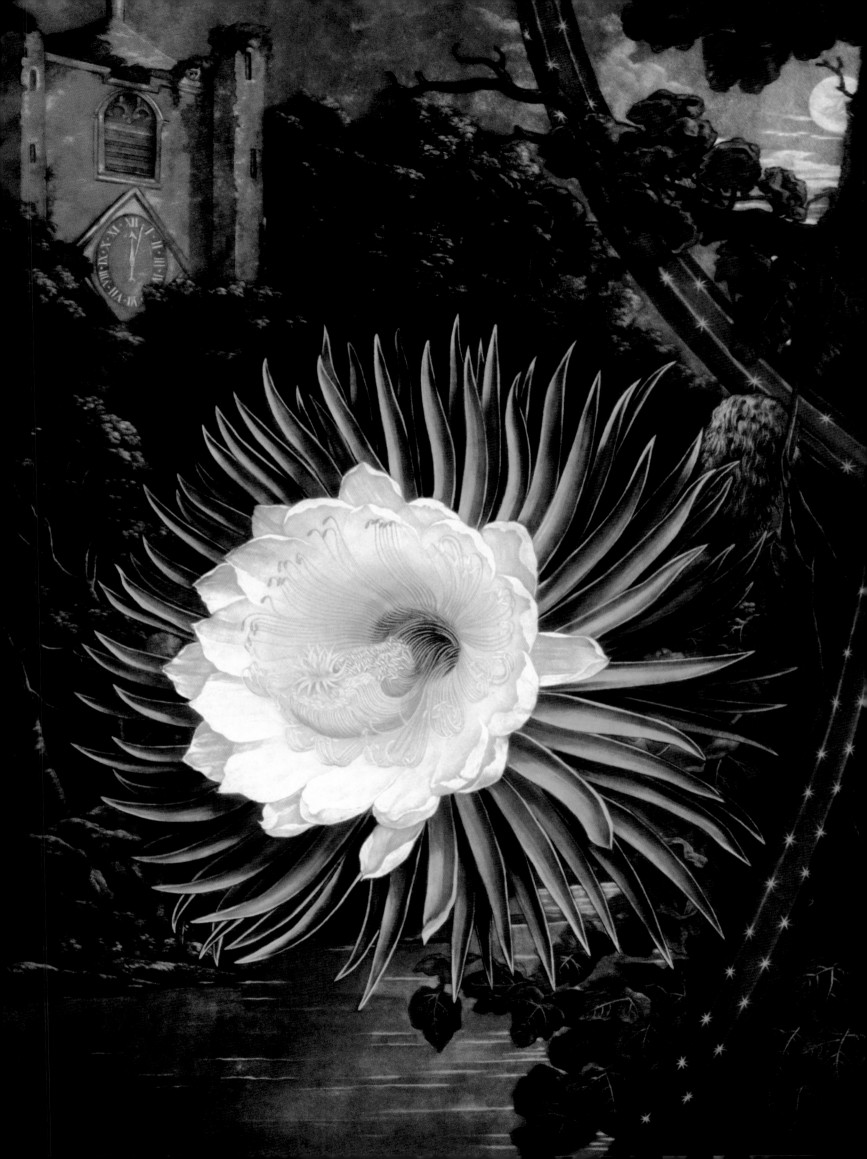

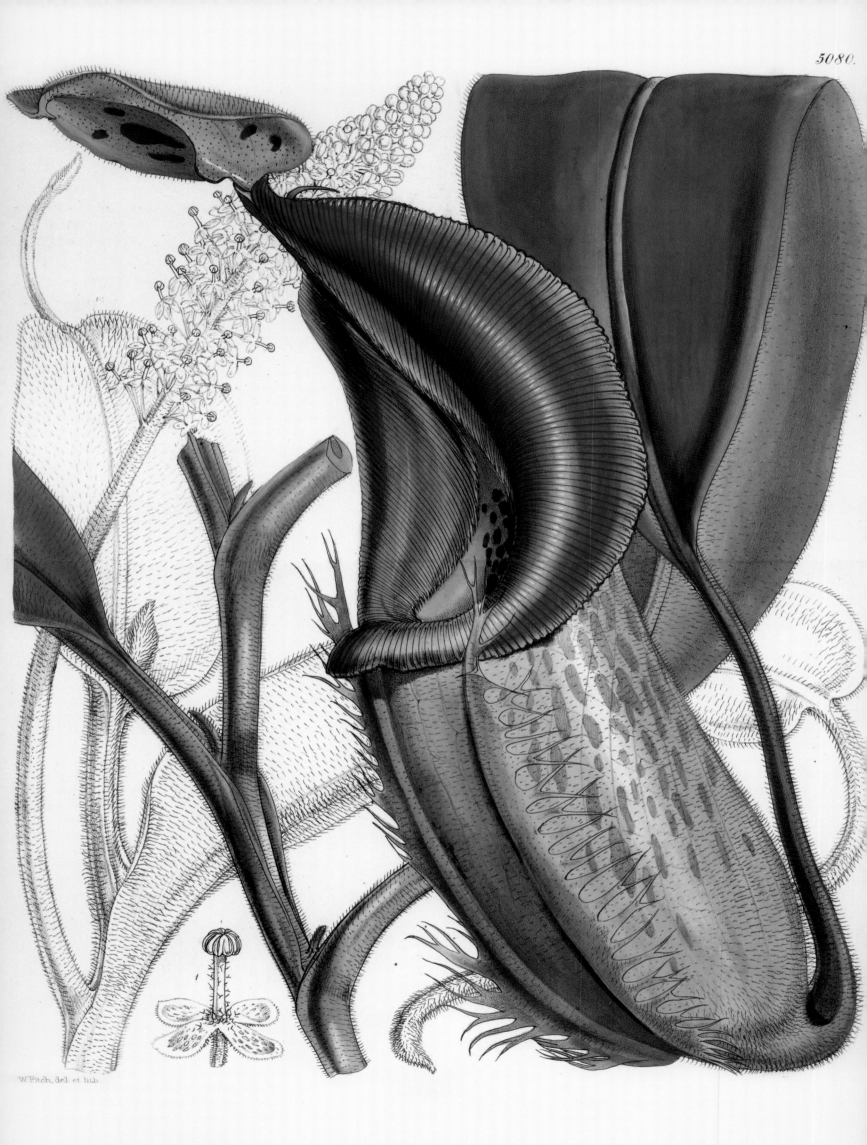

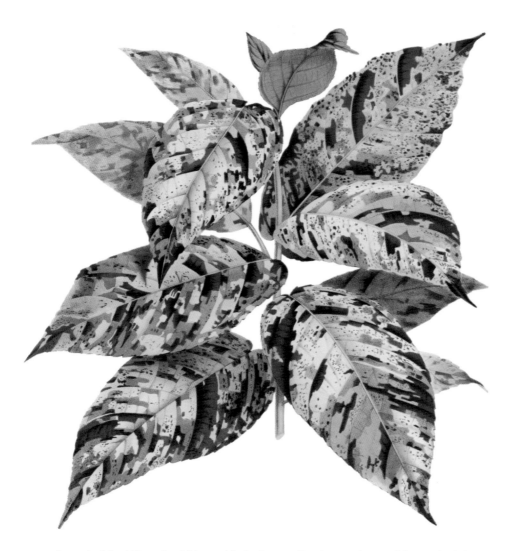

subtropical bedding. Orchids typified plant collecting at the wealthy end of the scale, although with the realisation in the mid-nineteenth century that many species could thrive in the cool greenhouse, the cost of heated accommodation was obviated. Perhaps the most elite specialisation was seen in the quest to flower the giant Amazon lily (*Victoria amazonica*), with its idiosyncratic demands for warm flowing water approximating its natural habitat.

As the nineteenth century progressed, plant collectors were increasingly employed by nurseries to ensure businesses maintained a competitive edge. Early commercial collecting had shown promise but it was the advent of the Wardian case, and the reliability it promised, that provided nursery proprietors with a spur for action. The Veitch dynasty of nursery proprietors commenced their business in the early nineteenth century, and soon maintained major nurseries at Exeter, Devon, and in London at Kings Road, Chelsea. The firm was a leader in plant imports and exports—its London business styled itself as the Royal Exotic Nursery—and from the 1830s Messrs Veitch employed their own collectors. Their earliest collecting was undertaken by the enterprising Cornish bothers William and Thomas Lobb, who travelled extensively in the Americas and the East Indies. From Chile came seed of the monkey puzzle (*Araucaria araucana*) in commercial quantities; from the rainforests of Java, the blue-flowered orchid *Vanda caerulea*; and from north-west America the western red cedar (*Thuja plicata*). Collecting for the Veitch nurseries continued apace throughout the nineteenth century, a tradition proudly recalled in the firm's lavish history, *Hortus Veitchii*, published in 1906.

Yet, as the twentieth century dawned, a great era of plant collecting was drawing to a close. Remote parts of China yet remained to yield their riches, but this was to be the botanical swansong in a rapidly changing world.

above: Of all the flowers popularised during the nineteenth century, none exceeded the orchid in the passion of its fanciers. The splendour of their blooms, the grace of their habit, and the exoticism of their habitats combined in unexcelled fusion. With prices matching passion, orchids bestowed social cachet on their owner, be it in the intimacy of the conservatory or the more public theatre of the show bench.

above left: The plant collecting of gardener Henry Parcel in the Pacific provides a foil to the better-known exploits of plant collectors sent by large British nurseries. Collecting during the late 1860s for Sydney nursery proprietor John Baptist, Parcel was rewarded for his collection of several commercially viable foliage plants, including the one named for him, *Ficus parcelii* (now *F. aspera*).

opposite: The pitcher plants of Borneo (such as *Nepenthes villosa*, introduced to horticulture by the Veitch nursery in the 1850s) possessed a fatal attraction, their engorged lips alluring to insects and collectors alike.

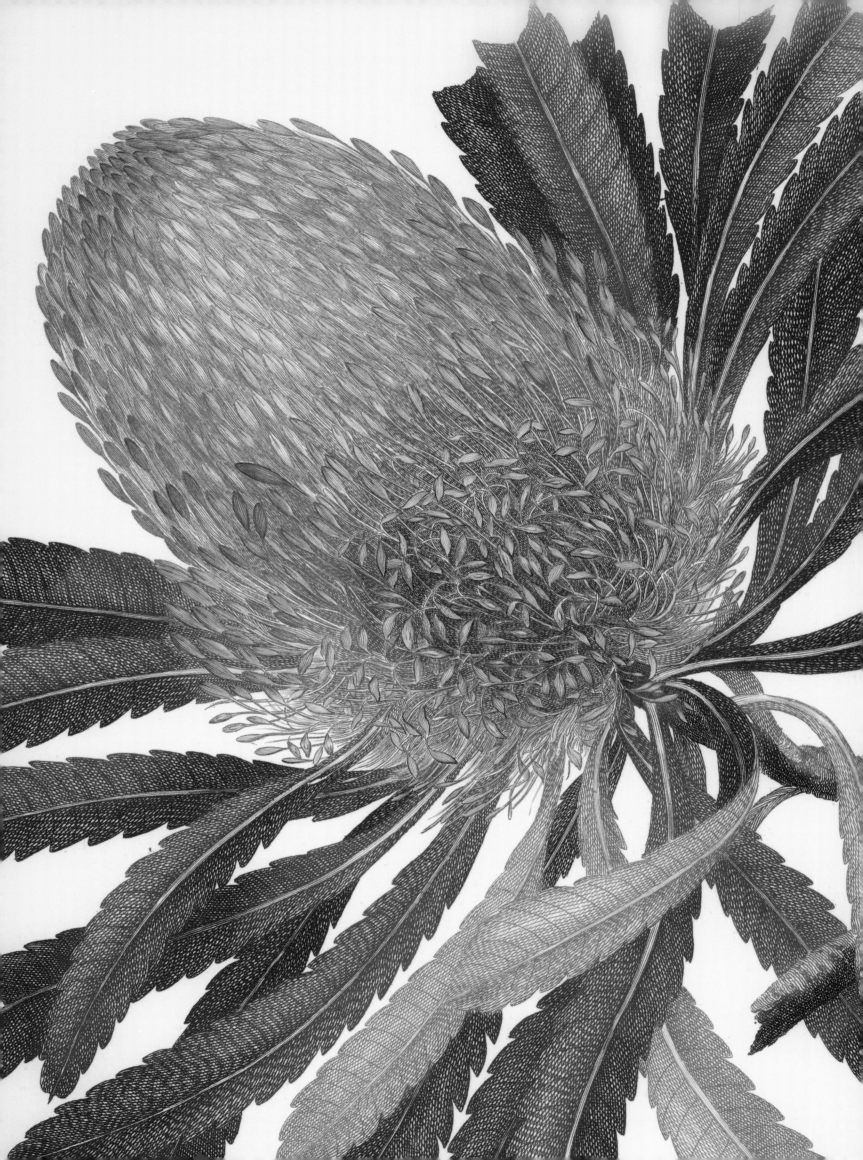

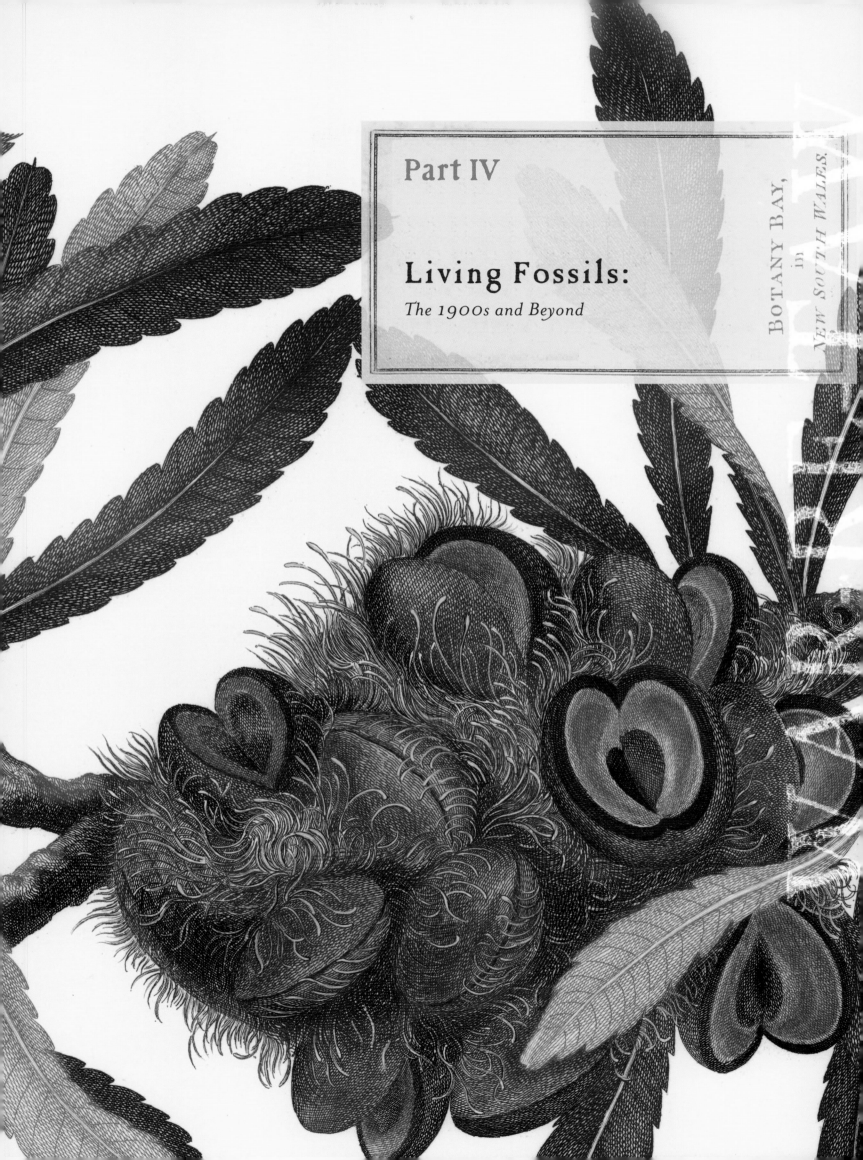

Part IV

Living Fossils:
The 1900s and Beyond

Wollemi Dreaming

WE CAN ALL DREAM OF WONDROUS NEW BOTANICAL RICHES, BUT, WITH isolated well-documented examples, the wild mountainous areas of China's inland provinces were to be the last great frontier for ornamental plant collecting. China had already proved a rich field for horticulture, and in 1898 the Russian physician and botanist Emil Bretschneider published his *History of European Botanical Discoveries in China*. This astonishing work, produced after a residence in Peking (Beijing) and extensive research in the herbaria and botanic gardens of Europe, catalogued major contributions to the world's gardens, especially by British, French, and Russian collectors. But as Bretschneider was concluding his work in St Petersburg, the great Veitch nursery in England was preparing to add a concluding chapter to this swirling chronicle.

Messrs Veitch were mindful of Chinese plant collecting that had, in the last decades of the nineteenth century, enriched European herbaria, especially those in Paris. Two French missionaries, Père Armand David and Père Jean Marie Delavay, had collected dried specimens and seeds in China's Hupeh, Szechuan, and Yunnan provinces during the 1860s–90s. From these, many plants new to European gardens had been raised, but many remained static in the compressed sheets of the herbarium. The Veitches were especially interested in the handkerchief or dove tree (*Davidia involucrata*), which David had described a generation earlier. A third collector, the Scot Augustine Henry, who had greatly enriched the herbarium of the Royal Botanic Gardens, Kew, now offered to assist Sir Harry Veitch and the nursery's collectors in China. Ernest Wilson was selected for the mission on the recommendation of William Thiselton-Dyer (son-in-law of Sir Joseph Hooker, and successor as director at Kew to Hooker father and son).

Ernest Wilson was just twenty-three when he sailed for China. Travelling via the Atlantic, Wilson met Charles Sargent, director of the Arnold Arboretum at Boston, for whom he later collected, enriching an outstanding institution. The object of the Veitch mission—viable seeds of *Davidia involucrata*—was found with improbable ease given the imprecise instructions that Augustine Henry had been able to offer. But the seed was merely the precursor of an abundant haul of hardy plants that could enrich newly fashionable woodland gardens at home. Species of *Rhododendron*, *Magnolia*, and *Viburnum* were all dispatched, along with the Chinese gooseberry (*Actinidia chinensis*), initially grown for its modest flower, but now a widely marketed fruit. Wilson's prize was undoubtedly the regal lily (*Lilium regale*), with its elegant slender stems and deliciously perfumed flowers ('wine-coloured without, pure white and lustrous on the face, clear canary yellow with the tube and each stamen filament tipped with a golden anther' he enthused). To gardeners around the world, these lilies offer a chance to recapture, in miniature, the 'veritable fairyland' of their origin.

The gardens in which these Chinese plants found homes included those influenced by the British horticulturist and taste-maker, William Robinson.

Lilium regale.

9185.

L.Snelling del.et lith.

His books promoted the use of low-maintenance hardy plants that might naturalise in Britain's cool temperate climates. His ideas were popularised at the turn of the twentieth century by the fashion for Alpine gardens, in which Chinese plants could provide exotic and keenly sought highlights. Those who followed Wilson in China—including George Forrest, Frank Kingdon Ward, and Reginald Farrer—broadened the range of plants suited to such gardens by locating and collecting many species known to earlier collectors, as well as introducing finds of their own. Amongst numerous plants introduced by Forrest were *Gentiana sino-ornata*, with its intense blue flowers, and the showy white-flowered *Rhododendron sinogrande*, noted also for its massive leaves, often half a metre or more in length.

Farrer and Kingdon Ward not only collected, but were prolific authors. Farrer's books on alpine gardening did much to popularise the newly introduced plants, while Captain Kingdon Ward's travel adventures were Biggles' tales for the horticultural world. Treacherous river journeys were mixed with the unbounded joyfulness of discovery, such as his first sighting in Tibet of the elusive blue poppy (*Meconopsis betonicifolia*). The flowers of *Gentiana sino-ornata* were 'smashing blue' to the swashbuckling Captain. Kingdon Ward was, however, often scathing of his hosts and their horticulture: 'The Chinese, though they excel in the practice of standardised plant socialism, whereby plants are turned out to a pattern, are totally ignorant of what may be achieved by helping rather than hindering nature'.

Published illustrations of the regal lily and blue poppy were, like their introducers, redolent of an earlier age. The regal lily was illustrated in a production bearing a stature and magnificence commensurate with the plant it depicted. Henry Elwes, a wealthy English plant collector and keen gardener, commenced his magisterial *A Monograph of the Genus Lilium* in 1877. Printed on fine paper in large format, the hand-coloured lithographs depicted their subjects in a manner little changed over two or three centuries. Text on each species by Elwes complemented illustrations by Walter Fitch, doyen of the illustrators working for the *Botanical Magazine*. The monograph was issued in 1880, and following the death of Elwes in 1922, a supplement was issued to bring the work up to date. It was this supplement, issued in parts from 1933 to 1940

Amongst the Chinese introductions of George Forrest was *Gentiana sino-ornata*, collected from the alpine meadows and streamsides of Yunnan. The flowers were greatly prized amongst plant enthusiasts—'drab lawns are sparkling with blue, as though the dome of heaven itself had cracked and rained splinters on the grass' enthused Frank Kingdon Ward over their homeland.

opposite: When Frank Kingdon Ward first sighted the blue poppy (*Meconopsis betonicifolia*) in Tibet—known previously in the West only from dried specimens—he was moved to astonished hyperbole: 'Suddenly I looked and there, like a blue panel dropped from heaven—a stream of blue poppies dazzling as sapphires in the pale light'.

PLATE 2 COAST BANKSIA

Banksia integrifolia Linnaeus fil.

GENERAL BIOLOGY

SYSTEMATIC NOTES

BOTANICAL DESCRIPTION

VARIETIES

BIBLIOGRAPHY

Few recent works can match the monumental achievement—botanically, artistically, or physically—of *The Banksias* by Celia Rosser and Alex George. Published in three magnificent folio volumes during 1981–2000, this work looks to book-publishing traditions of the past, yet embodies taxonomy for present-day botanists, and invites emulation by future generations of bibliophile publishers or patrons.

and printed to the same exacting standards as the original, that included *Lilium regale* in a fine representation by Lilian Snelling. Two further parts of the supplement were issued in 1960–62, illustrated by Margaret Stones, giving the work a publication span of almost one hundred years. Elwes also played a significant part in the revival of the *Botanical Magazine*, commenced by William Curtis in 1787 and in almost terminal financial decline by 1921 when Elwes and colleagues purchased the copyright, transferring it to the Royal Horticultural Society. The plates of 'Curtis' remained hand-coloured until 1948, when the end came for a venerated tradition that had by then become a costly anachronism.

The standards of production achieved by Elwes in his monograph have rarely been matched in subsequent years. Hand-colouring has long since been replaced by chromolithography and then photolithography, while few buyers can afford to purchase—let alone house—elephant folios. And yet, despite these obstacles—and the icy blast of modernism—several illustrated botanical books of outstanding size and quality have been commissioned in the last three decades. Coincidently, three of these illustrated the flora of Australia. Botanist Winifred Curtis, born in Edwardian England, combined with Australian-born artist Margaret Stones to produce the lavish iconography, *The Endemic Flora of Tasmania* (1967–78). Commissioned by plant enthusiast and diplomat, Baron Talbot de Malahide—who maintained estates in Ireland and Tasmania—the resulting volumes charted not only the botany of the plants, but Talbot's success in their cultivation. Even more astonishing, purely in physical grandeur, have been the three volumes of *The Banksias* (1981–2000), drawn by Celia Rosser and botanically described by

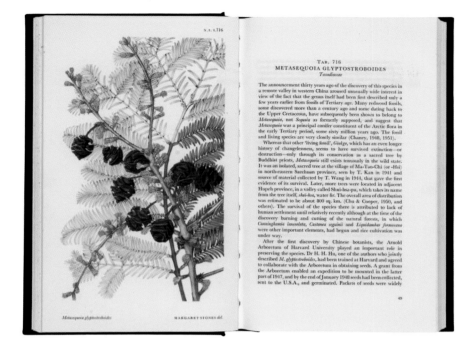

Alex George. In Rosser's paintings, the fine detail of this distinctive genus has been reproduced in a manner not surpassed in its combination of art and science even by the best contemporary photography.

One last publishing project links the past with the present—the publication in colour of the plates of *Banks' Florilegium*. Few projects can have had such a long gestation. When Joseph Banks sailed to New Holland as botanist aboard the first of Cook's Pacific voyages (1768–71), his artist Sydney Parkinson died before the expedition returned to Britain. Working under the direction of Banks from Parkinson's sketches, a team of artists produced engraved copper plates, yet these were not published. Impressions (in black ink only) were issued in 1900–05, but during 1981–88, the full set of 738 engravings was published, each plate painstakingly inked in colour. Of outstanding historical and artistic interest, the images provided a continuity of tradition equalled by few publications and perhaps surpassed by none.

China and Australia have suffused this conclusion to our story of the world's botanical riches, so let us revisit those countries for two final examples. In 1941, Chinese botanists identified a tree known from the fossil record, but now found represented by a solitary living specimen. Amidst worshipping villagers in remote Szechuan province, the miraculous survival of the dawn redwood (*Metasequoia glyptostroboides*) attracted worldwide botanical attention. The introduction of the plant to the West, in the late 1940s, by botanists of the Arnold Arboretum, gave horticulture its most celebrated living fossil since the introduction of the maidenhair tree (*Ginkgo biloba*) several centuries earlier.

Perhaps even more remarkable was the survival and discovery in 1994 of the Wollemi pine (*Wollemia nobilis*). Located in the inaccessible rocky gorges of a national park remarkably close to Sydney, the tree had remained hidden for over two centuries of European occupation. The tree, now potentially a stately addition to gardens worldwide following its release in 2005 by public auction, is a modern miracle in a world ravaged by deforestation, insidiously altered by global warming, and veering towards artless cynicism. The Wollemi pine gives us fresh hope that plants yet exist that have not been located, identified, appreciated, or utilised, be it for the seductive pleasure of ornament or the life-giving imperatives of medicine.

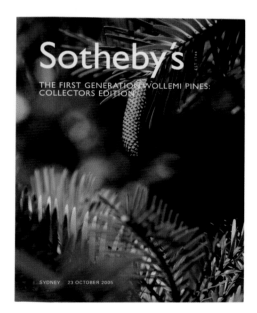

Notes on Sources

For full citations of all works having general applicability, please see the Select Bibliography.

INTRODUCTION

For a general overview of the State Library of Victoria, its history, and its collections, see Bev Roberts, *Treasures of the State Library of Victoria*, Focus Publishing, Bondi Junction, NSW, 2003. For an introduction to the paintings and dreamings of the peoples of Australia's Western Desert, see Geoffrey Bardon & James Bardon, *Papunya: a place made after the story. The beginnings of the Western Desert painting movement*, The Miegunyah Press, Carlton, Vic., 2004.

PART I: PLANTS OF THE ANCIENT AND CLASSICAL WORLDS

I do not profess to be an expert on the ancient and classical worlds, and have relied on the scholarship of many authors. The sweeping panorama of human history is covered in innumerable sources, and I found Lawson, *Science in the Ancient World* (2004), and Roberts, *Ancient History* (2004) especially useful. Many historical atlases cover world history, and these are listed below under relevant chapters. Many books on the history of gardens cover this period up to the Renaissance, but the one that stands apart for its emphasis on plants is Hobhouse, *Plants in Garden History* (1992). The scholarly notes to the facsimile edition of Fuch's great herbal by Frederick G. Meyer, Emily Emmart Trueblood & John L. Heller, *The Great Herbal of Leonhart Fuchs: De historia stirpium commentarii insignes, 1542 (Notable commentaries on the history of plants)*, Stanford University Press, Stanford, Ca., 1999, were also of great assistance, as were relevant chapters in Prance & Nesbit (eds), *The Cultural History of Plants* (2005). Many striking illustrations were located during my examination of the original botanical books in the outstanding collection of the State Library of Victoria but to locate individual plants I had at my side G.A. Pritzel's indispensable catalogue of botanical illustrations, *Iconum botanicarum index locupletissimus* (1866). On occasions I also had recourse to its revision and continuation by Otto Stapf (ed.), *Index Londinensis* (Oxford, 1929) and later supplements. Stapf usefully notes which illustrations are in colour, although Pritzel has the advantage of including illustrations of doubtful taxonomic value (sometimes omitted from Stapf's publication).

1: Timeless Traditions

Ethno-botany is the subject of a vast literature, and several key works have guided my research and writing. I have relied extensively on the recently published book edited by Prance & Nesbitt, *The Cultural History of Plants* (2005) and also Kochhar's *Economic Botany in the Tropics* (1998) for an alternative, non-Western voice. Other sources include Richard M. Klein, *The Green World: an introduction to plants and people*, Harper & Row, New York, 1979, and Michael J. Balick & Paul Alan Cox, *Plants, People, and Culture: the science of ethnobotany*, Scientific American Library, New York, 1996. Bunya lore is related in a recent special issue of the *Queensland Review*, St Lucia, Qld, 9 (2) 2002. Cinchona is the subject of several recent works, including Saul Jarcho, *Quinine's Predecessor: Francesco Torti and the early history of cinchona*, Johns Hopkins University Press, Baltimore and London, 1993; Mark Honigsbaum, *The Fever Trail: the hunt for the cure of malaria*, Macmillan, London, 2001; and Fiammetta Rocco, *The Miraculous Fever-tree: malaria, medicine and the cure that changed the world*, HarperCollins, London, 2003. See also Kjell B. Sandved (photos), Ghillean Tolmie Prance & Anne E. Prance (text), *Bark: the formation, characteristics, and uses of bark around the world*, Timber Press in association with the Royal Botanic Gardens, Kew, Portland, Oregon, 1993; Hobhouse, *Seeds of Change* (1999), pp. 3–52; and Stuart, *Dangerous Gardens* (2004), pp. 26–32. The story of cinchona bark and its use by sodden miners is related by Jarcho (pp. 4–5). Bark cloth is discussed generally in Sandved, Prance & Prance, *Bark* (1993), chapter 12; the special case of Oceanian tapa cloth is related in William T. Brigham, *Ka Hana Kapa: the making of bark-cloth in Hawaii*, Bishop Museum Press, Honolulu, 1911.

2: The Fertile Crescent

Early agriculture and its archaeological record are summarised in Prance & Nesbitt (eds), *The Cultural History of Plants* (2005), and Roberts, *Ancient History* (2004) amongst numerous sources. Penelope Hobhouse discusses the plants and horticulture of the Fertile Crescent in *Plants in Garden History* (1992), chapter 1, and *The Story of Gardening* (2002), chapter 1. Two books on biblical plants offer coverage of plants relevant to this chapter: Michael Zohary, *Plants of the Bible: a complete handbook to all the plants with 200 full-color plates taken in natural habitat*, Cambridge University Press, Cambridge, 1982, and F. Nigel Hepper, *Illustrated Encyclopaedia of Bible Plants: flowers and trees, fruits and vegetables, ecology*, Inter Varsity Press, Leicester, 1992. The history of several individual plants is traced in the commentary (volume 1) by Frederick G. Meyer, Emily Emmart Trueblood & John L. Heller of the facsimile edition of *The Great Herbal of Leonhart Fuchs: De historia stirpium commentarii insignes, 1542 (Notable commentaries on the history of plants)*, Stanford University Press, Stanford, Ca., 1999. Sumerian 'shade-tree gardening' is suggested in Samuel Kramer, *History Begins at Sumer* (Philadelphia, 1981), quoted in Lawson, *Science in the Ancient World* (2004), p. 3. King Tiglath-Pileser I is quoted in Hobhouse, *Plants in Garden History* (1992), p. 17.

3: Ancient Egypt

Major sources for plants and gardens of ancient Egypt include Lise Manniche, *An Ancient Egyptian Herbal*, British Museum Press, London, 1989; F. Nigel Hepper, *Pharaoh's Flowers: the botanical treasures of Tutankhamun*, HMSO, London, 1990; and Alix Wilkinson, *The Garden in Ancient Egypt*, The Rubicon Press, London, 1998. See also Hobhouse, *Plants in Garden History* (1992), chapter 1, and *The Story of Gardening* (2002), chapter 1, and Roberts, *Ancient History* (2004), part 1, chapter 3. The reliefs at Deir el-Bahari are reproduced in Edouard Naville, *The Temple of Deir El Bahari*, part III, Committee of the Egypt Exploration Fund, London, 1898, plates 69–80, with an accompanying commentary. See also Joyce Tyldesley, *Hatchepsut: the female pharaoh*, Viking, London, 1996.

4: Ancient India

Major sources for the history of Indian plants are George Watt, *The Dictionary of the Economic Products of India*, Department of Revenue and Agriculture, Government of India, Calcutta, 1889–93, and Ray Desmond, *The European Discovery of the Indian Flora*, Royal Botanic Gardens, Kew, in association with Oxford University Press, Oxford, 1992. An Indian publication, Kochhar, *Economic Botany in the Tropics* (1998), gives generous and knowledgeable treatment to Indian plants. Food plants are discussed in K.T. Achaya, *Indian Food: a historical companion*, Oxford University Press, Delhi, 1994. General historical information is to be found in Subodh Kapoor (ed.), *The Hindus: encyclopaedia of Hinduism*, Cosmo, New Delhi, 2000, especially the entry on 'Plants', volume 3, pp. 1429–32; Robert E. Buswell Jr, *Encyclopaedia of Buddhism*, Macmillan Reference USA, New York, 2004; and Roberts, *Ancient History* (2004), part 3, chapter 1. See also Hobhouse, *Plants in Garden History* (1992), chapter 2. Strabo's estimate of the banyan sheltering 400 men is quoted by Desmond (p. 2) who also gives many details of Pliny's writings on Indian plants.

5: Mesoamerican and Andean Civilisations

The editors of the *Oxford English Dictionary* credit the coining of the term 'Mesoamerica' to Paul Kirchhoff, *Acta Americana* (1943), I, p. 92. For general history of this region I have relied on Roberts, *Ancient History* (2004), part 3, chapter 3; Norman Bancroft Hunt, *Historical Atlas of Ancient America*, Checkmark Books, New York, 2001; and Angus Konstam, *Historical Atlas of Exploration 1492–1600*, Checkmark Books, New York, 2000. On the plants of this region generally see Nelson Foster & Linda S. Cordell (eds), *Chilies to Chocolate: food the Americas gave to the world*, The University

of Arizona Press, Tucson and London, 1992; Frederick G. Meyer, Emily Emmart Trueblood & John L. Heller, *The Great Herbal of Leonhart Fuchs: De historia stirpium commentarii insignes, 1542 (Notable commentaries on the history of plants)*, Stanford University Press, Stanford, Ca., 1999, volume 1; Kochhar, *Economic Botany in the Tropics* (1998); Prance & Nesbitt (eds), *The Cultural History of Plants* (2005). In particular, Prance & Nesbitt provide an excellent summary of recent archaeological botany. On cacao (and chocolate) see Sophie D. Coe & Michael D. Coe, *The True History of Chocolate*, Thames and Hudson, London, 1996, and Allen M. Young, *The Chocolate Tree: a natural history of cacao*, Smithsonian Institution Press, Washington and London, 1994. On maize amongst many sources see Betty Fussell, *The Story of Corn*, Alfred A. Knopf, New York, 1992, and Arturo Warman (Nancy L. Westrate, trans.), *Corn & Capitalism: how a botanical bastard grew to global dominance*, The University of North Carolina Press, Chapel Hill and London, 2003. On potatoes see Redcliffe N. Salaman, *The History and Social Influence of the Potato*, Cambridge University Press, Cambridge, 1949, and Larry Zuckermann, *The Potato: how the humble spud rescued the Western world*, Faber & Faber, Boston & London, 1998. On tomatoes see Andrew F. Smith, *The Tomato in America: early history, culture, and cookery*, University of South Carolina Press, Columbia, South Carolina, 1994. On vanilla see Tim Ecott, *Vanilla: travels in search of the ice cream orchid*, Michael Joseph, London, 2004. Friar Bernardo de Sahagun, who arrived in Mexico in 1529, is quoted on chillies by Prance & Nesbitt, p. 159.

6: Mediterranean Civilisations

Innumerable works chart the history of Mediterranean civilisations. For a recent overview I have relied on Roberts, *Ancient History* (2004), parts 4 & 5, and relevant entries in Lawson, *Science in the Ancient World* (2004). Many books cover the plants of the Mediterranean and an excellent guide is provided by Marjorie Blamey & Christopher Grey-Wilson, *Mediterranean Wild Flowers*, HarperCollins*Publishers*, [London], 1993. See also Patrick Bowe, *Gardens of the Roman World*, Frances Lincoln, London, 2004; Hobhouse, *Plants in Garden History* (1992), chapter 1, and *The Story of Gardening* (2002), chapter 2, and Blunt & Stearn, *The Art of Botanical Illustration* (1994), chapter 2. I have drawn on the following English-language translations of Dioscorides, Pliny, and Theophrastos: *The Greek Herbal of Dioscorides, illustrated by a Byzantine A.D. 512, Englished by John Goodyer A.D. 1655, edited and first printed A.D. 1933*, Hafner Publishing Co., New York, 1959; *The Natural History of Pliny. Translated, with copious notes and illustrations by the late John Bostock, M.D., F.R.S., and H.T. Riley, Esq., B.A.*, Henry G. Bohn, London, 1855–57; Theophrastos (Arthur Hort, trans.), *Enquiry into Plants and Minor Works on Odours and*

Weather Signs, William Heinemann, London, and G.P. Putnam's Sons, New York, 1916; and Theophrastus (Benedict Einarson & George K.K. Link, trans.), *De Causis Plantarum*, William Heinemann, London, & Harvard University Press, Cambridge, Mass., 1976. The stories of Daphne and Dionysus are told by John and Rosemary Hemphill in *Myths and Legends of the Garden*, Hodder & Stoughton, Rydalmere, NSW, 1997.

7: The Silk Road to Cathay and Beyond

For a cartographic depiction of the route taken by the Silk Road (and much else besides) see Kenneth Nebenzahl, *Mapping the Silk Road and Beyond: 2,000 years of exploring the East*, Phaidon Press, London, 2004. An invaluable source for this chapter has been Peter Valder, *The Garden Plants of China*, Florilegium, Balmain, NSW, 1999. See also Roberts, *Ancient History* (2004), part 3, chapter 2, & part 7, chapter 2; and Frederick G. Meyer, Emily Emmart Trueblood & John L. Heller, *The Great Herbal of Leonhart Fuchs: De historia stirpium commentarii insignes, 1542 (Notable commentaries on the history of plants)*, Stanford University Press, Stanford, Ca., 1999, volume 1; 'China' in Jellicoe et al. (eds), *Oxford Companion to Gardens* (1986) pp. 111–16; Hobhouse, *The Story of Gardening* (2002), chapter 10; and Blackburne-Maze, *Fruit* (2002) pp. 9–10, 104, 107, 108. For the history of Chinese gardens generally see Maggie Keswick, *The Chinese Garden: history, art, and architecture*, rev. edn., Frances Lincoln, London, 2003, and Peter Valder, *Gardens in China*, Florilegium, Glebe, NSW, 2002. For an introduction to the history of Japanese gardens see Alison Main & Newell Platten, *The Lure of the Japanese Garden*, Wakefield Press, Kent Town, SA, 2002, and Seiko Goto, *The Japanese Garden: gateway to the human spirit*, Peter Lang, New York, 2003. On the use of *Morus alba* for making silk see John Feltwell, *The Story of Silk*, Alan Sutton, Stroud, Gloucestershire, 1990. For a brief overview of the history of Chinese paper making see Kochhar, *Economic Botany in the Tropics* (1998), pp. 124–6, and Roberts, *Ancient History* (2004), p. 753. The claims for toilet paper come from Robert E. Krebs, *Groundbreaking Scientific Experiments, Inventions, and Discoveries of the Middle Ages and the Renaissance*, Greenwood Press, Westport, Connecticut, and London, 2004, p. 218. Many works address the history of the spice trade, including Andrew Dalby, *Dangerous Tastes: the story of spices*, British Museum Press, London, 2000; Jack Turner, *Spice: the history of a temptation*, Alfred A. Knopf, New York, 2004; and John Keay, *The Spice Route*, John Murray, London, 2005.

8: The Rise of Islam

For general historical background see 'Islam and the re-making of the Near East' in Roberts, *Ancient History* (2004), part 6, chapters 1 & 2; 'The Gardens of Islam' in Hobhouse, *Plants in Garden History* (1992), chapter 2; and 'The Gardens of Islam' in Hobhouse, *The*

Story of Gardening (2002), chapter 3. See also Penelope Hobhouse, *The Gardens of Persia*, Cassell, London, 2003. On Arabic science see Roshdi Rashed (ed.), *Encyclopaedia of the History of Arabic Science*, Routledge, London and New York, 1996, chapter 24 ('Botany and agriculture' by Toufic Fahd). For a brief English-language account of Ibn Sīnā see G.C. Anawati's entry in Gillispie (ed.), *Dictionary of Scientific Biography* (1978), volume 15, pp. 494–8. On opium see Martin Booth, *Opium: a history*, Simon & Schuster Ltd, London, 1996 and Toby & Will Musgrave, *An Empire of Plants: people and plants that changed the world*, Cassell & Co., London, 2000 (which contains a useful bibliography).

9: The Renaissance

For an overview of Renaissance science see Greene, *Landmarks of Botanical History* (1983), and Robert E. Krebs, *Groundbreaking Scientific Experiments, Inventions, and Discoveries of the Middle Ages and the Renaissance*, Greenwood Press, Westport, Connecticut, and London, 2004. There are many works on Renaissance gardens and their plants, including a useful summary in Hobhouse, *Plants in Garden History* (1992), pp. 96–135 ('Plants, botanists, plantsmen and gardeners of Renaissance Europe') and pp. 136–61 ('The gardens of the Italian Renaissance'). On herbals see Anderson, *An Illustrated History of the Herbals* (1977); Arber, *Herbals, Their Origin and Evolution* (1986); Blunt & Raphael, *The Illustrated Herbal* (1979); and Nissen, *Herbals of Five Centuries* (1958). See also Frederick G. Meyer, Emily Emmart Trueblood & John L. Heller, *The Great Herbal of Leonhart Fuchs: De historia stirpium commentarii insignes, 1542 (Notable commentaries on the history of plants)*, Stanford University Press, Stanford, Ca., 1999. The outstanding Hunt catalogue by Quinby & Stevenson, *Catalogue of Botanical Books in the Collection of Rachel McMasters Miller Hunt* (1958–61) is a sumptuous bibliographic feast with its details on books of this period. For a much smaller taste of these books see Byers, *Hortus Librorum* (1983). For the work of Liberale and Meyerpeck, see also William Patrick Watson, Sandra Raphael & Iain Bain, *The Mattioli Woodblocks*, Hazlitt, Gooden & Fox, London, 1989.

PART II: THE GREAT AGE OF MARITIME EXPLORATION

I have found historical atlases give an easily digested means of appreciating maritime exploration, and three relevant works are Norman Bancroft Hunt, *Historical Atlas of Ancient America*, Checkmark Books, New York, 2001; Angus Konstam, *Historical Atlas of Exploration 1492–1600*, Checkmark Books, New York, 2000; and Kenneth Nebenzahl, *Mapping the Silk Road and Beyond: 2,000 years of exploring the East*, Phaidon Press Limited, London, 2004. See also Howgego, *Encyclopaedia of Exploration to 1800* (2003) and 'New limits, new horizons' in Roberts, *Ancient History* (2004), part 7, chapter 6.

10: Empire Building in the Golden Age

Howgego, *Encyclopaedia of Exploration to 1800* (2003) contains useful summaries and extensive bibliographies of the two principal East India companies. On the cultural history of sugar, cotton, tobacco, and opium see, amongst many works, Hobhouse, *Seeds of Change* (1999), pp. 53–116, 175–236; Hobhouse, *Seeds of Wealth* (2003), pp. 189–244; and Musgrave & Musgrave, *An Empire of Plants* (2000), chapters 1–3, 5. See also specific references I have noted as sources for chapters 8, 12 & 14. For an intriguing perspective see James Walvin, *Fruits of Empire: exotic produce and British taste (1660–1800)*, Macmillan, London, 1997. On botanic gardens see John Prest, *The Garden of Eden: the botanic garden and the re-creation of paradise*, Yale University Press, New Haven and London, 1981. There are numerous books on the history of hothouses, but Gordon Douglas Rowley, *A History of Succulent Plants*, Strawberry Press, Mill Valley, California, 1997, chapter 4 ('The garden & the greenhouse') gives a very useful chronology of early developments of this specialised building type. The Belgic Lion is discussed in Jonathan Potter, *Collecting Antique Maps: an introduction to the history of cartography*, Jonathan Potter, London, 2001, pp.186–7, and the translated quotation is from L'Obel's *Plantarum seu stirpium historia* (Antwerp, 1576), quoted in F. de Nave & D. Imhof (eds), *Botany in the Low Countries (end of the 15th century–ca.1650)*, City of Antwerp (Plantin-Moretus Museum and Stedelijk Prentenkabinet), Antwerp, 1993, p. 13. The role of Deshima in the introduction of plants is discussed in V.S. Forbes (ed.), J. & I. Rudner (trans), *Carl Peter Thunberg: Travels at the Cape of Good Hope 1772–1775*, Van Riebeeck Society, Cape Town, 1986, p. xxxii. The symbolism of the passion flower is mentioned by many authors, including Elliott, *Flora* (2001), pp. 198–201; and Morley & Everard, *Wild Flowers of the World* (1970), p. 173, quoting Hilderic Friend, *Flowers and Flower Lore* (London, 1884). For a discussion of the various *Hesperides* see Janson, *Pomona's Harvest* (1996), chapter 16. For further detail on *Opuntia ficus-indica* see Rowley, *A History of Succulent Plants* (1997), pp. 48–9. For a comprehensive English-language account of Hernández see Simon Varey, Rafael Charran & Dora B. Weiner (eds), *Searching for the Secrets of Nature: the life and works of Dr Francisco Hernández*, Stanford University Press, Stanford, Ca., 2000, and also a companion volume by the same publishers edited by Varey, *The Mexican Treasury: the writings of Dr Francisco Hernández* (2000).

11: The New World

The Columbian bibliography is a long one indeed, and the interested reader is urged to consult the extensive list in Howgego, *Encyclopaedia of Exploration to 1800* (2003). Howgego can usefully be consulted for similar treatment of other explorers mentioned in this section. The voyages of Columbus and others are depicted in Angus Konstam, *Historical Atlas of Exploration 1492–1600*, Checkmark Books, New York, 2000. Contemporary maps are reproduced in Kenneth Nebenzahl, *Atlas of Columbus and the Great Discoveries*, Rand McNally, Chicago, New York & San Francisco, 1990. On the plants of this region generally see Nelson Foster & Linda S. Cordell (eds), *Chilies to Chocolate: food the Americas gave to the world*, The University of Arizona Press, Tucson & London, 1992. On Aztec plant knowledge see E.W. Emmart, *The Badianus Manuscript (Codex Barberini, Latin 24) Vatican Library: an Aztec herbal of 1552* (Baltimore, 1940) cited by Blunt & Stearn, *The Art of Botanical Illustration* (1994), p. 79. There are many accounts of the potato and its social and economic importance. One of the pioneering texts—and one that most later accounts freely acknowledge—is Redcliffe N. Salaman, *The History and Social Influence of the Potato*, Cambridge University Press, Cambridge, 1949. For Gerard, see Arber, *Herbals, Their Origin and Evolution* (1986), and Anderson, *An Illustrated History of the Herbals* (1977). The text of Gerard's *Herball* had as its basis a translation of Dodoens' *Stirpium Historiae Pemptades Sex* (Anvers, 1583)—see item 175 in Quinby & Stevenson's Hunt catalogue. Tobacco has an extensive literature and I have drawn especially on Hobhouse, *Seeds of Wealth* (2003), pp. 189–244. See also Corti Egon (P. England, trans), *A History of Smoking*, George G. Harrap & Co., London, 1931, and S. Gabb, *Smoking and its Enemies: a short history of 500 years of the use and prohibition of tobacco*, Forest, London, 1990. English-language accounts of Monardes are scant, but see C.R. Boxer, *Two Pioneers of Tropical Medicine: Garcia d'Orta and Nicolas Monardes*, Wellcome Historical Medical Library, London, 1963, and the entry by Francisco Guerra in Gillispie (ed.), *Dictionary of Scientific Biography* (1974), volume 9, p. 466.

12: Imperial Tales of the Near East

Amongst numerous sources, two useful general references on this period are Colin Imber, *The Ottoman Empire, 1300–1650: the structure of power* (2002), and Paula Sutter Fichtner, *The Habsburg Monarchy, 1490–1848: attributes of empire* (2003), both published by Palgrave Macmillan, Basingstoke, Hampshire, and New York. The botanical literature of this period is usefully documented in the exhibition catalogue by F. de Nave & D. Imhof (eds), *Botany in the Low Countries (end of the 15th century–ca.1650)*, City of Antwerp (Plantin-Moretus Museum and Stedelijk Prentenkabinet), Antwerp, 1993. A useful English-language source for Near East gardens and their plants is Leslie Tjon Sie Fat & Erik de Jong (eds), *The Authentic Garden: a symposium on gardens*, Clusius Foundation, Leiden, 1991. The most pertinent chapters are by D. Onno Wijnands, 'Commercium Botanicum: the diffusion of plants in the 16th century' (pp. 74–84), and Nevzat Ilhan, 'The Culture of Gardens and Flowers in the Ottoman Empire' (pp. 131–8). See also Elliott, *Flora* (2001), chapter 2 ('Turkish Empire') and Coats, *The Quest for Plants* (1969), pp. 11–40 ('The Mediterranean and Near East'). Busbecq published his travels as *Itinera Constantinople et Amasianum* (Antwerp, 1581). His *Turkish Letters* were published in numerous editions starting in 1633—I have drawn on Edward Seymour Forster (trans.), *The Turkish Letters of Ogier Ghiselin de Busbecq, Imperial Ambassador at Constantinople 1554–1562*, Clarendon Press, Oxford, 1927 (the 'fine blossom' quotation is from p. 25). Biographical details are contained in C.T. Forster & F.H.B. Daniell, *The Life and Letters of Ogier Ghiselin de Busbecq*, Kegan, Paul & Co., London, 1881. The standard reference on Belon is Paul Delaunay, *L'Aventureuse Existence de Pierre Belon du Mans*, Champion, Paris, 1926. A succinct English-language account is the entry by M. Wong in Gillispie (ed.), *Dictionary of Scientific Biography* (1970), volume 1, pp. 595–6. For Mattioli see Greene, *Landmarks of Botanical History* (1983), part 2, chapter 21. See also Blunt & Stearn, *The Art of Botanical Illustration* (1994), pp. 34, 73. See also Anderson, *An Illustrated History of the Herbals* (1977); Nissen, *Herbals of Five Centuries* (1958); and Arber, *Herbals, Their Origin and Evolution* (1986). The literature on 'tulipomania' is voluminous. Two recent specialised works are Anna Pavord, *The Tulip*, Bloomsbury, London, 1999, and Mike Dash, *Tulipomania: the story of the world's most coveted flower and the extraordinary passions it aroused*, Victor Gollancz, London, 1999. An economic historian's perspective is provided by Peter M. Garber, *Famous First Bubbles: the fundamentals of early manias*, MIT Press, Cambridge, Mass., and London, 2000. I have taken the definition of florilegium from Blunt & Stearn, pp. 13–14. Rauwolf's travels were published in an English translation by John Ray, *Travels through the Low Countries, Germany, Italy and France: with curious observations, natural, topographical, moral, physiological &c; also a catalogue of plants found spontaneously growing in those parts, and their virtues ...*, 2nd edn, Printed for J. Walthoe et al., London, 1738. Wheler's account was George Wheler, *A Journey into Greece ... in the company of Dr Spon of Lyon. In six books ...*, Printed for William Cademan and Robert Kettlewell, London, 1682. Tournefort's account, illustrated by the noted French botanical artist Claude Aubriet, was published as *Relation d'un Voyage du Levant* (Paris, 1717), and in English translation as Joseph Pitton de Tournefort, *A Voyage into the Levant, perform'd by command of the late French King ...*, Printed for D. Browne et al., London, 1718. For an assessment of Tournefort's botany, see Greene, *Landmarks of Botanical History* (1983), chapter 26 (which contains an extensive bibliography), one of few English-language works on this French botanist.

13: Exploring the Far East

Exploration of the East Indies is depicted cartographically in Robert Cribb, *Historical Atlas of Indonesia*, Curzon, Richmond, Surrey, 2000, and Kenneth Nebenzahl, *Mapping the Silk Road and Beyond: 2,000 years of exploring the East*, Phaidon Press, London, 2004, parts 2 and 3. Economic uses of plants from the East Indies are covered in S.L. Kochhar, *Economic Botany in the Tropics*,

2nd edn, Macmillan India Ltd, Delhi, 1998. George Watt, *The Dictionary of the Economic Products of India*, Department of Revenue and Agriculture, Government of India, Calcutta, 1889–93 contains a mass of detail on Indian plants, indigenous and cultivated. The references on China listed under chapter 7 apply in equal measure to this chapter, especially the books by Valder. See also Ray Desmond, *The European Discovery of the Indian Flora*, Royal Botanic Gardens, Kew, in association with Oxford University Press, Oxford, 1992, pp. 12–13 (which tells the story of del Cano's request for a spicy coat of arms) and K.T. Achaya, *Indian Food: a historical companion*, Oxford University Press, Delhi, 1994. The spice trade has a vast literature spanning many areas of interest. Three recent works which treat the subject in an accessible manner are Andrew Dalby, *Dangerous Tastes: the story of spices*, British Museum Press, London, 2000; Jack Turner, *Spice: the history of a temptation*, Alfred A. Knopf, New York, 2004; and John Keay, *The Spice Route*, John Murray, London, 2005. An English translation of Linschoten's *Itinerario* was published in London in 1598, and re-edited by Arthur Coke Burnell & P.A. Tiele (eds), *The Voyage of John Huygen van Linschoten, from the old English translation of 1598 ...*, Printed for the Hakluyt Society, London, 1885 (reissued, New Delhi, 1996–7). The quotes on the evils of datura are from Burnell & Tiele (eds), volume 2, p. 69. For a general account see Charles McKew Parr, *Jan van Linschoten: the Dutch Marco Polo*, Thomas Y. Crowell Company, New York, 1964. An account of Akbar's court is given in H. Blochmann (trans.), D.C. Phillot (ed.), *The Áin I Akbarí: a gazetteer and administrative manual of Akbar's empire ...*, Asiatic Society, Kolkata, 1993. The quote on durian aroma is from Berthe Hoola van Nooten, *Fleurs, Fruits et Feuillages Choisis de la Flore et de la Pomone de l'Ile de Java, peints d'après nature*, Émile Talier, Brussels, 1863. The support given to botanical interests by the English East India Company is discussed in the early chapters of Desmond (1992). Desmond also gives an account of early Mughal plantings, as does Hobhouse, *Plants in Garden History* (1992). On Rumpf see E.M. Beekman (trans. & ed.), *The Ambonese Curiosity Cabinet: Georgius Everhardius Rumphius*, Yale University Press, New Haven and London, 1999, which includes a brief biography and comprehensive bibliography. The difficulties attending publication of *Herbarium Amboinense* are recounted in Quinby & Stevenson's Hunt catalogue (item 518). On Rheede see J. Heniger, *Hendrik Adriaan van Reede tot Drakenstein (1636–1691) and Hortus Malabaricus: a contribution to the history of Dutch colonial botany*, A.A. Balkema, Rotterdam, 1986. The translated quote from Buddha is reverentially invoked in the foreword to Kochhar's book.

14: European Colonisation of the Americas

Exploration and European settlement of the Americas is covered in many sources, and a general introduction can be obtained from Angus Konstam, *Historical Atlas of Exploration 1492–1600*, Checkmark Books, New York, 2000, and William H. Goetzmann & Glyndwr Williams, *The Atlas of North American Exploration: from Norse voyages to the race to the Pole*, Prentice Hall General Reference, New York, 1992. On botanical discovery see Coats, *The Quest for Plants* (1969), pp. 267–93 ('North America: the eastern states') and pp. 328–51 (Mexico and the Spanish Main'); James L. Reveal, *Gentle Conquest: the botanical discovery of North America with illustrations from the Library of Congress*, Starwood Publishing, Washington, DC, 1992; and Elliott, *Flora* (2001), chapter 4 ('The Americas'). A short but useful history surveying the introduction of North American plants to Britain is found in Mavis Batey, 'An American Garden for Bletchley Park', *The Garden History Society News*, 71, Summer 2004, pp. 23–8. The flora of colonial Maryland is the subject of a special issue of *Huntia*, Hunt Institute of Botanical Documentation, Carnegie Mellon University, Pittsburgh, Pa., volume 7, 1987. On North American gardens and horticulture see also Robert P. Maccubbin & Peter Martin (eds), *British and American Gardens in the Eighteenth Century: eighteen illustrated essays on garden history*, The Colonial Williamsburg Foundation, Williamsburg, Va., 1984, pp. 19–25, and Hobhouse, *Plants in Garden History* (1992), pp. 256–87 ('The development of North American horticulture'). The gardens of Dutch Brazil are discussed in Maria Angélica da Silva & Melissa Mota Alcides, 'Collecting and Framing the Wilderness: the garden of Johan Maurits (1604–79) in North-East Brazil', *Garden History*, 30 (2), Winter 2002, pp. 153–76. See also R.A. de Filipps, *Ornamental Garden Plants of the Guianas: an historical perspective of selected garden plants from Guyana, Surinam and French Guiana*, Department of Botany, Smithsonian Institution, Washington, DC, 1992. Gordon Douglas Rowley's *A History of Succulent Plants*, Strawberry Press, Mill Valley, California, 1997, pp. 55–6, gives a comprehensive summary of the European fashion for *Agave americana*, as well as much else on American succulent flora. The cultural history of vanilla is the subject of two recent books: Tim Ecott, *Vanilla: travels in search of the ice cream orchid*, Michael Joseph, London, 2004, and Patricia Rain, *Vanilla: The cultural history of the world's favourite flavor and fragrance*, Jeremy P. Tarcher/Penguin, New York, 2004. For Merian, see Blunt & Stearn, *The Art of Botanical Illustration* (1994), pp. 142–5. The historical background to *Annona squamosa* is given in the *Botanical Magazine*, volume 58 (1831), accompanying plate 3095. The cultural history of sugar has attracted many authors, and the most recent include Hobhouse, *Seeds of Change* (1999), pp. 53–116; Musgrave & Musgrave, *An Empire of Plants* (2000), chapter 2; Peter Macinnes, *Bittersweet: the story of sugar*, Allen & Unwin, Crows Nest, NSW, 2002; and Sanjida O'Connell, *Sugar: the grass that changed the world*, Virgin Books, London, 2004. For Banister, Catesby, Compton, Houston, Plumier, and Sloane see the chapters in Coats, *The Quest for Plants* (1969) on

'Mexico and the Spanish Main' and 'North America' (pp. 266–351), and entries in Jellicoe et al., *The Oxford Companion to Gardens* (1986). On the plant introductions of the Tradescants see Mea Allan, *The Tradescants: their plants, gardens and museum 1570–1662*, Michael Joseph, London, 1964. John Bartram and his botanically inclined son William are the subject of several monographs, including Joseph Ewan (ed.), *William Bartram: botanical and zoological drawings, 1756–1788 ...*, American Philosophical Society, Philadelphia, Pa., 1968; Edmund Berkeley & Dorothy Smith Berkeley, *The Life and Travels of John Bartram*, Florida State University Press, Tallahassee, Fl., 1982; Edmund Berkeley & Dorothy Smith Berkeley (eds), *The Correspondence of John Bartram 1734–1777*, University of Florida Press, Gainesville, Fl., 1992; Thomas P. Slaughter, *The Natures of John and William Bartram*, Alfred A. Knopf, New York, 1996; and Nancy E. Hoffmann & John C. Van Horn (eds), *America's Curious Botanist: a tercentennial reappraisal of John Bartram 1699–1777*, The American Philosophical Society, Philadelphia, Pa., 2004. See also John Dixon Hunt (ed.), 'Bartram's Garden Catalogue of North American Plants 1783', special issue of *Journal of Garden History*, 16 (1), January–March 1996. For Catesby see *The Natural History of Carolina, Florida and the Bahama Islands ... by the late Mark Catesby, F.R.S. with an introduction by George Frick and notes by Joseph Ewan*, The Beehive Press, Savannah, Georgia, 1974.

15: The Cape Unveiled

M. Gunn & L.E. Codd, *Botanical Exploration of Southern Africa*, A.A. Balkema, Cape Town, 1981, include a comprehensive treatment of this period and its colonial botanical masters. See also W.J. de Kock & D.W. Krüger (eds), *Dictionary of South African Biography*, Tafelberg-Uitgewers, Cape Town and Johannesburg, 1972, for key individuals. This period is also covered by John Rourke's chapter 'Beauty in Trust: botanical art in southern Africa—a brief historical perspective', in Marion Arnold (ed.), *South African Botanical Art: peeling back the petals*, Fernwood Press in association with Art Link, Vlaeberg, South Africa, 2001; Coats, *The Quest for Plants* (1969), pp. 250–65; and Elliott, *Flora* (2001), chapter 3 ('Africa'). The gradual charting of Africa and the seaborne route to the East Indies is cartographically treated in Kenneth Nebenzahl, *Mapping the Silk Road and Beyond: 2,000 years of exploring the East*, Phaidon Press, London, 2004. English Army officer Cowper Rose penned the 'half way house' quote in his book *Four Years in Southern Africa* (London, 1829), p. 4 (quoted in Susan Hunt, *Cape Town: Half-way to Sydney 1788–1870. Treasures from the Brenthurst Library, Johannesburg*, Historic Houses Trust of New South Wales, Sydney, 2005).The 'elegant thistle' story is related in Gunn & Codd, p. 13, and that of the Guernsey lily is related in Blunt & Stearn, *The Art of Botanical Illustration* (1994), p. 113. The story of Gouarus de Keyser is

related by Gunn & Codd, pp. 14–15, who reproduce the relevant page (p. 503) from Mathias de Lobel, *G. Rondelletii ... methodicam pharmaceuticam officinam animadversiones* (London, 1605). Gunn & Codd (p. 21) also reproduce the first known illustration of *Zantedeschia aethiopica* from Guy de la Brosse, *Recueil des plantes du Jardin du Roi* (Paris, *c.* 1644). The history of zonal pelargoniums is given by William Stearn in Quinby & Stevenson's Hunt catalogue, volume 2, p. lii. See also William J. Webb, *The Pelargonium Family: the species of Pelargonium, Monsonia and Sarcocaulon*, Croom Helm, London and Sydney, 1984. Bradley's book and the Cape succulent flora generally are well covered by Gordon Douglas Rowley, *A History of Succulent Plants*, Strawberry Press, Mill Valley, California, 1997, especially chapters 7 and 10. Rowley speculates that disincornufistibilation is the state of being not without a hornpipe. An engaging account of seventeenth-century Dutch history is Simon Schama, *The Embarrassment of Riches: an interpretation of Dutch culture in the Golden Age*, Alfred A. Knopf, New York, 1997. The botanic gardens at Amsterdam and Leiden are discussed by William Stearn in his essay 'Botanical Gardens and Botanical Literature in the Eighteenth Century', in the second volume of Quinby & Stevenson's Hunt catalogue (1958–61). The history of the Company's Garden at Cape Town is traced in Mia Karsten, *The Old Company's Garden at the Cape and its Superintendents, involving an historical account of early Cape botany*, Maskew Miller, Cape Town, 1951. For the Commerlins see D.O. Wijnands, *The Botany of the Commerlins: a taxonomical, nomenclatural and historical account of the plants depicted in the Moninckx Atlas and in the four books by Jan and Caspar Commerlin on the plants in the Hortus Medicus Amstelodamensis 1682–1710*, A.A. Balkema, Rotterdam, 1983. For Ten Rhyne, see I. Schapera (ed.), I. Schapera & B. Farrington (trans.), *The Early Cape Hottentots Described in the Writings of Olfert Dapper (1668), Willem Ten Rhyne (1686), and Johannes Gulielmus de Grevenbroek (1695)*, The Van Riebeeck Society, Cape Town, 1933, from which the translated quotes are taken (pp. 89, 97).

16: Taking Stock

See Greene, *Landmarks of Botanical History* (1983), especially Greene's chapter 'Introduction to the Philosophy of Botanical History' (pp. 93–119). Although published too late to influence my text, the background to this chapter is analysed in detail in Pavord, *The Naming of Names* (2005). On botanic gardens see John Prest, *The Garden of Eden: the botanic garden and the re-creation of paradise*, Yale University Press, New Haven and London, 1981, and William Stearn's essay 'Botanical Gardens and Botanical Literature in the Eighteenth Century' in Quinby & Stevenson's Hunt catalogue, volume 2, pp. xli–cxl. For Hooke see Robert E. Krebs, *Groundbreaking Scientific Experiments, Inventions, and Discoveries of the Middle Ages and the*

Renaissance, Greenwood Press, Westport, Conn., and London, 2004, p. 217. For Linnaeus see Wilfrid Blunt, *The Compleat Naturalist: a life of Linnaeus*, Frances Lincoln, London, 2001; Frans A. Stafleu, *Linnaeus and the Linnaeans: the spreading of their ideas in systematic botany, 1735–1789*, A. Oosthoek's Uitgeversmaatschappij N.V., Utrecht, 1971; and Lisbet Koerner, *Linnaeus: nature and nation*, Harvard University Press, Cambridge, Mass., and London, 1999. For *Flora Graeca* see H. Walter Lack & David J. Mabberley, *The Flora Graeca Story: Sibthorp, Bauer, and Hawkins in the Levant*, Oxford University Press, Oxford, 1999. Pritzel, *Thesaurus literaturae botanicae ...* (1851) and Nissen, *Die Botanische Buchillustration ihre Geschichte und Bibliographie* (1951) both give useful thematic listings of floras. For a brief explanation of nature printing and its use in the *Physiotypia plantarum Austriacarum* see Blunt & Stearn, *The Art of Botanical Illustration* (1994), pp. 156–8.

PART III: SCIENTIFIC IMPERIALISM AND EXOTIC BOTANY

I found the following works useful as background: Richard H. Grove, *Green Imperialism: colonial expansion, tropical island Edens, and the origins of environmentalism, 1600–1860*, Cambridge University Press, Cambridge, 1995; Tony Rice, *Voyages of Discovery: three centuries of natural history exploration*, Scriptum Editions and The Natural History Museum, London, 1999; and Kim Sloan (ed.), *Enlightenment: discovering the world in the eighteenth century*, The British Museum, London, 2003. Although published too late to influence my text, Londa Schiebinger & Claudia Swan (eds), *Colonial Botany: science, commerce, and politics in the early modern world*, University of Pennsylvania Press, Philadelphia, Pa., 2005, contains much useful detail on the period under review. Sir Joseph Banks is a pivotal figure in scientific imperialism, and two recent studies by John Gascoigne place him in this context: *Joseph Banks and the English Enlightenment: useful knowledge and polite culture*, Cambridge University Press, Cambridge, 1994, and *Science in the Service of Empire: Joseph Banks, the British state and the uses of science in the age of revolution*, Cambridge University Press, Cambridge, 1998. For a general British perspective on this subject see Lucile H. Brockway, *Science and Colonial Expansion: the role of the British Royal Botanic Gardens*, Academic Press, New York and London, 1979; Donal P. McCracken, *Gardens of Empire: botanical institutions of the Victorian British Empire*, Leicester University Press, London and Washington, 1997; and Musgrave & Musgrave, *An Empire of Plants* (2000). For a French perspective, see Roger L. Williams, *Botanophilia in Eighteenth-Century France: the spirit of the Enlightenment*, Kluwer Academic Publishers, Dordrecht, 2001, and Roger L. Williams, *French Botany in the Enlightenment: the ill-fated voyages of La Pérouse and his rescuers*, Kluwer Academic Publishers, Dordrecht, 2003.

17: The Reach of Empire

The references listed under Part III above apply equally to this chapter. Bligh's quote is from p. 5 of his book *A Voyage to the South Sea, undertaken by command of His Majesty, for the purpose of conveying the bread-fruit to the West Indies, in His Majesty's ship The Bounty, commanded by Lieutenant William Bligh ...*, George Nicol, London, 1792. J.D. Hooker's quote, from *Hooker's Journal of Botany and Kew Garden Miscellany*, 1 (1849), is reproduced in Short, *In Pursuit of Plants* (2003), p. 61. The quote on floras is from D. Oliver, *Flora of Tropical Africa*, L. Reeve, London, p. i. The dating of the origin of the world is discussed in Simon Winchester, *The Map that Changed the World: the tale of William Smith and the birth of a science*, Viking, London, 2001, chapter 2. For a summary of the career of Redouté see George H.M. Lawrence (ed.), *A Catalogue of Redoutéana*, Hunt Botanical Library, Carnegie Institute of Technology, Pittsburgh, Pa., 1963, and Blunt & Stearn, *The Art of Botanical Illustration* (1994), chapter 14. For Roscoe, see entry by Donald A. Macnaughton in H.C.G. Matthew & Brian Harrison (eds), *Oxford Dictionary of National Biography*, Oxford University Press, Oxford, 2004, volume 47, pp. 735–8.

18: New Holland and the South Pacific

Exploration of Australia is covered by many texts: I have relied upon a special issue of the *La Trobe Journal*, XI (41), Autumn 1988, entitled 'The Great South Land', catalogue to an exhibition at the State Library of Victoria of books relating to the European discovery and exploration of Australia. For a general account of plant collecting see Coats, *The Quest for Plants* (1969), pp. 210–41 ('The Antipodes'), and Jill, Duchess of Hamilton & Julia Bruce, *The Flower Chain: the early discovery of Australian plants*, Kangaroo Press, East Roseville, NSW, 1998. For Dampier see Alex S. George, *William Dampier in New Holland: Australia's first natural historian*, Bloomings Books, Hawthorn, Vic., 1999. Amongst many books on Banks, his travels and his influence, see Brian Adams, *The Flowering of the Pacific: being an account of Joseph Banks' travels in the South Seas and the story of his Florilegium*, William Collins, Sydney, 1986; P. O'Brien, *Joseph Banks, A Life*, Collins Harvill, London, 1987; H.B. Carter, *Sir Joseph Banks*, British Museum (Natural History), London, 1988; R.E.R. Banks, B. Elliott, D. King-Hele, J.G. Hawkes & G.L.L. Lucas (eds), *Sir Joseph Banks: a global perspective*, Royal Botanic Gardens, Kew, London, 1994; and Musgrave, Gardner & Musgrave, *The Plant Hunters* (1998), chapter 1. European perceptions of the South Pacific are analysed in Bernard Smith, *European Vision and the South Pacific*, 2nd edn., Yale University Press, New Haven, 1985. See also Kim Sloan (ed.), *Enlightenment: discovering the world in the eighteenth century*, The British Museum, London, 2003, Part II ('The Natural World'). A key reference for this chapter is the series of papers collected in P.S. Short (ed.), *History*

of *Systematic Botany in Australasia: proceedings of a symposium held at the University of Melbourne, 25–27 May 1988*, Australian Systematic Botany Society Inc., South Yarra, Vic., 1990. Illustration of the Australian flora is treated in Helen Hewson, *Australia: 300 years of botanical illustration*, CSIRO Publishing, Collingwood, Vic., 1999. For local use of Australian plants see various entries in Richard Aitken & Michael Looker (eds), *The Oxford Companion to Australian Gardens*, Oxford University Press in association with the Australian Garden History Society, South Melbourne, Vic., 2002, and George Seddon, *The Old Country: Australian landscapes, plants and people*, Cambridge University Press, Cambridge, 2005. The main source for the horticultural use of Australian plants in Britain is a series of papers by Tony Cavanagh: 'Australian Plants Cultivated in England 1771–1800' in Short (ed.), pp. 273–83; 'Cultivation of Australian Plants in the Old World [1801–25]', *Seminar Papers: 17th Biennial Seminar, Robert Menzies College, Sydney, 27 September to 1 October 1993*, Association of Societies for Growing Australian Plants, n.p., n.d., pp. 5–17; and 'Bizarre and Beautiful—Australian plants in England 1826–1855', *The Brilliance of Australian Plants: Conference Papers, Ballarat 1995*, Association of Societies for Growing Australian Plants, n.p., n.d., pp. 14–26. On late eighteenth- and early nineteenth-century French interest in the Australian flora see Jill, Duchess of Hamilton, *Napoleon, the Empress & the Artist: the story of Napoleon, Josephine's garden at Malmaison, Redouté & the Australian plants*, Kangaroo Press, East Roseville, NSW, 1999. Charles-Louis L'Héritier de Brutelle, *Sertum Anglicum ...* [English Garland of Flowers], Typis Petri-francisci Didot, Paris, 1788, is available in a facsimile edition with introduction from Hunt Botanical Library, Pittsburgh, Pa., 1963, which includes a discussion on the significance of this work. The three early French publications mentioned in passing are E.-P. Ventenat, *Description des Plantes Nouvelles et peu connues cultivées dans le jardin de J.M. Cels*, Crapelet, Paris, 1800–03; Ventenat, *Jardin de la Malmaison*, L.É. Herhan, Paris, 1804; and Aimé Bonpland, *Description des plantes rares cultivées à Malmaison et à Navarre* , P. Didot l'aîné, Paris, 1813. Praise for the Kowhai is from the *Botanical Magazine* (volume 5, 1791), plate 167, commenting on the flowering specimen in the Chelsea Physic Garden, planted in 1774. Waratah lore is amply covered in Rosie Nice (ed.), *State of the Waratah: the floral emblem of New South Wales in legend, art & industry, an illustrated souvenir*, Royal Botanic Gardens, Sydney, 2000. Early history of Sturt's Desert Pea is given in *Curtis's Botanical Magazine* (volume 84, 1858) in the text accompanying plate 5051. The pithy summary by Andrews on the convict/flora quotient is from his *Botanist's Repository*, accompanying plate 569 (volume 9, 1809), quoted by botanical historian E. Charles Nelson in Short (ed.), pp. 292–3. For Bauer see David J. Mabberley, *Ferdinand Bauer: the nature of discovery*, Merrell Holberton Publishers and The Natural History Museum, London, 1999.

For Parkinson see D.J. Carr (ed.), *Sydney Parkinson, Artist of Cook's Endeavour Voyage*, British Museum (Natural History) in association with Croom Helm, London and Canberra, 1983. For Paterson (in the Cape and Australasia) see Vernon S. Forbes & John Rourke, *Paterson's Cape Travels 1777 to 1779*, The Brenthurst Press, Johannesburg, 1980.

19: Erica-mania

This period is covered in Coats, *The Quest for Plants* (1969), pp. 250–65 and Musgrave, Gardner & Musgrave, *The Plant Hunters* (1998), chapter 2. M. Gunn & L.E. Codd, *Botanical Exploration of Southern Africa*, A.A. Balkema, Cape Town, 1981, is concerned primarily with botanical history, and they conclude their narrative just prior to this era of collecting, but include biographical notes on Masson, Sparmann, Thunberg, Scholl, and Burchell, amongst others, in a lengthy appendix. See also relevant entries in W.J. de Kock & D.W. Krüger (eds), *Dictionary of South African Biography*, Tafelberg-Uitgewers, Cape Town and Johannesburg, 1972. Masson's account is available in a modern edition with introduction and annotations by F.R. Bradlow (ed.), *Francis Masson's Account of Three Journeys at the Cape of Good Hope, 1772–1775*, Tablecloth Press, Cape Town, 1994. For Thunberg and Sparrman respectively see V.S. Forbes (ed.), J. & I. Rudner (trans.), *Carl Peter Thunberg: Travels at the Cape of Good Hope 1772–1775*, Van Riebeeck Society, Cape Town, 1986, and V.S. Forbes (ed.), J. & I. Rudner (trans.), *Anders Sparrman: A Voyage to the Cape of Good Hope ... from the Year 1772–1776*, 2 volumes, Van Riebeeck Society, Cape Town, 1975–77, both of which contain extensive scholarly appendices. Henry Andrews is an elusive figure, and the known facts are assembled by Susanna Avery-Quash in Matthew & Harrison (eds), *Oxford Dictionary of National Biography* (2004), volume 2, pp. 123–4. For *Plantarum historia succulentarum* see George H.M. Lawrence (ed.), *A Catalogue of Redoutéana*, Hunt Botanical Library, Carnegie Institute of Technology, Pittsburgh, Pa., 1963 and G.D. Rowley, 'Pierre-Joseph Redouté—'Raphael of the Succulents', in *Cactus and Succulent Journal of Great Britain*, 18, 1956–57. For the relationship between Redouté and van Spaëndonck see Blunt & Stearn, *The Art of Botanical Illustration* (1994), chapter 14. For Hibbert see the entry by David Hancock in the *Oxford Dictionary of National Biography*, volume 26, pp. 993–4, and Desmond, *Dictionary of British and Irish Botanists and Horticulturalists including Plant Collectors, Flower Painters and Garden Designers* (1994), p. 339. Loudon's praise of Hibbert is quoted by Desmond from his *Encyclopaedia of Gardening* (London, 1822), p. 84. Andrews is quoted from the introduction to *Geraniums* in W.P. Watson (comp.), *A Magnificent Collection of Botanical Books being the finest colour-plate books from the celebrated library formed by Robert de Belder*, Sotheby's, London, 1987, p. 15. For Burchell see the entry by John Dickenson in the *Oxford Dictionary of National Biography*, volume 18, pp. 727–8.

20: Anglo-India and the Dutch East Indies

For India, see Ray Desmond, *The European Discovery of the Indian Flora*, Royal Botanic Gardens, Kew, in association with Oxford University Press, Oxford, 1992. There is no equivalent volume for the East Indies generally, but I was greatly assisted in an understanding of the region's history by Robert Cribb, *Historical Atlas of Indonesia*, Curzon Press, Richmond, Surrey, 2000. The history of *Rhododendron arboreum* is given by Desmond, *The European Discovery of the Indian Flora* (1992), pp. 303–4. On the history of rhododendrons generally see Jane Brown, *Tales of the Rose Tree: ravishing rhododendrons and their travels around the world*, HarperCollins*Publishers*, London, 2004. The relevant papers on plant transport are William Roxburgh, 'Directions for taking Care of Growing Plants at Sea', *Transactions Royal Society of Arts*, volume 27, 1809, pp. 236–38; and Nathaniel Wallich, 'Upon the Preparation and Management of Plants during a Voyage from India', *Transactions of the Horticultural Society of London*, second series, volume 1, 1835, pp. 140–3. For Wallich see Desmond, *Dictionary of British and Irish Botanists and Horticulturists including Plant Collectors, Flower Painters and Garden Designers* (1994), pp. 713–14. For J.D. Hooker see Ray Desmond, *Sir Joseph Dalton Hooker: Traveller and Plant Collector*, Antique Collectors' Club with The Royal Botanic Gardens, Kew, Woodbridge, Suffolk, 1999, and Musgrave, Gardner & Musgrave, *The Plant Hunters* (1998), chapter 4. Little has been published (in English) on the career of Karl Ludwig Blume. After his stint in Java he became director of the Leiden Rijksherbarium—see Stafleu & Cowan, *Taxonomic Literature* (1976–88). Blume's major works are *Flora Java* (3 volumes, Brussels, 1828–51); *Rumphia* (4 volumes, Leiden, 1835–49); and *Orchidées* (Amsterdam, 1858–9). The sighting of *Rafflesia arnoldii* is given in abbreviated form in Short, *In Pursuit of Plants* (2003), pp. 47–50. For Makassan trade with Australia, see Cribb, *Historical Atlas of Indonesia* (2000), p. 110, and David Horton (ed.), *The Encyclopaedia of Aboriginal Australia: Aboriginal and Torres Strait Islander history, society and culture*, Aboriginal Studies Press for the Australian Institute of Aboriginal and Torres Strait Islander Studies, Canberra, 1994, pp. 638–9.

21: North America's Western Frontier

Two complementary books treat plants being transferred to and from North America: James L. Reveal, *Gentle Conquest: the botanical discovery of North America with illustrations from the Library of Congress*, Starwood Publishing, Inc., Washington, DC, 1992, and Stephen A. Spongberg, *A Reunion of Trees: the discovery of exotic plants and their introduction into North American and European landscapes*, Harvard University Press, Cambridge, Mass., 1990, especially chapters 3 and 4. The North American tree flora is treated historically and bibliographically in Raphael (1989).

See also Coats, *The Quest for Plants* (1969), pp. 293–327 ('North America: the western states'). For Menzies see the introduction by W. Kaye Lamb to the recent edition of George Vancouver, *A Voyage of Discovery to the North Pacific Ocean and Round the World, 1791–1795*, Hakluyt Society, London, 1984. For Lewis and Clark see Susan H. Munger, *Common to this Country: botanical discoveries of Lewis and Clark*, Artisan, New York, 2003. For Poinsett see the entry by J. Fred Rippy in Dumas Malone (ed.), *Dictionary of American Biography*, Oxford University Press, London, volume 15, 1935, pp. 30–2. There are several biographies of David Douglas, the most recent of which is Ann Lindsay Mitchell & Syd House, *David Douglas: explorer and botanist*, Aurum Press, London, 1999, which contains a useful appendix listing Douglas introductions. For Nuttall see J.E. Graunstein, *Thomas Nuttall: naturalist*, Harvard University Press, Cambridge, Mass., 1967. On buffalo grass see *Gardeners' Chronicle*, 15 July 1871, p. 901. Engelmann's *Cactaceae of the Boundary* (1859) was included in *Report on the United States and Mexican Boundary Survey, under the order of W.H. Emory*, Washington, 1859, and reprinted in edited form in William Trelease & Asa Gray (eds), *The Botanical Works of the late George Englemann collected for Henry Shaw Esq.*, John Wilson and Son, Cambridge, Mass., 1887.

22: Central and South America

For a general introduction see Coats, *The Quest for Plants* (1969), pp. 328–52 ('Mexico and the Spanish Main') & pp. 352–77 ('South America'). For cinchona see references listed under notes to Chapter 1. For the role of Spanish botanist Cavanilles, see Francisco Pelayo & Ricardo Garilleti, 'Spanish Botany during the Age of Enlightenment', *Huntia*, 9 (1), 1993. The plants Humboldt claims as introductions to Europe are listed in the introduction to his *Personal Narrative of Travels to the Equinoctial Regions of the New Continent, during the Years 1799–1804 ... translated into English by Helen Maria Williams*, volume 1, Longman, Hurst, Rees, Orme and Brown, London, 1818. Humboldt's quote is related in Coats, p. 338. Of the many books on Charles Darwin, one of the most readable is Adrian Desmond & James Moore, *Darwin*, Michael Joseph, London, 1991. See also *The Works of Charles Darwin*, edited by Paul H. Barrett & R.B. Freeman, Pickering & Chatto, London, 1986–89. For the Monkey Puzzle and other Lobb introductions from South America see Musgrave, Gardner & Musgrave, *The Plant Hunters* (1998), chapter 6.

23: Piercing the Oriental Armour

For a general overview see Coats, *The Quest for Plants* (1969), pp. 62–85 ('Japan') and pp. 86–141 ('China'); Peter Valder, *The Garden Plants of China*, Florilegium, Balmain, NSW, 1999; and Emil Bretschneider, *History of European Botanical Discoveries in China*, Sampson Low, Marston and Co., London, 1898 (reprinted Zentral-

Antiquariat, Leipzig, 1962). On opium see Musgrave & Musgrave, *An Empire of Plants* (2000), chapter 5. The role of the Horticultural Society of London is derived especially from Brent Elliott, *The Royal Horticultural Society: a history 1804–2004*, Phillimore, Chichester, West Sussex, 2004, chapter 11, from whence the instructions to Robert Fortune are quoted. For Fortune, see Musgrave, Gardner & Musgrave, *The Plant Hunters* (1998), chapter 5. On tea see Alan Macfarlane & Iris Macfarlane, *Green Gold: the empire of tea*, Ebury, London, 2003. Mrs Earle's quote is from her *Pot-pourri from a Surrey Garden*, Smith, Elder & Co., 17th edn., London, 1899, p. 229. On Chinese plants to Australia see Peter Valder, 'China', in Richard Aitken & Michael Looker (eds), *The Oxford Companion to Australian Gardens*, Oxford University Press in association with the Australian Garden History Society, South Melbourne, Vic., 2002, pp. 138–9.

24: Commerce and the Insatiable Taste for Novelty

For a general overview see Hobhouse, *Plants in Garden History* (1992), pp. 222–55 ('Expansion and experiment in the nineteenth century'). The history of *Curtis's Botanical Magazine* is given in W. Botting Hemsley, *A New and Complete Index to the Botanical Magazine ... to which is prefixed a history of the magazine*, Lovell, Reeve & Co., London, 1906, and Ray Desmond, *A Celebration of Flowers: two hundred years of Curtis's Botanical Magazine*, Royal Botanic Gardens, Kew, London, 1987. Thornton's criticism of Curtis is contained in his 'Sketch of the Life and Writings of the Late Mr William Curtis. By Dr Thornton' (p. 21), which accompanied volume 3 of *Lectures on Various Subjects ... by the late William Curtis ...*, Printed for H.D. Symonds and Curtis, London, 1805. There are several histories of large London nursery firms, including David Solman, *Loddiges of Hackney: the largest hothouse in the world*, The Hackney Society, London, 1995; and the story of the Veitch nurseries by Sue Shephard, *Seeds of Fortune: a gardening dynasty*, Bloomsbury, London, 2003. See also the three books by E.J. Willson: *James Lee and the Vineyard Nursery, Hammersmith*, Hammersmith Local History Group, London, 1961; *West London Nursery Gardens, the nursery gardens of Chelsea, Fulham, Hammersmith, Kensington and a part of Westminster, founded before 1900*, Fulham and Hammersmith Historical Society, 1982; *'Nurserymen to the World': the nursery gardens of Woking and North-West Surrey, and the plants introduced by them*, The author, London, 1989. The role of women as botanical illustrators is discussed in Jack Kramer, *Women of Flowers: a tribute to Victorian women illustrators*, Stewart, Tabori & Chang, New York, 1996. For the Lobbs see Musgrave, Gardner & Musgrave, *The Plant Hunters* (1998), chapter 6. On techniques of collecting and modes of plant transport see Whittle, *The Plant Hunters* (1970), part 2; and 'The Wardian Case' in Short, *In Pursuit of Plants* (2003), pp. 329–34.

25: Wollemi Dreaming

For an overview see Coats, *The Quest for Plants* (1969), especially pp. 110–41. For details of late nineteenth-century botanical discoveries in China see Emil Bretschneider, *History of European Botanical Discoveries in China*, Sampson Low, Marston and Co., London, 1898 (reprinted Zentral-Antiquariat, Leipzig, 1962). For examples of plant hunting in the twentieth century see F. Nigel Hepper, *Plant Hunting for Kew*, HMSO, London, 1989. For Henry see the introduction by Charles Nelson to the recent edition of Augustine Henry, *Notes on Economic Botany of China*, (1st edn., 1893), Boethius Press, Kilkenny, 1986. For Wilson see Roy W. Briggs, *Chinese Wilson: life of Ernest H. Wilson, 1876–1930*, HMSO, London, 1993, and Musgrave, Gardner & Musgrave, *The Plant Hunters* (1998), chapter 7. For Forrest see Brenda McLean, *George Forrest: plant hunter, 1870–1932*, Antique Book Collectors' Club, Woodbridge, Suffolk, 2004, and Musgrave, Gardner & Musgrave, *The Plant Hunters* (1998), chapter 8. For Kingdon Ward see Musgrave, Gardner & Musgrave, *The Plant Hunters* (1998), chapter 9, as well as the strong biographical element revealed in his own books. Several of the quotes are from Kingdon Ward's *The Romance of Plant Hunting*, Edward Arnold, London, 1924, p. 6 ('plant socialism'), p. 157 ('smashing blue'), & p. 244 ('drab lawns'). For Farrer see John Illingworth & Jane Routh (eds), *Reginald Farrer: Dalesman, planthunter, gardener*, University of Lancaster, Lancaster, 1991, and Nicola Shulman, *A Rage for Rock Gardening: the story of Reginald Farrer, gardener, writer and plant collector*, Short Books, London, 2002. For Fitch see Blunt & Stearn, *The Art of Botanical Illustration*, chapter 20, and Ray Desmond, *A Celebration of Flowers: two hundred years of Curtis's Botanical Magazine*, Royal Botanic Gardens, Kew, London, 1987. For Stones see Irena Zdanowicz, *Beauty in Truth: the botanical art of Margaret Stones*, National Gallery of Victoria, Melbourne, 1996. The story of Banks' Florilegium is told in Brian Adams, *The Flowering of the Pacific: being an account of Joseph Banks' travels in the South Seas and the story of his Florilegium*, William Collins, 1986. The great portfolio of coloured impressions was published by J.A. Diment & C.J. Humphries (eds), *Banks' Florilegium*, Alecto Historical Editions in association with the British Museum (Natural History), London, 1980–88. On the discovery of the Wollemi pine see James Woodford, *The Wollemi Pine: the incredible discovery of a living fossil from the age of the dinosaurs*, Text Publishing, Melbourne, 2000.

Select Bibliography

Anderson, Frank J., *An Illustrated History of the Herbals*, Columbia University Press, New York, 1977.

Arber, Agnes, *Herbals, Their Origin and Evolution: a chapter in the history of botany 1470–1670*, rev. edn, Cambridge University Press, Cambridge, 1986.

Blackburne-Maze, Peter, *Fruit: an illustrated history*, Scriptum Editions in association with the Royal Horticultural Society, London, 2002.

Blunt, Wilfrid & Raphael, Sandra, *The Illustrated Herbal*, Frances Lincoln Publishers, London, 1979.

Blunt, Wilfrid & Sitwell, Sacheverell, *Great Flower Books 1700–1900: a bibliographical record of two centuries of finely illustrated flower books*, Collins, London, 1956.

Blunt, Wilfrid & Stearn, William T., *The Art of Botanical Illustration*, Collins, London, 1950; rev. edn, Antique Collectors' Club in association with The Royal Botanic Gardens, Kew, Woodbridge, Suffolk, 1994.

Byers, Laura Ten Eyck, *Hortus Librorum: early botanical books at Dumbarton Oaks*, Dumbarton Oaks Research Library Association, Washington, DC, 1983.

Campbell-Culver, Maggie, *The Origins of Plants: the plants and people that have shaped Britain's garden history since the year 1000*, Headline Book Publishing, London, 2001.

Coats, Alice M., *The Quest for Plants: a history of the horticultural explorers*, Studio Vista, London, 1969 (also published as *The Plant Hunters: being a history of the horticultural pioneers, their quests and their discoveries from the Renaissance to the twentieth century*, McGraw-Hill Book Company, New York, 1970).

Collins, John (comp.), *The Magnificent Botanical Library of the Stiftung fur Botanik Vaduz Liechtenstein Collected by the late Arpad Plesch*, 3 vols, Sotheby & Co., London, 1975–76.

Desmond, Ray, *Dictionary of British and Irish Botanists and Horticulturists including Plant Collectors, Flower Painters and Garden Designers*, Taylor & Francis and The Natural History Museum, London, 1994.

Dunthorne, Gordon, *Flower and Fruit Prints of the 18th and Early 19th Centuries: their history, makers and uses, with a catalogue raisonné of the works in which they are found*, Dulau & Co., London, 1938.

Elliott, Brent, *Flora: an illustrated history of the garden flower*, Scriptum-Cartago in association with The Royal Horticultural Society, London, 2001.

Gillispie, Charles Coulston (ed.), *Dictionary of Scientific Biography*, Charles Scribner's Sons, New York, 1970–80.

Greene, Edward Lee, *Landmarks of Botanical History* (1st edn, 1909), new edition prepared for the Hunt Institute for Botanical Documentation by Frank N. Egerton (ed.), Stanford University Press, Stanford, California, 1983.

Grimshaw, John, *The Gardener's Atlas: the origins, discovery, and cultivation of the world's most popular garden plants*, Reader's Digest, Surry Hills, NSW, 1998.

Hobhouse, Henry, *Seeds of Change: six plants that transformed mankind*, (1st edn, 1985), rev. edn, Macmillan, London, 1999.

——*Seeds of Wealth: four plants that made men rich*, Macmillan, London, 2003.

Hobhouse, Penelope, *Plants in Garden History*, Pavilion Books, London, 1992.

——*The Story of Gardening*, Dorling Kindersley, London, 2002.

Howgego, Raymond John, *Encyclopaedia of Exploration to 1800: a comprehensive reference guide to the history and literature of exploration, travel and colonization from the earliest times to the year 1800*, Hordern House, Potts Point, NSW, 2003.

Janson, H. Frederic, *Pomona's Harvest: an illustrated chronicle of antiquarian fruit literature*, Timber Press, Portland, Oregon, 1996.

Jellicoe, Geoffrey and Susan, Goode, Patrick & Lancaster, Michael, *The Oxford Companion to Gardens*, Oxford University Press, Oxford, 1986.

Knapp, Sandra, *Plant Discoveries: a botanist's voyage through plant exploration*, Scriptum Editions in association with the National History Museum, London, 2003.

Kochhar, S.L., *Economic Botany in the Tropics*, 2nd edn, Macmillan India, Delhi, 1998.

Lawson, Russell M., *Science in the Ancient World: an encyclopaedia*, ABC-CLIO, Santa Barbara, California, 2004.

Lemmon, Kenneth, *The Golden Age of Plant Hunters* J.M. Dent, London, 1968.

Matthew, H.C.G. & Harrison, Brian (eds), *Oxford Dictionary of National Biography*, Oxford University Press, Oxford, 2004.

Morley, Brian & Everard, Barbara, *Wild Flowers of the World*, Ebury Press and Michael Joseph, London, 1970.

Musgrave, Toby, Gardner, Chris & Musgrave, Will, *The Plant Hunters: two hundred years of adventure and discovery around the world*, Ward Lock, London, 1998.

Musgrave, Toby & Musgrave, Will, *An Empire of Plants: people and plants that changed the world*, Cassell & Co., London, 2000.

Nissen, Claus, *Die Botanische Buchillustration ihre Geschichte und Bibliographie*, Hiersemann Verlags-Gesellschaft m.b.H., Stuggart, 1951.

——*Herbals of Five Centuries: a contribution to medical history and bibliography*, L'Art Ancien S.A. Antiquariat, Zurich, 1958.

Pavord, Anna, *The Naming of Names: the search for order in the world of plants*, Bloomsbury, London, 2005.

Perry, Frances & Greenwood, Leslie, *Flowers of the World*, Hamlyn, London, 1972.

Prance, Ghillean & Nesbitt, Mark (eds), *The Cultural History of Plants*, Routledge, New York and London, 2005.

Pritzel, G.A., *Thesaurus literaturae botanicae ...*, F.A. Brockhaus, Leipzig, 1851.

——*Iconum botanicarum index locupletissimus ...*, 2 vols, Nicolaische Verlagbuchhandlung, Berlin, 1866.

Quinby, Jane & Stevenson, Allan, *Catalogue of Botanical Books in the Collection of Rachel McMasters Miller Hunt*, The Hunt Botanical Library, Pittsburgh, Pa., 1958–61.

Raphael, Sandra, *An Oak Spring Sylva: a selection of the rare books on trees in the Oak Spring Garden Library*, Oak Spring Garden Library, Upperville, Virginia, 1989.

Rix, Martyn, *The Art of the Botanist*, Lutterworth Press, Guildford and London, 1981 (also published as *The Art of the Plant World*, Overlook Press, Woodstock, NY, 1980).

Roberts, J.M. *Ancient History: from the first civilizations to the Renaissance*, Oxford University Press, New York, 2004.

Saunders, Gill, *Picturing Plants: an analytical history of botanical illustration*, Zwemmer in association with the Victoria and Albert Museum, London, 1995.

Short, Philip, *In Pursuit of Plants: experiences of nineteenth & twentieth century plant collectors*, University of Western Australia Press, Crawley, WA, 2003.

Stafleu, Frans A. & Cowan, Richard S., *Taxonomic Literature: a selective guide to botanical publications and collections with dates, commentaries and types*, 2nd edn, Bohn, Scheltema & Holkema, Utrecht, 1976–88 (and supplementary volumes, 1992–).

Stuart, David, *The Plants that Shaped our Gardens*, Frances Lincoln, London, 2002.

——*Dangerous Gardens: the quest for plants to change our lives*, Frances Lincoln, London, 2004.

Tomasi, Lucia Tongiorgi, *An Oak Spring Flora: flower illustration from the fifteenth century to the present time. A selection of the rare books, manuscripts and works of art in the collection of Rachel Lambert Mellon*, Oak Spring Garden Library, Upperville, Virginia, 1997.

Watson, W.P. (comp.), *A Magnificent Collection of Botanical Books being the finest colour-plate books from the celebrated library formed by Robert de Belder*, Sotheby's, London, 1987.

Whittle, Tyler, *The Plant Hunters: being an examination of collecting with an account of the careers & the methods of a number of those who have searched the world for wild plants*, Heinemann, London, 1970.

List of Illustrations

12: Imperial Tales of the Near East

13: Exploring the Far East

14: European Colonisation of the Americas

15: The Cape Unveiled

16: Taking Stock

Index

Page numbers given in bold refer to illustrations

LH

LUND HUMPHRIES

This book was designed and typeset by Pfisterer + Freeman
The text was set in 10 point Minion
with 3½ points of leading
The text is printed on 128gsm matt art

This book was edited by Clare Coney